IWO JIMA

To Lou Lowery, who got there first, — a helluva Marine and a great guy. all the best from lucky
Joe Rosenthal

KARAL ANN MARLING
AND JOHN WETENHALL

★★★★★★★★★★★★★★★★★★★★★★★★★★★★★

IWO JIMA

★★★★★★★★★★★★★★★★★★★★★★★★★★★★★

Monuments, Memories, and the American Hero

HARVARD UNIVERSITY PRESS
Cambridge, Massachusetts
London, England
1991

Library of Congress Cataloging-in-Publication Data

Marling, Karal Ann.
 Iwo Jima : monuments, memories, and the American hero /
Karal Ann Marling, John Wetenhall.
 p. cm.
 Includes bibliographical references and index.
 ISBN 0-674-46980-1 (alk. paper)
 1. Iwo Jima, Battle of, 1945. 2. Propaganda, American—
History—20th century. I. Wetenhall, John. II. Title.
D767.99.I9M28 1991
940.54′26—dc20 90-42283
 CIP

Frontispiece: The Pulitzer Prize-winning picture of the Iwo
Jima flag-raising, inscribed by photographer Joe Rosenthal
to Lou Lowery, the man who shot the first flag-raising on
Mount Suribachi that day.

Designed by Gwen Frankfeldt

For those who served on Iwo Jima

Contents

IWO JIMA

Among the Americans who served on Iwo island, uncommon valor was a common virtue.

Admiral Chester W. Nimitz, communiqué of March 16, 1945, later inscribed on the base of the Marine Corps War Memorial, Washington, D.C.

Uncommon Valor

The sky was a brilliant blue. The wind that ruffled the manicured turf of the hillock on the flank of Arlington National Cemetery was cold, bitter cold. A dazzling sun glinted off the gilded letters inscribed upon the marble wall behind the speaker's platform. "Marshall Islands," read the shimmering text, "Marianas . . . Peleliu . . ." And, to the left of center, under the gigantic boot of a thirty-two-foot bronze Marine—the last of a clot of rumpled figures struggling to plant a flagstaff on a pile of carefully disposed rocks—this legend: "1945: Iwo Jima."

Promptly at 10:15, with brass sparkling and sheet music tousled by the breeze, the Marine Band began to play. A delegation of Washington schoolchildren scrambled into their own reserved section, where they fidgeted and giggled. Less privileged members of the public at large drifted toward an enclosure for standees. As if on cue, a detail of starchy women Marines herded five thousand invited guests toward their assigned seats. With much stomping of feet, much rubbing of hands against the chill, the crowd filed into the rows of folding chairs that faced the flagpole and the gold letters and the spattering of dignitaries already assembled on the rostrum. They sat and squinted into the blue of the eastern sky.

It was November 10, 1954, and, on a swatch of grass overlooking the capital's gleaming white monuments to Washington and Lincoln, seven thousand Americans had gathered to celebrate the 179th "birthday" of

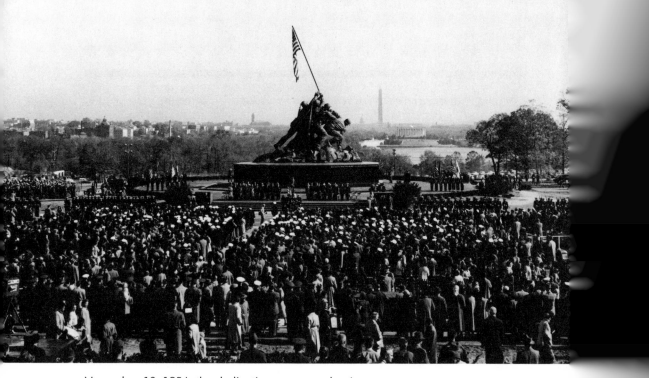

November 10, 1954: the dedication ceremony begins.

the United States Marine Corps by dedicating a new memorial, one hundred tons of bronze, specially finished in a patina of "Marine green." The new statue showed the Marines—five Marines and a Navy corpsman, to be precise—raising the flag over the Japanese-held island of Iwo Jima on February 23, 1945, at the height of the war in the Pacific. Secretary of the Navy James Forrestal, who was inspecting Green Beach on Iwo Jima that morning in 1945, saw the Stars and Stripes go up atop Mount Suribachi and heard the beleaguered troops below come alive with whistles and cheers and shouts of joy. He turned to Marine General Holland M. Smith and said, "The raising of that flag on Suribachi means a Marine Corps for the next five hundred years!"[1]

"Howlin' Mad" Smith took his seat on the dais at Arlington when the band began to play, and remembered that other morning, nine years before, blustery, windy, raw. Although he had commanded the Marines at Iwo Jima, General Smith did not have the best seat on the rostrum. The President—Eisenhower, another old general—was expected to attend the

ceremony, and Holland Smith had been given a place about as far as possible from Ike and today's brass, a place way off to the left, under the big boot, in among the ex-Marine commandants, the chaplains, the former divisional commanders from Iwo, the sculptor of the statue, and Joe Rosenthal, the Associated Press photographer who had snapped the picture on which the sculpture was based.[2] This was not a morning for the Old Breed, the old warhorses who had watched the war from decks and beaches. Nor was it a morning for chaplains, or for modest little fellows in thick glasses who took pictures for the newspapers. No, it was a morning for power and pride, for vast, lump-in-the-throat symbols, for flags, for hundred-ton statues. It was a day for heroes.

The heroes, their wives, their children, their mothers, sat in the first row, facing General Smith. Mr. and Mrs. John Bradley, from Antigo, Wisconsin, he the father of four, prosperous in a fine blue suit and overcoat, a furniture dealer, according to the official press releases: Bradley was the corpsman, the second in line in the statue, a thirty-two-quart canteen on his belt, a look of determination on his big square face, the only face visible in Rosenthal's photograph. Next to Bradley sat Ira Hayes, a Pima Indian from an Arizona reservation, alone, sullen, uncomfortable in a stiff new coat of heavy Melton cloth. The last man in the tableau, straining eternally to touch the flagpole his hand would never grasp, Hayes was described by Marine publicists as an employee of the Bureau of Indian Affairs in Phoenix. Next to Hayes, oblivious to him, sat Rene Gagnon, building contractor, from Hookset, New Hampshire, his wife, Pauline (Bradley had been their best man), and his seven-year-old son, Rene, Jr., all turned out in their Sunday best. Small, dark-haired, movie-star handsome, Pfc. Gagnon was almost invisible from this side of the statue, paired with Bradley in the act of thrusting the pole into sculpted rubble colored to match the treacherous black sands of Iwo Jima.[3]

Then came the Gold Star Mothers. First, Mrs. Ada Belle Block, from Weslaco, Texas: her son, Harlon, a corporal with Easy Company, Twenty-Eighth Regiment, Fifth Marine Division, the last of the group to be identified, had been killed in action on Iwo on D+10 (the tenth day after D-day, or March 1, 1945). By her side sat Mrs. Goldie Price of Ewing, Kentucky, mother of Franklin Sousley, the youngest of the Suribachi flag-raisers, who, at age nineteen, had died near the enemy stronghold of General Kuribayashi, only days before his buddies were pulled out of combat and sent home as heroes. Finally came Mrs. Martha Strank of

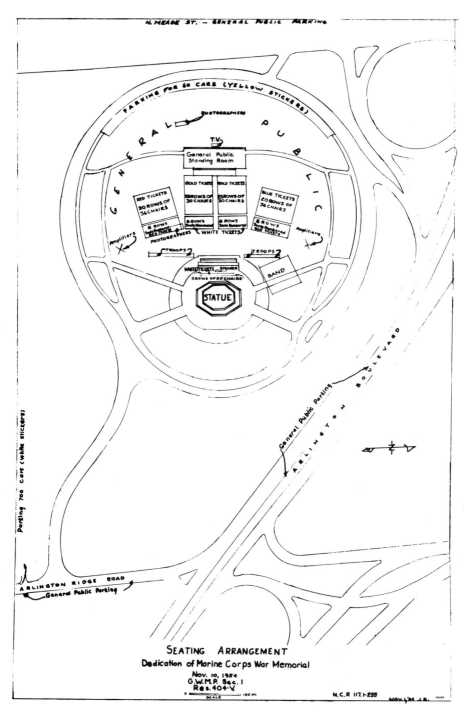

SEATING ARRANGEMENT
Dedication of Marine Corps War Memorial
Nov. 10, 1954
G.W.M.P. Sec. 1
Res. 404-V

Seating chart for the dedication of the Memorial.

Conemaugh, Pennsylvania, a Czech immigrant: her boy, Michael, a career Marine, had died alongside Harlon Block in the firefight on Nishi Ridge. Sergeant Michael Strank lay buried in Arlington Cemetery, within sight of his mom and his friends and the other holders of the rare white tickets that designated the day's front-row honorees.[4]

Toward the back of the assembly, in the quadrant reserved for bearers of lesser invitations edged in gold or blue, were scattered the members of another contingent of Iwo Jima flag-raisers. Their seating arrangements, at some remove from the gaze of the TV cameras and the notice of the podium, reflected acute Marine distress over their role in the ceremonies. While Lou Lowery, Chuck Lindberg, Hal Schrier, and Jimmy Michaels all rated invitations— Michaels, Schrier, and Lindberg were survivors of the patrol that raised the first small flag over Iwo Jima, and Lowery photographed them doing it; Joe Rosenthal's more dramatic picture, showing

The Iwo Jima flag-raisers in the VIP section. From left to right: Mrs. Bradley, John Bradley, Ira Hayes, Rene Gagnon, Mrs. Gagnon.

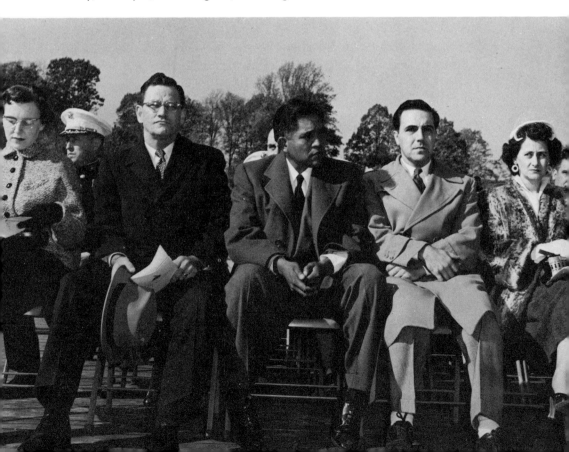

Handsome and affable, Rene Gagnon was the center of attention.

the replacement of their little flag with a larger one, was taken several hours later—they were living contradictions to the official Marine story of a singular moment of heroism on Iwo Jima. Based on the visual drama of the Rosenthal photo, a drama heightened, magnified, and given a ponderous, eternal presence in Felix de Weldon's new statue, the story adopted by the Marines was one of triumph, of heroic action under fire, of a fierce blaze of courage that stood for the "uncommon valor" of the Corps. That this splendid moment had been one among several raisings; that it was second-best, somehow, not quite authentic; that the worst of the battle for Suribachi might actually have been over by the time Bradley and Hayes and Gagnon and their comrades reached the peak: such doubts and quibbles had no place in a ceremony affirming a splendid symbol of American heroism.

Some journalists dimly remembered Lowery's pictures of the first flag to go up on Suribachi. Others recalled a stirring front-line radio interview with young Sgt. "Boots" Thomas, who had led the Third Platoon to the summit at 10:35 that February morning, planted the flag along with

Lindberg and Michaels, and then fallen in battle eight days later.[5] But most reports of the dedication rites hewed to the official version, disseminated in press releases prepared by the firm of J. Walter Thompson, the Marines' long-time publicity agent. According to Madison Avenue, there had been one and only one flag-raising, at 10:35 A.M. on D+4. Joe Rosenthal had captured it on film. And the dramatis personae had consisted of Bradley, Hayes, Gagnon, and the three dead Marines whose mothers sat quietly in the sun beside the trio of surviving heroes.

Now a retired electrician living in a Minneapolis suburb, Charles W. Lindberg still wonders why he and the other remnants of the first expedition were invited to Washington in the first place. "They put us way in the back," he says, "and nobody paid any attention to us. One reporter came and talked to us, and I'll bet there were 150 talking to the other guys. That really hurt."[6] The young Marines collecting invitations at the perimeter of the monument were highly skeptical of Lindberg's claim to have been an "original" raiser, too: even when he went back to his car and fished out copies of Lou Lowery's step-by-step photo essay, following the Thomas patrol up the mountain, they only "half-believed" the former corporal, holder of the Silver Star for bravery under fire.

Lindberg did get to shake hands with Richard Nixon, the principal orator of the day, but the vice-president seemed uninterested and "looked at somebody else" during the brief encounter. The presence of James R. Michaels of Riverside, Illinois—he proudly brought daughters Mary Sue and Donna Marie with him to the dedication—was noted only by his hometown paper. As for photographer Lowery, he went all but unnoticed.[7]

Other telling revisions of history marked the 1954 observances. Although his photo was duly acknowledged as the inspiration for the statue and he was accorded a seat on the platform, Rosenthal was not asked to speak. Clearly, a first-hand description of events transpiring inside the volcanic cone of Suribachi around noon on the morning in question could only have blurred the crisp outlines of an emerging myth of Iwo Jima. Nor, despite the prior assurances of the sculptor, did Rosenthal's name appear anywhere on the monument. Rosenthal had exchanged the first-class airline tickets supplied by the Memorial Foundation for cheaper seats in order to bring his kids, Joe, Jr., and Anne, with him from San Francisco, to see what Daddy had done during the war. He planned to walk them around the statue and ask, "Whose name do you see?" When the Rosenthals had circled the base twice, however, with no sign of the

Joe Rosenthal and his family: his Pulitzer Prize-winning photograph was the inspiration for the statue.

family name in evidence, Joe was glad that he hadn't asked the question.[8] To the meaning of a patriotic icon, facts, photographs, and the eyewitness testimony of the photographer himself were all but irrelevant. The symbol had taken on an independent life of its own.

As a symbol, the sculpture stood for national unity of purpose, the common cause of six soldiers struggling to achieve a single end. Because their features were hidden by helmets, the figures were not really singular

individuals, either, despite the best efforts of the Marine Corps to identify each man and give him a suitable biography. The Marines in the statue were faceless, anonymous Americans, typical American boys, who stood for the resolve of the nation at large. That the group indeed included a son of immigrants, an Indian, boys from the Midwest, the plains, the East, only confirmed the representative character of the image.

Under strong stateside pressure—from mothers and fathers who saw their own boys in the picture, from Treasury Department officials eager to use the "raisers" to sell war bonds—the Corps had scrambled to identify and personalize its generic heroes in 1945. In the "let's all pull together" climate of wartime, such facts as personnel records revealed about the trio of survivors tended to support the belief that they were, like their pictorial image, typical of the social, racial, and geographic diversity of America. Yet, by virtue of their perfect conformity to the American norm, Bradley, Hayes, and Gagnon were under pressure from their superiors to be perfect, Madison Avenue Marines as they toured the nation peddling their bonds, endlessly raising their tattered flag, showing stay-at-homes that the war still raged and still demanded the common effort of all Americans. Late in May of 1945, General Vandegrift, then Marine commandant, had personally ordered Ira Hayes back to his overseas unit after discovering the private drunk and incoherent only hours before a major bond rally.[9] The honor of the Corps demanded swift action on the general's part: so, perhaps, did the self-image of the nation that saw itself embodied in the Iwo Jima flag-raising.

In November 1954, accuser and accused faced each other once more, Vandegrift seated at Holland Smith's elbow and, in the chairs below, Ira Hayes tucked safely between Bradley and Gagnon, as if to guard against further embarrassing outbursts. But just the previous autumn the tabloids had been full of Hayes, the "Hero of Iwo Jima," found wandering dazed and shoeless through Chicago, jailed, transferred to a sanitarium with the proceeds of a public subscription, and finally arrested, drunk again, in Los Angeles.[10] The press skirted these episodes in its coverage of the dedication. They went unnoticed, too, in the "fact sheet" issued by the Marines, in which Hayes became a blameless bureaucrat and the unexceptional lives of his companions were also given an added polish.

Bradley, for example, was identified as a furniture dealer, although his primary business was undertaking and it was his anatomical knowledge that had led him to become a Navy corpsman in the first place. The blurb

on Gagnon, the building contractor, made no mention of his thwarted ambitions to become a state trooper or an airline pilot, or the seven-year Hollywood contract his wife had made him turn down.[11] There was nothing wrong with burying the dead, of course, or with having a hard time readjusting to civilian life after the war. But being a "Hero of Iwo Jima" admitted of nothing unusual or odd, no sign of failure or failure of nerve, however slight. So the heroes sat in the sunshine on a chilly knoll above the Potomac, surrounded by friends and families, wrapped in brand-new topcoats, clothed in biographies that conformed to the all-American, middle-class, suburban ideal of 1954: the merchant, the public servant, the entrepreneur.

At 10:45, the vice-president arrived, the band played its final flourish, the officials on the platform reshuffled themselves, and the audience fell silent. One of the chaplains rose and prayed. The deputy secretary of defense reminded the audience that the statue was a war memorial, commemorating "a climactic moment in the bitter struggle for a remote and dusty little island in the far reaches of the Western Pacific." It symbolized American victory in World War II, he continued. "It epitomizes all the devotion and . . . determination of those who participated in that bloody battle."[12]

The head of the special foundation set up outside the military to raise the $850,000 cost of the Marine Corps War Memorial then described the work of his organization (omitting reference to a former director who had absconded with a third of the collections). The assistant secretary of the interior, pledging the commitment of the Park Service to the care and maintenance of the newest national shrine, directed the attention of the guests to Memorial Bridge, to the city beyond it, to America's other most cherished monuments. This statue of "six small town boys" was, the secretary declaimed, a "tribute to the common virtue of uncommon valor found in the ordinary men of America when an enemy threatens the heritages of Washington, Jefferson and Lincoln," a heritage confirmed by the marble shrines visible from Arlington: "Beneath this towering monument, on which a fleeting moment snatched from real life has been preserved in bronze, the ordinary man stands small and humble. The heroes, in their hour of greatness, quite fittingly loom like giants."

The program called next for the arrival of the president, but he was nowhere to be found. Colonel Santleman and the band swung into another tune. One observer thought the interlude came as a welcome relief to the

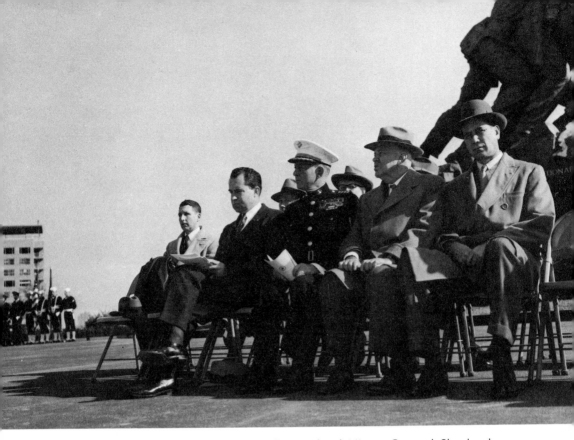

On the speakers' platform, Vice President Richard Nixon, General Shepherd, Defense Secretary Charles E. Wilson, and Secretary Gates. At left, Lieutenant Colonel William P. McCahill, USMC ret., chairman of the dedication committee.

designated heroes squirming in their front-row seats, obviously flustered "by all the words."[13] Minutes passed. A stir on the stage. A false alarm. No Ike. Another musical selection. And then, suddenly, he was there, coatless in the wind, settling into the vacant chair between Nixon and General Lemuel Shepherd, the current commandant of the Marines. Shepherd rose and officially presented the monument to the people of the United States. The band struck up "The Star-Spangled Banner." An honor guard of four Marine NCOs marched foward in close cadence. ". . . O'er the land of the free, and the home of the brave!" Suddenly, seventy-eight feet above the pavement, Old Glory fluttered atop the Iwo Jima flagstaff once more. The wind had been cold and strong in the Pacific that February morning. And so it was again in Washington, November 10, 1954.

When the flag went up, the president vanished, pleading, through White

Arriving late for the ceremony, President Eisenhower is flanked by Admiral Arthur Radford and Deputy Defense Secretary Robert B. Anderson.

House aides, the press of events: his morning news conference, a scheduled meeting with the Japanese ambassador. The explanation for his eleven-minute appearance seems more complicated than that, however. Since the end of the war in the Pacific, the size and the mission of the Marine Corps had been subjects for acrimonious debate. In 1948 Secretary Forrestal—the same Forrestal who had predicted a long future for the Marines on the beachhead below Suribachi—had warned the Corps not to begin thinking of itself as a second Army. According to Pentagon strategists, the A-bomb had rendered the old amphibious assault obsolete. And so, in the immediate postwar years, Marine manpower was sharply reduced. "Birthday" celebrations by the Marine Corps were first discouraged, then banned. Around Washington, President Truman's distaste for Marine self-promotion was an open secret. As long as he occupied the White House,

Truman vowed, the Corps would remain "the Navy's police force" and nothing more, despite "a propaganda machine that is almost the equal to Stalin's." Angry Marines bound for Inchon during the Korean War chalked "Horrible Harry's Police Force" on the sides of their jeeps.[14]

Korea would become a kind of litmus test of Cold War patriotism for combatant and civilian alike. In an unusual ceremony, held in Washington in January 1954, the Marine Corps awarded medals to returning POWs who did not "bear false witness against their country." A tacit reproach to other detainees "brainwashed" by their Communist captors, the citations also recalled the anti-Communist hysteria of the 1952 presidential campaign. When Adlai Stevenson scored on Eisenhower's failure to distance himself from the McCarthy witch-hunt for Communists in government, the general countered by vowing to go to Korea immediately, if elected, and find out why the U.S. hadn't won the war. The Truman administration dismissed the campaign pledge as irresponsible demagoguery, but the prospect of besting the North Koreans and their Red Chinese allies helped to win the election for Ike. On November 29, 1952, under a blanket of elaborate security precautions, Eisenhower left for a three-day tour of the Korean front.[15]

En route, for reasons that he did not share with the press corps that accompanied him, the president-elect stopped off on Iwo Jima. He went straight from the airstrip to the small Marine Corps monument on the mountaintop and stayed there for a long time, studying a metal replica of Rosenthal's photograph mounted under a tall flagpole. He surveyed the black sand beaches below, where so many had died. He listened intently to a first-hand description of the order of battle provided by two combat veterans of the Fourth Marine Division.

The next morning Eisenhower climbed Suribachi again. The plane bearing the cameramen had arrived late the previous evening, and the wire services wanted pictures of Ike standing on the spot where the flag had gone up in 1945. Although staged, the photographs taken that second day betray strong emotion. They show a solemn, pensive Eisenhower, deeply engrossed in what he is seeing or remembering there: an act of heroism, the American flag, the silent dead of Iwo Jima, an intransigent foe, an alien battlefield far from the beaches of Normandy. And if the parallels between the terrible war of attrition in the Pacific and the present conflict in Korea were not plain enough, the historic scene on Mount Suribachi would be replicated during Eisenhower's oriental

sojourn. On December 4, in a snow-covered valley near enemy lines, he watched a Korean unit assault a hill in a realistic training maneuver. At the conclusion of the exercise, the president of South Korea gave Ike the big silk flag his troops had just secured atop their make-believe objective.

President-elect Eisenhower on Mount Suribachi, December 6, 1952.

"I assure you," said Eisenhower, "that it will hang in a suitable place where people will see it and not forget it."[16]

That Korean flag promptly disappeared into the maw of the federal bureaucracy, but the Marines had not forgotten Korea. "Iwo Jima," read the gilded letters on the base of their new statue above the Potomac, "Okinawa . . . Korea." Perhaps it was the sad reminder of yet another war, onlookers mused, that drove the president from the November ceremony with precipitous haste. Perhaps the ex-Army man balked at endorsing the Marines' latest round of self-congratulations too warmly. Whatever the reasons for his patent discomfort, Eisenhower had dodged the invitation to appear at the dedication for months. Would he come and speak, please? Letters of inquiry went unanswered. Aides cited a vast and ever-changing litany of prior commitments. Oblique hints to Mrs. Eisenhower fell on deaf ears. Even the weekly presidential round of golf became a serious impediment to participation.[17]

The first real clue to White House attitudes toward the Marine Corps Memorial emerged when the speeches were over and the dignitaries gone. Several days after the statue had been duly presented and received, Senator Clements of Kentucky wrote to Eisenhower, proposing that special presidential citations for heroism be given to "the gallant six" who had raised the flag on Iwo Jima (including a posthumous award to his late constituent Pfc. Franklin Sousley). Eisenhower dismissed the suggestion out of hand. The letter of refusal drafted by his staff, with the apparent assent of the Marines, offered a description of the attack on Suribachi at variance with the highly colored version circulated during the dedicatory hoopla. Individual acts of heroism were minimized. Great stress was laid upon the concerted regimental effort to seize the peak. Senator Clements was made privy to the fact that Lindberg and his patrol had already hoisted their flag by the time Joe Rosenthal reached the summit. The White House document, in fact, went on to imply that the most famous picture of World War II was something of a fake—that "Rosenthal requested 5 Marines and one Navy corpsman who happened to be available nearby to *pose* [italics added] for the picture." Thus the big statue based on the photo, while broadly symbolic of Marines in combat, did not justify the award of medals to those depicted:

> Although the six men who were photographed by Rosenthal had partaken in the fighting and were veterans of that glorious day, they are not one whit more deserving of recognition—nor, it should be stated, one whit less either

—than any of their comrades who also participated in the fighting, many of whom were killed during the bloody progress up the lava-strewn slope.[18]

The discrepancy between two Iwo Jima stories—the one grounded in hard, cold military data and the other, to all appearances, a heroic fable contrived for the occasion—gnawed at General Eisenhower, who had posed for the cameras on Iwo himself. For Ike, the flag-raising that Rosenthal had witnessed (or "posed") was not a key factor in the conquest of Iwo Jima. Yet the notion that a single incident, trivial in its own right, could illuminate the broader meaning of historical events seemed an incontestable premise for a national monument. And when Eisenhower sped away, nettled by the conventions of artistic symbolism, his place at the podium was taken by Felix de Weldon, the man who had made the monument and who now rose to tell how each small detail spoke to larger issues of bravery and American "determination . . . to defend democracy against those who would deny the fundamental rights and dignity of mankind." The outstretched hands of his figures, he said, stood for America's help to the suffering peoples of the world, a striving after the blessings of a higher power, the strength of a nation united in the pursuit of a single goal. The three dead Marines in his group of six recalled the sacrifice of all who fell in battle; the three survivors, the gallantry of all who served.[19]

The sentiments were easy to read, easy to understand. So was the statue, a people's statue, lacking the usual complexities of high art. There were

Sculptor Felix de Weldon addresses the crowd.

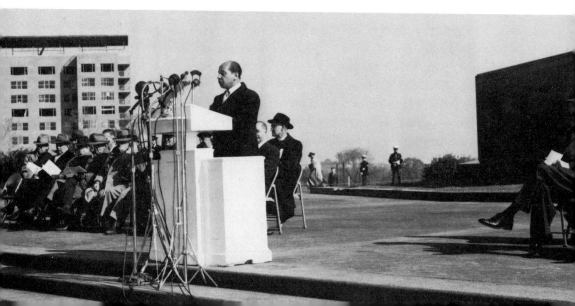

no grieving maidens in togas here, no allegories, no odd shapes to puzzle over, no enigmatic beings doing who-knows-what. A literal transcription of a well-known photograph, the monument took on the documentary qualities of its prototype. It seemed wholly real and truthful, *un*artful, despite its staggering size. Columnists never tired of citing the gargantuan statistics: thumbs as big around as most men's arms; welders climbing inside through a door-size cartridge belt; a twelve-foot carbine; a hundred tons of bronze in 108 separate pieces.[20] The numbers helped describe the work in mundane, concrete terms. They reinforced its realism. So did the vials of Iwo Jima sand reportedly packed inside the cornerstone, a finish tinted to match the green of actual Marine fatigues, a real flag snapping and billowing from a bronze pole.

De Weldon's was a matter-of-fact realism, but a realism pumped up with the sheer splendor of size and power. Both down-to-earth—democratic—and profoundly grand, it touched a responsive chord in Washington's Cold War elite. During the period between his first Iwo Jima statue—a six-ton rendition unveiled in downtown Washington by General Vandegrift and Corpsman Bradley on November 10, 1945—and the ceremony at Arlington, the former Navy petty officer from Austria had also sculpted Truman, Vandegrift, and Admiral Nimitz, Marine generals Erskine and Denig, and Bradley, Hayes, and Gagnon. He would shortly begin a bust of Eisenhower. Virtually all the notables on the program were de Weldon's sitters or respectful visitors to his studio, where Rosenthal finally met the three men he had immortalized and where the crusty Holland Smith burst into tears when he saw "his boys" posing for the unfinished memorial.[21]

Taken together, the inflated size and the theme of de Weldon's statue betokened military might, the new doctrine of armed deterrence, the global ambitions of American foreign policy in the aftermath of World War II. Ironically, however, it was not the artist but a master politician who most clearly perceived the implications of the monument. Filling in for Eisenhower, Vice-President Richard Nixon made the morning's last speech, the actual dedicatory address. To Nixon, the historical background of the bronze tableau—the Rosenthal photo, the identity of the raisers, who got there first, Iwo Jima itself—was far less important than its message for the perilous world of 1954. The image *was* America, vast and powerful; America, heroic and strong. "This statue symbolizes the hopes and dreams of America and the real purpose of our foreign policy," Nixon insisted:

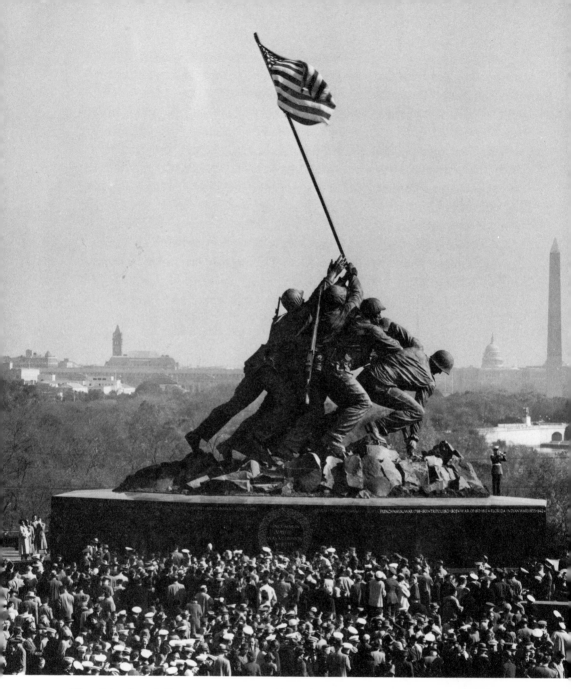

"Taps" is played; the ceremony comes to a close.

We realize that to retain freedom for ourselves, we must be concerned when people in other parts of the world may lose theirs. There is no greater challenge to statesmanship than to find a way that such sacrifices as this statue represents are not necessary in the future, and to build the kind of world in which all people can be free, in which nations can be independent, and in which people can live together in peace and friendship.[22]

At the fringe of the crowd, far to the back, barred from the VIP seats by wary Marine MPs, a delegate from one of the most important of the hemispheric allies strained to hear Nixon's vision of the coming *pax Americana*. Colonel Ramón Barquín, military attaché from the Republic of Cuba, personal friend of El Presidente, and fervent admirer of the United States Marine Corps, wore his dress uniform with sword and sash and carried his invitation to the festivities in an immaculately gloved hand that fairly quivered with indignation. The colonel had arrived at the designated gate in full regalia only to be turned away: his name, it seems, did not appear on the register of special guests. He tried another entrance. And another. Each time, the way was barred. Meanwhile, the embassy car had been boxed in by other vehicles. Barquín couldn't stay—but he also found himself unable to leave. So he stood in the back and fumed, embarrassed, he admitted, because, "quite a large crowd" had witnessed his serial humiliations. When the vice-president sat down and the spectators began to fold their programs and search for their purses and scarves, Colonel Barquín stomped off toward the parking lot, before any of his American acquaintances in the front rows could observe his sorry predicament.[23]

Up on the rostrum, the padres said their amens. A lone bugle sounded taps. Secretaries and assistant secretaries sprinted for waiting limousines. Old generals slowly rose and flexed their aching knees. Young Marines, ramrod straight in dress blues, gazed up at the likeness of six rumpled young warriors in Marine green, stumbling, struggling to raise their country's flag. Three of the boys depicted in the statue, older now, brushed and pressed and polished but still erratic in formation, straggled toward the monument, each at his own pace, trailed by relatives and well-wishers, autograph-seekers, reporters, photographers.

A photograph had brought this group together, and so they posed for pictures now, more instant memories, more monuments on film. Joe Rosenthal with his camera; Joe with his wife and kids. Rene Gagnon with a star-struck little girl. Nixon with the raisers: the politics of heroism.

After the dedication, Nixon meets Bradley, Gagnon, and Hayes.

The hero business almost done, Gagnon grinned. Bradley ventured a chuckle. And for the first time that morning, Hayes smiled broadly, in relief. Within three months, Ira Hayes would be buried at Arlington, in a hero's grave on the slope just above the statue, another casualty, his old Marine buddies later said, of the bloody battle for Iwo Jima.[24]

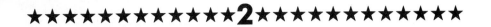

The first night on Iwo Jima can only be described as a nightmare in hell . . .
Iwo is the most difficult amphibious operation in U.S. history.

Robert Sherrod, war correspondent, radio dispatch to *Time*, March 1945

Bloody Iwo

It wasn't beautiful. It wasn't "worth 50¢ at a sheriff's sale," said one Marine. Even the Japanese defenders of Iwo Jima found the island an ominous and desolate place. Major Yoshitaka Horie of the Imperial Army, who proposed that it be cut in two with explosive charges and then sunk before the enemy fleet arrived, described a half-dead place, with "no water, no sparrow, . . . no swallow." But in the early spring of 1945 it was, in the words of the American vice-admiral whose ships were closing on the tiny pinpoint of lava 640 miles south of Tokyo Bay, "as well defended a fixed position as exists in the world today." If it could be taken at all, the island would have to be seized by a classic amphibious assault: men put ashore to kill or capture anyone who stood in their way. It would be taken in hand-to-hand combat by determined and courageous men prepared to pay for "eight square miles of hell" with their lives. Casualties would be heavy. The black sands of Iwo Jima would turn red with blood.[1]

Before the war, Iwo Jima was green in the spring, green with fields of cane, papaya, pineapple, green with pandanus trees, bananas, and bean vines. The 1940 census counted 1,091 permanent residents, mostly farmers and workers in the refinery that sent sulphur to the home islands. "Iwo" meant sulphur, and the stench of rotten eggs from bubbling, hissing deposits of the mineral hung heavy in the air. But life went on, pleasantly for the most part. There were seven teachers in two schools, three bar-

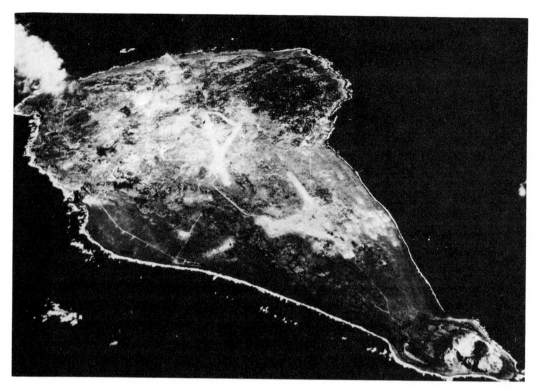

From the air, Iwo Jima looked like a giant pork chop floating in the Pacific.

maids at the Taihei-ken inn. Supply boats from home called at Iwo Jima and Chichi Jima and the other little islands of the Volcano group, a part of the larger Bonin Island chain—the Nanpo Shoto—that stretched like a string of Pacific pearls from the Marianas to Tokyo. In 1887 the mayor of Tokyo had made a stop at Iwo Jima aboard the SS *Meiji* and had incorporated Iwo into the prefecture of the capital. When World War II broke out, then, Iwo Jima was not just another insignificant island in the central Pacific: it was a part of Japan itself, a part of the sacred homeland.[2]

The Nanpo Shoto had attracted American attention in the nineteenth century. Captain Reuben Coffin of Nantucket landed the whaler *Transit* at Haha Jima in 1823 and claimed that island for the United States. Several years later, a British consul asserting his nation's sovereignty over the area sent a group of colonists from Hawaii to Chichi Jima. Among the Portuguese, the Italians, and the English was one American,

Nathaniel Savory of Massachusetts, who sold a beach to Admiral Perry in 1853 for use as a coaling station. Perry was unable to persuade Washington of the value of the property, however, and United States influence soon waned—except on Chichi Jima, that is. There, Nathaniel Savory's descendants, well into the 1910s, still celebrated Washington's Birthday and the Fourth of July by flying the American flag.[3]

After the war, signboards were found in the blasted landscape of Iwo Jima: written in Japanese *and* English, the notices prohibited the taking of pictures, the making of maps. The signs, dating from August 1937, suggest that military preparations were already under way four years before Pearl Harbor. In 1940 and 1941, barracks went up. A naval detachment of ninety-three men arrived. The evacuation of the civilian population began. An airstrip was built along the narrow saddle of land that joins Mount Suribachi to the broader plateau at the north. But a carrier raid on Truk in February 1944 forced the Japanese high command to consider a greater strategic role for Iwo Jima in the mounting air war. At that moment, just a year before the American landing along the sandy east coast on Futatsune Beach, only twenty planes and 1,500 airmen were stationed on the island. There were no fortifications anywhere on Iwo Jima.[4]

Tsunezo Wachi remembers the extraordinary change that took place in the final months before the invasion. Now a Buddhist priest committed to praying for the souls of those who died in battle there, in March 1944 he was Captain Wachi, the officer in charge of the new 5,000-man Japanese naval garrison on Iwo Jima. Before he left the island early in 1945, 21,000 troops were entrenched in an underground network of defensive installations dug deep in the *konhake* rock. There were more than 750 gun emplacements; scores of blockhouses with five-foot concrete walls; 13,000 yards of tunnels; beneath Mount Suribachi, a complete hospital and a four-story gallery. The sides of the volcano bristled with 1,000 pillboxes. The fortifications were the work of General Tadamichi Kuribayashi, newly appointed commander of Iwo Jima, a man whose "partly protruding belly is packed full of strong fighting spirit," rhapsodized Radio Tokyo.[5]

Kuribayashi was a tyrant, according to some, but it took a tough customer to build so much, so soon. And the general knew what he was facing. As a young officer posted in Canada, Kuribayashi had visited the United States, where he was much impressed with American industry and mass production. To Kuribayashi, guns and planes and ships won

battles—and the Americans had more of them than anybody else. "Give me these things," he radioed Tokyo, "and I will hold Iwo." In the absence of materiel, however, he was forced to rely on clever tactics and high troop morale. The garrison on Iwo Jima had its own song, urging the defenders to "Work and struggle, strive and trust, / 'Til the hated Anglo-Saxons / Lie before us in the dust."[6] Ordinary soldiers were told that the American Marines soon to land on their island were murderers, lunatics, and felons, freed from institutions on condition that they fight. Officers thought the Marines brave and formidable but despised their hunger for publicity and the insolent nonchalance with which the U.S. military went about the serious business of war: between rounds from the heavy American guns sent to soften them up for the kill, Japanese defenders huddled in their bunkers could hear pop music wafting across the sea from the battle-wagons anchored offshore.[7]

Bombardment was a fact of life on Iwo Jima. In the summer and early autumn of 1944, air raids had already frightened away most of the fish and made it too dangerous to sleep in barracks above ground. The constant pressure of attacks from sea and air—a form of psychological warfare— may have had the paradoxical effect of driving the Japanese underground, of strengthening their already powerful defenses as D-day approached. Those fortifications, in turn, seem to have shaped Japanese tactics. Unlike other commanders in the Pacific, Kuribayashi forbade the suicidal *banzai* attack: he planned to let the Marines land against token opposition, lure them up onto the beaches, and then mow them down in a withering crossfire from well-protected artillery positions. "The whole Japanese system of fighting is based on . . . the 'Iwo idea,' that they can make us pay so high a price for beating them that we will pick up our dollars and go home," wrote an American journalist who hit the beach with the Marines.[8]

The Japanese high command began predicting an imminent invasion of Iwo Jima in December 1944. General Kuribayashi himself expected the attack to come some time between November 27, 1944, and January 21, 1945. When the deadline passed, local speculation pegged the landing for FDR's birthday or George Washington's. But no one doubted that the Americans were coming. The strategic logic of the case was apparent to both sides. Curtis ("Old Ironpants") Le May's 21st Bomber Command, based in the Marianas, had targeted Tokyo and Japan's other industrial centers for the kind of saturation bombing that was winning the war in

Europe. But Le May's giant B-29s—the Japanese called them "Bi-ni-ju-ku"—were, by his own admission, garnering better publicity than results. Operating from bases more than a thousand miles from target, the Super-fortress was forced to carry more fuel and fewer bombs. Since fighter escorts could not make the long flight at all, the B-29s had to bomb from high altitudes, above the clouds, reducing accuracy and burning fuel at an alarming rate against fierce Japanese headwinds. Planes hit over Japan had little hope of limping back to a friendly airstrip: casualties were appalling and crew morale low.[9]

Iwo Jima was the problem—and the potential solution. One of the only atolls in that part of the Pacific large and flat enough to accommodate a runway, the island lay directly in the line of flight from the Marianas to Tokyo. Japanese planes rose from Iwo to raid Saipan and harass Tokyo-bound traffic. Iwo radar gave the home islands advance warning of American sorties. But if the United States were to capture Iwo Jima, the Motoyama airstrips could provide American fighter cover for the air war on Japan and a safe harbor for damaged B-29s on the homeward leg of their long flight. With escorts, and with no need for evasive action en route, the Superfortress could begin a program of effective low-level bombing, calculated to hasten the end of the war in the Pacific. "Without Iwo Jima," Le May told the chief of the American task force bearing down on the island in January 1945, "I couldn't bomb Japan effectively."[10]

When the order came down to take Iwo Jima, the question that remained for Navy and Marine brass in charge of doing the job was how to make Operation Detachment work. Aerial reconnaissance photos showed enough of Kuribayashi's defenses to warrant several postponements of the landing. The newly formed Fifth Marine Division, which contained a high percentage of combat-hardened former Marine Raiders and Paramarines, was sent to Hawaii to assault mountains that looked like Suribachi and other natural features akin to those on "Island X." The Fourth and Third Divisions were drilled for their respective assignments, too. B-24s bombed the objective daily: in seventy-two days of raids, the Seventh Air Force estimated that it had flown 2,700 missions and dropped 5,800 tons of ordnance on Japanese forces. Nonetheless, new photos taken over Iwo Jima were troublesome. Those shot at the height of the air attack indicated that it had had "no appreciable effect," while intelligence pictures made afterward showed a major increase in the number of defensive strongholds.[11]

For that reason, Holland Smith requested a ten-day period of naval

bombardment before his Marines were put ashore. He got three days' worth, 21,926 shells. After the war, Smith would blast the Navy for callous indifference to the fate of the Marines slaughtered by guns that might have been knocked out with sustained fire. To this day, among military historians and veterans, the Navy's role in the Iwo Jima campaign remains one of the most controversial aspects of the Pacific war. Advocates of the naval position hold that the underground bunkers on Iwo Jima were impervious to shelling anyway, that Admiral Blandy and the Fifth Fleet actually set a new record for expenditure of ammunition during their three days offshore, that the weather, the supply of shells, and planned operations around Okinawa all conspired to make a longer engagement impossible. Postwar restudy of the issue suggests that, given the damage inflicted in the time allotted to Iwo Jima—roughly 22 percent of the island's defensive positions had been hit before D-day, and by some estimates the face of Mount Suribachi had been pushed back fifteen feet —an eight-day "fire" might have broken enemy resistance. As things stood in February 1945, however, the Fourth and the Fifth Marines would land "in full knowledge that most of Iwo Jima's . . . defenses were intact" and lethal.[12]

A five-inch Japanese gun trained on the landing beach.

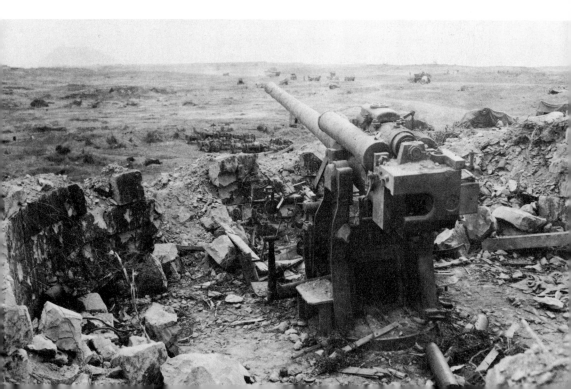

There were optimists—none of them Marines—who thought the operation was going to be a pushover. Naval gunners, overestimating the accuracy of their aim, predicted things would be all wrapped up within seventy-two hours, four days at most. Pictures taken during the shelling showed explosions, destruction, smoke everywhere. But, as a Marine wounded on Iwo later noted, "photography and reality are sometimes at variance." Insisting to the end that "shells are cheaper than lives," Holland Smith felt certain he would lose 15,000 men. He was wary of Kuribayashi, whose ability to rebuild under punishing fire had fleshed out a real personality, malevolent, invincible. Kuribyashi's island even looked ominous. The novelist John P. Marquand, viewing Iwo Jima from the deck of a battleship shelling the coastline on D-day minus 3, saw "a slightly wounded but dangerous animal." Iwo exuded "a sullen sense of evil," wrote another journalist as the hour of battle approached.[13]

Aboard the *Eldorado,* Admiral Richmond Kelly Turner's flagship, the mood was bleak. Before the Iwo Jima campaign began, the Navy had been notorious for keeping a lid on news from the front. The feeling in the Washington press corps was that, left to his own devices, the chief of naval operations would have issued a single communiqué during the course of the war: that it was over and we had won. But, at a shipboard press conference on February 16, Turner announced a major change. "It is the express desire of the Navy Department that a more aggressive policy be pursued with regard to press, magazine, radio, and photographic coverage of military activities in the Pacific Ocean areas," he stated:

> We feel that photographers are not evil. Correspondents we also have the highest regard for; they take the same chances we do. We expect facts in stories to be verified [but] censorship will be liberal . . . We will make every effort to get your stories out promptly . . . The planes will fly your stories back to Guam for transmission . . .[14]

The revised policy had several immediate effects. The volume of words and pictures filed on Operation Detachment was unprecedented: to the homefront reader, Iwo Jima became the best-known battle of the war in the Pacific. As a consequence, however, the bloodshed, the ferocity of the fighting, and the sickening toll of casualties were also given full coverage, often in highly colored language. "They had died as amphibious creatures die: not far inland, not far from the sea," was the way one combat correspondent described the Marine corpses he found on the beach on D-day.

The wounded were "slashed and mangled," John Lardner wired the *New Yorker.* "They died with the greatest possible violence," wrote *Time*'s man on the scene.[15]

The relaxation of censorship loosened journalistic restraint, and what the writers and the photographers saw on the black sands of Iwo Jima was every bit as terrible as their dispatches maintained. But in a sense, the pessimism of the brass predisposed combat reporters to paint an especially dire picture of the battle for Iwo Jima. "We expect losses," Admiral Turner told the seventy-plus journalists who attended the *Eldorado* press conference: "The defenses are thick . . . It is, I believe, as well defended a fixed position as exists in the world today. We expect . . . losses of troops, and we believe they will be considerable . . . However, we expect to take the position." Holland Smith, in his turn, predicted casualties as high as 40 percent among the shock troops on the beaches. The presence of Secretary of the Navy Forrestal, in a plain khaki uniform, only underscored the gravity of the hour. Praising earlier Marine operations in the Pacific for the precision of their planning and the swift deployment of materiel, Forrestal argued that Iwo would be "a different kind of war," to be won by sheer "force of arms, by character and courage." Through its own gloomy assessment of the situation and through judicious management of the press beforehand, the military was attempting to prepare the public for the worst: the grisly stories, the horrific pictures, and the shocking lists of dead and wounded soon to dominate the front pages of American newspapers.[16]

On the transports bound for Iwo Jima, the mood was somber, apprehensive. For the umpteenth time, units were drilled on their assigments using three-dimensional rubber maps of Island X, relief maps developed by the Hollywood movie industry. After the fleet left the Marianas, where transfers to the landing craft were practiced again in rough seas, Island "X-ray" was finally identified as Iwo Jima. To most Marines, the word came as no surprise. A reconnaissance photo of Iwo Jima, without the usual alterations of distinctive topographical features, had been published by mistake in a Honolulu newspaper, confirming Japanese suppositions about U.S. intentions. Radio Tokyo had even announced the coming invasion. No American operation had ever been less secret. The fact that the enemy was poised and ready added to the tension aboard ship. "The Marines bound for Iwo spoke more flatly . . . of the expectation of death than any

assault troops I had ever been with before," wrote a seasoned correspondent who made the long voyage north with them.[17]

D-minus-one—February 18—fell on a Sunday. Attendance was off at final church services. Below decks, men packed clean socks, toothpaste, gum. There were jokes, gallows humor. Ira Hayes, a Fifth Division Marine, played taps on his harmonica. It was for 19-year-old Franklin Sousley, the Indian said. Sousley wasn't coming back.[18] Some were seasick. The regimental surgeon reported an outbreak of diarrhea. Nerves. The Navy cooks served a wonderful last supper—turkey, mashed potatoes, ice cream. After dinner, everybody listened to Tokyo Rose, just for laughs. She warned the Marines that they were in for a very rough morning on Futatsune Beach.

Then it was Monday, D-day. At 5 A.M., the men ate steak and eggs, traditional fare on landing days. After breakfast, the Marines put on their helmets, went out on deck, and shuffled toward the ladder nets. As the sun came up over the line of debarkation, just beyond the range of the shore batteries, Iwo Jima revealed itself for the first time. "It never looked

A pre-invasion briefing aboard ship: the Fourth Marine Division.

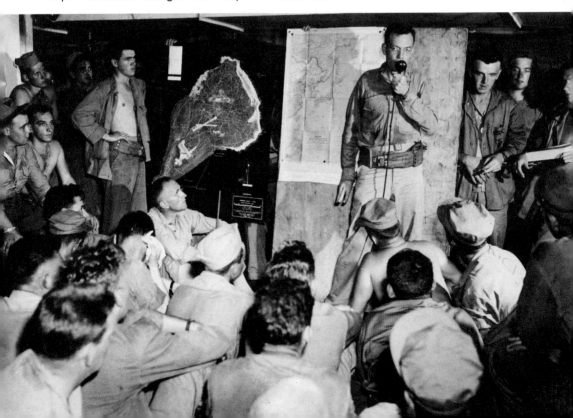

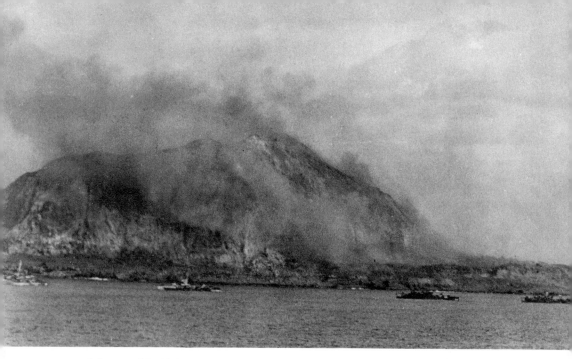

February 19, 1945: Mount Suribachi at H-hour, seen from the deck of the USS *Texas*.

more aesthetically ugly than on D-day morning, or more completely Japanese," Marquand noted. "Its silhouette was like a sea monster with the little dead volcano for the head, and the beach area for the neck, and all the rest of it with its scrubby, brown cliffs for the body. It . . . had the minute, fussy compactness of those miniature Japanese gardens."[19]

H-hour: 0900. Down into the boats. Out to the line. Orders bawled from a loudspeaker on the bridge of the control ship. "The choreographed movements of some classic military ballet." The first assault troops in their amtracks began "their long, slow, bobbing run for the beach." Green and Red Beaches to the left, closest to the mountain. The plan called for the Fifth Marines to land here, cut off Suribachi, and then pivot north. Yellow and Blue beaches to the right. The Fourth Marines, primed to wheel

Opposite, top: A wave of Fourth Division Marines splashes ashore on D-day.

Opposite, bottom: Marines burrow into the black volcanic sand as they leave the landing craft.

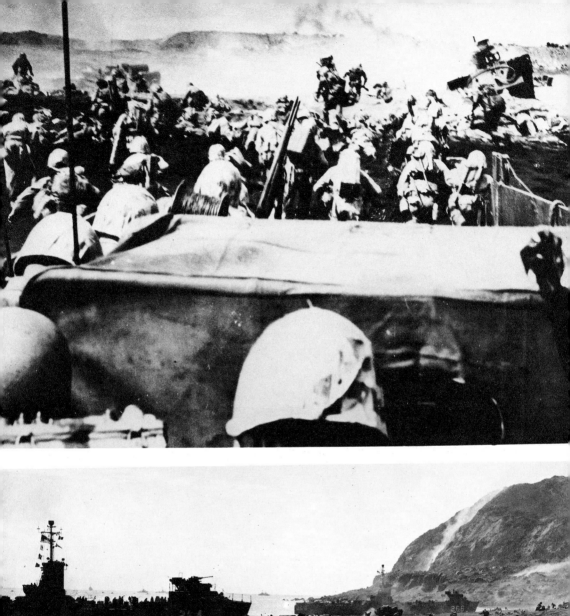
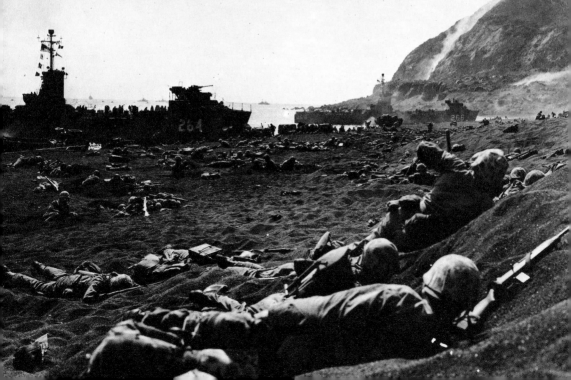

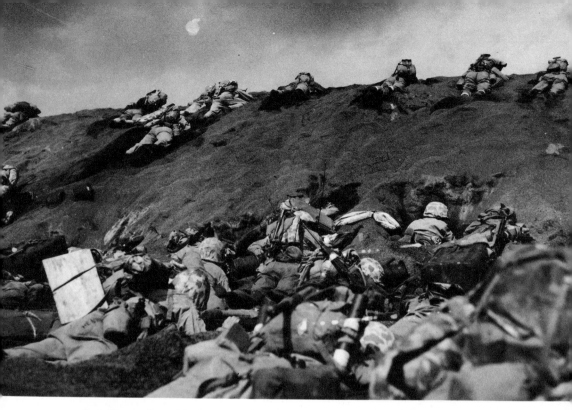

Red Beach One: Marines caught in withering fire on the terraces of sand above the waterline. Suribachi is to the left, over the next rise.

northward, too, toward the airstrips. A soft seven-knot breeze hardly rippled the turquoise sea. All was quiet. No fire from the island.[20]

The first wave hit the beach and tried to move quickly toward cover on the bare, treeless slope, rising upward from the Pacific in a series of steep terraces. But running proved impossible in the soft volcanic ash. The black sand sucked at the feet. Men found themselves sunk in the stuff up to their ankles, unable to climb, unable to dig in. It was like "trying to dig a foxhole in a bag of wheat," cried a southern boy, scrambling up a terrace in panic. When Kuribayashi's cave-dwellers rose from the depths, when the Japanese mortars finally opened up—*whishhh, whishhh*—the Marines were trapped on the sand, with no place to hide. Pinned down on a boiling strip of shore, they watched landing craft wallow in the surf, tanks and weapons mire in the sand, rubble and bodies pile up at the water's edge, behind them. Ahead lay only the booming artillery and certain death.

Suribachi looked down on the beach and the slaughter. The mountain seemed to take on a malignant life of its own, watching the Marines, "looming over them, pressing down on them."[21]

As an observation post, Suribachi commanded a view of two-thirds of the island. It was also the source of much of the fire raking the beaches. Webley Edwards, a CBS broadcaster who flew over the mountain in an observation plane, described Suribachi's punch for the listeners back home on the morning of D-day. "I looked at that volcanic crater," Edwards shouted over the noise of the engines, "and I realized it would take all the power we could muster to crack it . . . I could see its sides packed with caves and gun openings." The guns spit fire. The men on the beaches died. A "ghastliness hung over the Iwo beachhead," said a wounded Marine public relations officer, huddled in a shellhole within view of the bodies of his comrades. "Everyone was seized with an insensate lust to live." But there was no safety, anywhere. No safety for anybody, not even heroes. "Manila John" Basilone was an authentic American hero, the first enlisted Marine to win the Medal of Honor in World War II (he held off a Japanese assault singlehandedly on Guadalcanal in 1942), a hero kissed by starlets on war bond tours and feted by the mighty. Tired of being a "Hollywood Marine," he had asked to be reassigned to combat. At 10:30 on February 19, Basilone plowed up the beach on Iwo Jima, heedless of danger, looking for a spot where his men could set up a gun. As he turned back to urge them forward, he was hit by an artillery burst. He died a hero.[22]

At 11:30, the AP photographer Joe Rosenthal was still in a landing craft, waiting to go in, a full five hours after clambering aboard. The waterline was choked with wreckage, boats, vehicles trapped in the sand. The beach was all but invisible, under a pall of dust kicked up by shells and charges hurled down from above. The situation was apparent to the Marines about to go ashore. "I avoided becoming too friendly with the kids," Rosenthal said. "I was afraid that if I made friends it would only be to lose them." They were so very young:

> I kept thinking, "Here are guys who haven't lived yet . . . If I'm killed it will be no great loss, but these kids haven't had a fair chance, and we know the odds. The odds mean that four or five of them are not coming back and that some of the others will be injured."
>
> As we moved in, though, and the grimness weighed even heavier, . . . the kids smiled and then we ducked our heads and the ramp went down.
>
> No man who survived that beach . . . can tell you how he did it. It was like

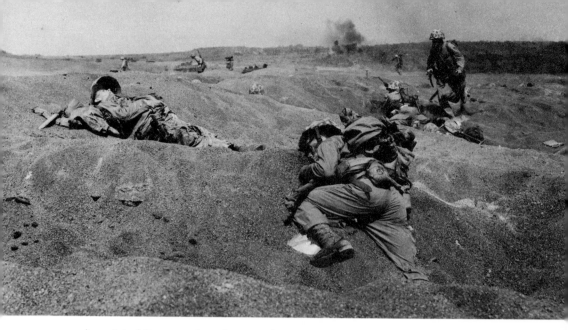

Associated Press combat photographer Joe Rosenthal hit the beach with the troops on D-day and showed the home front the terrible toll the invasion took.

walking through rain and not getting wet, and there's no way you can explain it.[23]

When the boat touched the shore, Rosenthal stood up and snapped two pictures of the "kids" racing down the ramp lugging their mortar carriages behind them. Next, some pictures of Marines slogging across the beach. He stopped behind a smashed blockhouse to try for a shot of a burning jeep. No luck. Heavy fire. Up and running in the sand behind two Marines bound for a shellhole. Then the photographer heard a loud clang. The helmet of the man in front of him shot straight into the air and the Marine fell dead. Rosenthal struggled into the hole, gasping for breath. When he poked his head over the edge of the crater, he saw another dead Marine, lying on an uphill slope, his gun at the ready, frozen in the act of charging forward. It struck Rosenthal as symbolic of the whole awful day. And so he worked himself around, dashing from crater to crater, until he got an angle on the picture, and waited for another Marine to run past. Then he clicked the shutter. The living and the dead.[24]

By nightfall, the press plane had left for Guam, carrying what Navy dispatches would call "some remarkable photographs taken by the civilian

pool photographer, Mr. Joe Rosenthal of the Associated Press." By Wednesday, February 21, his photo of the dead Marine was on the front pages of papers from San Francisco to New York, alongside alarming casualty figures and disturbing stories straight from the beaches. Official sources were quoted as saying that "the American position" on Iwo Jima had "appeared doomed" for most of D-day. Radio Tokyo crowed that the amount of real estate controlled by the Americans on Iwo Jima was "not more than the size of the forehead of a cat." Told of the situation in the Oval Office, President Roosevelt was said to have gasped in horror, for the first time in World War II.[25]

But the Marines hung on. On Tuesday, D+1, "Harry the Horse" Liversedge's Twenty-Eighth Regiment crossed the isthmus above Green Beach and turned south to attack its primary objective, Mount Suribachi, Mount Plasma, Hot Rocks. His "exec" made the whole thing sound easy: "A frontal attack, surround the base, locate a route up, then climb it!" By the end of the day, the Twenty-Eighth had gained two hundred yards and had lost a man for every one of them. The night was cold. The Japanese kept up a steady tattoo of fire until dawn.[26]

Wednesday, D+2. A storm. The beaches closed. But an air attack under a lowering sky pounded the precipice with rocket fire; the smell of napalm hung thick in the chilly air. The Twenty-Eighth jumped off again at 8:30,

D-day afternoon as seen by Pvt. Bob Campbell: smoke and dust distort the shape of the ominous peak above the beaches.

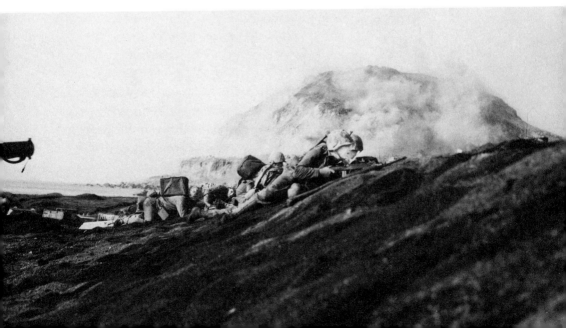

pushing toward the mountain. By 11 A.M., Easy Company had come within a few yards of the base. Sgt. Henry Hansen took point with Donald Ruhl, a Pfc. from Montana. They spotted a camouflaged bunker. Suddenly, Ruhl yelled. Something rolled toward the pair. Hansen ducked. Ruhl threw himself on a live grenade. He won the Medal of Honor for saving his sergeant's life.[27] By sunset, the unit was a thousand yards closer to the goal. The north side of the base was now Marine territory and American lines extended halfway around the mountain.

Thursday, D+3. Washington's Birthday. Torrential rains. The sand turned to viscous mud, clogging weapons, sucking at boots. At 8 A.M., the attack on the mountain stronghold began. Intelligence estimated that six hundred defenders remained dug in on Suribachi. If grenades and flame-throwers failed to flush them out, then the Marines were ready to seal up the bunkers with explosive charges.[28] Poor visibility hampered the Japanese more than it did the advancing Marines. Opposition came in short,

February 22, 1945: Marines in a forward position, facing Japanese defenders entrenched on Mount Suribachi.

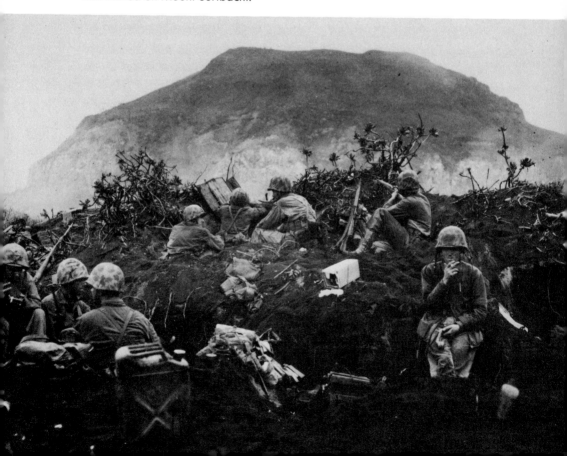

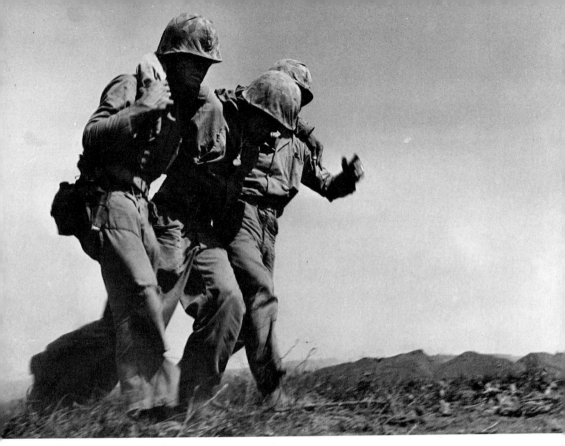

A Fifth Division Marine wounded by a mortar shell.

wild bursts now. The sustained fire of the previous days was over. Resistance was weakening. By nightfall, for the first time since landing on Iwo Jima, Easy Company believed that Suribachi could be taken. Thus far, the drive had cost the Fifth Division 2,057 men. Offshore, Holland Smith tallied the casualties for the first four days. The total stood at 4,574, killed or wounded.

The numbers—and the obvious carnage ashore—presented Smith and the Marine Corps with two immediate problems. One was troop morale. The other was public opinion. In the past, morale had often been boosted by praise for Marine bravery contained in press clippings attached to letters from folks back home. The Corps tried to encourage such favorable comment and to curry favor among civilians in general by creating its own news. General Denig of the Public Relations Division fielded a cadre

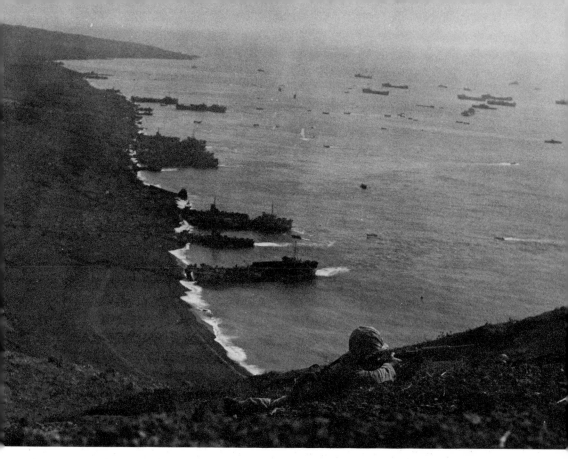

From Suribachi, the Japanese had a panoramic view of Marine action below. Lou Lowery of *Leatherneck* took this picture, wondering all the while how anyone on the beaches had survived.

of Marine combat correspondents, "fighting writers" who carried both guns and typewriters and were instructed to add a human dimension to war news.[29] They publicized Marine heroes like Ruhl and Basilone, but they were just as likely to file stories of local interest about how the hometown softball pitcher had learned to toss a grenade. Marine combat photographers walked the same fine line between straight reportage and "soft" news. What amazed the Marines' detractors was the sheer volume of hype the Corps cranked out. Soldiers and sailors delighted in a song that circulated during the war lampooning "the Marines, the Marines, those publicity fiends" who "pat their own backs [and] write stories in reams / All in praise of themselves—the U.S. Marines."[30]

In the wardroom of the *Eldorado* on the evening of February 22, nobody was laughing. General Smith was closeted with Secretary Forrestal. The topic was Mount Suribachi. It was apparent that the Twenty-Eighth Regiment was close to its objective: the mountain fortress would fall. The question of the hour was when—and how. Troop morale demanded some highly public act, some dramatic symbol that would rally the Marines on Iwo Jima and proclaim a shift in the tide of battle. At home, the numbers and the bloody headlines had begun to spark unease. Charges that the higher-ups were indifferent to the lives of American boys were heard, along with appeals for the use of poison gas against entrenched Japanese positions. At home, a visible sign of progress—one good picture in the papers—could make all the difference. The word came down the line to Harry Liversedge: "You must take Mount Suribachi tomorrow. The success of the whole operation is hanging in the balance."[31]

Flags were discussed. As a sign that Suribachi had been captured, the first unit to the top was ordered to raise the Stars and Stripes. To stress the importance of that event, Forrestal himself planned to go ashore on D+4 and "witness the last stage of the Suribachi battle" in person.[32] His presence on the still-dangerous beachhead would direct the attention of the press to the drama of the long, slow climb to the summit, the sight of Old Glory fluttering in triumph over Japanese soil. Thanks to the Navy's revised policy on news coverage, the photos would reach the American breakfast table less than eighteen hours later.

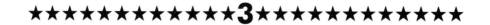

I didn't know nothing about the flag until I got back to Saipan when I saw these pictures coming out of the States. I looked at that and then—my God, something's wrong here. That ain't the one we raised.

Cpl. Charles Lindberg, remembering the Iwo Jima flag raising in 1985

Our Flag Was Still There

"Japs observed using pyrotechnics—Assume they are probably calling from Hotrocks for Arty . . . 45 enemy dead in our area . . .—Fr. Div.— Enemy using booby traps in saki bottles & terracotta mines . . . Our troops have reached the very base of hill . . . Enemy is throwing hand grenades from top of Hot Rocks on troops at base of Mt . . . Reports of at least 3 counterattacks . . . Fr. LT 128 observed Japs committing Hari by jumping off cliffs . . . Receiving counterattack on entire front. All units losing ground (stopped at 17:32) . . . NG7 officer reports 20 swimmers off purple beach fired upon by Able Company—3 known casualties."[1]

Through the kaleidoscopic confusion of battle dispatches, a vision of the impending capture of Suribachi began to appear. After four days, the Fifth Division had fought its costly way around the base of the volcano, driving the defenders deep down into their caves and upward toward the summit. Combat digests described a state of siege: "By the end of the period Mt. SURIBACHI had been reached by our forces and what enemy remained there were defending from the heights of the volcano. A POW captured . . . by BLT 1/28 stated that SURIBACHI contains five main caves on three levels connected underground; the largest . . . opens to the south, is capable of housing 300 men and has five openings . . . When the foot of the volcano was reached its steeply rising sides and the fact that naval gunfire had destroyed paths leading up these sides brought our advance practically to

a standstill. The enemy rolled hand grenades and other explosives down the cliffs on to our troops."[2] Their encircled adversaries wavering between desperation and despair, American forces now gathered for the final assault on Suribachi.

Damp, grimy, footsore, hungry, and reeling with fatigue, the fighting men of the Twenty-Eighth Marines greeted the dawn of D+4 with fresh hope. They had run the gauntlet of camouflaged pillboxes around the base of Suribachi—and survived. Behind them, machine-gun emplacements now lay silent. The mountainside no longer poured down a storm of mortar fire upon them. The rains, too, had stopped: weather stations reported a moderate 69 degrees and promised clearing skies. A 20-knot breeze freshened the air. On this Friday morning, the fear and horror of the previous days subsided into nagging anxiety. Like a colony of ants in a sandhill, the Japanese remained underground, leaving the average Marine on the line to wonder what kind of last, desperate ambush the enemy had in store for him.

Capt. Art Naylor, commanding officer of Company F ("Fox"), wanted hard facts. Just after 8 A.M., he hollered over to Sgt. Sherman Watson to take some men—as many or as few as he wanted—up the north face of Suribachi to reconnoiter a trail. Watson found three privates to join him: his friend George Mercer, from Iowa; Ted White, who had grown up on a Kansas wheat farm; and Louis Charlo, a tall, burly Indian from northwestern Montana. The detail set out over the loose, rocky terrain of the bombed-out slope. Slowly they ascended, Mercer on point, with Charlo, Watson, and White spread out behind. No sign of motion ahead. Only friendly fire, strafing the heights above them. The enemy stayed in their caves even as the volcano steepened near the crest where snipers surely lurked, waiting to pick off the little patrol. Alert, silent, tense, they approached the summit, ready to fire, but nobody opposed them. Unchallenged, they stood and surveyed the area from positions just below the lip of the crater. An abandoned machine-gun turret. Emplacements that could have cut them down were empty. A breathtaking view. No one, anywhere. Spooky. They turned and ran, sliding, skidding, scampering down the mountainside.[3]

Watson reported to Naylor. Then the sergeant checked in with Col. Chandler Johnson at the command post and left with Mercer for a hard-earned breakfast. White and Charlo went back to their own company, now preparing to follow another platoon up the volcano. But Colonel Johnson

hadn't waited for Watson. He heard that a scouting party from D Company had found the other side of the peak too sheer and rock-strewn for an attack in force. Confident that he knew a better way, Johnson had already ordered his executive officer to lead a forty-man detachment from Easy Company up the north face. That platoon left even before the first patrol returned: it passed Watson by at a distance and kept going, intent on capturing the summit and planting the American flag.[4]

The American colors had been part of the Suribachi plan from the beginning, back when the Fifth Division underwent training on the "Big Island," in Hawaii. On a bleak day in mid-December 1944, officers of the Second Battalion gathered in the camp war room for a briefing by Chandler Johnson. In the middle of the room, a "sand table" held a contour model of an island—Iwo Jima—guarded by a forbidding volcano at its southern end. Capt. Dave Severance, Easy Company's CO, listened with growing unease as his battalion chief pinpointed their landing sites on the southernmost shore, all open to a Japanese barrage from Suribachi's deadly heights. Brutal as the fighting across the lowlands might become, Severance envisioned Armageddon on the slopes above those beaches: wave after Marine wave crawling up the precipice, exposed to hailstorms of machine-gun fire, showered by explosives—his best men mowed down by the fire of defenders entrenched along the upper rim of the crater.[5]

Fear fed the tide of bravado that swept the room. "A case of champagne to the first man to the top!" cried one CO. The battalion adjutant, 2d Lt. Greeley Wells, loudly announced that he would carry the flag. According to the Marine Corps Staff Manual, that was the adjutant's job, and Wells promised his ensign to the first unit up Suribachi, so they could plant it on the highest point of land. According to company folklore, whenever Johnson drilled the officers on the invasion plans afterward, Wells always ended his list of duties with "and I carry the flag!" "Why?" Johnson would snarl. "Because it says so here!"[6]

Later, on the cold, swelling seas off Iwo Jima, a group of officers from the Twenty-Eighth Marines met to chew over the invasion plan one last time. Greeley Wells was aboard the transport that evening, popping off again about his flag. "You get the flag and I'll get it up on top of Suribachi!" bellowed 2d Lt. George Haynes, in his strong southern accent. From the back of the compartment, even the Catholic chaplain, Father Charles Suver, joined in the boasting: "You get it up and I'll say Mass under it!" Haynes dared the padre to take a church pennant along so that he could

hoist that up, too.[7] When D-day arrived, the brave banter stopped. But as the subdued men of the Twenty-Eighth Marines boarded their landing craft, Wells still hoped to hold yesterday's braggarts to their word. In the adjutant's map case, he carried a small (54×28 inches) American flag, one he had scrounged from the attack transport *Missoula*.

Now, it was D+4. The men of the Third Platoon, Easy Company, had known since the night before that they would lead today's dangerous climb up Suribachi; Captain Severance chose them because they held positions at the base of the northern slope, astride the most feasible route to the top. At first light, the platoon gathered at Johnson's command post for their final orders, spoiling for a fight. Those who had 'em, smoked 'em. Others cleaned weapons and checked their packs while the officers jaw-boned. *Leatherneck* photographer Lou Lowery turned up, hoping to join the expedition: this might be the biggest story of the whole Iwo campaign. As he approached the huddle, Lowery heard Johnson's last words to his lieutenant: "If you're able to get up the mountain I want you to take this flag . . . If you can't make it all the way up, turn around and come back down. Don't try to go overboard." And he handed him the banner Wells had carried ashore in his map case.[8]

The unit belonged to Lt. Harold Schrier, a career Marine since 1936, a member of the elite Marine Raiders, and a veteran of Midway, Guadalcanal, New Georgia, and Bougainville. Schrier replaced 1st Lt. Keith Wells, who had been wounded on Wednesday leading the Third through a ferocious firefight: he screamed orders even after his legs were torn by shrapnel. Known as "Tex" (for his home state) or "G.K." (for Genghis Khan), Wells had prepared his men for this kind of difficult assault, indoctrinating them with a fanatical "can do" attitude. "Give me fifty men who aren't afraid to die," Wells was fond of saying, "and I can take any position!"[9] Although his leadership early in the battle would earn him the Navy Cross, today, on D+4, he lay offshore, in a hospital cot. Schrier was in charge and duty as second in command fell to Platoon Sgt. Ernest Ivy Thomas, the popular "Thomas the Tiger" from Tallahassee, who had dropped out of college at seventeen to join the Corps. "Boots" Thomas had taken command from Wells during Wednesday's bloody skirmish, exposing himself to machine-gun fire while directing tank strikes against enemy pillboxes. He, too, would win the Navy Cross for the action on D+2.

Two days later, on Friday morning, the Third Platoon moved out across the low ground, casually at first, holding fear at bay with studied noncha-

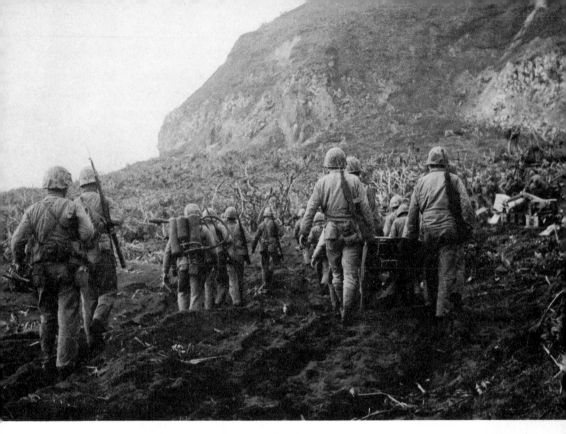

The forty-man patrol sets out for Suribachi. This photo begins Lou Lowery's moment-by-moment documentation of the first flag-raising.

lance. Toward the front, Schrier and Thomas were joined by Platoon Guide Sgt. Henry O. Hansen, a tall, thin New Englander known as "The Count" for his debonair manner. Also near the lead, combat vet Cpl. Harold Keller carried a heavy BAR (Browning automatic rifle) in tandem with Jim "Chicken" Robeson, the youngest platoon member. Robeson's forward position reflected his thirst for action; as the platoon fell into a single column after regrouping at the foot of the mountain, "Chicken" stayed out in front.

Up, up they climbed, passing burned-out enemy positions near the bottom, and the occasional corpse, mutilated, stinking. They moved on: squad leader Sgt. Howard Snyder; Cpl. Robert Leader, an art student from Boston; Jim Michaels; "Katie" Midkiff from West Virginia; Clarence "Snowjob" Garrett; Manuel Panizo; Leo Rozek, another BAR-man. Near the middle of the line of march, big men like Robert Goode and Chuck Lindberg carried seventy-pound flamethrowers high on their backs: they would burn the Japanese out of their caves. Upward they toiled, slowing

as the gradient rose, ever more alert as they approached the crest. A few peeled off from the column to cover the exposed mouths of caves, looking for potential snipers. In the rear, prepared for the worst, trailed the stretcher-bearers and the Navy corpsmen, with their splints and vials of morphine: the soon-to-be-famous John Bradley climbed with the medical contingent. And tagging along at the very end, armed with a 120mm Rolleiflex and four packs of film, came Lou Lowery, posterity's witness to history in the making.

Lowery photographed the blasted landscape, where heavy artillery had pounded boulders into sandy rubble and trees into splinters. Cannon barrels leaned drunkenly from battered redoubts. The reinforced concrete of pillboxes had crumbled like plaster. But such scenes of ruin and emptiness on the lower slopes of Suribachi did not mean that the crater's cone was also deserted. Fearing that the patrol might be driven back from the summit, Lowery asked the Marines with the flag to hold it out for him so

Ascending Marines pass the mutilated corpse of an enemy soldier.

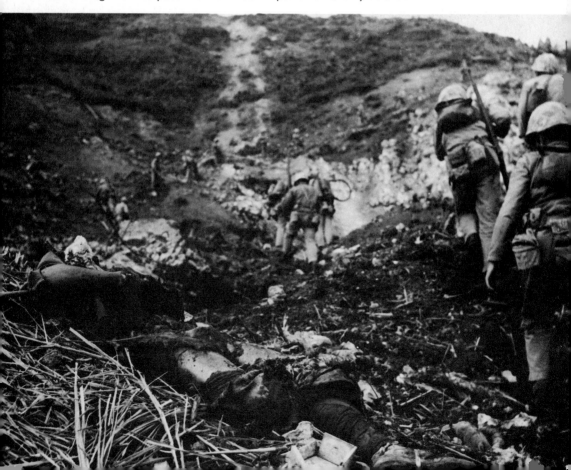

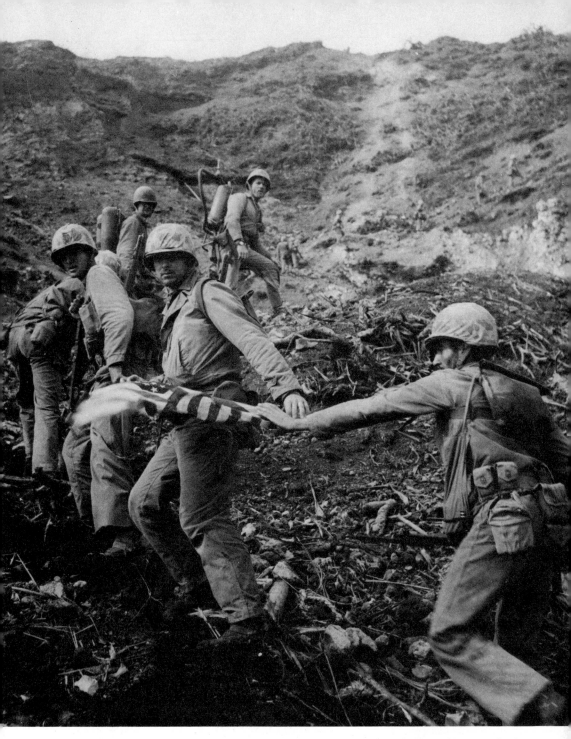

Panizo reaches for the flag while Lindberg and Goode (with flamethrowers) look back from above.

he could take a picture—maybe for a story about the *first* attempt at seizing the peak.[10] Lindberg looked back and snorted in disbelief as his friends struck a pose for Lowery. Phony baloney!

Radios monitored the progress of the Third Platoon from below: "9:50 . . . R3 reports 40 man patrol under Lt. Schrier proceeding up face of volcano in front of 2nd BN C.P." They pressed on, up the steepest part of the slope, using their hands to pull themselves along. Still no signs of the enemy. The men in the lead avoided what remained of the trail, fearing land mines, finding none. Within half an hour, they neared the top, without resistance. Only the lip of the crater lay ahead. The platoon fanned out along the crest, crouching, silent, ready to fire. One by one, they vaulted over the edge—Snyder, Keller, Robeson, Schrier, the radioman, Rozek, Leader, and the rest.[11] And then— nothing. Nothing at all. The mountaintop had been abandoned by the Japanese. The enemy had retreated into their maze of underground tunnels. Nobody fired a shot.

"10:15 . . . Troops en masse observed on top of Suribachi led by Lt. Schrier . . . 10:18 . . . Fr. Lt 228—Patrol atop crater—states enemy positions are just under rim—that 3 D.P. guns exist on left base of volcano. Refuses PR coverage 'til mission accomplished."[12] Schrier ordered his men

The tensest moment: surmounting the crest.

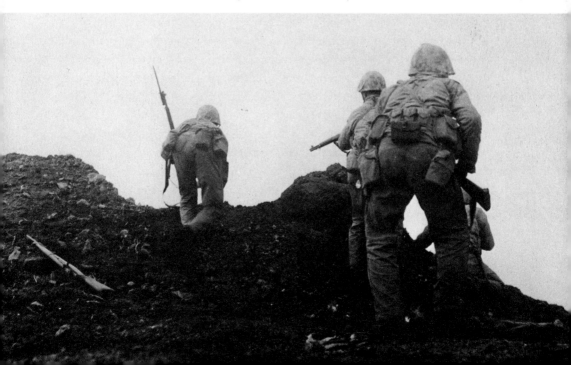

to circle the interior of the crater, keeping low, alert for snipers from the caves beneath their feet. He also sent several Marines to search along the outer rim for a pole or staff on which to hoist the flag. Leader and Rozek found a section of drainage pipe, still straight and trim, despite the wholesale wreckage around it. As Lowery circled the group, documenting every step in the process of raising the first American flag of World War II to fly over sovereign Japanese territory, Schrier, Thomas, Hansen, and Lindberg shook out the flag and ran a line through a hole in the pipe to fasten the banner in place.[13]

They worked at a casual pace, more relaxed now, relieved at how easily they had achieved the summit. Sounds of a minor skirmish echoed inside the cone—a few cracks from snipers' guns, answered by the ping of Marine carbines and the clatter of BARs.[14] But the action was light and the noise of battle still in the distance when they lugged the pole, with the flag now dangling from it, toward the highest pinnacle atop Mount Suribachi. Lindberg kicked his heel into the loose dirt, gouging out a hole. His buddies held the makeshift flagstaff horizontally, waiting for a signal. Michaels crouched nearby, his carbine at the ready, watching for signs of a challenge from the absent foe.

A shout from Lowery: wait a minute! He'd just run out of film and needed a second to reload. Lindberg growled at him to hurry. Hanging around in a clump was a good way to get shot: men with flags made easy targets. Somebody yelled at Chick Robeson to come on over and join the historic picture. Forget it, guys. He kept his BAR firmly in hand, turned his back on the scene, and muttered the cruelest epithet of all: "Hollywood Marines!" Lowery moved back down the slope a little, to a spot where he could see both the raisers and the vigilant Michaels on guard. He signaled "ready" as the Marines hoisted Old Glory into the wind and shot his picture just as the pole reached its full height, the flag blowing stiffly in triumph. He took more pictures as the men worked the pipe deeper into the ground and lashed it down with guy ropes. Then, as Lindberg remembers it, "all hell broke loose." The Marines saw the flag. And the enemy saw it, too.

Shouts and cheers rose from the beaches below. Offshore, boats sounded their horns. Men on lower ground congratulated one another. "American flag flies on highest point of Suribachi Yama," trumpeted radios around the island, just after 10:30 that morning. Those who had watched the movement of the patrol through field glasses saw the flag and knew that Easy Company had made it. Loudspeakers throughout the invasion

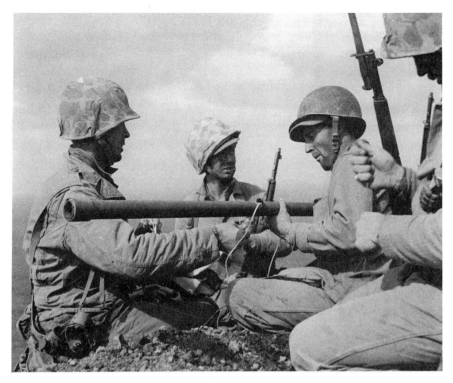

Schrier, Thomas, Hansen and Lindberg fasten their flag to a makeshift pole.

Lindberg kicks at the ground to make a hole while the others ready the flagstaff (Hansen wears a cap; Thomas is visible behind him).

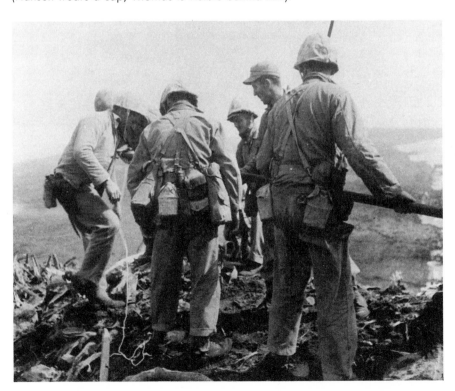

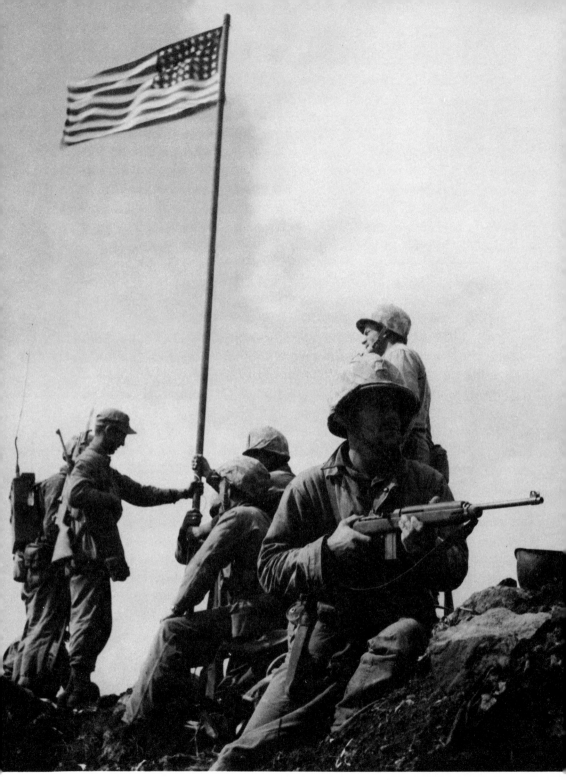

The Stars and Stripes over Suribachi! As Lowery snaps the shutter, Michaels holds the carbine in the foreground; Lindberg stands in the rear.

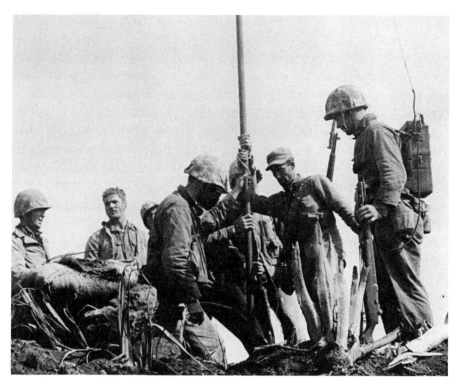

Marines finish planting the flag while their buddies look on. In a minute, a skirmish will break out.

armada confirmed the capture of Suribachi. Dick Wheeler, an Easy Company Marine being treated aboard a hospital ship for a shrapnel wound, was thrilled by the news, he recalls, although he had yet to learn that his own buddies were the heroes of the hour. Near the Fox Company command post, a broad smile spread across the face of Father Suver as he peered at Suribachi through his binoculars. "Get my Mass kit," he shouted to his assistant. "We're going up!" And on a Higgins boat heading toward the beach, an unassuming man wearing khakis and a life vest put down his own binoculars and turned to address his escort, Marine General Smith. "Holland," he said, "the raising of that flag on Suribachi means a Marine Corps for the next five hundred years." So spoke the Secretary of the Navy, James Forrestal, elated by the morning's main event.[15]

Farther out at sea, from the bridge of Admiral Turner's flagship, CBS

radio correspondent Don Pryor described the scene for the folks back home. He first caught sight of the flag through the porthole of his cabin, "tiny and wonderful, standing clear against the sky above that awful mountain." For Pryor and his listeners, this was "the supreme moment . . . It won't be long now before the rest of the Japs in Suribachi are wiped out, and the fire that has raked and scarred the beach will be quieted . . . The upper hand is ours and Old Glory flies now over all our work." By 11:00 that morning, the official radio dispatch had reached command posts all over the island: "Lt. Gen. Holland Smith and Vice Admiral Turner join in congratulations on the capture of the summit of Suribachi at 1035."[16]

For one brief moment on that volcanic annex of hell, the weary, frightened soldier could pause to savor a feeling of real joy. The band of Marines who hoisted their colors atop the mountain that had embodied Japanese will gave Marines all over Iwo Jima new inspiration, new pride and confidence. Although small against the bulk of the mighty Mount Suribachi, the fluttering emblem meant that the American drive could now shift to the north, without fear of attack from the rear. In that shining moment, nobody knew who had raised the flag—nor did anybody really care. But every American with an eye turned toward the mountain, with an ear glued to a radio, thrilled at the red, white, and blue declaration that the United States Marines had taken the enemy's strongest stronghold. Now the defeat of Kuribayashi was only a matter of time.

As the horns blared and the radios crackled with news, "all hell" indeed broke loose on the top of Mount Suribachi. Japanese defenders, maddened by the sight of the flag, determined to challenge its bearers. A sniper popped out of a cave and opened fire, narrowly missing Schrier and the other raisers. Robeson wheeled and unleashed a deadly volley from his BAR: hands reached out of the cave and drew the lifeless body back inside. A frenzied officer charged the flag, waving a broken sword. Snowjob Garrett cut him down. Suddenly, a full-fledged firefight was in progress. Grenades hissed and boomed. The air sizzled with gunfire.

The Marines drove the Japanese back into their bunkers. Lindberg and Goode lugged flamethrowers to the entrances, spewing fire into the darkness. Burned out of their hiding places, enemy troops bolted from escape tunnels, easy targets for the riflemen who shot them, one by one, as they emerged. Demolitions teams blew up other exits, jammed with beaten Japanese. More skirmishes broke out on the far side of the crater, where Fox Company had joined in the mopping-up operation. Lowery stuck with

the flamethrowers, still photographing the taking of Suribachi, step by dangerous step. At the mouth of one cave, as the Marines moved away, live grenades flew out, straight toward the cameraman. He jumped backward over the crater's edge, avoiding the blast but tumbling thirty or forty feet down the stony incline. Scraped, bruised, and clutching a shattered camera, Lowery picked himself up with a sigh of relief. "That's enough for today," he thought, and hobbled back down the mountain with a pair of Marines, one badly wounded in the leg.[17]

Meanwhile, the Catholic chaplain and his assistant, Fisk, were on their way up. A fellow down below told Father Suver to forget it: some colonel or other had cordoned off the volcano to unauthorized personnel. Tipped off in advance, Suver circled wide of the checkpoint and found a path winding upward. He made his own way to the top and looked over the edge, at the pockets of fighting below. Standing there, he could hear the eerie sound of the Japanese soldiers trapped in the caves beneath his feet; their impending slaughter saddened him. But Suver's reverie was interrupted by frantic signals from Marines on the other side of the crater. Get

Flamethrower (at left) streams deadly fuel into a cave, causing the enemy to flee from the other side of the crest (at right), where Marine sharpshooters can pick them off as they surface.

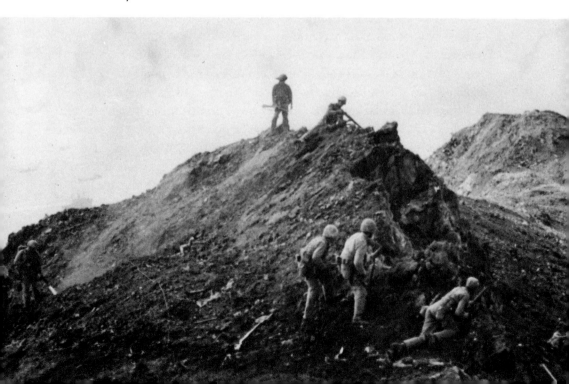

down, they motioned. Get down! Japanese were up and moving in a cave just under the spot where Suver and Fisk stood, and the Marines wanted to get on with the shooting. The padres took cover. Rifle fire raked the cave. Grenades were lobbed inside. Then came the demolitions men. After that, there were no more sounds beneath Suver's feet. Father Suver saw Captain Naylor shouting into another cleft in the rock, imploring those inside to give up. He yelled in English, in broken Japanese. He even tried "a little Marine language." No one came out. The cave was sealed with a charge of "C2."[18]

A short distance from the flag, some fifty yards or so, Suver found a depression that had once held an artillery piece and, with the captain's permission, broke out his Mass kit. Fisk set up a makeshift altar on the Japanese gunmount. Suver donned his vestments, screwed together a field chalice, arranged his paten and hosts, and rounded up a battle-hardened flock. Shortly after noon, Father Chuck Suver and twenty young Marines began to pray. Over the ancient words of the liturgy, the flag played a hymn of its own in the breeze, a hymn punctuated with shots, fewer and fewer of them now.[19]

The mop-up up was almost over. While Suver said his Mass, other Marines curled up in dugout hollows all around the crater—miniature versions of home where they could break out rations, have a smoke, shoot the bull, or just loaf. Sentries were posted before the biggest caves. Guards took up positions around the perimeter. Small scouting parties continued to circulate in search of snipers. Men scrounged for souvenirs: a "Jap" flag, a pistol, maybe even a samurai sword. An American observation post was set up, overlooking the beaches. A few Marines hung around the flag—just in case somebody tried to take it down again. The guys atop Suribachi could feel lucky they weren't in the north, where murderous fighting around the airfields now raged. For the moment, the Twenty-Eighth Marines would remain here, behind the lines, in reserve. For them, the battle of Iwo Jima seemed almost over: mission accomplished. And today, that had been remarkably easy. Sure, a few guys were banged up. But no American died during the final assault on Mount Suribachi.

For the forty-man patrol from Easy Company, mopping up brought a special relief. Later, they found that one big cave inside the crater contained more than 150 Japanese: rather than coming out to fight, they had committed mass suicide by pulling the pins of live grenades clutched to their stomachs. But they'd been down there, all the time, nearly 300

Father Charles Suver offers communion during the first Mass on Mount Suribachi.

enemy soldiers, all told. Why, Schrier wondered, had they declined to defend the mountaintop? Attacking from the tunnels, after the flag went up, the Japanese were easy targets. But earlier, on the way up, the American patrol had been vulnerable, virtually helpless, woefully out-numbered. "We'd have been real dead ducks," Schrier admitted. "They could've killed us all."[20]

Sometime in the early afternoon, with the position secure, Lindberg and Goode descended Suribachi to refuel the flamethrowers and grab some lunch. About 5:00, on their way back to the top, they met a cantankerous lieutenant, limping from leg wounds, trailing bandages, trying to hobble up the slope. It was their old commanding officer, Keith Wells, who had staged a tantrum aboard the hospital ship in order to rejoin his platoon of flag-raisers. Lindberg, Goode, and Robeson carried Wells to the summit, where he promptly took charge. Several days later, when Easy Company finally abandoned their perch, Chandler Johnson met the outfit at the bottom. Spotting Lindberg with his arms full of souvenirs, he gave him a good bawling out: "You've got more Japanese equipment than you have

your own!" And then he took a piece out of Wells, too—"jumped down his throat," according to Lindberg—and ordered the wounded officer back aboard ship for treatment. The chastised platoon marched off across the flatlands, grumbling all the way.[21]

Saturday, February 24, 1300 hours. The inevitable radio message reached the Twenty-Eighth Marines' command post: "Request you designate one member group flag raisers report aboard Eldorado (AGC 11) early morning 25 Feb. Purpose news broadcast." The press needed a celebrity. When his platoon first raised their flag, Schrier frustrated the Marine publicity machine by refusing all coverage "'til mission accomplished." Later that day, when he did allow photographers to roam the area at will, the volcano was already secure and the story of its capture old news. The only flag-raising that these late-comers shot was the minor ceremony in the afternoon, when a few Marines substituted a larger flag for the small original. But now, journalists wanted a *somebody,* a warm body to personify the morning's history-making events. As leader of the patrol and one of the actual flag-raisers, Schrier should probably have gone to the *Eldorado* himself. Instead, however, "PR" duty fell to Boots Thomas, the expedition's second in command. So, very early on a clear, calm February morning, even before the sun had risen over this tottering outpost of Hirohito's empire, Thomas found himself on a landing craft chugging toward the command ship, where the boys from the press waited to make him a hero.[22]

Stubble-faced and worn out, Thomas climbed aboard Turner's flagship unsure of what to expect, only to find the Admiral himself waiting to lead the congratulations, along with "Howlin' Mad" Smith. Smith drew the young sergeant aside for a warm handshake and a hearty "job well done," as photographers snapped stills for the wire services. In his ancient leather jacket, his spectacles twinkling, the avuncular general seemed truly pleased and proud. Thomas leaned toward Smith, gripping his hand firmly, looking the Old Man straight in the eye, smiling a little. It was a winning picture: the military equivalent of father and son, calculated to warm the hearts of readers back home. The photogenic Thomas had passed the first hero-test. The second was an oral exam: with the "praises of high-ranking officers still ringing in his ears," Thomas mounted to the admiral's bridge, where Don Pryor of CBS stood by with a microphone.[23]

It was only 4:30 A.M. on the waters off Iwo Jima, but for listeners tuning

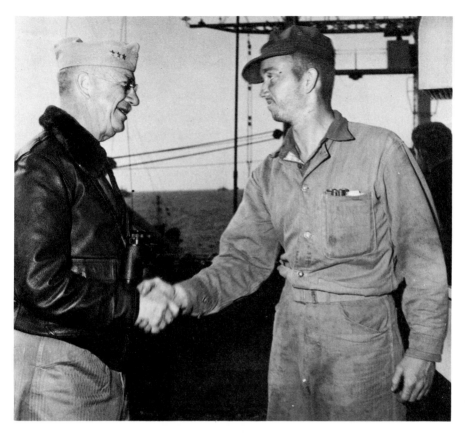

General Holland Smith congratulates Ernest Thomas aboard Admiral Turner's flagship.

their radios on the other side of the planet, it was 2:30 on a sleepy Sunday afternoon, Eastern War Time. Pryor introduced his special guest to the audience as a "modest but tough 20-year-old fighting man from Tallahassee," leader of the Marine platoon that captured Suribachi, "the first American in history who has ever raised Old Glory over a part of the Japanese home empire." A stunned pause. "No, Mr. Pryor," Thomas interjected. "I don't want to give that impression. The honor belongs to every man in my platoon. Three of us actually raised the flag—Lieutenant Harold G. Schrier, our company executive officer, Sergeant H. O. Hansen of Boston, and myself. But the rest of the men had just as big a part in it as we did."

Sure, he had felt "mighty proud" when he looked up to see his own platoon's flag "whipping up there in the wind." For the most part, though, everybody had been too busy to do much thinking. Snyder and Keller: they were "the first men to reach the spot where the flag was raised." Garrett picked off the first enemy soldier. Company F helped out on the southern rim. To the enormous frustration of Pryor, who was working hard to cast Thomas as the hero of the hour, in the sergeant's own version, every Marine on Suribachi had helped to get that flag up. So the journalist gave up. Pryor ended the interview by excusing his weary celebrity for a well-earned snooze: "I think you've done your share for a few hours." Then he signed off by reminding his listeners that they had just heard from the man who had "led" the patrol up Suribachi—as if all of Thomas's disclaimers had somehow slipped his mind.[24]

When Tech. Sgt. Keyes Beech heard Thomas unfurl his story, he knew the Marines had a problem. As publicity liaison for the Fifth Division, Beech bore responsibility for heroics destined for home consumption. "Young Marine Leads Battle Charge up Mountain: Raises Flag atop Enemy Stronghold amid Storm of Bullets." Terrific headlines—but it didn't happen that way. Forty men had climbed Suribachi without a fight. Until their deed was done, the flag-raisers had never come under direct fire. And Thomas had not even been in command! Worse for Beech, Thomas refused to accept unwarranted praise. To the consternation of the public relations expert, he was the typical World War II fighting man: self-effacing, understated, suspicious of overwrought patriotism.[25] He was proud of what he had done but modest about it, unwilling to claim more than his share of the credit. Far from matching any Hollywood pattern for a hero, Thomas was a celebrity by accident or circumstance, a surrogate for his buddies back on the line. In other words, Thomas confounded heroic expectations and by doing so, exposed the inherent conflict between the fabled publicity-seeking of the Corps and the code of behavior of the individual Marine.

To do his own job, Beech moved swiftly to take control of both Thomas and his story. He posed him for more pictures with General Smith (and appeared in some of them himself). It was Beech who fed the official Marine account of the young man's exploits to the wire services—a masterful piece of storytelling that parlayed Wednesday's meager heroics into Friday's headline spectacular. Beech's version of the flag-raising was delib-

erately sketchy on the specifics. Thomas was a "soft-spoken Marine" who led his men up "bitter slopes" and now wanted to share the credit for his "heroic deed." Skimming over Suribachi—where not much had happened—Beech deftly shifted the narrative to earlier fighting below the mountain, to Wells's wounds, to Thomas taking command, barbed wire being cut, a battle raging in a "hotbed of pillboxes," and back to Thomas alone, leading the tanks, saving the day. On D+2, his platoon of forty-six men had taken seventeen casualties in forty-five bloody minutes: Thomas had saved his unit from more deaths, more suffering. As a war story, Beech's yarn spliced the high drama of one incident into the bloodless accomplishments of another. The flag-raising and the heroics under fire had been separate episodes: now they were woven together into the fabric of national myth. But soon, the disparity between one day's battle and the hoisting of the flag on another would no longer matter much. By the time Beech's story ran on front pages all across America, Boots Thomas was dead.[26]

Ernest Ivy Thomas died on March 3, in fighting on the northwest side of the island. The enemy had pinned down his platoon in a ravine in among the caves of Nishi Ridge. Caught in a crossfire, Thomas was reporting his position on the field telephone. A sniper's bullet blew the rifle out of his free hand but he kept talking. The second shot knocked him down, killing him instantly. When word reached the press pool, Keyes Beech had to write a new story about Sergeant Thomas and Old Glory. This time, it was an obituary that ended on a sad, personal note: "I knew Thomas, too, and this is not an easy story to write. But one thing helps. From where I sit, I can see the flag over Suribachi."[27]

After securing the southernmost end of Iwo Jima, the Twenty-Eighth had enjoyed nearly a week in reserve. By combat standards, their duty was a piece of cake: checking caves, manning observation posts, working behind the lines. At night, sometimes, the Japanese lobbed long-range rockets their way. Five-foot "buzz-bombs" launched from wooden chutes, they normally missed the mark. But on D+10, March 1, Harry "the Horse" Liversedge's Twenty-Eighth Marines rejoined the battle line inching along the western coast: first, Hill 362-A, then Nishi Ridge, pressing northward toward Kitano Point. The engagements fought along these rocky outcroppings proved more deadly than the march on Suribachi. On the first day, Lindberg and Leader were evacuated with bullet wounds; Hansen died

from machine-gun fire. The following day, while inspecting enemy caves behind the lines, Chandler Johnson was hit by an errant shell: there wasn't enough left of him to bury.[28]

Other heroes of Suribachi fell later as the story of the flag-raisers submerged itself in the epic of the Marines' fight to the death at Motoyama 1 and 2, Hill Peter, Turkey Knob, the Amphitheater, Hill 383, the Meat Grinder, Cushman's Pocket, Kuribayashi's Cave—colorfully named chapters in a crimson campaign that would cost more than six thousand men their lives and leave another twenty thousand wounded, most of them after Suribachi had been taken. Of those who came ashore on Iwo Jima with Easy Company's Third Platoon, only Keller and Michaels survived the whole battle untouched. Charlo and Mercer, half of Sergeant Watson's original scouting party, also died on Iwo Jima.[29]

The Marine Corps later awarded Schrier the Navy Cross for "courageous conduct" in leading the "tortuous climb up the precipitous side of the volcano" and planting "the flagstaff firmly on its topmost knoll." Cpl. Charles Lindberg received the Silver Star for his service with the flame-thrower: his citation specifically mentioned his role in the Suribachi ascent, how he carried the heavy weapon up the mountain "and assisted in destroying the occupants of the many caves found in the rim of the volcano, some of which contained as many as seventy Japanese." Awarded posthumously, Boots Thomas's Navy Cross lauded his bravery on February 21, when he took command and led his men to the foot of the mountain —not his part in raising the flag.[30]

But neither history nor Marine citations ever recorded the names of all the men who helped to raise the first flag on Mount Suribachi. In addition to Michaels, Lindberg, Thomas, Hansen, and Schrier, Lou Lowery's classic flag-raising picture includes another figure, partially hidden from the lens, holding the length of pipe, along with a radio operator and two (maybe three) anonymous Marines with their backs turned to the camera, guarding the others. Over the years, many have identified the radioman as Charlo, although Charlo carried a BAR. Besides, the Indian seems to have been on the other side of the crater, with Fox Company, when the flag went up, and other photos by Lowery that show the face of the radioman reveal features unlike Charlo's. But, if not Charlo, who is he? Easy Company's regular radio operator, Gene Marshall, also draws occasional mention, but others dispute this identification.[31] As old debates about who got there first and who did what heat up from time to time,

new claimants to glory appear, none of them with verifiable evidence, none of them widely believed.

Distracted by the fighting and by his own brush with death, even Lowery could not identify all the men who raised the flag for his camera. The men themselves hardly thought about the incident as it was happening. Their lives were in danger, they believed. The caves still teemed with blood-thirsty snipers. Only later, afterward, when the media created a stir about the flag, did Suribachi's conquerers think much about who had done the actual raising. And afterward, it was not *those* raisers the press was interested in. When the troops got back to bases at Saipan, Guam, and Hawaii, they discovered some other flag at the center of attention. Lowery's photos hadn't even been published: *Leatherneck* had withheld them, so as not to compete with the accepted picture of what had suddenly become the official, bona fide Iwo Jima flag-raising—another event altogether.

The men who took Suribachi found themselves forgotten, before anyone knew their names. At the time, most of the guys didn't really care: it was enough to have lived through the battle of Iwo Jima. There could have been "26 flags" raised on that damned island, Lou Lowery thought, safe, and dry, and home at last: "It wouldn't have made any difference to me."[32]

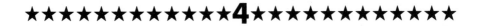

It was just one of those things. All the accidentals and imponderables that go to make a great photograph were combined. I just happened to be there.

Joe Rosenthal, remembering his famous Iwo Jima photo in 1954

Eyewitness to History

He was short, portly, nearsighted enough to rate a 4-F classification from his draft board back home in San Francisco. He wore a mustache and smoked his cigarettes in a holder, like FDR. At thirty-three, he seemed too old, too dignified to be dodging bullets and scrambling into landing boats carrying twenty-five pounds of cameras and film packs. Yet his reconstruction of the sequence of events after the first flag went up would become a key part of the legend of Iwo Jima. He was Joe Rosenthal, an Associated Press photographer assigned to the Iwo photo pool, and on the morning of D+4, some eighty-seven hours after the invasion had begun, he was getting ready to go ashore again.[1]

He had spent the night aboard the *Eldorado* and, along with the rest of the press corps, sensed a big story in the making. Rumor had it that the final push for Suribachi was about to begin. General Smith and Secretary Forrestal were both out on deck in life jackets, peering anxiously toward the mountaintop through binoculars. A Higgins boat was waiting to take Forrestal to Red Beach for a first-hand look at the action. So Rosenthal and Bill Hipple, a correspondent for *Newsweek,* wrapped their equipment in their ponchos and toiled down the nets toward the LCVP—Navy lingo for "Landing Craft, Vehicles and Personnel"—reserved for reporters, hoping to make shore in time to record Forrestal's act of bravado.[2]

Rosenthal passed his Speed Graphic and his little Rolleiflex safely across

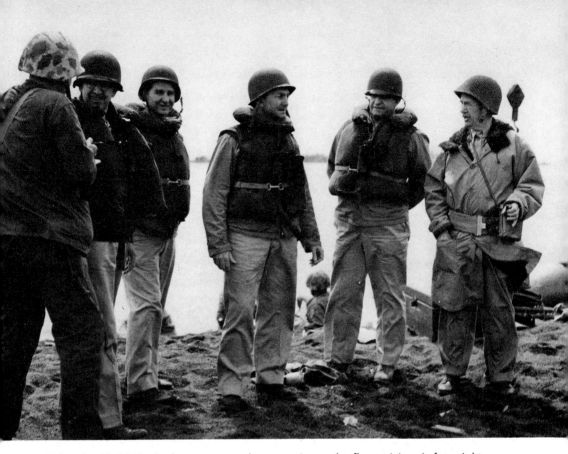

February 23, 1945: the brass come ashore to witness the flag-raising. Left to right: Rear Admiral Louis E. Denfeld, Colonel C. V. Whitney, Secretary Forrestal, Rear Admiral Earle W. Mills, General Holland M. Smith. Back to camera, Pharmacist's Mate C. W. Cozby.

the watery gap. But, as he positioned himself for the leap from ship to landing vehicle, the photographer slipped and fell into the Pacific: he lost his helmet and narrowly missed being crushed between the hulls of the bobbing craft. After he was fished out, dried off, and deposited back on the command vessel, he took his pictures of Forrestal and Smith at the rail of the *Eldorado,* with Suribachi looming up before them as they gazed toward shore. Better safe than sorry, he thought to himself. The way his luck was running, Joe Rosenthal hated to count on getting a decent shot of the secretary later.[3]

Around 10:00, by their reckoning, Rosenthal and Hipple set out for Iwo Jima for the second time that morning. As the boat made for shore, the

coxswain heard on his radio about a patrol bound for the top of Suribachi. "They're going to plant the flag!" he shouted, pointing at the mountain. "See the red spot part way up? That's them taking it up."[4] Rosenthal could see nothing at all, but his mind's eye envisioned the flag-raising as an important picture, even a historic one. Once ashore, he grabbed the fire-blackened helmet of a dead Marine and picked his way through a mine field to the command post of the Twenty-Eighth Regiment, at the base of the volcano.[5] Was he too late? Was the flag already up?

Nobody seemed to know. But a fresh patrol had just left, he was told, heading for the summit with a flag. The sounds of gunfire and explosives traced their progress up the slope. "Hot Rocks" was still hot—and civilian photographers weren't permitted to carry weapons. Bill Genaust, a motion picture cameraman, and Bob Campbell, a still photographer, were both Marine combat reporters, however—and Marines had guns. Would they make the climb and provide a little cover along the way? Genaust thought it might be too late. But maybe they could make it, if they hurried! Hipple, Sergeant Genaust, and Private Campbell all picked up their gear and followed Joe Rosenthal up the mountain.[6]

Unbeknownst to the band of journalists trailing them up Mount Suribachi, the patrol ahead was carrying a *second* flag, scrounged from the Navy. The first flag had been raised at 10:35, an event duly noted in the official logs. Forrestal saw it on his way to shore and, stirred with emotion, made his famous prediction about the future of the Marines to Holland Smith.[7] When cheers arose from the beaches, the battalion commander, Lt. Col. Chandler Johnson, decided another ensign was needed. The sight of the American flag flying over the enemy's most prominent defensive position had been calculated to lift the spirits of Marines still engaged in bitter combat, and it was having the desired effect. But because Schrier's flag was so small it was visible, with effort, only from the landing zone. Johnson wanted a bigger banner. Nor did Johnson underestimate the Marine propensity for trophy-hunting. "Some son of a bitch is going to want that flag for a souvenir," he bellowed, "but he's not going to get it . . . We'd better get another one up there."[8] Ted Tuttle, a second lieutenant, went looking for a substitute and found it among the stores on one of the landing craft: a full 96×56 inches, the new flag from LST 779 had originally come from the salvage depot at Pearl Harbor.[9]

Tuttle raced back to the command post, where he surrendered his parcel to Pfc. Rene Gagnon, Johnson's runner, headed for the top with a load of

radio batteries. On the climb to the summit, the messenger caught up with the Second Platoon from Company E: when they all reached the cone of the volcano, where the small banner was already flying, Sgt. Michael Strank took the flag from Gagnon and delivered it to Lieutenant Schrier. The colonel, he told him, wanted the larger one run up high, so "every son of a bitch on this whole cruddy island can see it."[10]

Meanwhile, on the face of the mountain, well below the lip of the crater, Rosenthal's party continued to inch its way toward the top, stopping only when the troops in the lead also paused to clear a pillbox or roll a grenade into a cave. About halfway to Schrier's communication post, the journalists encountered traffic limping down, in the person of Lou Lowery, photographer for *Leatherneck,* the Marine magazine. "You guys are late!" Lowery announced, telling his friend Bill Genaust that he'd already photographed the flag-raising. "But you might like to go up," he added. "It's a helluva good view up there." The little guy with the glasses took the news about the flag hard, Lowery thought.[11]

"I had just decided *not* to go when Lou said that," Rosenthal later

Chandler Johnson on the phone at Easy Company CP early that morning: it was on Johnson's orders that the small flag was replaced with a bigger one.

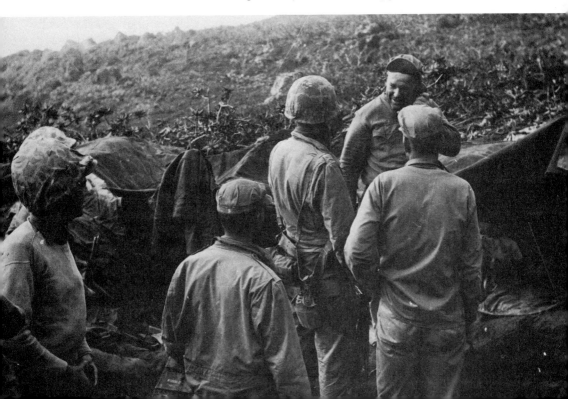

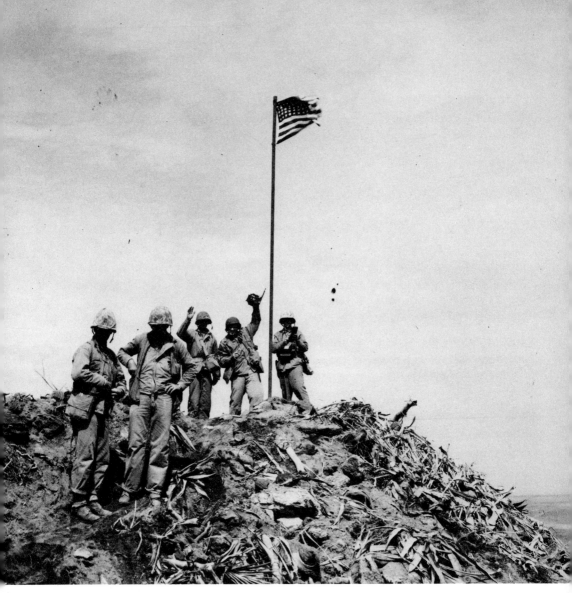

The photographers—Genaust, Rosenthal, Campbell—in front of the first flag.

remembered. Heartened by the thought that the trek might prove worth-while after all, he pressed on, still looking for one good picture. The edge of the crater came into view. Rosenthal could see a group of Marines struggling to haul a length of heavy pipe up the slope from the twisted ruins of a radar installation.[12] As he scrambled over the lip, he finally

saw the flag, too, high above him, a tiny thing, waving bravely from the top of a very tall pole. At the base knelt an officer with a triangle of red, white, and blue under one arm. Another flag? "What's doing, fellas?"[13] The plan, he soon learned, was to take down the old flag, pole and all. Simultaneously, the big flag would go up in its stead, tied to the pipe a detail was now dragging toward the spot. It was Lieutenant Schrier's idea to do it that way, in a sort of *ad hoc* ceremony that would keep the Stars and Stripes flying despite the change in banners. Having once planted the American flag atop Suribachi, the young officer was determined never to see it come down again.

Intent on getting it right, Schrier was brusque with the photographers. It would happen when it happened. Hipple finally sat down to wait. Genaust paced. Campbell went back over the edge, looking for a low angle from which both flags would be visible at once. Rosenthal decided against going for two flags: it was too risky, especially given the offhand arrangements for making the switch. All sorts of people were milling around but nobody seemed to know what the signal would be, who would do the raising and the lowering. So Rosenthal moved back about thirty-five feet or so. From that spot, he thought, he could see anything that happened. He heaped up some rocks and a few Japanese sandbags to give himself a higher vantage point. Then, without warning, the flagpoles started to move. Schrier stepped between Rosenthal and his subject and then moved off. Genaust crossed his field of vision carrying the movie camera and stopped about a yard to the right. "I'm not in your way, am I, Joe?" he called out. "No," replied Rosenthal, swinging his own camera back, away from Genaust. "And there it goes!" The Speed Graphic was loaded with Agfa film. It was set for 1/400 of a second, between f/8 and f/10. The shutter clicked. Joe Rosenthal had his picture.[14]

It had happened so fast. And after the flag was up, the men wandered off, back to the war. Rosenthal had no idea who was in his picture: the caption would have to omit the "left to right" listing of names and hometowns the wire service liked. Besides, with all the movement and the confusion, he wasn't entirely sure of the picture, either. To cover himself, Rosenthal took a second flag shot—the pole being tied in place with guy ropes. Too static: he knew the picture was a dud even as he aimed the lens. So he decided to stage a "jubilation" under the flag. "Come on," Rosenthal called to the men moving off toward the sound of gunfire. "This will be a historic picture. Wave your helmets and give it the old gung ho!"

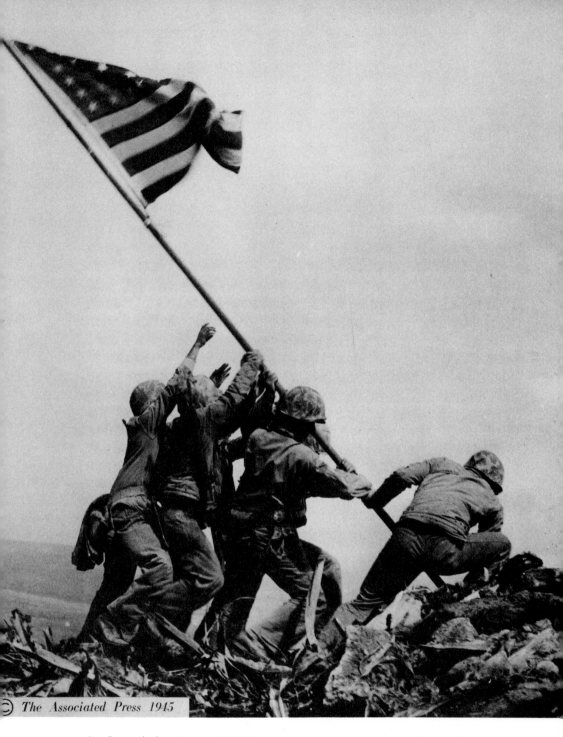

Joe Rosenthal's picture: "Old Glory goes up on Mount Suribachi, Iwo Jima,"

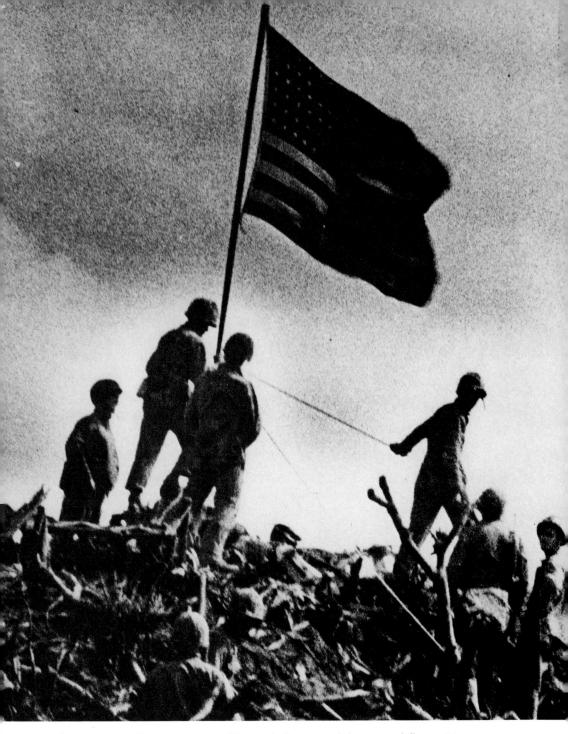

A few seconds after Genaust and Rosenthal captured the second flag-raising, a Coast Guard combat photographer took this view of action on the mountaintop.

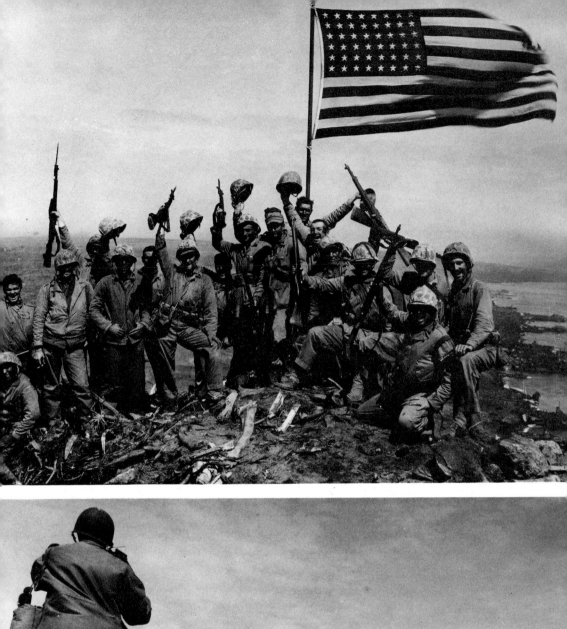

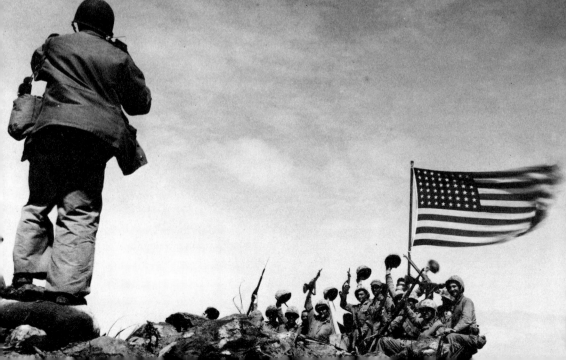

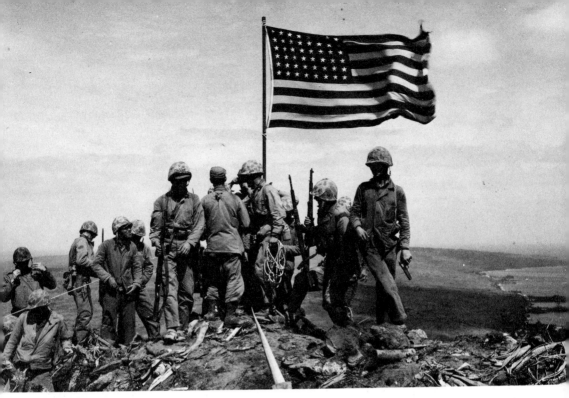

The second flag in place, the patrol prepares to secure the area in this Campbell photo.

"No," came the reply, "we're not Hollywood Marines!" But, by sheer persistence, he managed to coax twenty-odd tired and skeptical Marines into standing under the flag, raising their carbines, and cheering. A good one! A crowd-pleaser! Just for insurance, Rosenthal changed film packs and took it again.[15]

All told, Joe Rosenthal took eighteen pictures that day: Forrestal and Smith, the flag-raising, tying down the pole, the group shot (twice), and other, forgettable photos—the view from the mountaintop, his fellow cameramen sitting in a fancy armchair dragged out of a Japanese bunker, a

Opposite, top: Rosenthal's "jubilation" shot of Marines in front of the second flag. The staged picture gave rise to the rumor that the candid shot had also been posed.

Opposite, bottom: Bob Campbell caught Rosenthal in the act of "posing" the Marines.

Marine with a kitten found meowing around the rubble, more Marines holding up a homemade sign that read "Weehawken, New Jersey." By a little before 2 P.M., he had worked his way back down to the command post and was posing for the camera himself: a picture of Rosenthal and Bob Campbell having a smoke alongside the barrel of a big Japanese gun would make the papers back in the States. People were curious to see the intrepid journalists who followed America's fighting men into battle. And Rosenthal's name had recently been attached to some of the most dramatic images yet to emerge from the Battle of Iwo Jima.[16]

For any combat photographer, one of the hardest parts of the job was getting the film out. On a previous day, when the casualties were heavy and boats were diverted to carry the wounded from the beaches to the hospital ships anchored offshore, it had taken Rosenthal nineteen hours to travel the half-mile back to the command ship. Things went faster on the afternoon of February 23. After a hasty meal aboard a Coast Guard landing craft moored on Red Beach, Rosenthal caught a press shuttle back to the *Eldorado* with no trouble.[17] Quickly, he labeled his film packs and dispatched them in a watertight container to Guam aboard a special pontoon plane. There, the film would be processed, the censor would check each frame for sensitive data, and the picture pool coordinator would separate the good pictures from the rejects. The good ones went stateside, via radio, along with the copy supplied by the photographer.

Joe Rosenthal's "grab shot" survived its chemical bath. The censor okayed it. Murray Befeler, chief of the picture pool, put it on the wire. The caption read: "Atop 550-foot Suribachi Yama, the volcano at the southwest tip of Iwo Jima, Marines of the Second Battalion, 28th Regiment, Fifth Division, hoist the Stars and Stripes, signaling the capture of this key position."[18]

Sleepy Americans came awake with a jolt on the morning of February 25; fat Sunday papers from coast to coast featured Rosenthal's flag-raising on the front page and announcements that Secretary Forrestal would reminisce about the incident that night, on the radio. "Old Glory Over Volcano." "The Spirit Of '45." "Stars and Stripes on Iwo." "Colors Go Up." The *New York Times* ran the picture, front and center. The *Los Angeles Times* gave it three columns in the middle of the page and added a caption insisting that one of Marines depicted was "Pfc. Raymond Jacobs, 19, of 279 E. 15th St." But the intriguing thing about the picture, as it appeared in the first, grainy wirephoto versions that Sunday, was its anonymity.[19]

The picture showed little more than an outline of massed men and their flag silhouetted against the sky; nobody was sure who the individual Marines were—or even how many of them had helped to raise the cumbersome pole. Some editors counted four. Some saw five or six. Like the documentary photographs of the Depression era, Rosenthal's picture spoke of group effort, the common man—working in concert with his neighbors—triumphant. The very facelessness of the heroes sanctified a common cause. The raisers were not individuals, acting for their own, private motives: they were just American boys, and they made war on behalf of all Americans. The photo stood for something more than what had happened atop Mount Suribachi, just after noon, two days before. It was a symbol.[20]

It was a symbol of victory. That, above all, was what the act of planting a flagstaff meant: enemy terrain captured, the highest point seized—triumph. That was what display of the flag over hostile territory had meant throughout World World II. It had always meant the end of a campaign. In the case of Iwo Jima, however, the battle had barely begun.

Newspapers and magazines back home lost no opportunity to run the Rosenthal picture as a sign of imminent American victory in the Pacific.

The Fleming Gazette

| g County's Newspaper | | Don't Stop Buy More B |

XIV FLEMINGSBURG, KENTUCKY, THURSDAY, APRIL 26, 1945 NU

RIGHT IN E HOSPITAL

Bright and Mr. Bright, of this city word that their Pfc Oliver Lan has been reported he first week in been located in a gue. The messages through the Red red to th soldier's

well known Flem s who was assic father in business d constitutionally the eyesight is However, ex believe that ble to read with quite lense. Mr. o convey to until they were greetings he re-

Mrs. Lydia Porter Is Called By Death

Mrs. Lydia Carter Porter, 64, passed away Monday morning at her home on Maxey Flat following a illness of several weeks.

She was born in Rowan county on November 10, 1880, the daughter of the late Calvin and Nannie Carter. She was first married to Ed Allen and then to Cecil Porter, both of whom preceeded her in death.

Surviving are three sons, George E. Allen, Beechburg, Andrew Porter, Plummers Landing, and Will Porter, Covington; one daughter, Mrs. Melvin Gooding, Plummers Landing.

Funeral services were conducted Tuesday afternoon at the Crain Creek church with Rev. C. W. Roberts in charge. Burial was made in Rowan county.

RONALD HONICAN DIES ON LUZON

Mr. and Mrs. Ernest Honican of Sherburne, received word Saturday morning that their younger son, Pfc Ronald Brooks Honican, had been killed in action on Luzon Island on March 4. He entered the armed forces June 2, 1943, received his basic training at Fort McClellan, Ala., and was sent overseas six months later. He was born March 17, 1925. Besides his parents, he is survived by one brother, Sgt. Eugene Honican, also in the Philippines.

His parents received a telegram that he had been slightly wounded on January 9, but only remained in the hospital four days. They received only two letters since then from the time he was wounded until they heard of his death. He was a member of the Sher-

JURORS NAMED FOR MAY TERM

The following have been summoned to appear at the Court House at 9 a. m., Monday May 14 for the purpose of serving as grand jurors for the May term of circuit court:

J. T. Hutton, Charles M. Gardner, O. B. Evans, Claude Lukins, Ray Flora, Dan Kidwell, Sam Eubanks, Roy May, Garr Hickerson, William Parker, Smith Newman, Jack Grannis, R. C. Powell, Paul Carpenter, Mace Colgan, Som Fleming, Walter Stockdale, Tom Hurst, Austin Story, R. F. Case, J. K. Ryans, C. M. Darnall, Soreney Porter, C. R. Cowan.

Summoned to appear Tuesday, May 15, for the purpose of serving as Petit jurors are the following:

Loyd Compton, John Butcher, R. W. Neal, Marion Story, E. C. Rankin, Dave Porter, William Cassidy, Ben Saunders, Dutton Grannis, Claude Powell, Fred Lawrence, Clyde Marshall, A. J. Doyle, B. S. Lynum, Ben Humm, Elmoe Biddle, Arnold Crain, Clarence Williams, Andy Jackson, Sam Burns, Robert Darnall, Logan Esham, Douglas Foxworthy, Robert Dorsey, Clarence Maxey, Howard Biddle, G. H. Williams, Bingham Standiford, J. W. Helphenstine, Clarence Marshall, Clay Henry, A. P. Plummer, C. R. Whaley, Bob Hutton, W. H. Fischer, Jr., Paul Flora.

Chandler Is Named Baseball Commissioner

FLAG RAISING ON IWO

Above is the famous picture of the Mt. Suribachi flag raising on Iwo Jima which was taken by photographer Joe Rosenthal and which is being used on posters and advertising of the Seventh War Loan drive. The picture holds special significance since the Marine pictured on the extreme left is Pfc Franklin R.

Sousley, son of Mrs. J. Hensley Price, of Hilltop. Sousley was killed a short time later while still engaged in battle with the Japs on the Northwest corner of Iwo.

This picture is said to be one of the finest taken of our forces during the entire war and has been rated with the famous picture of Washington "Crossing the Deleware".

Fleming County High In Accredited Class

At the March 16 meeting of the State Board of Education the public and private high schools of the state were given their official accredited ratings. These ratings were made on the recommendation of the Commission on Secondary Schools of the Kentucky Association of Colleges and Secondary Schools.

It was the policy of both the Commission and the State Board of Education to maintain school standards unimpaired for the future but to apply them with liberality during the present emergency.

School were rated A, B, AE, BE, (E-Emergency) and U. The Fleming County High School was again accredited class "A".

SGT. BRUCE BRAMEL DIES OF WOUNDS

Sgt. Bruce M. Bramel, 22, has died of wounds received in action in Germany on March 26, according to a message received by his family last Saturday. Three days previously they had been advised that the soldier had been missing in action as of March 20.

Roy H. May Is

SIX STUDENTS IN STATE FE

The six Fleming Co school students who r top in the District Moorehead went to Le Thursday and participate State Festival on Fri urday. Approximately few, including debaters 60 schools from various Local students to take Margaret Planck, Ma Linville, Frances S. I Butcher, Evelyn Mart Ann Rhodes. The first were given ratings of the preliminary contes Rhodes was one of from 17 participants. matic, monologue even part in the finals Sat ing. This was her f advance to the finals rated "Excellent" i schools listed in the only 34 had represen vance to the finals. I with the Fleming Co Rhodes of Covington High of Covington Senior High, Newport ton.

The debate tournam by St. Xavier of L Pikeville was runner-

Sgt. Glen E. Esh Awarded a

An 8th Air Force tion, England—Sgt. Gl son of Mr. and Esham, Flemingsburg been awarded the "meritorious achieven serving as a B-17 ball turret aerin Bombardment Grou by Lt. Col. W. T.

JAS APPRASMITH

Three of the Marines in the photograph were to die in combat before it was over. And the "official" flag ceremony, in which the colors were run up by the sergeant who had also done the honors on Tinian and Saipan, was held on the slope below Suribachi on March 14—almost three weeks *after* the Rosenthal picture was taken. Fighting was still going on as the bugle blared, and the island would not be declared secure for another forty-eight hours.[21]

But history would not remember the day in March when the United States formally proclaimed its sovereignty over the Volcano Islands by running up a new flag and folding away the old one, the flag from LST 779 that had flown over Suribachi for twenty-four days. Instead, history would remember February 23 as Joe Rosenthal saw it. The careful orchestration of the drive up the mountain on D+4, the attendance of the Secretary of the Navy, and the large numbers of reporters shepherded to the scene all suggest that Rosenthal's candid "grab shot" and its impact on the American public were byproducts of a conscious manipulation of imagery by the military. The taking of Suribachi, signified by the presence of the flag, was intended to rally troops hard-pressed elsewhere on Iwo Jima. But the flag, with its overtones of a victory already achieved, also sent strong messages to the folks back in New York and L.A.

Looking back on the stir the picture created, *Life* magazine decided that it had "arrived on the home front at the right psychological moment to symbolize the nation's emotional response to great deeds of war." The photograph did stir emotions. A congressman introduced a bill to authorize a monument modeled after the image he saw on the front page of the *Washington Post:* the action of the Marines, posed as if "baring their breasts" to the foe, was symbolic, he said, "of the efforts of the Nation to crush the despicable enemy, Japan." A teenager impressed with the picture he clipped from the *Kansas City Star* wrote to the editor, suggesting a similar bronze statue for that city. Poets paid tribute to the power of the press, too:

> Then suddenly there came to view,
> News of a place we little knew;
> The blazing headlines told the story
> Of how our friends were making glory.
> Soon they'd be raising the Red, White, and Blue.[22]

Newspapers and magazines announced special issues, featuring the Iwo picture printed on heavy stock or enhanced with color; demand always

exceeded supply. The Marine Corps was deluged with requests for copies and questions about the identity of the raisers: Is that one, the one in front, my son, my dad, my boyfriend?[23]

In San Francisco, the draft board voted to make Joe Rosenthal a 2-A(F), denoting "essential deferment" from service. "A registrant doing the work this man is doing," they explained, "is deserving of better than a 4-F (bad eyes) classification." From Guam, Forrestal called Rosenthal "as gallant as the men going up that hill" and dubbed his photo "unforgettable". In a letter to Holland Smith, General Vandegrift credited the picture—not the flag-raising itself—with the secretary's sudden enthusiasm for the Marines. At the Patuxent Air Test Center outside Washington, a sculptor in naval uniform intercepted the picture on its way to the front page of *Stars and Stripes:* working through the night, Felix de Weldon emerged from a makeshift studio with a sculptural version of the photo. Near Roseville, California, a lucky cameraman found a squad of six- and eight-year-olds raising a flag over a pasture, in imitation of the Iwo Jima Marines. From the White House, President Roosevelt requested that the young men in the Rosenthal picture be found and brought home, pronto.[24]

The emotional impact of the photograph was equal to the strength of the emotions aroused by the battle itself. Before the Rosenthal picture hit the papers, the news had all been bad. On February 22, for instance, a wire-service story carried by many of the nation's dailies cited a rising toll of dead and wounded but quoted Holland Smith as saying that he would take the island "no matter how high the price in blood." Even the first reports of the capture of Mount Suribachi stressed the losses incurred in taking it: the flag took second billing to the carnage.[25] The capture of an airfield, announced on February 24, gave field commanders their first opportunity to justify the costly assault on Iwo Jima on strategic grounds. But their logic was overshadowed in West Coast papers by headline appeals for donors: "Your Blood Is Needed By Marines On Iwo Jima." In this supercharged atmosphere, an image that smacked of victory, a picture that seemed to herald an end to the dying, went straight to the hearts of American readers.[26]

Ironically, however, publication of the photograph also served as a kind of collective catharsis; now that the situation on Iwo was at last in hand, critics of the operation felt freer to voice their views. Mothers wrote letters to the Navy Department decrying the "murder" of "our finest youth . . . on places like Iwo Jima." Editorials urged the use of poison gas against fortified islands, like Iwo Jima. In San Francisco, where Rosenthal's photo

had received its warmest reception, the Hearst paper, the *Examiner,* ran a front-page editorial on February 27, taking the Marine Corps to task for the high casualty rate on Iwo Jima and suggesting that General MacArthur would have done things differently.[27] Enraged by the slur on the Corps, seventy-five angry Marines surrounded the *Examiner's* offices, prompting a riot call to the Shore Patrol. The *San Francisco Chronicle* answered the charges the next day. The *Chronicle* was Rosenthal's old paper. The only son of one of the owners had died three days before of wounds suffered during the Iwo landing. "To hint that the Marines die fast and move slowly on Iwo Jima because Marine . . . leadership in that assault is incompetent is . . . a damnable swindle," thundered the reply. The problem was Japanese fanaticism, "the strategy of any people in a defensive war of desperation." The triumph implicit in Rosenthal's photo, in other words, explained the tragic circumstances in which it had been taken.[28]

The high emotional pitch of the discourse about the battle was also one of the most stirring elements in the photograph, with its upward thrusting wedge of figures, climaxed by the American flag, unfurled to the wind. Always an important patriotic emblem in a country that pledged allegiance to its flag and sang of its origins in the national anthem, the Stars and Stripes took on a new symbolic weight during World War II. Shortly before Pearl Harbor, Felix Frankfurter had reminded FDR that "we live by our symbols and we can't too often recall them." Beginning with the Memorial Day parade in Washington in 1942, Roosevelt took the justice at his word: flags appeared everywhere and, thanks to the president's example, the display of Old Glory on private homes, businesses, and commercial products became common practice. In 1943, Congress legalized a Flag Code, mandating rituals of usage that confirmed the status of the flag as a quasi-sacred object, a focus for unity in a nation lacking the cohesive factors of shared race or religion. While GIs sometimes scoffed at flag-waving and the "corn about the grand old flag" endemic to Hollywood war movies, the Red, White, and Blue meant country, home, Main Street, apple pie—all the things for which the soldier fought. It covered the coffins of the war dead. The sight of it, as he pulled himself up to the crest of Mt. Suribachi, clutched at Joe Rosenthal's heart. "I still think of it as *our flag,*" he said, forty years later. "That was just the way I thought about it. I still don't have any other words."[29]

"Forever America, and forever Americans. Forever the flag!" declaimed

yet another congressman determined to turn Rosenthal's news picture into a monument. "The more one looks at that picture of the flag-raising on Iwo Jima, the firmer becomes one's conviction of the dauntless permanency of the American spirit." In February 1945, politicians were by no means the only Americans fumbling for words to describe how deeply they were moved by the photo—and why. The *New York Times* called it "the most beautiful picture of the war." The sculptural, strangely classical feel of the photo was attributed to diffused sunlight, filtering through a layer of clouds, or to proportions that accidentally conformed to the Golden Section.[30] But it was left to the *Times-Union* of Rochester, New York— the "Camera City," where the visual vocabulary of photography was a familiar language—to define the aesthetic qualities that made the picture a real work of art, a masterpiece comparable to Leonardo's *Last Supper.* While others had invoked *The Spirit of '76, Washington Crossing the Delaware,* and the usual patriotic potboilers, the *Times-Union* was reminded of *The Last Supper* on compositional grounds. Leonardo had started ripples of action from each end of his long table, waves of line and form that always converged on the central figure of Christ:

> Now observe the Iwo picture again. The space is almost halved on a diagonal and divided by the staff. The action takes place almost entirely in the lower left half of the picture.
>
> But there is the acute angle formed by the staff, the outstretched arms and the foremost man's left leg [that] leads the eye directly to the flag.
>
> Oddly, though, the eye does not rest there. A slight breeze is stirring, not enough to unfurl all the folds of the flag, but enough to enlist the forces of nature on the side of the Marines who are hurrying to raise the staff.
>
> So the eye, turning back to a line parallel to the outstretched arms, follows the blood-red stripes to the entirely empty space in the upper right where the flag, in just a moment, will be.
>
> Few artists would be bold enough to make empty space the center of their picture. And yet this bit of art from life has done just that. In that space is a vision of what is to be.[31]

Joe Rosenthal, in the meantime, had no idea that he was being likened to Leonardo da Vinci. When he reached Guam early in March, a fellow correspondent complimented him on a fine picture of the flag. "Did you pose it?" he asked. "Sure!" Rosenthal answered, thinking of his "jubilation" shot, the "Sunday School picture," the one photo in the batch he really was sure of. It was only when his mother's letter arrived, with the front page of the *New York Sun* stuffed inside, that he learned the truth.

In the same day's mail call came a wire from Associated Press headquarters bearing hearty congratulations, word of a raise, and orders to take the next available transport home. Their man on Iwo Jima had become a celebrity, in absentia.[32]

En route to New York, Rosenthal stopped over in Honolulu and there, for the first time, heard that the authenticity of his work was being challenged. Malicious rumors had reached the Associated Press: the film was actually somebody else's; Rosenthal had "restaged" the flag-raising to look like a work of art; the picture was just "too good to be true." The stories, it appears, originated with a *Time-Life* war correspondent who overheard part of Rosenthal's conversation on Guam and assumed—incorrectly—that the newly famous, front-page picture was the one under discussion. In any case, *Time* refused to run the photo and the magazine's weekly radio show on the Blue Network dubbed the picture "historically a phony . . . Arriving atop Mt. Suribachi too late, [Rosenthal] could not resist re-staging the scene." Questioned by AP representatives in Hawaii about the circumstances surrounding the picture, Rosenthal insisted that he hadn't orchestrated events on Mount Suribachi in any way. "I did not select the spot nor select the men," he stated, "and I gave no signal as to when their action would take place." AP was satisfied, and by the time Rosenthal reached the West Coast, on March 17, *Time* had decided to retract its statement, albeit ungraciously. "The great thing was that the country believed in that picture," the photo editor complained, "and I just had to pipe down."[33]

Joe Rosenthal was unruffled by the controversy. Interviewed in New York on the hoopla about his photo, he freely admitted he hadn't been there for the first flag-raising. But that didn't make his picture of the second one a "phony." And suppose he *had* rearranged the Marines a little? "It wouldn't have been any disgrace at all to figure out a composition like that. But it just happened I didn't. Good luck was with me, that's all—the wind rippling the flag right, the men in fine positions, and the day clear enough to bring everything into sharp focus."[34]

The clearest proof of the candid nature of Rosenthal's picture comes from photographs taken simultaneously by his companions on the mountaintop. Campbell's action still, for example, shows both flags in motion, Lou Lowery's coming down, Joe Rosenthal's going up. And the 198 frames of 16-mm. Kodachrome shot by Genaust further document the spontaneity of the event. The motion picture sequence begins abruptly, with the flag-

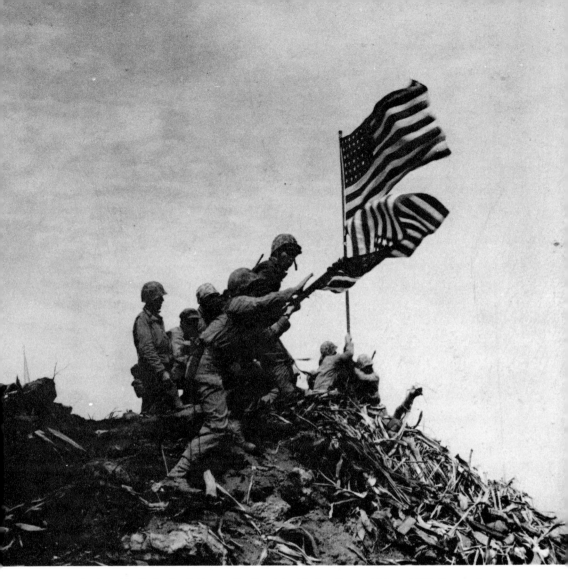

Pvt. Bob Campbell climbed Mount Suribachi with Joe Rosenthal and Bill Genaust. His photo shows the first flag coming down as the second one goes up, proving the spontaneity of Rosenthal's picture.

pole already rising: there is no time for "staging" and no hesitation on the part of the raisers who, in all the photographs of that phase of the day's activity, remain oblivious to the presence of cameras.[35]

In 1945, of course, such visual comparisons were impossible, and the confusion was compounded by tangled lines of communication from the

front. The first dispatches from the Pacific about the flag over Suribachi were written reports and radio broadcasts, filed shortly after 10:35 on the morning of D+4. Several made mention of Ernest Thomas, a member of the first flag detail, who was promptly hailed as a hero stateside. But because Lou Lowery worked for a monthly magazine, his photos of that raising—"staged" pictures, taken only because he had begged the Marines to wait until his camera was reloaded and in focus—went home by mail, arriving long after Rosenthal's shot had become famous. Thus, most Americans assumed that there had been *a* flag raising on Suribachi, at 10:35 or thereabouts, that Thomas and his men had been there, and that Joe

The camera that took the most famous picture of World War II: Rosenthal's Speed Graphic.

Rosenthal had frozen the historic moment on film. It was only in later years, when discrepancies between accounts of two distinct moments on the mountain led many historians to think they had been deceived, somehow, back in '45, that persistent rumors of fakery percolated up again, from the dark side of American folklore.[36]

In the spring of 1945, no such doubts lingered. Joe Rosenthal was a national hero, feted, toasted, and showered with awards. The New York Photographers Association and the Catholic Institute of the Press (he had converted to Catholicism six years earlier) both gave him plaques. *U.S. Camera,* published in Rochester, gave him a medal and a $1000 war bond for outstanding "still-picture achievement." After the rules were suspended to make a picture taken in the current year eligible for consideration, he won the Pulitzer Prize for photography. His war exploits—landings on Peleliu, Guam, Angaur, and Palau—were celebrated. Solicitous hosts had his photo carved in ice for a banquet centerpiece. American Legion Post No. 13 entered a float based on his picture in the Tournament of Roses Parade: the flag was made of sweet peas and delphiniums while Mount Suribachi was executed in "pink and dark orchid pompoms."[37] Bob Wills and his Texas Playboys, a western swing band popular in the bars frequented by California war workers, went to Hollywood in April of 1945 to record a song destined to become one of the few topical favorites of World War II. "Stars and Stripes on Iwo Jima" was a tear-jerker, sung by soloist Tommy Duncan in a plaintive whine, and it was an enormous hit. "High on the hill of Shure-i-backi," Duncan moaned, "waves Old Glory and she always will":

> When the Yanks raised the Stars and Stripes on Iwo Jima isle,
> There were tears in their hearts 'though they smiled.[38]

The Yanks still on Iwo Jima were delighted with the picture, too, and immensely proud of the effort it stood for. *Stars and Stripes,* the GI daily, gave it the whole front page.[39] But more gratifying to the Marines fighting on Iwo were the clippings that came in the letters from home—the fuzzy pictures from magazines and hometown papers that showed they hadn't been forgotten after all. Waldron T. Rich, serving with the Seabees on Iwo Jima, got the Rosenthal picture in a letter from his wife, who tore it out of *Life* magazine late in March. For the next eight weeks, Rich devoted his spare time to carving the picture, in high relief, on the face of a sandstone bluff at the north end of the island. The first Iwo Jima Memorial

Seabee Waldron T. Rich carved the first of many Iwo Jima monuments in 1945. Rich's was in the side of a cliff on the island itself; he copied it from the Rosenthal photo, clipped from an issue of *Life*.

ever completed, it was a free adaptation of the original that "corrected" some of the visual confusions of its documentary source. The untidy clump of raisers in the photo became four distinct individuals, for instance, and the flag extended itself fully, in a gorgeous ruffle of stars and bars.[40] Rich enhanced the iconic aspects of the image. But the carving on Picture Rock also echoed questions being asked in the Pacific and in Washington in the spring of 1945. How many guys were there in Joe Rosenthal's picture? What were their names? And where were they now?

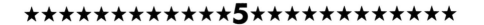

No Fiction, no Imagination, but real live marines exposing themselves to devastating fire that our flag might be raised above the enemy on the highest peak.

Edmund C. Mayo, describing a statuette of Rosenthal's flag-raising photo,
May 10, 1945

The Shifting Sands of Heroism

Congressman Mike Mansfield, former Marine, future Senate Majority Leader, wanted to set the record straight. According to last Friday's *Daily Missoulian,* reports out of Iwo had misidentified one of the four Marines who first scaled the "hard-won peak of volcanic Suribachi." The Associated Press dispatch credited "somebody named Charles." The real hero was a young man from Evaro, Montana, a town in Mansfield's district. The hero was a constituent; his family and his tribe were, too.[1]

Now it was Wednesday, March 7, two weeks after the fall of Suribachi. Even as Allied Forces in the European Theater smashed through Hitler's Rhineland defenses, even as Cologne fell, Americans remained entranced by the picture of their Leathernecks raising the flag on a godforsaken peak half a world away. The Pacific Front had produced the most stirring photograph of the war, and Mansfield took the House floor to propose that the Treasury Department officially adopt the famous picture as the symbol of their upcoming bond drive. To the congressman from Montana, the flag-raising scene confirmed the Marine Corps tradition of always doing what it set out to do. Inspired by Rosenthal's picture, he thought, Americans would pull together like the Marines on Iwo Jima, buying bonds so that "we as a people . . . do our part in keeping the flag flying at home as they have done in keeping it flying on foreign battlefields."

For the record, however, no Private Charles ever raised anything with

the "five boys shown in the remarkable picture," Mansfield hastened to add. The boy in question was Louis C. Charlo, "grandson of the great Chief Charlo of Nez Perce war fame and son of Mr. and Mrs. Antoine Charlo, of Evaro, Montana." Noble by birth and ennobled by his deed, Louis Charlo was a hero—and more. By his mere presence, an arresting image gained new significance. Charlo's Native American heritage endowed the Iwo Jima photo with echoes of American history and American ethnic diversity: he authenticated a democratic ethos that found room for Indian boys from Montana. The figure of Charlo allowed Mansfield to conflate the proud past of the Indian with the proud tradition of the United States Marines:

> This Indian boy, this real American, is to be congratulated on the part he played in this epic action and we of Montana and the nation at large pay homage to him for his devotion to duty, his courage and his determination. He is a real Marine and as such he has exemplified in action the attributes which have made the Marine Corps the real fighting organization it always has been through all the years of its magnificent history.[2]

But Charlo, of course, did not raise the flag on Iwo Jima. The AP dispatch carried in the *Daily Missoulian* had described Sherman Watson's scouting party: Charlo's name was correctly listed, along with those of Mercer and White. At the time the story was filed, some correspondents painted the four as heroes because they were the first Americans to climb Suribachi. The Army's *Yank* magazine even put them on the cover of its Pacific edition.[3] But such reports also linked the Watson patrol to the flag-raising. And Mike Mansfield made that same erroneous connection. When he first learned that Charlo had been "one of the four Marines" to scale Mount Suribachi, he leapt to the conclusion that Charlo's detail had also planted the American standard there. He even forgot his own assertion that Rosenthal's photograph pictured not four "boys" but five (never mind the sixth, barely visible in the rear of the group). In trying to correct an apparent mistake, he made new one.

In this, the congressman from Montana was not alone. A week before, a representative from Florida had called for a national war memorial based on the Rosenthal picture. The reason? One of the flag-raisers, the member crowed, was "a Florida boy," Ernest Ivy Thomas. Two weeks later, a senator would urge the Post Office to issue a special Iwo Jima stamp, on the strength of Thomas's heroism. Such mistakes multiplied during the early weeks of March because politicians, like most Americans,

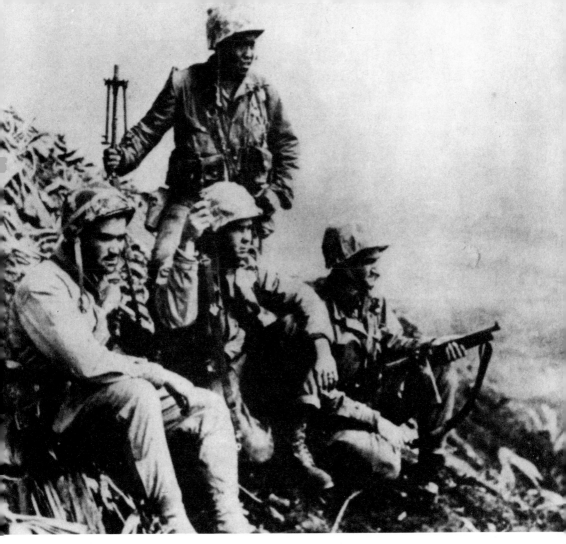

Heroes of Iwo Jima: Louis Charlo standing behind (from left to right) Sherman Watson, Ted White, and George Mercer a day after their scouting party reconnoitered Mount Suribachi. The photo appeared on the cover of the Pacific edition of *Yank*.

attached the only names they knew to a picture they admired. In the public mind, something glorious had happened on Iwo Jima. National enthusiasm ignored niggling distinctions of time and place: the action of the first flag-raising was grafted onto the image of the second.[4]

The mounting confusion about the flag-raisers did not escape the notice of the nation's editors. Their reporters wanted names to go with the

picture—the real names. The Marines did, too. So, shortly after stateside publication of the celebrated photograph, orders filtered down through the ranks of the Twenty-Eighth Regiment that everyone involved must be identified.[5] Inquiries were set in motion, but few remembered very clearly what had been happening when Joe Rosenthal snapped his shutter. After all, the guys in the picture were just running up a bigger flag: they had faced no extraordinary danger and, in a military sense, their action hadn't meant much. On an island awash in blood, even bona fide flag-raisers regarded their act as pretty "insignificant."[6] What especially bothered the actual participants, however, was a total lack of interest in the names of the men who got there first and put up the original flag. Those men, at least, had helped to capture a key enemy installation. But nobody seemed to give a damn.

In an atmosphere poisoned by misunderstanding and growing resentment, Lieutenant Schrier submitted a list of four names which, because of its glaring incompleteness, satisfied no one. Headquarters circulated more pictures of the afternoon on Suribachi through the regiment and demanded a fifth name. But by that time, the Twenty-Eighth Marines were back in combat, moving north, fighting for their lives: Chandler Johnson was dead and Schrier had been transferred to Company D. Capt. Dave Severance, the officer in charge of Easy Company, now bore the brunt of reporters' demands to interview "the" flag-raisers. And at the time, Severance was understandably more interested in the ongoing battle for Iwo Jima. Attrition had reduced his unit's fighting strength to two small platoons, of about twenty men each; his front lines were manned by green replacements. The combat-seasoned regulars were gone—dead, wounded, just plain missing.[7]

The pesky reporters couldn't talk to Sergeant Strank anyway. During the March 1 assault on Hill 336A, the first major obstacle on the road to Nishi Ridge, Strank and four others were trapped in a gully, exposed to Japanese mortar fire. They held out for hours. But finally, the enemy scored a direct hit, killing Strank and Harlon Block, the corporal from Texas whose name would be added to the list of flag-raisers two years later, after a congressional investigation. The reporters' scramble to get to Sgt. Hank Hansen also proved futile: he was killed by a machine-gun burst on D+10. And Severance flatly refused to recall Franklin Sousley just for a chat with the press. Sousley's platoon was struggling to hold a line of foxholes along the critical northern front, and besides, the trip

back to base was probably more dangerous than staying put. But events contrived to postpone Sousley's interview permanently. On March 21, near the entrance to Kuribayashi's cave on Kitano Point, Sousley died, just as Ira Hayes had jokingly predicted when he played taps for his buddy on board the transport bound for Iwo.[8]

Badly wounded in the leg on March 12, Corpsman John Bradley was evacuated first to Saipan, then to Hawaii, and finally to Bethesda Naval Hospital in Washington.[9] Ira Hayes had not yet been tagged as a flag-raiser: he finished out the campaign unharmed and unnoticed. Of all the men in the Rosenthal picture, Rene Gagnon was the only one who could have met the press in the Pacific—the only known flag-raiser who was not a battle casualty—but there is no indication that the war correspondents ever found him. Indeed, as their stateside editors built the Marines of Mount Suribachi into front-page heroes, reporters on the scene learned almost nothing about them in the confusion of combat that marked the early weeks of March on Iwo Jima.

The first official Marine identification of Rosenthal's flag-raisers came near the end of the battle, from the same Fifth Division publicist who had smoothed out the wrinkles in the Boots Thomas story: Keyes Beech. Before leaving for Washington, on a mission that would make him chaperone to the Marines' newest celebrities, Beech released the names to the troops who had fought alongside the raisers. By now, it was March 23—a full month after the picture was taken. Most of Iwo's Marines had heard about it, or seen a copy enclosed in a letter from home. Even cynical combat vets must have been curious: who were these guys? Now, the word came down the line: "Fr T/S K. Beech—In picture of Flag Raising on Mount Suribachi (Photo by Joe Rosenthal [AP]) Flag Raisers identified from left to right—Pfc. Franklin Sousley, Sgt. Michael Strank, Pfc. Rene A. Gagnon, Sgt. Henry O. Hansen, Ph. Mate John Bradley (in background) —all from Easy Co. 28 Regt." On Iwo, these were simply names, names of ordinary gyrenes: at home, they were about to become legends.[10]

At home, the adulation of the Rosenthal photo continued. Throughout the month, proposals popped up to immortalize the image in some public and permanent form—to put it on coins or stamps, to make it into a statue, a memorial to the war dead.[11] One lawmaker wanted to strike a flag-raising medal, to be given to men who served on Iwo. Another wanted to rename Iwo Jima "The Marines' Island." But it was the idea of a grandiose monument based on the photo that captured the imagination of

Congress. On March 1, Rep. Joe Hendricks of Florida introduced legislation to that end, stipulating that the monument follow the photograph precisely, since no "product of the mind of the artist" could equal the majesty of reality.[12] Another supporter entered into the *Congressional Record* a hometown editorial that called for a statue as "heroic in proportions as in theme"—an answer to "sophisticates" who pooh-poohed the flag and flag-waving patriotism. On March 13, Senator Raymond Willis of Indiana urged his colleagues to move with "utmost haste" on companion legislation to honor "the all but unbelievable valor" of the Marines in the Pacific. But the Marines moved even faster.[13]

In a dingy studio near the mouth of Chesapeake Bay, far from the horrors of war and the hyperbole of Congress, a diminutive Navy petty officer with a strong foreign accent toiled through a cold February night. Felix de Weldon had just seen the Rosenthal photo—even before the Sunday papers would show it to the rest of the country. A member of the Navy's artists' corps, he had come to Patuxent air station to paint a mural of the Battle of the Coral Sea. But Capt. T. B. Clark, his executive officer, showed de Weldon the news photo as soon as it came off the wire: it might make a great statue, the captain thought. De Weldon agreed. He rushed back to the studio, grabbed whatever was handy, and began working lumps of wax into a sketchy pyramid of men straining to raise a toy flag on a spindly mast of balsa wood. Without Rosenthal's providential tailwind, de Weldon's little flag drooped, but the idea was there, all right. De Weldon worked all night, driven by the notion of national unity the picture suggested to him. For an immigrant like himself, this *was* America: men of all kinds, working together. On the weekend that Suribachi fell, Felix de Weldon finished his Marine Corps Memorial in a frenzy of inspiration.[14]

As an art student in Vienna, de Weldon had been exposed to the masterpieces of the past. His training now helped him to recognize the monumental potential of a photo which, in both composition and nationalist implications, fulfilled many of the traditional criteria for public statuary taught by the academies of Europe. The academies relied heavily on precedents and examples, for instance, and the Marines in the picture surged forward against the sky like the famous ancient deity known as the *Winged Victory of Samothrace*. Its crush of bodies, topped by a wafting banner, also recalled the romantic passion of Delacroix's well-known painting of martial fervor, *Liberty Leading the People*. And its triangular composition duplicated the visually uplifting, pyramidal profile of almost

every great Parisian monument of the nineteenth century. The movement, the muscular strain, and the diagonal thrust of the individual figures in the group balanced and complemented one another, too: five men constituted a single shape in a textbook demonstration of unity, order, and stability of form. Like any good sculptor schooled in the grand manner, de Weldon realized that the Rosenthal photo corresponded in every visual particular to the time-honored ideal of monumental sculpture.

Word of his overnight statue soon reached the highest echelons of the military. Two admirals came to look; Commandant Vandegrift viewed the wax version with open delight. The Corps "borrowed" de Weldon from the Navy and installed him in a studio at Marine headquarters. When the flag-raisers returned to the States for their war bond tour, they sat to de Weldon for portraits; Marine historians scrambled to provided the artist with pictures and measurements of those who did not come back. Other leathernecks and sailors drew "posing duty" for studies of anatomy. Marine cartographers found an accurate map of Iwo Jima so de Weldon could reproduce the coastline on the base of a greatly enlarged edition of his first statue. Within a matter of weeks he had completed a second, table-sized version in clay. Cast in plaster and painted to look like bronze, this was the prototype for another enormous monument beginning to take shape in the artist's imagination.

De Weldon's model was not an exact likeness of the photo. Although generally faithful to the original, the sculpture emphasized the coherent grouping over the individuals, blurring distinctions between one man and another. The men were bunched more tightly, too, the central figure shoehorned in between his mates. And de Weldon realigned the Marine at the base of the flagpole, angling his shoulder and upper arm to define a three-sided shape, answering the triangle of clustered men behind him. Compacted in this way, the raisers made a rigid shape, a Mount Suribachi of men and uniforms more upright and static than its prototype. The loose modeling of the clay also translated the crisp outlines of Rosenthal's picture into an impressionistic blur of action. Of all the components, however, only the flag did not survive the leap from two to three dimensions with its essential integrity intact. Etched on a crumpled piece of sheet metal, the stars and stripes lacked the liveliness of the billowing standard in Rosenthal's shot. But it was close enough for the Marines.

Through the Treasury Department—then using the flag-raising as the

Art critic Harry Truman comments on the Iwo Jima statue as Felix de Weldon and Joe Rosenthal look on: June 4, 1945.

trademark of the Seventh War Loan—Marine publicists arranged a special presentation to President Truman. On Monday afternoon, June 4, Seaman Felix de Weldon, dressed in Navy whites, wheeled the clay statue into the Oval Office. The cameras flashed. The sculptor basked in the praise of his Commander-in-Chief. Photographer Joe Rosenthal looked on, pleased by his new role as a sculptural muse. Sculpture had brought an obscure swabbie to the White House. For a new American, flanked by the president of the United States and one of the most famous men in the

nation, it was an awesome moment. And for de Weldon it was only the beginning of a long public career predicated wholly on the little statue topped by the stiff metal flag.[15]

As the Marines pressed forward on the monument front, stamp enthusiasts pressured the Post Office for philatelic recognition of the flag picture. On March 10, Senator Joseph O'Mahoney, a member of the Military Affairs Committee and a former postal official himself, wrote an open letter to the Postmaster General, urging a special Iwo Jima issue. O'Mahoney, in fact, suggested five stamps, a wartime series honoring each branch of the armed forces; the Marine stamp—the Rosenthal photo— would be "a memorial to the men in whose blood our victory is being written." Public opinion endorsed the plan. One newspaper even dubbed the Iwo stamp a contribution to the "democratization of ideas" in America—presumably because *everybody* would see it. The California State Legislature passed a special resolution endorsing the commemorative issue. Letters of support flooded federal offices.[16]

In their form letters to petitioners, however, postal authorities begged to differ. The photograph, they insisted, "did not lend itself particularly well" to use on a stamp. Given wartime stringencies, the stamp would have to be printed in monotone: Old Glory would not appear in red, white, and blue. They also feared that the complex folds of the flag in the photo would make a reproduction in miniature unintelligible as a flag. Besides, purists objected to any depiction of the national emblem, noting that it had not appeared on a stamp since 1869. Others questioned the propriety of putting living persons on stamps. Beyond simple logistics and questions of taste, however, the question came down to one of patriotism when the National Flag Code Committee declared the Iwo Jima stamp an affront to American civil law.[17]

"Heaven forbid the placing of the Iwo picture on any U.S. stamp," wrote committee chairman Gridley Adams to the President. "On [a stamp] . . . that one remaining Symbol of Liberty . . . will be subjected to being licked behind its back and run through cancelling machines—the very contamination the Huns and Japs set their hearts upon doing." Adams was dead serious. To him and to his cohorts, tongues and cancelling machines would make a "mockery" of the war effort. The innocuous ways in which the stamp would be used would send American fighting troops abroad a message of "defeat, desecration and humiliation!" In letters to the Post Office Department, he cited local flag-desecration ordinances and warned that

sale of an Iwo Jima stamp would subject postmasters all over the land to immediate arrest. If they had to use the picture, Adams concluded, they had better cut off the top and omit Old Glory.[18]

Legal advice deemed the laws cited inapplicable to government agencies and irrelevant, too, given the patriotic intention of the stamp. It was also noted that descendants of American presidents had never objected to the cancellation of their forebears, nor did the National Flag Committee seem troubled by the American flag that appeared "on its letterhead for advertising purposes." Perhaps the most pungent reply to Adams came from a stamp collector in Philadelphia. According to the committee's twisted logic, he wrote, Americans "should put Hitler's features on one of our stamps. By all means we should substitute John Wilkes Booth's face for Lincoln's. And on other stamps we could put the features of such characters as Benedict Arnold . . . so they could be pounded many millions of times."[19]

By early June, political pressure and popular demand had persuaded postal bureaucrats that they could no longer forestall the Iwo Jima stamp without seeming "oblivious to the glorious efforts of our armed forces." But another controversy bubbled up when the department announced that the new issue would be purple, like all the other three-cent stamps. The American flag in purple? Purple Marines? To allay criticism, a military shade of green was chosen instead. By the time of issue, on July 11, all the carping had been forgotten: the stamp was a great hit.[20] Even the Postmaster General, never an enthusiast for the Iwo Jima commemorative, was forced to admit that the Rosenthal picture had prevailed "over mere custom and ancient usage." First-day ceremonies were attended by the Marine commandant, Senator O'Mahoney, flag-raiser John Bradley, wounded Iwo vets from Bethesda, the Post Office Department orchestra, and the press. Dignitaries made speeches, interspersed with loud renditions of "The Stars and Stripes Forever," "The Star-Spangled Banner," "The Marine Hymn." For Washington bigwigs, the occasion was a celebration of Marine gallantry under fire. Collectors turned it into a buying frenzy, setting a day-of-issue record of nearly three million sold. Before the Iwo Jima greens went out of circulation in 1948, Americans had bought more than 137 million of them.[21]

Beyond the stamps and the statues, the most unusual testimony to the ubiquity of the Iwo Jima flag-raising in 1945 came from the Pacific, from another battle-scarred atoll in Japan's vanishing empire. The largest

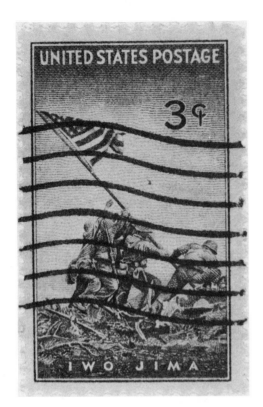

The Iwo Jima stamp,
in Marine green.

island in the Ryukyu chain stretching from Taiwan to the mainland, and only 350 miles from the Japanese city of Kyushu, Okinawa was the final stepping-stone toward the invasion of the home islands. On April 1, Easter Sunday morning, sixty thousand American troops stormed ashore on the west coast of Okinawa. Light opposition intensified rapidly as two Marine divisions and the Tenth Army moved inland; offshore, the fleet was pounded by kamikazi attacks. It would take the Americans almost a month to secure the northern half of Okinawa, and defenders in the south held out much longer. But on June 21, men from Company G, Second Battalion, Twenty-Second Marines, mounted a brief ceremony to mark their control of the island.

They gathered around a brush-covered mound on a coral cliff over-looking the Pacific, and, as armed guards protected the area against snipers and photographers checked lens settings, they prepared to raise a flag. The pole was a spindly branch of wood, roughly trimmed. Three

Marines and a Navy corpsman carried the makeshift flagstaff up the little rise and stuck it in on top. Their gesture marked the transfer of Okinawa from Japanese to American hands.

For Marines, flag ceremonies recalled the origins of the Corps: Quitman raising the colors above the "Halls of Montezuma" in Mexico City, O'Bannon crossing the African desert and laying claim to "the shores of Tripoli" with the Red, White, and Blue. During World War II, flags became sacred relics, especially when they had flown over conquered territory. Marine Corps Headquarters collected the first American flag to fly over Guadalcanal, the first flag to fly on Guam since its fall in 1941, the flag made by Marine POWs on Wake Island. The Marines later made museum pieces of the Suribachi flags.[22] To the Marines on the cliff on Okinawa,

June 21, 1945: Marines lay claim to Okinawa by using the imagery of Iwo Jima.

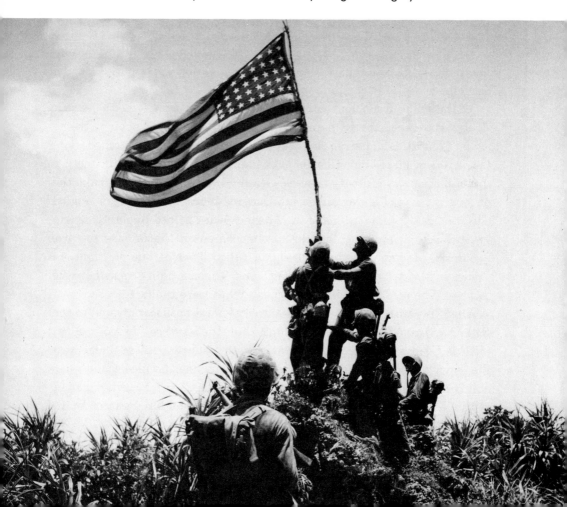

then, their flag stood for the traditions of the Corps. It represented duty, resolve, sacrifice, and victory: it evoked cherished ideals of freedom and home. On this day in June, it also marked their own, personal place in American history.

The bugler sounded "Colors." Four men raised their flag into the Pacific wind, steadying a mast bent low by the billowing fabric. A moment of silence. Then words of tribute for the brave men who had fallen along the island route to Tokyo. The rite ended the eighty-two days of Okinawa, the largest amphibious operation of the Pacific War.[23] But what distinguished this ceremony from others like it was the form it took. Even on Iwo Jima—despite all the hoopla about Mount Suribachi—when Marines finally marked their victory in March of 1945, they ran up the flag on a proper pole sited at a command post. By contrast, the men of Okinawa chose a remote and rugged spot. Eschewing a flagstaff rigged with a halyard, they lashed the ensign to a tree branch and pitched it vertically, against the wind. In fact, the men who raised the Okinawa flag assumed the poses of the men in Joe Rosenthal's photo, and they did so in a scene staged before a waiting crowd of photographers. So important had the Iwo Jima photograph become that it affected a time-honored military ritual. The imagery of Iwo Jima validated the subjugation of Okinawa. On the battlefields of the Pacific, life imitated art.[24]

On the home front, as the battle for Okinawa began, Americans still struggled to reconcile the heroic symbolism of Rosenthal's photo with the actual deeds that had given rise to it. In February and early March, despite the odd mention of Louis Charlo, most interpreted the flag-raising picture through the story of Boots Thomas. Orating in favor of a bill to make the photo the basis of a war memorial, Congressman Joe Hendricks singled out Thomas by name as one of the Marines who "helped to plant our flag in Suribachi," implying that he also appeared in the famous picture. Senator O'Mahoney's stamp bill again called Thomas one of "the men shown in the act of raising the flag." But Thomas didn't appear in the picture. Who did? Who were those men? What were the facts?[25]

When he returned home in mid-March, Joe Rosenthal confessed to the *San Francisco Chronicle* that he didn't know the names of the guys in the picture. Unaware of the massive identification effort that was under way, the paper stated that the men behind the anonymous profiles would probably remain forever unknown. Yet spurious facts and potential heroes continued to pop up on all sides. Puffing his memorial bill, Senator Willis

tried to make Joe Rosenthal a war hero, detailing how he had made his way up Suribachi, "picking his way thorugh minefields." The Marines, meanwhile, added a few new fillips to the Thomas story. In a speech delivered on March 20, General Vandegrift took the Keyes Beech version as his starting point, glossing over the flag-raising and lingering instead on Thomas's leadership in fighting below the mountain. But as he reached the end of his text, the commandant could not resist embellishing the ascent of Suribachi just a bit. "The little band fought on, driving upward," he intoned, "carefully sheltering the flag they carried with them." A few weeks later, the legend of the flag-raising had grown so fantastic that a prominent businessman described a statuette of the immortal scene this way: "No Fiction, No Imagination, but real live marines exposing themselves to devastating fire that our flag might be raised above the enemy on the highest peak."[26]

The story of the flag-raisers—the ones in Joe Rosenthal's picture—had assumed a life of its own. Marines fought valiantly up a mountain bristling with enemy troops, bullets flying, bodies falling, Rosenthal doggedly following the action. With its blasted tree-stumps and battle-weary men, the picture itself seemed to imply that a battle was raging, and so, in the minds of many who saw the picture, a battle *did* rage. At the time of the capture of Suribachi, the papers failed to distinguish between a first and a second raising. Minor misstatements about Thomas, about Schrier's patrol, and about Rosenthal's climb to the top all added up to a murky impression of what had happened. In the absence of a complete account, people filled in the gaps between what they half-knew and what they saw in the picture with inferences about what *must* have happened—and a full-blown myth was born. By the time *Life* finally published Lou Lowery's photo of the first flag-raising, on March 26, few Americans seemed interested in the mundane truth anymore. *Newsweek* hid its story detailing a first and a second raising back on page 60 and omitted Lowery's picture. In little more than a month's time, the belief that a heroic image pictured a heroic act had won out. There was no conspiracy. Nobody told lies. Fiction was simply more interesting than fact, and, it seemed, truer.[27]

The truth of the war was often brutal. Henry Morgenthau, Jr., recoiled in fright when he heard that Admiral Brown was on the line. The last time he had gotten a call from the military, it had been the Navy, telling him that his son's ship had been sunk at sea. Young Bob Morgenthau had survived the disaster and was now back on the Pacific, somewhere off the

coast of Iwo Jima. His father, the Secretary of the Treasury, breathed a sigh of relief as Brown announced the reason for today's call: he wanted to talk war bonds. The Treasury had already chosen the Rosenthal picture as the official symbol for its "Mighty Seventh" loan drive. Artists were designing posters. Writers were composing snappy slogans. Admiral Brown wanted to talk about the projected bond tour—another of those traveling carnivals staged by the Treasury to hype government securities to the American people. President Roosevelt, the Admiral said, wanted the Iwo Jima flag-raisers in the show.[28]

By the time of the Admiral's call—March 24—Americans had come to demand that living heroes step out of the black-and-white shadows of Rosenthal's inspiring picture. FDR recognized the public thirst for heroes and planned to quench it with a healthy draught of bond-buying. As Brown told it to Morgenthau, the president first got the idea from a Chicago editor who wanted the flag-raisers sent there to spearhead local war loan activities. General Vandegrift was cool to the suggestion, questioning "the advisability of picking those people out rather than some of the men who had done more heroic fighting." Bringing men home on the basis of a picture rather than proven valor in combat, Vandegrift added, could do serious damage to Marine morale. The commandant understood the difference between the two flag-raisings. He knew that the courage required by the first did not extend to the second, the evidence of the picture to the contrary. "However," as Admiral Brown reported, "if the President wanted it done, . . . he was only too glad to do it." "It would be nice to have them here . . . and have some kind of flag ceremony," Morgenthau replied. "They could raise some sort of thing."[29]

The orders went out. On April 7, the *New York Times* headlined the "Lone Marine Survivor of Iwo Photo Due Home." The hero in question was Pfc. Rene Gagnon. The first sketchy news had him en route from Pearl Harbor to Manchester, New Hampshire, where his mother and sweetheart waited anxiously. When reporters did catch up with Gagnon in Hawaii, he played the stoic Marine who'd rather "face another operation than make a bond tour." Three days later, the *Times* gave the Gagnon story a sentimental twist, with a picture of the hero at the breakfast table back home. On the left, his adoring mother with a plate of toast for her boy; on the right, a nubile fiancee, wreathed in smiles: in the middle, quietly pleased by all the fuss, the handsome Gagnon, every inch the "poor man's Tyrone Power" of his former sergeant's epithet. Even before the

A hero's homecoming: Rene Gagnon flanked by his mother, Irene, and his girl, Pauline Harnois.

bond tour began, Gagnon stood for the all-American dream of family reunions, coming home, hot toast, Mom, and a wonderful future.[30]

Directly beneath this scene of domestic bliss, the *New York Times* revised its earlier report of a lone Marine survivor by reproducing a version of Rosenthal's picture with names and arrows added, identifying each participant. Based on information supplied by Gagnon, the *Times* disclosed that another Marine flag-raiser had also made it: Pfc. Ira Hayes of Bapchule, Arizona. Labels on the photo pointed to Sgt. Henry O. Hansen, levering the end of the pole into the ground; Bradley and Gagnon, at front of the group; Hayes and Sgt. Michael Strank, right behind them; and in the rear, a sixth Marine, now dead, whose name was being withheld pending notification of his next of kin. Later, officials would change Gagnon's IDs, placing Hayes in the rear and Pfc. Franklin Sousley second from the left: Harlon Block would remain misidentified as Hansen for

Soon to be famous as the Indian who raised the flag on Iwo Jima, Private Ira Hayes was a graduate of Marine Paratrooper School, where he was known as "Chief Falling Cloud."

another two years. But now, three survivors were ready for the bond tour—Gagnon, already home and a minor celebrity; Navy corpsman Bradley, about to be released from the hospital; and Ira Hayes, soon to receive orders sending him to Washington.

Ira Hayes, a soft-spoken Pima Indian affectionately known as "Chief," did not want to go. The former Marine paratrooper had fought stoically though Vella Lavella, Bougainville, and the whole Iwo Jima campaign, but public attention of any kind terrified him. For a while, the Chief had managed to elude reporters, and he begged Gagnon not to squeal on him. Confronted with enlargements of the picture and badgered by Marine brass to disclose the name of the sixth raiser, however, Gagnon finally relented. Ira Hayes was their man. Orders were flashed to Camp Tarawa in Hawaii: Hayes was reassigned to "civilian morale" duty with the bond tour. He pleaded with his superiors to reconsider. He wasn't a hero, Hayes protested. He had never even won a medal on Iwo Jima. All he had done was raise a flag.[31]

Because he had raised a flag, Hayes found himself in Washington, D.C., sitting next to Rene Gagnon somewhere in the bowels of the Treasury Building, on the morning of April 20. They were waiting for Secretary Morgenthau, waiting to show him a bond poster picturing their immortal flag-raising. Here were the heroes of the picture, home at last, heroes created by chance, confusion, and the symbolic power of imagery. Two heroes. Two anonymous players about to step into heroic roles created by popular demand, they sat waiting to validate, by their very presence, the authenticity of Joe Rosenthal's inspiring photograph. In a few moments, Morgenthau would take them to the White House, where they were slated to give a picture of their moment of inadvertent glory to the president, shake his hand, pose for more photos. But the secretary's meeting ran overtime and the heroes were left to sit there, side by side, bored, apprehensive, poised on the brink of the abyss of fame, waiting for the "Mighty Seventh" to begin.[32]

The bond tour was really lots of fun for a while. We found out it would not be so easy after a week on the road. We done the same old stuff. It got so boring and tiresome . . . I couldn't stand much more, especially newspaper reporters and photographers.

Ira Hayes, in a letter to his mother, June 1945

The Mighty Seventh

Despite the recent death of President Roosevelt, who had delighted in such rites of spring, opening day went on as scheduled at Griffith Stadium. They played the national anthem and then taps, for FDR. Sam Rayburn, the Speaker of the House, prepared to throw out the first ball. But suddenly, the program was suspended. The loudspeaker called the attention of the crowd to three figures in uniform, standing to the right of home plate: two Marines and a slender sailor on crutches. "Ladies and gentlemen," said the voice crackling over the public address system, "you've all seen the picture of six Americans raising our flag on Iwo Jima! Three of them survive! These are the three—Marine Private Gagnon, Marine Private Hayes and Pharmacist's Mate Second Class Bradley!" The applause was thunderous, sustained. Twenty-four thousand fans rose to their feet and cheered. When the game finally got under way, the guests of honor—"heroes in every sense of the word"—observed strict neutrality. For the first five innings, they sat above the Yankee dugout. Then they moved to a box on the Senators' side of the field. In the end, the New York team won, 6-3.[1]

The three servicemen honored in Washington that April afternoon were bound for New York, Philadelphia, Boston, Indianapolis, Chicago, Tucson. And they had just come from the White House, where Harry Truman had

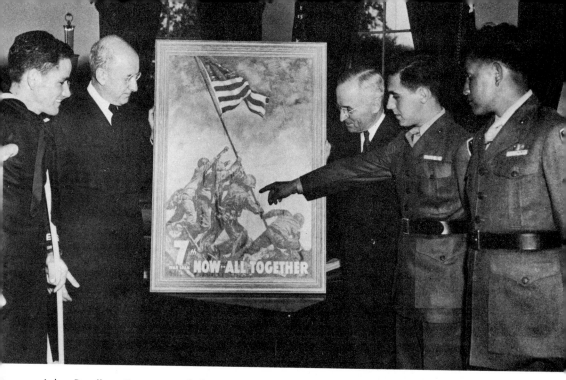

John Bradley, Secretary of the Treasury Morgenthau, President Truman, Rene Gagnon, and Ira Hayes at the White House for the kickoff of the Seventh War Loan drive, April 20, 1945.

officially dispatched them on their mission, for the benefit of the cameras. In the Oval Office, Secretary of the Treasury Morgenthau presented a painting of the Mount Suribachi scene to the new president, as the surviving subjects of the picture looked on and pointed to the figures they thought might represent themselves. The painting was being made into a publicity poster advertising the Seventh War Loan Drive, the biggest yet, and Gagnon, Hayes, and Bradley had just been reassigned to the Treasury as bond salesmen.[2]

The Treasury's war bond program was the pet project of Franklin Roosevelt and his friend Henry Morgenthau. The cost of prosecuting World War II was enormous. And while it proved difficult enough to persuade Congress to raise taxes, the borrowing needed to cover the balance also touched off controversy. The Treasury—Morgenthau and his presidential ally, at any rate—believed in keeping bond purchases on a strictly voluntary basis. That policy, they thought, would sustain the war effort and

dampen the inflation produced by a combination of full employment and rationed goods. Compulsory sales, on the other hand, while yielding similar revenues, would only encourage Congress to ease off on income taxes.[3]

For strict voluntarism to work, however, the Treasury needed a massive sales campaign of an entirely new type. During World War I, strong-arm tactics and coercion had been used to move bonds: vigilantes splashed the houses of those who refused to buy with yellow paint. For World War II, Morgenthau put his faith in the power of modern advertising. With a little Hollywood hoopla and lots of "hard sell," his Madison Avenue recruits were determined to "make the country war-minded." Showmanship was the way to win the war of dollars on the home front.[4]

Sales psychology for the Seventh Bond Drive ("The Mighty Seventh," in the copywriters' lingo) was particularly tricky. A poll taken at the conclusion of the fifth such campaign, in 1944, warned against overemphasis on patriotic themes as the war in Europe was winding down. A full 50 percent of those questioned thought that troops overseas would not get weapons and ammunition if they stopped buying, but "this literal-minded attitude," said the Treasury's pollsters, "may lead to the thought that it is unnecessary to buy Bonds once hostilities cease." In that uncertain atmosphere, Rosenthal's Iwo Jima photograph was "a lucky break" for the admen in the Treasury, a "soul-stirring" symbol which, if properly used, would guarantee record sales. The Mighty Seventh had found its logo— "the most dramatic poster and insignia of all the war loans."[5]

Fresh off the plane from the Pacific, Joe Rosenthal was asked for his opinion of the poster in progress. Although he privately thought it "a little overdrawn," with a wild wind whipping the flag and bombs bursting in the sky, the occasion did not invite searching criticism of the new full-color version of his photo with the lump-in-the-throat emphasis on the Red, White and Blue. Rosenthal's inspection of the sketch was a staged event, a press conference at which Generals Vandegrift and Denig of the Marine Corps and Ted Gamble of the Treasury Department all smiled and pointed while the cameras clicked. Gamble, a former movie theater owner, now director of the War Finance Division of the Treasury, was an old hand at the art of illusion. No niggling reservations, no uncertainties or imperfections would mar the heroic image of the flag-raising on Iwo Jima his poster so dramatically illustrated.[6]

That poster, based on a florid oil painting by the magazine illustrator C. C. Beall, improved upon the original in two ways. The addition of color

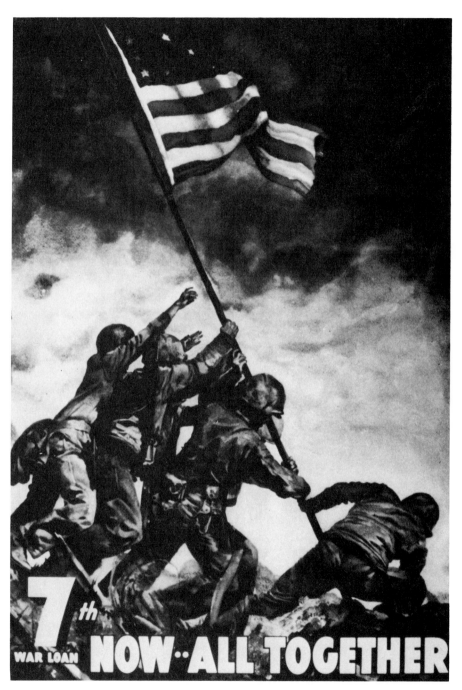

The official poster for the 1945 bond drive was painted from the Rosenthal photo by C. C. Beall.

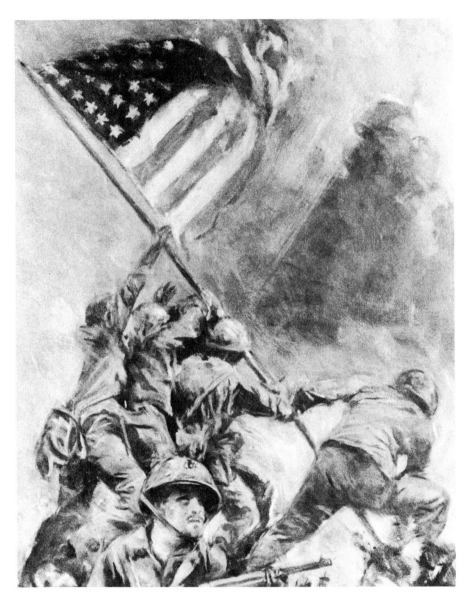

Howard Chandler Christy's version, combining Lowery's and Rosenthal's raisings, was summarily rejected.

made the flag the dominant element in the scene. And by a judicious use of a band of light behind the figures, the artist also managed to break Rosenthal's tangled cluster of arms and legs into six discrete forms. Had he posed his tableau on Mount Suribachi, Rosenthal often remarked, he would have "picked fewer men, for the six are so crowded in the picture that [for] one of them . . . only the hands are visible." Although Beall did not reposition the flag-raisers—he denied changing a single line of the photograph—color alone sufficed to create a more rational composition, one in which each soldier, as a struggling individual, bore a clearer cause-and-effect relationship to the ascending banner.[7]

The decision to use the Beall-ized version of the photo had been "fairly settled" by early March, when the Treasury's poster committee reconvened to take up the issue of what slogan should be superimposed on the image. Several volunteer ad agencies, including the prestigious firm of Young and Rubicam, submitted copy: "Lend a Mighty Hand!" "Shoulder Your Share!" "Spirit of the 7th!" "Now, All Together!" The committee (of which Mrs. Morgenthau was a member) looked and read and looked again and finally settled on a tag line of its own—"Now, All Together for the 7th"—linking the collective action depicted to the effort demanded on the home front. It was, the weary members concluded, "the best spirited copy for this Drive" and, by May 14, when the push began, it would adorn three and a half million posters. More than a million storekeepers had promised to put them in the front window. Posters were going up in 16,000 movie theaters, 15,000 banks, 200,000 factories, 30,000 railroad stations, on 15,000 big outdoor billboards. The Treasury Department would, Gamble pledged, display the Iwo Jima flag-raising "more widely than any other picture has been displayed in history."[8]

A smaller, simpler insignia was approved for use in streetcars and buses, for insets in the corners of full-page ads run by public-spirited firms. Designed by Joseph Reichert, art director for Ruthrauff and Ryan, the ancillary trademark for the Mighty Seventh extracted only two figures from the seminal photograph—the crouching man at the far right and the Marine with the carbine, second from the end at the left.[9] The most important and visually arresting participants in the actual planting of the flag, the remaining pair also hint at the ubiquity of a picture the public could now recognize in the most attenuated of forms. The shorthand version of the picture included several added ingredients, too, elements that point toward the meaning already vested in the flag-raising icon in

The official bond drive insignia was a variation on the Rosenthal picture, simplified and reduced to its basic elements.

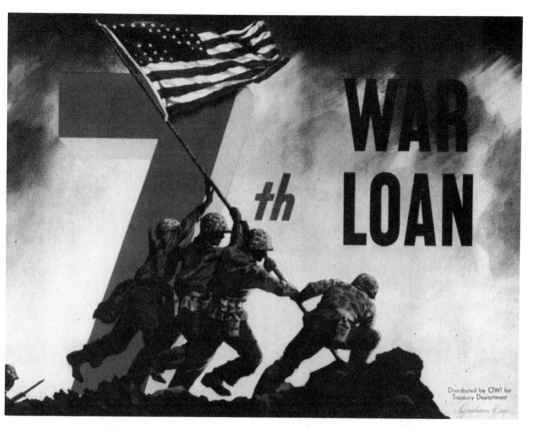

Another stripped-down version was used on display cards in buses and trolley cars.

March of 1945. The terrain is simplified: the lead figure pushes the flagpole into a sharp, upward slope evoking the name of *Mount* Suribachi and underscoring the rigors of an uphill fight, of obstacles overcome. On the opposite side of the insignia, on the downward slope, a figure found nowhere in the prototype confronts an unseen enemy. On this Mount Suribachi, a place of danger and hardship, the battle still rages. On this Mount Suribachi, those who raise the flag are clearly heroes, brave heroes under fire.

If the public wanted heroes, the Treasury Department and the Marine Corps were going to provide them. Discussion of a first flag-raising was dampened; reporters quizzed Joe Rosenthal on his brushes with death and

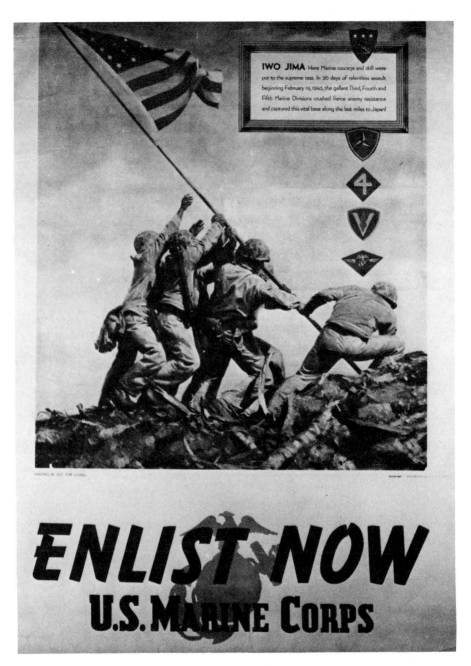

IWO JIMA Here Marine courage and skill were put to the supreme test. In 26 days of relentless assault beginning February 19, 1945, the gallant Third, Fourth and Fifth Marine Divisions crushed fierce enemy resistance and captured this vital base along the last miles to Japan!

PAINTING BY SGT. TOM LOVELL

ENLIST NOW
U.S. MARINE CORPS

Sergeant Tom Lovell turned the icon into an effective Marine recruiting poster.

played up the parts about "artillery and mortar fire . . . rising to a high pitch of intensity," the mines, the "crack of rifle fire." Putting aside any reservations about the forced heroics of the graphics, Rosenthal smiled for more pictures, this time showing him presenting a poster to Spencer Tracy, representative of the Hollywood bond effort.[10] In fact, the whole campaign smacked of Hollywood and smiling make-believe. Private Hayes, just off the plane from Hilo, voiced concern that the raiser at the foot of the pole, officially identified as Henry Hansen, was really his friend Harlon Block. Hansen had only figured in the first flag detail, he argued. But Hayes was told to keep quiet. Both men were dead. It didn't matter to them. What mattered was the bond tour. What mattered was public confidence in an event already enshrined in American mythology. What mattered was raising the flag and being a hero.[11]

On May 9, 1945, the heroes of Iwo Jima hoisted over the U.S. Capitol building the same tattered flag they had once raised over Mount Suribachi. It was V-E Day, and their gesture, calculated to remind the public that the war had not yet ended in the Pacific, proved effective with bond buyers. A mobile booth set up on Capitol Plaza was mobbed. Some came because they had boys of their own on Iwo, but others in the crowd of a thousand or more were simply curious about the three heroes, celebrities now, made famous by Rosenthal's famous photo: the Indian, a full-blooded Pima, pulling solemnly on the guide rope; the sailor, straightening the folds; the third kid, a "poor man's Tyrone Power," standing at rigid attention.[12]

A host of other notables saluted or covered their hearts on signal: Forrestal, Morgenthau, Vandegrift, Rayburn. The Speaker opened the ceremony by calling what had happened on Iwo Jima "a symbol of victory to Americans." The commandant recalled how the sight of the flag, fluttering over Suribachi, had inspired the Marines below. The same flag—a stateside publicist had fired a pistol at the banner, to make it look more authentic—must now "inspire the utmost efforts of all in the hard fighting that is to come," he added, reminding his audience of the coast-to-coast bond tour scheduled to begin in New York City the following morning. The big bond show—the patented "hero routine"—was off and running. The breeze picked up. The flag billowed, showing off its synthetic tatters and its brand new hole. A Marine in the crowd, just back from Iwo Jima himself, looked up. "A hell of a lot of people got killed to get that up there," he said, in a small, sad voice.[13]

Bond tours rarely dwelt on death, however. A series of ads reminding

This movie-star shot of Rene Gagnon was taken at Pearl Harbor in April, as the young Marine was on his way home to sell bonds. Unlike his two buddies, Gagnon was never camera-shy.

buyers of the recent demise on Iwo Jima of Medal of Honor winner John Basilone was proposed early on for the Mighty Seventh. The maudlin pitch—"He traveled all over America, urging every American to buy more bonds [but] he can't ask you now!"—was dumped in favor of the upbeat flag-raising. Interspersed with a little inspirational razzle-dazzle, it was

songs, dances, gags, and pretty girls that really moved the merchandise. Celebrity auctions were sure-fire hits. During the course of World War II, Betty Grable's nylons and June Havoc's panties both went on the block, for instance, and Jack Benny's $75 violin brought $1 million in bond pledges during frenzied bidding at Gimbel's department store. Miss America for 1945, Bess Myerson, was in great demand as a bond speaker; during her Washington appearances, Julius Garfinkel and Company gave out chances on free (unused) nylon stockings to shoppers who bought a $25 bond.[14]

Smaller cities made do with homegrown attractions. In Tampa, a cannon was shot off on the hour during bond drives. In the Bronx, purchasers got to ring a replica of the Liberty Bell. In Cheyenne, Wyoming, bonds were sold at "pie socials." If Tampa and Cheyenne missed the bonds swaps held in big-city movie palaces, where touring bands of starlets and bit players exchanged perfume, cigarettes, and juicy steaks for sales, they could still join in the excitement on the radio. Bob Hope kicked off the Mighty Seventh with a show carried on all the major networks. He clowned with Morgenthau, Vandegrift, and comedian Jerry Colonna in a Washington studio and sang a duet with Bing Crosby via a remote hook-up with Hollywood. Disk jockeys all over the country played Crosby's recording of "Buy, Buy Bonds" for months afterward.[15]

War heroes were useful additions to a good bond tour. They led the parades, right behind the flag. They collected the ceremonial keys to the cities on the circuit. They were photographed in uniform with the politicians and the starlets. They gave the interviews and reminded everybody that there was a war on. Recalled to the home front for a bond tour in 1942, John Basilone did it all—three solid months of speeches, parades, and kissing movie stars that culminated in a rally in Raritan, New Jersey, his hometown, where "trophies" collected on Pacific battlefields were raffled off and organizers gave the hero of Guadalcanal a $5000 bond. When it was over, he had had enough. Basilone felt, he said, like "a museum piece," not real, not himself.[16]

Tours took their toll on young men unaccustomed to public attention, young men sometimes consumed with guilt because they were back home, being toasted and cheered, while their friends, just as brave as themselves, were still fighting and dying. That they were representative of fighting men everywhere was a distinction wasted on the designated heroes who ate the steaks and answered the questions about their deeds of valor. Line

troops, too, on occasion resented seeing one of their number suddenly sent home, to become a "Hollywood Marine." More often, however, they sympathized with the poor guy: a bond tour was known as hard duty and cautionary tales about those who had succumbed to an insidious mixture of cocktails, nightclubbing, and adoring women were a part of the serviceman's folklore. Informed that he was being shipped back to Washington to work for the Treasury, Rene Gagnon declared that he would rather go back into battle "than make a bond tour." And the usually taciturn John Bradley was voluble on the subject of tours, which he clearly found frivolous: "Men of the fighting fronts cannot understand the need for rallies to sell bonds for the purchase of seriously needed supplies. The bond buyer is asked only to lend his money, at a profit. The fighting man is asked to give his life."[17]

But Bradley, Gagnon, and Hayes shook hands with the president and smiled for the cameras. They endured the applause of the Senate and the cheers of local baseball fans. They raised their flag over the Capitol. Then they packed their bags and caught the train. The first stop on the Iwo Jima tour was New York City. In the lobby of the Paramount Theater a huge enlargement of Rosenthal's photo dangled between portraits of Roosevelt and Truman. In Times Square, under a canvas shroud at 43rd Street, stood a fifty-foot statue of the flag-raising. In Wall Street, outside the Bank of Manhattan, a half-size replica of the big sculpture lurked under cloth wrappings. Posters were everywhere. Organizers checked rosters of volunteer workers, the so-called Blue Star Brigade. During a luncheon at the Astor Hotel, representatives of the ready-to-wear industry set themselves a $100 million sales goal. Life insurance executives, dining elsewhere, pledged the efforts of 30,000 New York area agents to the cause.[18] Lights! Cameras! Action! Bring on the heroes!

The Times Square rally was held on May 11, a Friday, in a midday crush of spectators that included fifty wounded Iwo Jima Marines, currently under treatment at a nearby naval hospital. The mayor was on hand. So were Mr. and Mrs. Salvatore Basilone from Raritan, who had lost their much-decorated son, John, on Iwo Jima. So was a group of theater owners, the War Activities Committee of the Motion Picture Industry, sponsors of the statue, the backdrop for a tightly scripted pageant of patriotism, full of pathos and national pride. The veterans were introduced, the Basilones, and three once-faceless boys who had stepped out of a front-page photo into history. As Gagnon, Hayes, and Bradley

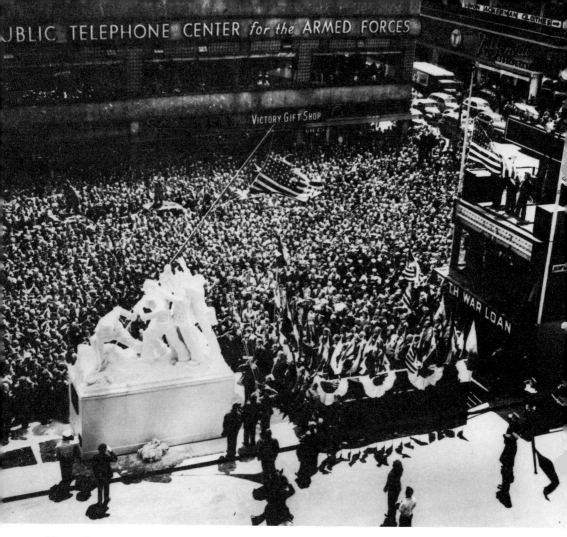

Times Square, May 11, 1945: Gagnon, Bradley, and Hayes raise the flag over a sculptural replica of the Rosenthal photograph as bond buyers look on.

unveiled the replica of the picture and ran up the flag, General Vandegrift praised the "unsurpassed gallantry" of America's men in uniform. The three raisers stood for all of them. "Their courage," he continued, "was from exactly the same cloth as that which smashed Germany's war juggernaut in Europe and which has driven back the Japanese in every sector of the Pacific. Such courage is a part of the legacy this statue commemorates."[19]

As the sale got under way, Vandegrift's party sped toward Wall Street

and the day's second rally: another crowd, another statue undraped, more speeches on courage and heroism, a pledge that every bond bought would "help carry the flag" deeper into enemy territory. This time, however, reporters cornered the raisers in the lobby of the Bank of Manhattan. What was it like, being a hero? Looking a little harried, the threesome explained that appearing in the Seventh War Loan Drive "is not as much fun as it would seem." How did a real Indian get a name like "Ira Hayes"? How many "Japs" had the Chief killed? Hayes retreated into morose silence. At the Roxy Theater, he autographed posters without a word to the bond buyers who thrust them into his hand. At a gala bond dinner, where speeches were expected, he uttered a single sentence, in a defeated monotone: "I'm glad to be in your city an' I hope you buy a lot of bonds."[20]

Tech. Sgt. Keyes Beech, the Marine publicist who had found the survivors in the first place, had been brought home to shepherd the trio through the tour. From Day One, the sergeant worried about Hayes: his shyness, his temperamental unsuitability for what Beech called a "vaudeville act to persuade a bunch of fat cats who had grown rich on the war to invest in a sure thing." In New York, Beech's worst fears came true. Goaded by the press, and by his own growing sense that the real heroes were buried on Iwo Jima with Johnny Basilone, Hayes began to drink heavily. Beech locked him in his room at the Waldorf. Thereafter, local bond promoters were alerted to the problem. Wherever the tour went, Hayes had a "tail," to keep him out of real trouble.[21]

Written from the posh confines of the Waldorf, Hayes's letter to his mother back in Arizona gave no hint of trouble. He told of upcoming stops in Philadelphia and Boston and looked forward to the arrival of the entourage in Phoenix, in a month's time. He was, he told her, "excited but happy." Philadelphia was fine. It rained in Boston but more than 200,000 turned out anyway for a Purple Heart parade of wounded vets that stretched for six miles. Because he was a New Englander, Gagnon carried the flag in the lead car, followed by a column of jeeps bearing city officials and a Hollywood bond troupe. He and his two companions auctioned off autographed copies of the Rosenthal photo on Boston Common and took front-row seats for an all-star show headlined by Jane Wyman, Cesar Romero, Joan Fontaine, and the Ritz Brothers. Then, after a side trip to Worcester, it was back to New York and Wall Street to meet the Gold Star Mothers.[22]

The emotional high point of the tour, the second Wall Street ceremony

was, in fact, the official kick-off for the national sales campaign. Against a screen of giant posters "picturing the six Marines at the climax of their heroic surge up Mount Suribachi" sat Gagnon, Hayes, Bradley, and the mothers of their three fallen comrades: Goldie Price, Franklin Sousley's mom; Martha Strank, Michael's mother, from Pennsylvania; and Mrs. Madeline Evelley from Somerville, Massachusetts, whose son, Sgt. Henry O. Hansen, led the inaccurate list of raisers compiled by the Marines. Although the president of the New York Stock Exchange was slated to present $1000 bonds to the guests of honor later in the program, New Yorkers by the thousands packed the narrow thoroughfare to witness something else—the first meeting between the three who had come back and the grieving mothers, a moment of deep sorrow put on public display in the interests of a successful bond drive. But when the time came, "the touch of their fingertips called up memories that caused onlookers to fall silent and avert their eyes." The hype and the hoopla seemed all the more unreal in the face of genuine grief, endured in silence: "The survivors did not look at the posters, nor did the mothers of their fallen comrades. And few words were spoken by either group. Each seemed to understand what was in the others' hearts."[23]

After the rally, Mrs. Price remembered that Franklin, on his last furlough, had told her he wanted her to be proud of him. "I don't think he could have done anything greater than to help raise that flag," she said. Exactly who had raised the flag was becoming an issue among the touring heroes, however. Hayes was convinced that Sergeant Hansen had been misidentified. His doubts fed the sense that the whole exercise was a sham. His letters from Boston and New York grew impatient with the rigor of the schedule, the silliness of it all, events like "some lady's rally where there will be 2,000 women and no men except us."[24] But the tour moved north and with it the heroes of Iwo Jima, whose memories of that Friday morning back in February were dimming by the day. The tour headed west, collecting bonds, watches, wallets, and a growing burden of guilt—and anger. Rochester, Cleveland, Akron, Canton, Detroit, Indianapolis.

The Rochester stop was much like all the rest. Main Street was festooned with bunting. A platform was built there—part reviewing stand, part stage—to hold a big cutout of the poster, from which a real flag would be raised in solemn ceremony. High school bands practiced military marches. Local veterans of the Iwo Jima campaign were found and brought home

for the occasion. Local businesses ran giant ads urging attendance at all bond functions. Business leaders set ambitious goals for employee payroll-savings plans. Newspapers followed the progress of the bond tour as it moved toward the city, adding an aura of suspense to an otherwise predictable round of events. A parade, in the rain. The flag-raising. Radio interviews. Posing for pictures, holding up the real Iwo Jima flag. Bond luncheons. Bond dinners.[25]

In Rochester, thanks to some fortuitous Iwo Jima connections, the relationship between the bond tour and local industry was even more apparent than usual. Folmer-Graflex of Rochester had made Rosenthal's camera. The Treasury's poster for the Mighty Seventh was being printed by Stecher-Traung Lithography. So the flag-raisers visited those factories— and the plants of other major Rochester firms, big war contractors, too powerful to overlook. Hayes, Bradley, and Gagnon appeared at Eastman Kodak and Bausch and Lomb. They made a broadcast from Stecher-Traung, formally dedicating the poster. They attended a fancy banquet hosted by Graflex at the Chamber of Commerce building, where the heroes ate steak and the rest of guests settled for ham. When the dinner was over, Beech and his charges each received a "well-filled wallet" from the business community and then faced the press, to sing for their suppers— reluctantly. "Wherever they go their arrival is heralded by cheering citizens who refer to them . . . as 'the Iwo Jima heroes.' But if you ask them," noted the Rochester *Times-Union,* "that's a pretty trite phrase": "What about the other three guys who helped them lift the flag on that memorable occasion, now with many other Yankees in an impromptu cemetery on what was once a battlefield on Iwo Jima? . . . They give you the impression that they feel a bit guilty about their jobs as Bond salesmen."[26]

When pressed to recall the dangers of their exploit, Bradley mentioned the Japanese lurking in caves atop the mountain, watching as they struggled with the pipe. "The action was tense," he said. But what interested the corpsman more than yesterday was tomorrow: after the war, he was going back to Wisconsin and pick up where he had left off, as an apprentice mortician. Gagnon talked about the future, too. When the war was over, he wanted to "hustle" straight back to New Hampshire and join the State Police. As for Hayes, he flushed and strode away, down the staircase and out into the street, with reporters scurrying in his wake, "declaring at every step that he would rather be back in the Pacific war theater eating

K rations than getting fat on steaks twice a day while his buddies are still carrying on."[27]

The bad feelings boiled over in Chicago. It was a cumulative thing, the result of the pressures, the constant drinking (bottles were shipped from stop to stop in the case intended for the flag), the careless eagerness of the public to bestow its praise (even Beech was now being introduced as "a hero of the Iwo Jima campaign").[28] The phoniness got to everybody: Gagnon was infuriated by dignitaries who lauded Hayes in public but shunned the Indian in private, and began to think that the first raising had been "hushed up" on purpose, to sell more bonds. Into Bradley's platform remarks crept an ill-disguised contempt for civilians who wouldn't buy war bonds without first being entertained, edified, and flattered. At the beginning of the Chicago drive, Hayes seemed to be the most stable member of the whole traveling circus. Honored by his fellow Native Americans at a Bismark Hotel luncheon, he gave his first bona fide speech of the tour, sketching the raising for his listeners in expansive detail, with real feeling. "Nothing in the world mattered but to put the flag up," he concluded.[29]

In the show-biz world of the bond tour, things weren't quite so simple. Chicago brought more reenactments, more autographed pictures, more movie stars. The "cheering multitude" at the State Street rally in the heart of the Loop was a "gay payday crowd," eager to be amused. Ida Lupino, the Warner Brothers star assigned to get the bond sales rolling, offered the gold clips from her dress for bid and got $75,000 for them. Then, responding to the pleas of the cameramen below the platform, she performed another popular ritual: the kissing of the hero. She bussed Bradley and Gagnon with mock fervor. But when she reached for Hayes, he was gone. Instead, Keyes Beech kissed the movie queen, who complained kittenishly that she was a favorite "of all service men—except *one*." Ira Hayes didn't turn up again until morning.[30]

When Hayes did roll into the Stevens Hotel, an hour before the start of a gigantic "I Am An American Day Rally" at Soldier Field, it was in the custody of the police: he'd been picked up in a Loop bar, not far from the scene of yesterday's debacle. As Beech pumped black coffee into his charge, Hayes questioned him about the upcoming event. Wasn't it sponsored by the Hearst paper in Chicago? And wasn't Hearst the one "that ran that shit about how MacArthur was right and the Marines got too many men

killed at Iwo?" Well, why raise the flag for an s.o.b. like that? There were no answers. His companions hustled Hayes to the stadium and shoehorned him into position in an open car to make a circuit of the field. Wedged between Gagnon and Bradley for support, Ira Hayes looked presentable enough, at least from a distance, and Beech breathed a sigh of relief. Then came the soft voice from the row of seats just behind him: the commandant! "I understand your Indian got drunk on you last night," Vandegrift whispered. How much longer did the tour last? A month. "My god!" sighed the General. "My god."[31]

Out on the field, the car pulled up next to a mound of earth scraped into a rough approximation of Mount Suribachi. With the wobbly Hayes still in the middle, the trio contrived to slog up the dirt pile and raise their flag—for the last time, as it turned out. Humphrey Bogart and Lauren Bacall stood at attention. General Vandegrift made a speech. The reporters circled the celebrity guests. Should the United States give captured islands in the Pacific to some international body after the war? "Hell, no!" Gagnon answered. "The Marines fought and died to take those islands. We had 20,000 casualties on Iwo alone. We don't want to go through that again!" Fine. Thanks. Now when did Bogart and Bacall plan to marry?[32]

Chicago was the end of the road for Ira Hayes. A Marine PR officer dispatched from Washington on a damage-control detail handed him an airline ticket to the Coast and ordered him to rejoin his unit in the Pacific immediately. Beech's pleas for a reprieve fell on deaf ears. Word had come down from the highest authority. The private was *not* to stop in Arizona to see his family. The flight left Midway at 9 P.M. and the private *would* be aboard. Except in Phoenix, where Beech had to tell "some fair-sized whoppers" to account for his absence, Hayes's abrupt departure was readily explained away. He had railed against the steak dinners often enough that the public believed the official story. He would "rather fight than sell war bonds," according to one published report, "so he is going back . . . at his own request." Hayes "constantly has reiterated his desire to return to combat," read another. After Memorial Day, at the remaining stops on the tour, the speeches always began with a reference to the brave Indian lad who had begged to go back to war.[33]

"People shoved drinks in our hands and said we were heroes," Hayes later said of his two awful weeks of bond selling:

I was sick. I guess I was about to crack up, thinking of those guys who were better men than me not coming back at all, much less to the White House. On the reservation I got hundreds of letters and I got sick of hearing about the flag-raising and sometimes I wished that guy had never made the picture.[34]

In July of 1945, Hayes was in Hawaii with Easy Company, a celebrity even there, and still miserable as he followed the tour through the stream of clippings mailed to other guys in the outfit. His fellow heroes were still on the road, winding through the southwest, signing autographs and raising flags without him. Beech and Bradley were sick of it. Only Rene Gagnon, according to letters that reached the Pacific, "could have gone on and on."[35] He alone had learned to live with being a "Hollywood Marine."

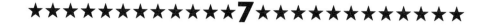
A surging, smashing saga . . . A sure-fire money maker at the box office anywhere . . . A story which is still fresh in the memory of the American public . . . Brings back the debt the nation owes the men . . . who stormed those Pacific beaches . . . One of the largest sets ever built!

<div align="center">Movie ads and reviews of Sands of Iwo Jima, 1949–50</div>

Guts and Glory: *Sands of Iwo Jima*

The bond drive hoopla never really stopped. In distant Hawaii, training for the invasion of Japan, Ira Hayes was still pestered by idle war correspondents asking him to tell his story all over again. Although new orders to report for reassignment marked the end of Rene Gagnon's celebrity duty, his Baltimore wedding (on a ten-day furlough) was packed with journalists. Even Bradley, whose wounds earned him an early discharge, could not quite escape his fame: the press turned up in Wisconsin when it was learned that the third surviving "hero of Iwo Jima" planned to marry his high school sweetheart.[1]

Their three comrades—Strank, Sousley, and Hansen (or was the last dead hero Harlon Block?)—lay under wooden crosses in the Fifth Marine Division cemetery below Mount Suribachi. Six months after the battle, some things were much the same as they had been in February: Japanese soldiers continued to filter out of underground bunkers on Iwo Jima to harry construction battalions working on the airstrips. Within the first ninety days, 850 damaged B-29s had landed there, saving the lives of an estimated 9,000 crewmen. In July, a pit was dug on the edge of one runway. If the plane bound for Japan carrying the first atomic bomb was unable to make the drop, Colonel Tibbets had been instructed to land the *Enola Gay* on Iwo and offload his cargo into the hole. In the event of total

February 19, 1947: Joe Rosenthal stands beside a replica of his photo at the Marine Cemetery on Iwo Jima on the second anniversary of the landing.

malfunction, he was told to ditch there: despite the terrible price paid for the island, Iwo Jima was, in the end, expendable.[2]

The war ended abruptly in August. Hayes served briefly in Japan and then shipped out for San Diego; discharged on December 1 as a corporal, he headed for Arizona and the Pima Reservation. Gagnon, in China with the Sixth Marines, stayed in uniform until April 1946. Then he, too, went home, home to New Hampshire and his bride. Although a monument to their moment of glory had been built on the top of Mount Suribachi the previous October, complete with flagpole and a low relief of the Rosenthal photo, public attention had turned to other matters: inflation, a housing shortage, nothing in the stores. But bad news was offset by high expectations, the underlying confidence that there were no material limits on

the nation that had won the war. According to the polls, returning veterans wanted to forget that war as soon as possible. Getting a job, finding an apartment, buying a car, and having a first baby were all high on the list of peacetime priorities. Retrospection was not.[3]

The exception was Ira Hayes. Unable to find a niche for himself in the postwar scramble for comfort and security, he was haunted by memories of "the flag deal." Specifically, Harlon Block was on his mind, and his failure to insist that Block—not Hansen—was the crouching man in the picture. "Some Colonel told me to be quiet," Hayes remembered, and he remained silent until that first summer after the war. Then he called Mrs. Block, she called her congressman, and Iwo Jima was back in the news again. Under pressure from Congress, the Marines launched a top-priority investigation into the true identity of the flag-raisers. One of Vandegrift's aides deposed Hayes in Arizona. Bradley and Gagnon were both quizzed as well. The Corps took testimony from former Twenty-Eighth Regiment officers scattered from Texas to Tokyo. In April of 1947, certain changes in the official order and listing of those in the photo were announced. As a result of the inquiry, Hansen was dropped in favor of Block. Previously, the last figure on the left, farthest from the flag, had been identified as Sousley, with Hayes just ahead of him. Now the order was reversed. Hayes was the last man in line.[4]

What made Ira Hayes remember Iwo Jima and the picture was an observance of the first anniversary of V-J Day, held in Buffalo, New York, in August 1946. Organizers planned a huge, patriotic parade, culminating in a reenactment of the Iwo Jima flag-raising outside the Buffalo Civic Auditorium, and invited the three principals to attend, at city expense. Hayes and Gagnon went. Always the most talkative member of the touring trio, Rene Gagnon had angered other members of Easy Company with stories of his hair-raising climb up Mount Suribachi—stories that seemed to grow more colorful with each retelling.[5] In Buffalo, he was just as eager to talk to reporters. "I don't think any other city in . . . the country remembers V-J Day," he said, and then launched into a disillusioned litany of complaints about "all those promises . . . that were made when the war was on" but had yet to be fulfilled. Yesterday's hero had fallen on hard times in New Hampshire: "I had no success in my attempt to obtain a police or fire department job in Manchester. I can't even find a place to live in my own town. I have to live with my wife's relatives in Hooksett, about eight miles away."

When it was his turn to answer questions, the once laconic Hayes also decried the fact that those who had won the war had not shared equally in the rewards of peace. With a long list of arrests for vagrancy and drinking already on his record, Hayes blamed racial prejudice for his inability to make a decent life for himself. "I want to be out on my own," he insisted. "But out in Arizona the white race looks down on the Indian . . . and I don't stand a chance anywhere." What had happened to the high ideals of freedom and democracy for which America once fought? Had those ideals died, along with the Marines now buried below Mount Suribachi? "Most of our buddies are gone. Three of the men who raised the flag are gone. We hit the beach on Iwo with 250 men and left with 27 a month and a half later. I still think of those things all the time."[6]

Americans remembered Iwo Jima when Hayes and Gagnon raised the flag in Buffalo. In the first quiet years of peace, in fact, Rosenthal's photo became the definitive, collective memory of war: its classical, sculptural calm; the absence of bloodshed; the triumphant lift of the Stars and Stripes all suited the national temper. The flag-raising was a natural for parade floats, too. All anybody needed was a flatbed truck and six eager Boy

An Iwo Jima float in the 1946 Tournament of Roses Parade.

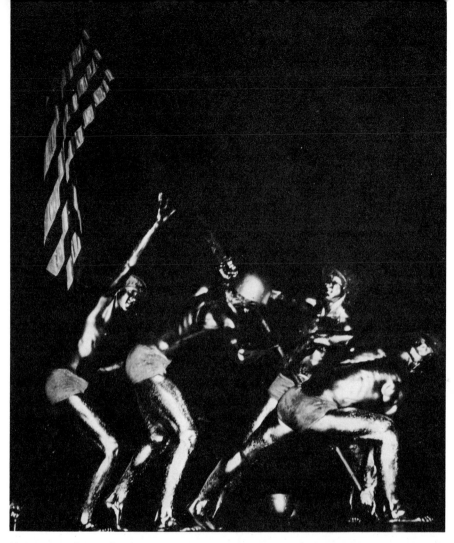

University of Maryland students began recreating the flag-raising in 1946; this performance dates from 1952.

Scouts. The Gymkhana Troupe at the University of Maryland used the tableau as their show-stopping finale. An Iwo Jima scene was the center-piece of a halftime show at the Orange Bowl. Disabled veterans replicated the photo in matchsticks and kidney beans during physical therapy sessions. A hobbyist in New Milford, Connecticut, spent ten months on a version in wood inlay, with 10,000 separate pieces of veneer. The Gorham Manufacturing Company of Providence, Rhode Island, sent General Vandegrift the prototype for a desk-size statuette adapted from the picture.

In Washington, discussion began on a proposal to enlarge Felix de Weldon's bond drive sculpture and cast it in bronze as a permanent monument to Marine valor.[7]

When the flag over Iwo Jima worked its way into the symbolic vocabulary of postwar America, Hollywood was quick to take notice. In 1943, war pictures accounted for almost 30 percent of the industry's output: by the end of 1945, the overworked theme had been all but discarded. But events conspired to make the studios take another look at the genre. The House Un-American Activities Committee (HUAC) began its investigation of Communist influence in the film community in 1947; less than a year later the notorious "blacklist" of Red sympathizers was issued. Although Harry Truman later denounced HUAC and the "spy mania" which had suddenly gripped the nation, one by-product of the Hollywood hearings was a rush to prove one's patriotism. So, beginning in 1948, the war film—with a full panoply of flags, insignia, martial music, and expressions of love for country— made a strong comeback.[8]

The revival was bolstered by disturbing news from the Far East, where Communist forces were overrunning China, and from Eastern Europe, where what Winston Churchill called "the iron curtain" had descended, apparently forever. World War II seemed clean, straightforward, refreshingly unambiguous in a Cold War world of espionage and ideology. In less than a decade, World War II and its symbols came to stand for the postwar ideal, for things as they should have turned out: American valor and know-how supreme; America always victorious. Because it was the clearest expression of that make-believe version of recent history, the flag-raising on Iwo Jima became a wildly popular Hollywood film in 1949.

The idea was born at Republic Pictures, best known as a factory for low-budget Westerns. Producer Edmund Grainger had seen the phrase "sands of Iwo Jima" in a newspaper story at the end of the war. Taken in conjunction with the Rosenthal photograph, he found the words evocative. Grainger was also convinced that the Battle of Iwo Jima had marked a turning point in World War II. If the enemy had held Iwo, he reasoned, "they would have felt that they could have stood off the assault on the mainland of Japan." So the producer copied down the phrase, pinned up the photo, and began work on the broad outlines of a story of a tough Marine sergeant and his squad of twelve raw recruits in the Pacific.[9]

With a forty-page treatment in hand, Grainger brought in Harry Brown, a screenwriter with a reputation for realistic combat scripts, and began

to consider casting.[10] Kirk Douglas was the original choice for the male lead, but, during negotiations with Douglas's agent, the script fell into the hands of John Wayne, Republic's perennial cowboy hero. Wayne was fascinated by the paternalistic aspects of the screenplay, "a beautiful personal story" destined, the actor thought, to make "a different type of war picture." After a long tussle with the head of the studio, who resisted starring a B-movie cowboy in what would become the most expensive film in Republic's history, Wayne got the part of Sergeant John M. Stryker. Adele Mara, the Marines' number-one pinup in World War II, was signed for the role of Allison Bromley, the young war bride. Budgeted at $1 million, *Sands of Iwo Jima*—Republic's first "prestige" picture—prepared to go before the cameras on location at Camp Pendleton in July 1949.[11]

Camp Pendleton, home base of the First Marine Division, was only a hundred miles south of Hollywood, but the distance emphasized Grainger's determination to make, with the help of the Marine Corps, the most accurate and realistic war picture to date. "There will be no heroics," he stated, as his 200-man crew arrived in Oceanside, "but it will show the heroism of the average American as he readjusted from civilian life to the war. Our story is fictional but all the combat sequences [will be] authentic to the last detail." Named technical adviser to the project, Capt. Leonard Fribourg purged the script of the worst inaccuracies and assembled actual combat footage that could be edited into the dramatic sequences. He also ran a "boot camp" for the actors quartered in nearby Carlsbad. By the end of their mock training, Fribourg joked, the Hollywood contingent could be distinguished from the Marine extras assigned to the picture only by the relative age of their shoes (Forrest Tucker's and John Agar's were newer).[12]

But Marine cooperation went farther than mere advice. Grainger estimated that without the material support of the Corps, "the picture would have cost at least $2.5 million." Fully one-third of the Seventh Regiment did something to aid the effort, whether assaulting a mockup of Mount Suribachi built over an artillery observation post or setting up plaster palm trees and sprinking ersatz volcanic ash in the quarry where most of the filming was done. The Marines supplied jeeps, tanks, planes, landing craft. And, to flesh out the squad of "Hollywood heroes" already in residence, the Marines also supplied a detail of real, live heroes of the Pacific. "Howlin' Mad" Smith was coaxed out of retirement to show the director, Allan Dwan, how to storm a beachhead. Col. David Shoup, who had won

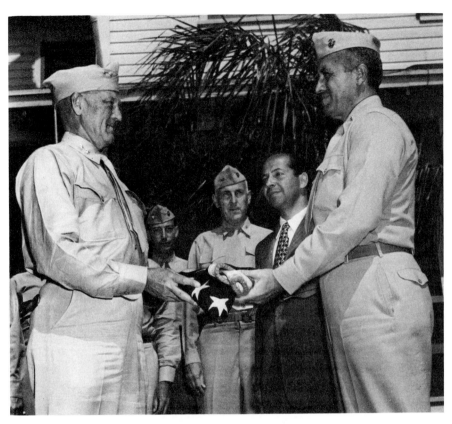

The original Iwo Jima flag was sent to California under armed guard for use in the movie *Sands of Iwo Jima*. Major Andrew Geer, liaison officer from Washington, presents it to General Graves Erskine at Camp Pendleton. The officer at Erskine's left is Lieutenant Colonel Jack Miller; next to him, at Geer's right, is Felix de Weldon, technical advisor to the filmmakers.

the Medal of Honor on Tarawa, and Lt. Col. Henry "Jim" Crowe, a battalion commander in the same campaign, made sure that Wayne/Stryker's men took the island again, with the cameras rolling. Lt. Harold Schrier, who had led the first charge up Suribachi with the flag, lent credence to the reenactment of that drive, the climax of the movie. Ira Hayes, Rene Gagnon, and John Bradley came to raise the flag over Iwo Jima one more time, in the grand finale. Under special armed guard, their ragged flag was shipped to the set from the Marine Corps Museum in Quantico, Virginia.[13]

The journey of the flag and the arrival of the three raisers for their first reunion since the bond tour provided Republic with a bonanza of free publicity. The studio further capitalized on public interest in the three-some by releasing still photos of the heroes, back in uniform, posing with John Wayne, authentic flag in hand. The sculptor Felix de Weldon was brought out from Washington to make sure they assumed the proper attitudes around the flagpole. Because of the prominence of the flag-raising in the advance publicity, filmgoers had every right to be surprised when the final cut of *Sands of Iwo Jima* turned out to be about other Marine assaults. The flag went up in less than ten seconds at the very end of the picture, none of the much-photographed raisers had a speaking

General Erskine meets the heroes—Gagnon, Bradley, Hayes—as de Weldon looks on.

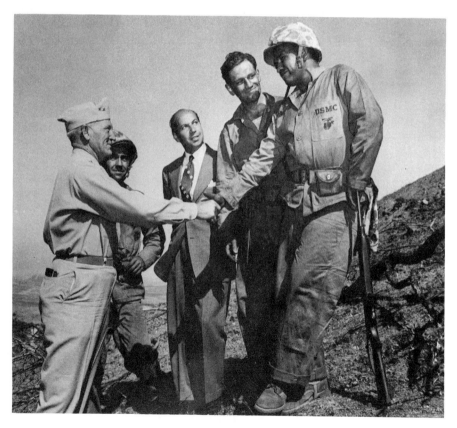

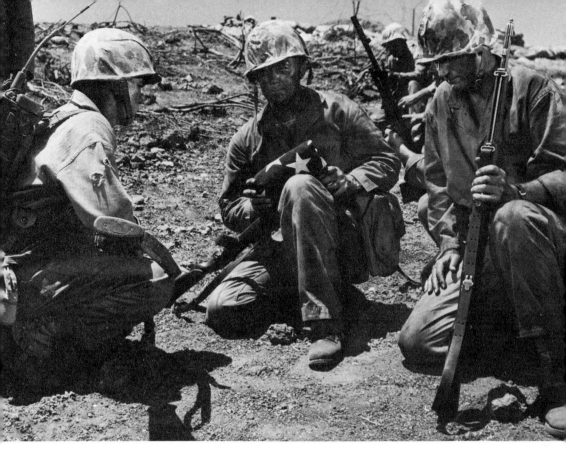

Hal Schrier played himself in the film. Here, he sends John Wayne and his men up Mount Suribachi with the historic flag.

part, and, despite the fuss over their presence in the opening credits, the three ex-Marines were nearly impossible to spot in their single crowd scene. Although Rene Gagnon later claimed to have been offered a contract after his one-day shoot at Camp Pendleton (and said that Republic had looked over "the Chief" for its regular cowboy-and-Indian offerings), the gap between hype and reality remained just as wide in 1949 as it had been on the 1945 bond tour. Gagnon and Bradley and Hayes were window-dressing for a reinterpretation of the war and of a symbol to which they had suddenly become so many human footnotes.[14]

David Shoup, a future Marine commandant, was the first to admit that the picture was "sort of a screwed up thing, really. The sands of Iwo Jima didn't really have anything to do with most of the film." Yet he was impressed with the authenticity of the Tarawa scenes, in which he played

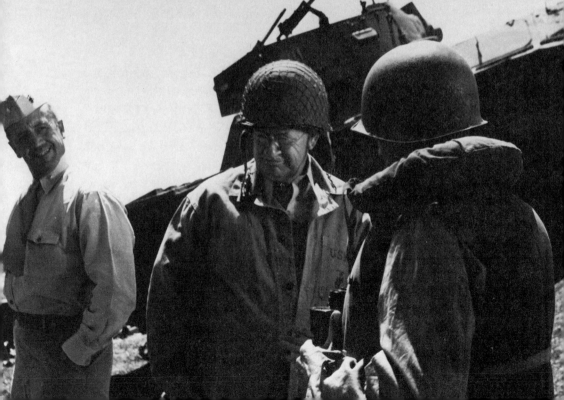

himself. The set, Shoup declared on first seeing it, "looks so real, it scares me!" And when he objected to the corny dialogue attributed to him in the script, Grainger and Dwan seemed eager to let him speak the words he had actually spoken at the seawall. With Marine footage of the battle blended into the Camp Pendleton scenes in the cutting room, "it was a fearsome thing to look at because having experienced the battle, goddam, I didn't want to go through it again."[15] Reviewers, too—even those unimpressed with the story, the performances, and the sometimes stereotypical Marines—universally lauded the "savage realism" of *Sands of Iwo Jima*. "The battle scenes in this film are terrifyingly real," said *Variety*. "The invasions are represented here in a frighteningly authentic manner," echoed the *New Yorker*, "and no attempt has been made to gloss over the squalor and horror that go with war."[16]

In 1945, writing about newsreels taken during the Iwo Jima invasion, the film critic James Agee had recoiled from their brutal realism. The uncensored battle footage from the Pacific, he wrote, amounted to pornography—the pornography of violence: "I am beginning to believe that, for all that may be said in favor of our seeing these terrible records of war, we have no business seeing this sort of experience except through our presence and participation." But, by 1949, black-and-white newsreel clips and grainy newspaper reproductions of Rosenthal's flag-raising had come to stand for the past, for history, for the graphic essence of World War II and its gritty flavor. Grainger's use of a dramatic texture matched to the visual characteristics of the newsreel and the newpaper photo bears witness to his aesthetic search for a realism based on the historical record. His story, on the other hand, moves away from the gung-ho simplicities of the war years, when Ira Hayes was told to keep quiet about that first patrol on the mountaintop and cinematic soldiers were always heroes.[17] Grounded in the complex new realities of postwar America, the saga of Sergeant Stryker and his men—from "the 'mccoy' storming of Iwo Jima's

Opposite, top: A publicity shot derived from that scene substitutes Wayne for Schrier. Left to right: Hayes, Bradley, Gagnon.

Opposite, bottom: "Howlin' Mad" Smith, another technical advisor, offers tips to a make-believe James Forrestal as Geer looks on.

The star, between takes.

beaches to the historic flag-raising episode atop the sandy atoll"—is both provocative and troubling.[18]

As played by John Wayne, Sergeant Stryker is a deeply flawed hero. A great Marine with an abiding sense of responsibility to the men he trains and leads, Stryker is nonetheless unsuited to life outside the military. He drinks to excess. His marriage has failed. He is estranged from his only son. His young charges respect what Stryker says about war but avoid his company off duty. The emphasis on Stryker's unheroic professionalism— the training, the drill, the routine—may stem from the close advisory

Co-star Forrest Tucker works on his tan. Unlike the actors, the real Marines on the picture wore beat-up shoes.

Marine extras: Pfc. Frank Capiewski, Corp. William Trask, Pfc. John Maseh, surrounded by stuffed enemy soldiers.

relationship between Republic and the Marine Corps. Wayne's character, at any rate, anticipates an emerging trend in Pentagon thinking: in the 1950s, Defense Department analysts came to believe that the national security was best ensured by the creation of a professional military elite, untouched by the passions and politics of civilian life. Whether or not such ideas were current in Hollywood in 1949, the Marine decision to support production of *Sands of Iwo Jima* in hopes of enhancing the reputation of the Corps was predicated on a script in which John M. Stryker exemplifies the new, postwar warrior.[19]

The troubled Stryker, pursued by private demons, is also typical of the World War II heroes of postwar Hollywood. While Edmund Grainger was working on the story line for *Sands of Iwo Jima* in 1948, the trade papers were full of news about other blockbuster war pictures in production, including MGM's *Battleground* and *12 O'Clock High,* directed by Henry

King.[20] As a group, the battle epics of the late 1940s and the 1950s represented the feelings of men at war—not their heroic deeds. King's film, for example, probes the professional leadership skills required of an officer and chronicles the mental breakdown of the conscientious commander of a flight wing stationed in England. Dwelling on character, human relationships, and psychology, *12 O'Clock High* evokes peacetime values and exposes the callous inhumanity of the war mentality. *Sands of Iwo Jima* addresses the same issues, albeit less directly. Stryker softens his attitudes toward the world outside the Corps after a domestic interlude in the apartment of a woman with a baby. Yet, by killing Stryker off at

Showing Marines how to storm a beachhead in the photogenic manner: Southern California as Iwo Jima.

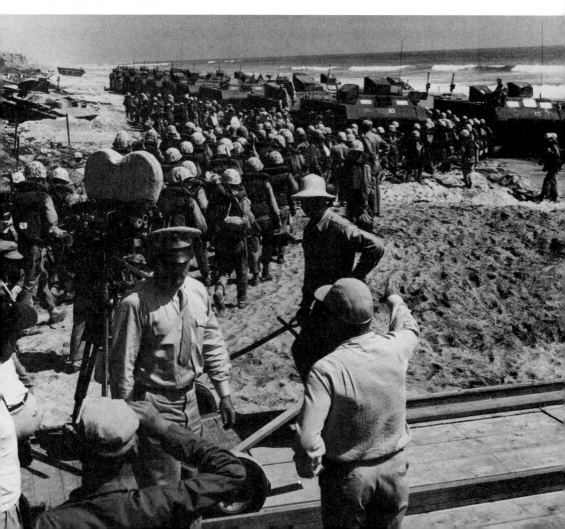

the moment of military victory, the film also seems to imply that he is not fit for civilian life. By disposing of Stryker, *Sands of Iwo Jima* casts off wartime attitudes, while preserving its fallen heroes in respectful memory. In another sense, of course, Wayne's hardboiled, blood-and-guts sergeant provided an imaginative antidote to the placid—even boring—course of life in the peacetime suburbs. Marriage and a mortgage, for such a man, could only put a stop to his adventuring. Perhaps the Strykers of the world were better off dead, if the alternative was crabgrass. Only the fortunate moviegoer could enjoy home life and a wild, vicarious freedom from its strictures simultaneously.[21]

After Stryker is felled by a random shot atop Mount Suribachi, his squad gathers to read the sergeant's last letter to his son. In that letter, Stryker admits his failures and thereby sends a message to a postwar America of families, of fathers and sons. His is not the path to follow. Stryker is dead. The flag goes up. The symbol encapsulates the war and its heroes; it seals them away in place called "history," far away and long ago. All that is over, now. Stryker's men will move on into an America of wives and babies, wedding presents and dreams of Hollywood stardom, the world they have always cherished, the world their unbending sergeant neither understood nor loved. At the end of *Sands of Iwo Jima*, John Agar and Forrest Tucker, John Bradley, Rene Gagnon, and Ira Hayes belonged to a new America, where the old heroes were dead and the new ones were movie stars.

Sands of Iwo Jima made John Wayne a small fortune. It also made him a major star. He was nominated for an Academy Award in the Best Actor category. Fourth in the box-office polls in 1945, he rocketed to number one in 1950. *Photoplay* readers named him their favorite actor. Outside Grauman's Theatre, they cast his footprints in cement made from the black sand of Iwo Jima.[22] The part matched the player: the role, Wayne told Allan Dwan, had allowed him to say things he really believed in. In March of 1949, as he was negotiating his percentage of the proceeds with Republic, John Wayne was sworn in as president of the anti-Communist Motion Picture Alliance in a mass rally at a Los Angeles Legion Hall. His acceptance speech disposed of Hollywood "Reds" in a single sentence: "We don't want a political party here that any bully boy in a foreign country can make dance to his tune."[23] Almost as single-minded as Sergeant Stryker's, Wayne's hell-for-leather thinking would prove equally hard to square with the moral ambiguities of the 1950s. But his views had little

bearing on the raw charisma of the star Republic sent on tour in December of 1949 to promote *Sands of Iwo Jima,* surrounded by a twinkling galaxy of bit players who had once been war heroes.

Sands of Iwo Jima was scheduled to go into general release on March 1, 1950; to spark interest in the film, however, the studio planned a series of Christmastime premieres at theaters in major markets. The first of these gala openings—the "world premiere"—was slated for the Fox in San Francisco on December 14. Days in advance, the local papers began the ballyhoo. Hollywood stars would be present *in person:* Wayne! Mara!

Practicing the flag-raising.

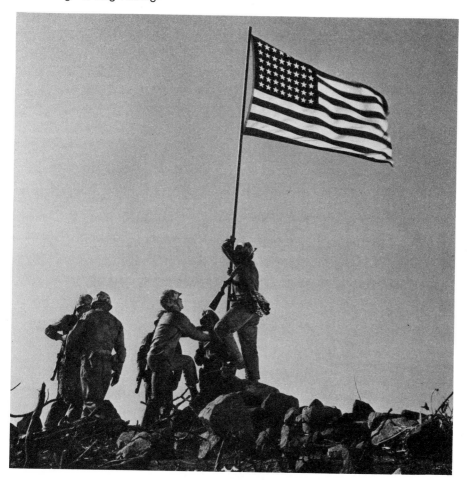

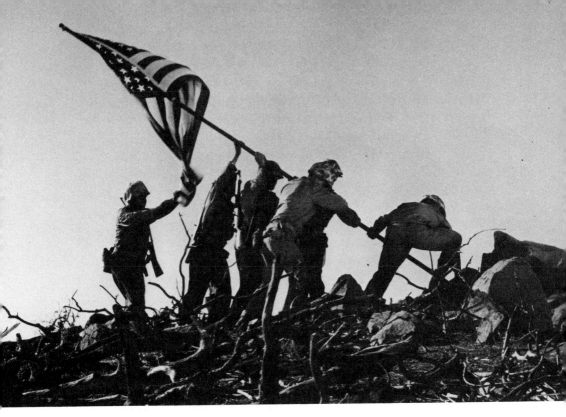

Hayes, at left, is now stouter and slower.

Tucker! Shoup, Crowe, and Schrier were expected, too: "In the movie," screamed an ad thinly disguised as a news story, "each of these officers played the role he performed in battle." No increase in prices! No seats reserved! Box office opens to the public at 7! Live coverage on KPIX-TV! Glamour! Lights! Crowds! Stars![24]

Potential confusion between actor and war hero was compounded by the juxtaposition between newspaper articles about the movie and reports detailing the turbulent home lives of the stars. The *Chronicle* provided a synopsis of the film, for instance, in which the actor John Agar was identified as Private Conway, the young Marine who marries a New Zealander, and Forrest Tucker as the hot-tempered Private Thomas. But elsewhere in the paper for that week, the same individuals appeared as defendants in messy divorce actions. Agar, an Air Force veteran, was being charged with drunkenness and domestic abuse by his wife, the former child star Shirley Temple. Tucker's ex-wife, "a former Earl Carroll beauty," produced evidence of extreme cruelty in a Los Angeles court

action for custody of their only daughter and $450 a month in support payments. Events like the premiere blurred the line between private and public life, between life and art. Being a celebrity, in the end, made the deeds for which one was celebrated all but irrelevant: it was enough that Colonel Shoup and Private Agar (a.k.a. Conway) were famous. That fact alone justified the klieg lights, the red carpets, the original Iwo Jima flag in a glass case, and a marquee decorated to resemble the face of Mount Suribachi.[25]

On the night of the big premiere it rained in San Francisco, but the showers did not dampen the enthusiasm of assorted fans and autograph hunters huddled under the marquee. Nor did it silence the Marine Band,

The poster advertised the finished product.

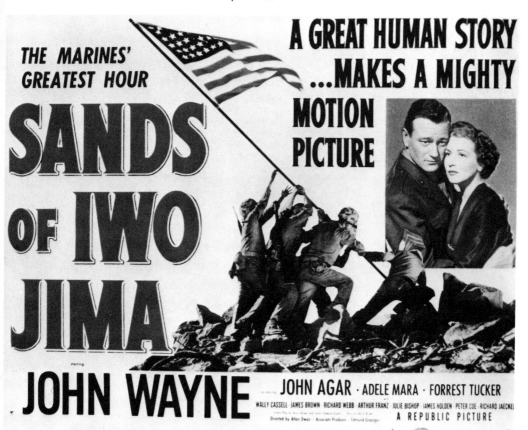

in full dress uniform, saluting arriving guests from the sidewalk across the street. The governor and the mayor stepped from sleek limousines. Fanfares greeted military officers from the Bay area, the minor character actors, the studio executives, the movie Marines—Shoup, Schrier, Crowe. Then came the evening's real stars, "representatives of the three phases of the saga of Iwo Jima," according to the press kit: Maj. Gen. Keller Rockey, commander of the Fifth Marine Division on Iwo; Joe Rosenthal of the *Chronicle;* and John Wayne.[26] Under the glittering marquee, the battle, a picture of the battle, and a movie about it became equivalent experiences, so many parts of a story that encompassed reality, representation, and make-believe.

And so it went. Next, the San Diego premiere, headlined by Gen. Graves B. Erskine, Iwo veteran and commanding general of Camp Pendleton, who had recently ordered that the Iwo Jima set built there by Republic be left standing, for real Marines to train on. Then a sparkling New Year's Eve premiere at the Mayfair in New York. Finally, Washington, the Warner Theatre, and a live "Salute to the Marine Corps" at intermission. The flag in its glass case. A model of Felix de Weldon's "flag-raising memorial, now under construction, eventually to have a prominent location on the Memorial Highway." The Marine Band. Gilt-edged invitations to the Cabinet, the diplomatic corps, the ranking Pentagon brass. Splashy ads tantalizing movie-lovers with the chance to see "Celebrated guests! Stars of the Picture—*Live!*" And, on the next page of the *Washington Post,* reports of interservice rows, a Marine "revolt" during hearings conducted by the House Armed Services Committee, Marine dissatisfaction with the Corps's lack of representation on the Joint Chiefs of Staff.[27]

But the real news was the arrival of the original Iwo Jima flag-raisers at Union Station, under the watchful supervision of Captain Schrier. "A little older, a little heavier," they had come to Washington to see themselves pretend, on film, to do what they had really done five years before. Although they smiled and waved when the photographers asked them to, being in the public eye continued to bother the trio. "Any time they want to stop taking pictures of us will be all right with me," said Bradley. "I just want to forget the matter and go on living."[28] In fact, reporters had very little to ask the men about the ostensible reason for their visit to Washington: the flag-raising stuff had all been done before. Discussion turned rapidly to private matters, unrelated to the seminal event of 1945,

to biographical reports on life in peacetime Wisconsin, New Hampshire, and Arizona.

Bradley had finally finished his apprenticeship. He was a licensed mortician, a homeowner with a mortgage and two kids, a girl and a infant son. Gagnon had a little boy, too. He worked part time, as a doffer in a yarn factory—but not for long. "For two years now I've been learning to fly and have a private license. What I really want to do," he confessed, "is to be a commercial airline pilot." Bradley and Gagnon had made a start on the future. Only Ira Hayes seemed stuck back in 1945. No wife. No children. No dreams. Sometimes he helped out on his father's 180 acres. The Indians on the reservation all knew that he was the Marine on the left side of the picture. He had gained sixty-four pounds. Otherwise, Hayes hadn't changed much—except that he was famous now.

Fame made Ira Hayes intrinsically interesting, whatever he did. Back in Arizona, although Republic and the Marines never alluded to the fact, Hayes drank. He didn't get a speaking part in *Sands of Iwo Jima* because he had shown up on the set dazed and staggering, with liquor on his breath. He boozed his way through the Washington premiere, too. Hayes's string of arrests for vagrancy and public inebriation totaled nearly fifty in the spring of 1953, according to the *Arizona Republic*. Why he drank was harder to understand. Hayes spoke of his memories, of guilt, of prejudice. Keyes Beech, a reporter again, working for the *Chicago Daily News,* thought the bond tour had started him on the downward spiral. Treated like a star, Hayes had begun to think like one, expecting as his due the adulation, the gifts, the trappings of the "high life." But when Sergeant Stryker drank, it was just a movie; John Wayne got a cash bonus for a stellar performance. When Ira Hayes drank, he landed in the Phoenix jail.[29]

In May 1953, after years of arrests and menial jobs, Ira Hayes decided that the time had come to make something of himself: if he wasn't John Wayne material, he might at least do as well as Bradley and Gagnon. Under a federal relocation program for Indians, he went to Chicago to take up a trade, tool-grinding at the big International Harvester plant. But from the very beginning, stardom blighted his search for a normal, workaday life. At LaSalle Street Station, he was met by a delegation of Indian leaders in warbonnets. Cameras recorded the spectacle. A microphone was thrust into his face: the "Welcome Traveler" show gave him a

watch and repeated all the old stories—war hero, Old Glory, courage under fire.[30]

Publicity brought invitations: everybody wanted a star. Could Hayes autograph an Iwo Jima stamp? Say a few words to the local VFW? Come and have a drink with the boys? Maybe the celebrity business, Chicago style, wasn't so bad. When station KOY in Phoenix asked Hayes to record a Flag Day message for the folks back home, he refused. "I was out in Arizona for eight years and nobody paid any attention to me," he said. Why should he do anything for people who didn't acknowledge his existence?[31] He went on the "National Barn Dance" show instead, for a fee. And soon, between the shows and the free drinks, he couldn't seem to get to work any more. By the end of July, after five new arrests for the same old problem, he signed on with the railroad, out of town, in hopes that distance would keep him out of trouble.

It didn't work. In the wee, small hours one Thursday morning in October, they found Ira Hayes staggering down North Clark Street without a shirt, shoes, or a wallet. Booked for disorderly conduct, he was jailed and photographed behind bars, dazed and miserable, by a pack of journalists sensing a hot story. The next morning, brought before Judge John T. Zuros in the Racine Avenue court, he drew the customary sentence: $25 plus costs, to be worked out at $2 a day in the House of Corrections. Headlines reminded Chicagoans of Iwo Jima. A cautionary parable about the tragic fall of the hero played itself out in the pages of the *Sun-Times* after that paper paid his fine, sent him to a North Side sanitarium for a week, and solicited donations to give the man "who raised the American flag . . . in World War II" a fresh start. The money dribbled in by dimes and quarters: a mother who had lost a son on Iwo Jima sent a dollar; so did a former serviceman, himself a self-described alcoholic. The total reached $1,165.53 by the time the "hero of Iwo Jima" emerged from the hospital, shaky but hopeful. A new job awaited him in Hollywood. "I guess the best way I can say what is in my heart is to promise that I won't make anyone regret that he helped me," Hayes vowed, fingering his ticket to the Coast.[32]

The *Sun-Times* campaign—"Do you think . . . the hero of Iwo Jima is worth a second chance?"—was widely reported elsewhere. Elizabeth Ann Martin, the former wife of comedian Dean Martin, read the story in Los Angeles and hired Hayes, long distance, as chauffeur and bodyguard for her four children. The pay was $300 a month. Grateful, he said, "for a

second chance," the man the Martin kids called "the Chief" got his own room, meals, and lots of attention from the media. He appeared on Ken Murray's TV show, along with Edgar Bergen and Charlie McCarthy. Joe Rosenthal was the other guest of honor. Hayes had never talked with the man who made him famous, and the interview was an emotional one, with both veterans of the Pacific in tears. "He told me he was getting credit for a lot of things that other men deserved," Rosenthal said later. Hayes told Mrs. Martin the same thing: "The real heroes are still on Iwo Jima."[33]

Hounded by his memories, Hayes went on another binge, bankrolled with his television earnings. This time, the LAPD found him lying in a street, unconscious. Jail again. More pitiful photos. Lurid headlines. The end of the glory road. "I'm all through," he sobbed. "I guess I'll go back to Arizona." He got off the bus in Phoenix on Veterans Day, the morning after the 178th birthday of the Marine Corps.[34]

In the final pages of *Battle Cry,* a World War II novel published in 1953 to great acclaim, a group of Marines comes home from the Pacific in 1945. As the hero steps off the train and into the waiting arms of his family and his best girl, he hears a newsboy hawking papers: "I caught a glimpse of the front page he waved. They were raising the flag on a mountain top in the picture . . . 'Read all about it! Marines on Iwo Jima!'"[35] But the war is over for the young Marine in the book. War is a picture in the paper. Life is just beginning. And in life, perhaps, Hollywood heroes are better than the genuine article. Make-believe heroes are seldom disappointing.

★★★★★★★★★★★★★**8**★★★★★★★★★★★★★★★

This really happened, one of the most dramatic incidents of any war, vibrant, perpetuated in bronze in our nation's capital, enduring for posterity.

From the Marine film, *Uncommon Valor*, 1954

A Marine Corps for the Next Five Hundred Years

General Vandegrift tugged at the cord. The several thousand onlookers applauded. The band played "The Marine Hymn." And a chilly November wind rippled the black shroud that cascaded down, revealing a thirty-six-foot statue. It was Suribachi, all over again! This time, the heroic flag-raisers planted their standard atop a man-made promontory, a sculpture base modeled on the pork-chop profile of Iwo Jima. Within nine months of the event he had caught on film, Joe Rosenthal's famous image stood immortalized as a statue on home ground, within sight of the White House, a few blocks from the Washington Monument. Just back from the Pacific, Corpsman Bradley was the guest of honor at the dedication, his presence a living guarantee of the authenticity of the capital's newest landmark. The unveiling inaugurated observances of a splendid Veterans Day, 1945—and the 170th birthday of the United States Marines.[1]

"Uncommon valor was a common virtue," read the inscription. The artist's name was there, too: "Felix W. de Weldon, Sculptor." In the five months since his meeting with Harry Truman, de Weldon had enlarged the tabletop model he showed the president to nearly twice life size, a heroic feat in its own right, involving some three thousand pounds of plaster and ten tons of clay. Although the finished product now ensconced on Constitution Avenue seemed to glisten with all the pomp and majesty of polished bronze, it was really made of painted plaster, prey to the rains

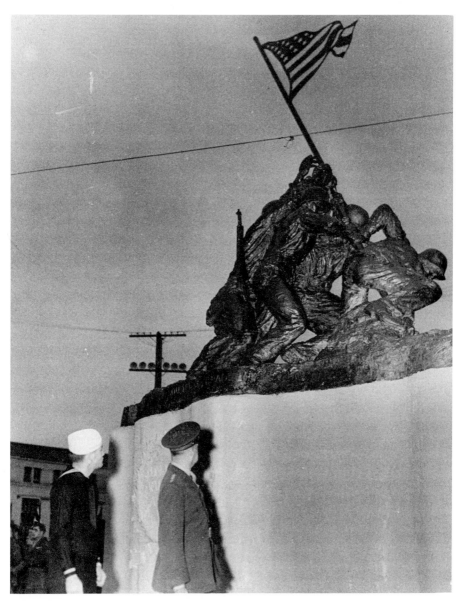

General Vandegrift and Navy Corpsman Bradley inspect the new Iwo Jima statue on Constitution Avenue: Dedication Day, November 10, 1945.

and snows of the coming winter. But nobody on the dais talked about plaster and bronze-colored paint. They were interested in the image, and what it meant today, in November 1945. The sculptor told the crowd how the survivors of the "heroic action" in the Pacific had posed for him and how the Marines had found him photos of the three brave men who had died on Iwo Jima. On the base, the names were listed under each of the heroes, including the misidentified Henry Hansen, his face copied faithfully from an official service portrait. Rifles, helmets, boots, fatigues, even a real American flag fluttering from the sculpted pole: every element of the statue seemed to reproduce the Rosenthal picture with extraordinary fidelity. For de Weldon, and for those who witnessed the unveiling, this was a new kind of monument, one grounded in "accuracy and realism," true to physical appearances, true to life.[2]

To Treasury Department functionaries, the unveiling provided another photogenic boost for the ongoing bond effort. The Pacific war had ended in August, but many feared that the economy would collapse under the burden of a long military occupation, care for veterans, and the generous benefits of the new G.I. Bill. Inflation also threatened to make fiscal chaos of America's return to peacetime buying and selling. So the Treasury had launched one last bond drive to pay off the postwar debt. The slogan— "They Finished Their Job—Let's Finish Ours!"—gave the hucksters a golden opportunity to replay the plangent themes of the Mighty Seventh. With the unveiling of de Weldon's statue, the Iwo Jima heroes lived again, in perpetuity (or for as long as the plaster could withstand the elements). So, on this sunny November day, the Treasury marketeers who sponsored the ceremony plucked the sentimental chords of golden memory, sure to sell the latest quota of bonds. Tomorrow, they would try a more direct approach. Three Navy patrol bombers, loaded with powerful radio transmitters, would fan out across the nation, thundering their message through the heavens as though with the voice of God: "Buy Bonds! *Buy Bonds!*"[3]

But today belonged to the Marines. General Vandegrift lauded the gallantry of his beloved Corps and then turned his speech of praise into a stern warning to policymakers who entertained thoughts of weakening it. "An America strong in heart, in spirit, and in arms," he intoned, with a nod toward the statue behind him, "is our best assurance of preserving the freedom for which they fought." That evening, in a formal birthday cake-cutting at the Marine Corps Barracks, Vandegrift and his guests

repeated the message. Secretary of the Navy Forrestal attended, for example, and delivered a radio address taking special note of the "comradeship" among the various armed forces. But he also cautioned that interservice unity "cannot be produced by edict and must not be broken by controversy."[4] Reporters realized that the day's references to national strength and military cooperation were not idle speech-making. Instead, they were pointed allusions to a major political debate in the making. To the Marines, the ceremonials of 1945 were something more than celebrations.

The Marine Corps War Memorial was born from a hard-fought struggle to preserve the identity and the integrity of the United States Marines. Beginning with the presidency of Andrew Jackson, the Marines had survived eleven serious proposals to disband the Corps or to merge it with the Army.[5] In 1944, Congress took up a cost-cutting measure to consolidate the armed forces. April of 1945 brought a special investigation to gauge the effectiveness of uniting the branches of the military in a single federal department. Although the final report argued against a merger, by October Congress was once more holding hearings on a variety of other unification bills.[6] Debate on the status of the Marine Corps continued through 1946, when Vandegrift was forced to warn President Truman against a War Department scheme to reduce the Corps to a motley collection of "ranger-type battalions," shore parties, signal crews, and ship-to-shore detachments.[7] Not until passage of the National Security Act of 1947 was the issue resolved: Congress preserved separate administrative structures for the Army, the Navy, and the Air Force—and affirmed the historic function of the Marines as a distinct amphibious force.[8]

Against a backdrop of threats to the existence of the Corps, Marine leaders found strong symbolic support in the idea of a monument dedicated to the Suribachi flag-raising, a monument that would wed Secretary Forrestal's pledge of another "five hundred years" with the triumphant overtones of Joe Rosenthal's photo. Never mind that Forrestal had been talking about another flag-raising. Never mind that the Pulitzer Prize-winning picture depicted a strategically unimportant event. In the public mind, the image identified the Marines with an epic moment in American history. A monument would make that moment eternal. It would remind Americans that the Marines remained inseparable from Americanism—from determination, guts, drive.

Gen. Robert Denig, the Marine publicist who had led the drive to pro-

mote the Rosenthal picture, put the Corps squarely behind the statue campaign. Commandant Vandegrift adopted de Weldon's project as one of his own "babies." Together, the generals pulled strings all over Washington. They made sure the sculptor could work on the monument full time and supplied him with several dozen assistants drawn from the ranks, six of them Iwo Jima vets. And the $20,000 de Weldon needed for materials and work space (he rented the enormous studio in Washington where Paul Wayland Bartlett had once created the east pediment for the U.S. Capitol) came from a loan secured though the G.I. Bill. The sculptor and the Marines thought in grandiose terms: the plaster version de Weldon was building in his yawning studio was little more than a model for an even bigger, permanent statue in bronze, to which a $350,000 price tag had already been attached. So the statue unveiled on Constitution Avenue in 1945 was really a stopgap affair. It served the immediate needs of an embattled Marine Corps. And it was a kind of advertisement for the ambitions of its creator, in whose mind's eye glimmered visions of the commission of a lifetime.[9]

The Constitution Avenue model provided wonderful publicity. It was "a favorite of tourists," according to one Washington newspaper. Another daily sponsored a special photo contest for pictures taken at the site, and camera shops throughout the city were suddenly developing more snapshots of the Iwo Jima statue than of the perennial favorite, the Washington Monument. Ceremonies, presentations, and wreath-layings gravitated to the temporary monument, too. It even became a focal point for community outrage when vandals snapped off the flagstaffs that ringed its perimeter.[10] Although intended to stand only for the duration of the Victory Loan drive, the Iwo Jima plaster held its place on the lawn facing the Navy Department for more than two years. According to de Weldon, Secretary Forrestal vowed that the statue would never be removed so long as he was in charge of things.[11] It stayed, in fact, until November of 1947, when the new Pan American Union annex arose on the spot. Then the statue was carefully moved to Virginia, to the entrance of the Marine Corps base at Quantico.

The drive to put a permanent Iwo Jima memorial in Washington was managed by the Marine Corps League, a private organization closely allied to the Corps. In the process of securing congressional permission to build such a monument and soliciting private capital to do so, the League hired the architect Paul Franz Jaquet to lay out an appropriate setting

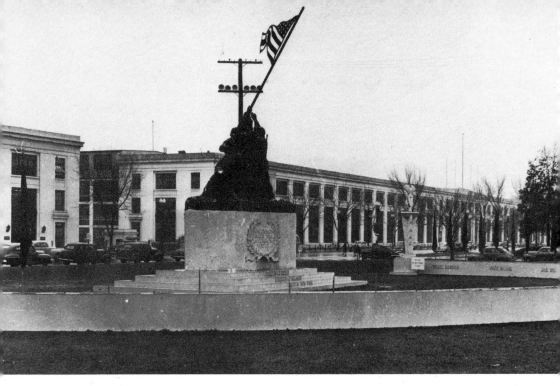

The temporary Iwo Jima monument on Constitution Avenue in February 1946, just after vandals broke off surrounding flags.

for the statue. Jaquet's spectacular plan dwarfed even the sculptor's lofty ambitions. His scheme perched the tall bronze group high atop a landscaped hill. The approach to the monument was a controlled experience, each step along the way fraught with meaning. First came an elliptical walk surrounding the complex, which offered "advantageous" views of the statue and drew visitors toward a bandstand that doubled as a speaker's rostrum. From that point, a processional staircase beckoned pilgrims up to a "Memory Walk" bordered by plantings, flags of the forty-eight states, and green granite plinths toned to the color of the Marine uniform. Then four great steps—each inscribed with the name of a cherished American right—led up once again, to the "Court of the Four Freedoms" where a thirteen-sided statue base of dark stone (the facets stood for the original colonies) bore the names of famous battles of the two world wars. Finally, a flat slab, directly under the flag-raising scene, where the words of Admiral Nimitz interpreted the legacy of Iwo Jima: "Uncommon valor," the letters chiseled in the granite spelled out, "was a common virtue."

A "Memorial Shrine" under the statue was to be a museum of Marine tradition. Huge metal doors led to a domed cavern sheathed in polished black marble, where panels carved in rich relief would tell the story of the Corps in ten epic chapters, from the landing in the Bahamas in 1776, through Tripoli and Mexico, the Boxer Rebellion and Nicaragua, right up to Iwo Jima. Across from the entrance, a mock crypt was to hold a sarcophagus bearing the names of all the Marines killed in action over the history of the Corps. At the center of this eerie shrine, an eternal flame would flicker above a roster of places in the far Pacific, names forever associated with the United States Marines: Wake Island, Guadalcanal, Bougainville, Tarawa, New Britain, Marshall Islands, Saipan, Guam, Tinian, Peleliu, Iwo Jima, Okinawa.[12]

Vast in scale, overweening in its self-glorification, the proposed memo-

Scale model of Paul Franz Jaquet's proposed Marine Corps Memorial as seen from the east, circled by the "Memory Walk." Doors lead to the crypt. To the left (south) is the bandstand, facing on a reflecting pool; the ceremonial staircase would have been on the far (west) side of the statue.

rial epitomized a new postwar aesthetic evident in the national yen for huge cars, bulky furniture, big ranch houses, and titanic shopping centers in the sprawl of suburbia. It echoed the boundless scale of America and the might of a consumption-driven economy.[13] It was an aesthetic that also catered to the political temper of the times: size described the greatness of a nation still giddy with victory and success. The flag flying over a bloated monument composed of courts and crypts, fire and water, and the names of battles won in foreign climes gave notice to the world that Americans stood eternally ready to ensure their hegemony by force of arms.

The scale was a sticking point with members of the other services, who resented Marine presumption—and coveted the choice site the Marine Corps League had earmarked for the memorial. The spot was Haynes Point, a jetty along the Potomac directly south of the Capitol, from which the bronze Marines would dominate all river views of the city. Maj. Gen. Ulysses S. Grant III, influential chairman of the Battle Monuments Commission, decried the placement of the League's monument for several reasons. It would deprive the District of Columbia of parkland, aggravate parking problems in the area, and pose a hazard to planes landing at National Airport, Grant complained—and who had given the Marine Corps the right to appropriate the Washington skyline in the first place? The National Park Service and the Airport Authority heartily concurred. A monument on Haynes Point was clearly impractical from a political standpoint. But the most damning indictments of the monument came from the artistic community.[14]

The aesthetic battle over Iwo Jima was not a predictable struggle between postwar modernists and philistine Marines, but a more interesting intramural dispute among advocates of traditional, representational art. Leading the opposition to de Weldon's model was the powerful National Sculpture Society, seeking to preserve its own de facto monopoly on federal patronage: for generations, its members had done all the big public statuary jobs, ranging from the memorials in World War I cemeteries and the architectural sculpture on the buildings of Washington's Federal Triangle to the monuments being built on the World War II battlefields of Europe. Allying itself with the Sculpture Society, the government's Commission of Fine Arts also joined in the attempt to dump de Weldon. A presidentially appointed body of aesthetic consultants with jurisdiction over art placed on federal property in the capital, the com-

mission lobbied Congress to pass legislation forcing the Marine Corps League to select an artist through open competition, virtually assuring that a member of the Sculpture Society's clubby, old-boy network would win. Neither group wanted to limit the contest they envisioned to a sculptural rendering of the Rosenthal photo, although they might tolerate the Iwo Jima scene if a legitimate, approved artist won. The Marines, on the other hand, cherished the flag-raising and all it stood for. They knew de Weldon's version of it, and they knew what they liked. His was the only statue they wanted.[15]

The Marines' loyalty to de Weldon only served to sharpen opponents' attacks on the supposed defects of his monumental plaster. Donald De Lue, a well-known artist and then president of the National Sculpture Society, asserted that the Commission of Fine Arts should never have allowed the temporary version on Constitution Avenue to go up in the first place. Another member of the Washington art set put it more bluntly: "Instead of immortalizing the brave marines who have given their lives for their country, the proposed design, if permitted to be carried out, would . . . be only a source of bitter resentment, violent criticism and ridicule." Ten professors from American University collectively dismissed de Weldon as a mediocrity and called his statue "ordinary," "ineffective," and "unsculpturesque." As for enlarging it, the professors cautioned that "in doubling the size of the temporary monument, Mr. de Weldon is simply creating something twice as bad."[16]

The personal attack on de Weldon—the nobody, the outsider—was even more virulent. Wheeler Williams, a future president of the Sculpture Society, sent a three-page memorandum to Secretary Forrestal in which the characterizations of de Weldon ran the gamut from artistic hack to sleazy con-man. Claiming to have consulted eleven different sources (including a secret Naval Intelligence dossier and confidential records from the Immigration Bureau), Williams put together a personal indictment peppered with faked credentials and shady business practices. The de Weldon story, as Williams told it, included an arrest warrant for an expired visa, after an episode of frantic border-hopping; an attempt to secure citizenship under false pretenses; misrepresentation of a portrait of Edward VIII of England as "official," although the king had neither posed for it nor commissioned it; shipping busts made of wet clay and then suing for damages when the drying materials fell apart in transit; and

lodging claims for fees against the subjects of portraits who denied ever asking for them.[17]

Some of the charges bordered on farce. According to Williams, de Weldon had caused a stink when he was drafted into the Navy as an ordinary swabbie: his induction was all a "great mistake," the sculptor was said to have claimed, because President Roosevelt and Justice Frankfurter had personally promised him a commission as a Lieutenant Commander. Williams even questioned de Weldon's name (he had apparently been known as "Weiss" or "Weihs" back in Vienna).[18] In all, it was a devastating attack, and Williams closed his tirade by contending that to let such a creature do the Marines' memorial constituted "an affront to the dozens of American Sculptors of long standing loyalty to our country, unquestioned professional integrity and far greater repute as artists, both here and abroad."

By August of 1947, when the Iwo Jima proposal came before the Commission of Fine Arts for aesthetic approval, the cause had already been lost. But Col. Frank Halford, testifying on behalf of the Marine Corps League, relied on a good war story to sway the art crowd. He asked the commissioners to imagine "those boys out there in Iwo Jima with one eye looking through the sights as they poured it into the Japs, and the other eye watching their buddies struggle up that hill." Hear it for yourselves, he begged: "The good American roar that went up . . . [and] silenced all the firing for that few seconds." The commission didn't hear the cheers or see the Marines toiling up Mount Suribachi as the colonel talked, however. All they could see was an overblown plan topped off by a statue they did not like. So they rejected it, for all kinds of plausible reasons: Haynes Point was a lousy site; the "colossal size" was out of scale with the city's other monuments. But they also concluded that the League should find itself another artist, drawn from "the first rank" of American sculptors. As for the model, "artistically it falls far short of the high standards of excellence established for memorials in Washington." The Marines ought to hold a competition—and pick a better subject! Or, if they insisted on the flag-raising at Iwo Jima, maybe a nice, inconspicuous "bas-relief " would be just the ticket.[19]

Adversity stiffened Marine determination. General Vandegrift put de Weldon back to work on a new, improved model to be sent on national tour as the trademark of a Marine Corps recruitment drive. In April 1949,

leading backers of the statue formed the Marine Corps War Memorial Foundation; its president was General Denig, de Weldon's old patron and backer. Harry Dash, a high-profile, big-spending insurance broker from New York, took charge of the financial end and spearheaded a massive appeal for funds throughout the Corps and its veterans. De Weldon pared down the overblown Jaquet scheme on his own initiative and began construction of an armature to support a statue three times the size of the Constitution Avenue version. The controversial Haynes Point site was quietly abandoned in favor of a tract of land midway between Washington and Mount Vernon, just off the George Washington Memorial Highway. The project was back on track and on the move.[20]

For more than a year, the Foundation worked toward meeting its revised budget, slashed from a whopping $3 million to $350,000 by elimination of the walks and crypt. In gratitude to Dash for paying start-up costs himself, the board arranged to make him a major in the Marine Corps Reserves: now the whole business was in the Marine family. Major Dash returned the favor by throwing lavish parties for his colleagues on the forty-six-foot yacht he kept moored in the Potomac and by heating up the fund drive. But unbeknownst to the Marines, the good major's fundraising techniques included black-marketeering, book-juggling, and outright embezzlement. By the time Foundation brass wised up to the swindle, Dash had already made off with more than $100,000 in contributions, only $40,000 of which could be found among his numerous bank accounts. On that note, the fund drive ceased and the Foundation busied itself with explanations of headlines that screamed, "Officer Is Seized in Marine Larceny" and "Ex-Marine Major Held in Iwo Jima Fund Theft."[21]

For the remainder of 1951, the Foundation dealt with the Dash affair. Reserve Maj. Arthur B. "Tim" Hanson was hired as legal counsel, in an attempt to recover lost assets. Hanson's investigation disclosed that Dash had used Foundation money for his own business deals, had traded in black market metals with funds earmarked for the statue, and had routinely withdrawn large sums from official accounts by signing his name on what should have been two-signature checks. And the Marines were not alone in their woes. Dash had also looted the pension fund of a stevedoring concern, pocketed the insurance premiums paid by his customers (without issuing policies), and even defrauded his own sister. That money was gone. But thanks to Hanson's efforts with the banks and bonding companies involved, the Foundation's final losses amounted to

little more than $10,000.[22] Board member Ruth Chaney Streeter, a Marine colonel and former head of the wartime Women's Reserves, made up the amount of the defalcation so that the Foundation could not be accused of abusing the good faith of its contributors. And having done so anonymously, Colonel Streeter resigned, disgusted by the whole sorry episode. Only Hanson knew where the money had come from.[23]

Meanwhile, Harry Dash's brush with the law took on all the earmarks of a tabloid tragicomedy as the press followed the misadventures of the high-society flimflam man. The New York papers got wind of the fact that Dash (an old crony of ex-Mayor William O'Dwyer) was an honorary deputy fire commissioner: editorials pontificated about Tammany Hall and the evils of political patronage. The incident became a modern morality play, with a salutary lesson—how a "yachtsman," a "free-spending . . . entertainer about town," a "favorite of cafe society" wound up copping a plea to the theft of $41,000.[24] Hanson pressed the court to show no mercy. Major Dash, he said, had stolen "the quarters and fifty-cent pieces of Privates . . . who have since died on the field of battle in Korea." In his own defense, Dash claimed the Marines' money was only a "loan"; his lawyers said the yacht served charitable ends, since he had taken Boy Scouts and veterans for rides. Unmoved, the judge ruled that Dash's history of "fraud and deceit" had earned him a spot in the "meanest" ranks of crime. "The peculations from the Marine Corps," he continued, "indicate a selfishness, a ruthlessness of character that would restrain any Judge from granting any clemency." Dash got two-to-five in Auburn prison.[25]

Through it all, de Weldon kept working. In the cavernous Washington studio, assistants covered the metal armature with chicken wire and the chicken wire with plaster-soaked fabric that hardened when it dried. Using a mechanical device called a pointing machine, helpers transferred the proportional length of an arm or the width of an eye on the small model to the larger dimensions of the new statue. Once the figures had been roughed out in this way, de Weldon and his assistants could modify details readily enough by filing away the soft surface or adding some fresh plaster to build up a concavity. A crew of skilled artisans, headed by stone-carver Idilio Santini, handled the manual labor: de Weldon functioned as their foreman.[26]

When the photographers came around, de Weldon grabbed the tools himself and struck a pose with a hammer and chisel, as though he were struggling with a balky block of marble, like some modern-day Michel-

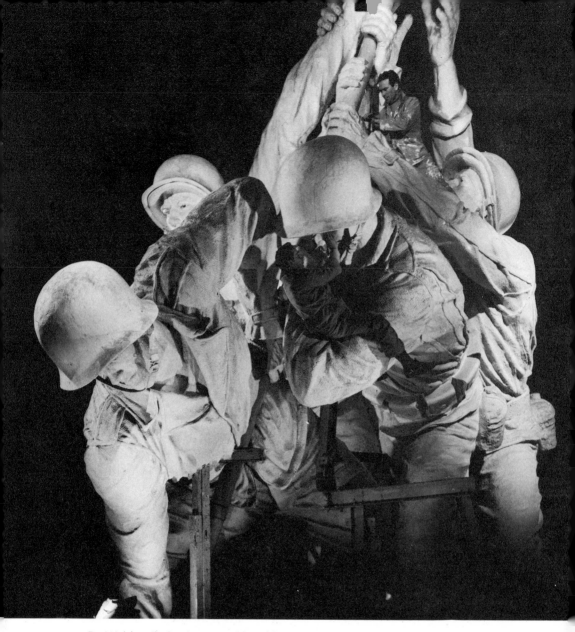

De Weldon (below), assisted by Idilio Santini, at work on the large plaster version. The dramatic lighting is courtesy of the movies: the scene was posed for the filming of *Uncommon Valor* (1954).

angelo. In day-to-day practice, however, the artist outlined what was to be done and left it to the men; he was able to absent himself from the studio for extended periods. His was a team-oriented method of making statuary. The most impressive aspect of his latest enlargement was neither subtlety nor creative artistry but the sheer magnitude of the scale. With figures approaching the height of a three-story building, the making of the Memorial required tons of plaster and the mind of a structural engineer. The rotogravure photos to the contrary, the statue was not a product of hammers, chisels, and refined taste. It was a creature of ladders and cranes, trusses and winches, work-schedules and payrolls, a triumph of organization as much as it was a work of art.[27]

Still, de Weldon did make some artistic changes as the work progressed.

"Accuracy and realism": de Weldon chats with his models—Rene Gagnon, Ira Hayes, John Bradley.

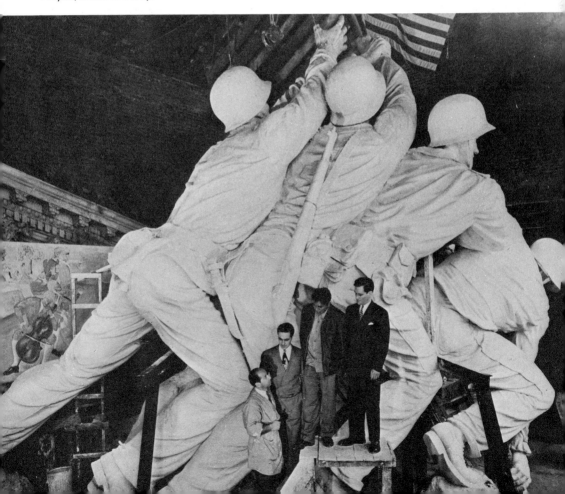

He recomposed the figure at the foot of the pole (Block now, not Hansen), turning him and lining him up with the others to eliminate the awkward prominence of his buttocks. Positioned in this way, the angular elbow and jutting knee were also minimized and the composition as a whole gained greater coherence—no more odd man out, at the right side of the group. All the figures fit snugly together, unified in action and thus more eloquent as testimony to the collective spirit of the Marine Corps and the cohesiveness of the nation. What seemed to interest de Weldon more than symbolism, however, was verisimilitude. For the smaller versions, he posed models in the nude, "clothing" the figures afterward to reproduce the sensation of physical strain. He took special pride in the portrait heads of each flag-raiser, the exactitude of the uniforms, and the Marine regalia that gave the impression of total realism. For the big version, he even replicated the woven texture of fabrics and carefully incised a camouflage pattern in each helmet cover. Colossal in scale, precise in the replication of every detail, de Weldon's was an art of heroic realism, a sculptural tour de force in which size equaled power and accuracy equaled truth.

While the Marine Memorial was taking form, de Weldon was also establishing a business that churned out hundreds of busts, medals, commemorative statues—and versions of the Iwo Jima scene to suit every need and budget. He went after prestigious subjects (both living and dead) with a vengeance, creating, in short order, a pantheon of famous and politically useful Americans that included admirals Caperton, Remy, Leahy, and Nimitz, Marine generals Erskine, Clement, Hart, Denig, and Vandegrift, the newly appointed treasury secretary, several chief justices of the Supreme Court, and presidents from Washington and Monroe to Harry Truman. Such subjects enhanced his reputation and swelled his bank account, but the bulk of his effort still went into Iwo Jima. During the work on the Marine Corps Memorial, de Weldon cranked out thirty-six various working models of the flag-raising, all readily dispersed to museums and collectors. He made other big Iwo Jima monuments, too. In fact, Mount Suribachi scenes amounted to a kind of cottage industry for de Weldon in the early 1950s.[28]

Late in 1949, the statue that had once stood on Constitution Avenue was nearing its foreordained end at the gates of the Quantico Marine base. Four years of sun and rain had cracked the plaster. The phony bronze surface had peeled away, leaving a scabby ruin, an eyesore. When it was transferred to Quantico in the first place, de Weldon had tried to persuade

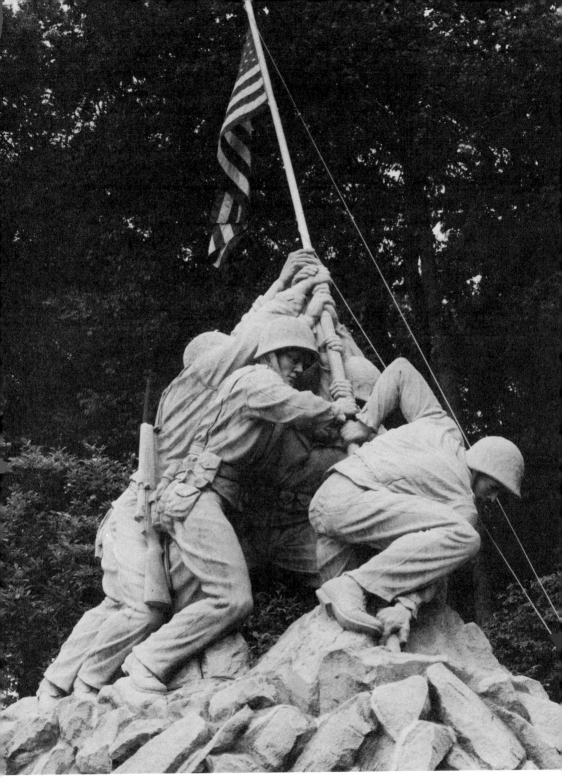

The limestone Iwo statue at Quantico: the metal rifle barrel was added after antiwar protesters broke off the stone original during the Vietnam years.

De Weldon's statue *in situ* at the U.S. 1 entrance to the Quantico Marine base.

the Marines to cast the statue in real bronze, at the cost of $40,000, but the powers that be had vetoed the expenditure. Now, again confronted with a big bill—a stone reproduction could be had for $10,000—the brass still resisted, preferring to put the money into the Enlisted Men's Club.

The man who saved the statue at Quantico was the base commandant, Gen. Lemuel Shepherd, a former commander on Okinawa. Because of the prominent position of the decaying monument along Highway 1 and the honor it paid to "a dramatic chapter in Marine Corps history," Shepherd got the necessary authorizations to pay for labor and limestone (after de Weldon had waived his "usual fee" of $50,000). One hundred thirty-five tons of Indiana limestone were delivered in short order. De Weldon and six assistants built a hut around the old statue. They unpacked their pointing machine, and set about making a wrinkle-by-wrinkle copy on the spot. But midway through their labors, the money for wages and supplies ran out. There was more haggling. Officers scoured the base for nickels and dimes. They sold tickets on a raffle, with big-ticket prizes "donated" by the wholesalers who wished to keep their contracts with the PX. Painfully, the Marines dredged up another $13,000. De Weldon and the boys kept carving. After almost a year, the shed came down and the statue was done.[29]

Dedication day, November 10, 1951. Another birthday for the Corps. Five hundred Marines at the gate of Quantico, standing before a shroud-covered monument. A wreath laid. A prayer said. A slow, sad rendition of

"echo taps" played by a pair of buglers. Lt. Gen. Keller Rockey, former commander of the Fifth Division on Iwo, stood shoulder to shoulder with Easy Company's old chief, Maj. Dave Severance, and yanked at the rope. "It was the most thrilling, breath-taking sight I ever saw," he said, looking up at the statue and remembering that morning in the Pacific. "This same flag was raised in plain view of the Marines fighting on the beaches and the men on hundreds of ships lying off shore. The Japanese, too, witnessed the dramatic event, and must have known what it meant for them." General Rockey, to be sure, was remembering an event altogether distinct from the flag-raising now before his eyes: he was thinking of Schrier, Thomas, Hansen, Lindberg, and Michaels even as he stared at the stony features of Hayes, Gagnon, Bradley, and the rest. He was thinking back to the first flag, a flag lying unhonored, even as he spoke, in the Quantico Museum. Stories about the unveiling ceremony perpetuated the general's mistake, with sidebars following the wrong flag-bearers as they "fought their way up the bunker-studded slopes" and telling how the scrappy Joe Rosenthal had taken his picture "under fire." In the shadow of a larger-than-life limestone reality, the mundane truth about Iwo Jima escaped even those who had been there.[30]

There would be more statues, more dedications, more muddled retellings of the same old tales. De Weldon did another Iwo statue for the Marine recruitment drive, for instance. The tour was canceled, but casting that particular plaster gave him a chance to make a mold, from which infinite numbers of the Constitution Avenue statue could be produced. He kept the master cast in the old Bartlett studio, while the Marines moved their version (painted to look like bronze) to the training camp at Parris Island. Another dedication, another moment for remembering, this time on the parade ground, with eight thousand people looking on. September 5, 1952. Maj. Harold Schrier the one to pull the string, this time. The base commander tailored his speech to the mission of the post and the young faces in the crowd: "The raising of the flag upon the steep hill in the face of the enemy and at the peril of one's life personifies the spirit of youth and the strenuous actions of young men engaged in a patriotic and hero's task." In the place where new Marines learned the traditions of the Corps, where John Wayne taught history with every screening of *Sands of Iwo Jima*, the Suribachi saga took on another coat of shining make-believe bronze. Amid the pageantry of a full-dress Marine occasion, Rosenthal's flag-raisers stood bathed in the glory of art and memory, while Schrier, string

in hand, must have recalled another moment atop Mount Suribachi and the men whom no one else remembered.[31]

While lesser Iwo Jima statues proliferated, the Foundation revamped its drive to raise funds for *the* Marine Memorial. Contributors' cards and manuals of procedure were printed. Every echelon of the Corps—platoon, company, battalion—was systematically canvassed. At Parris Island, solicitors showed up on paydays: they put buckets over the heads of reluctant "boots," according to one report, and banged on 'em until the recruits "decided that the Iwo Jima Monument was a fine idea after all." But for the most part, Marines paid up without a whimper. Outside funds were also sought through magazine ads, plugs on Kate Smith's TV show, and a box-office percentage on the Warner Brothers Korean War feature *Retreat Hell*. The Foundation sold Iwo Jima statuettes, lighters, and prints. Yet most of its income came from the recruit depots; the Corps itself provided the bulk of the $850,000 eventually required to build the Memorial. Although the Foundation could boast of getting the statue up without spending public money to do so, the success of the drive gave ammunition to critics who charged that, because so few civilians had participated, this was not really a national monument at all but just another typical Marine tribute to the United States Marines.[32]

As receipts picked up, logistical arrangements finally began to fall into place. The Foundation had a new site—the twenty-seven-acre Nevius Tract directly west of Arlington Cemetery. Since the end of the war, the open land had been coveted by a variety of interests seeking to use it for a carillon, a parking lot, more graves, or a monument to the "Five Freedoms" (Eleanor Roosevelt's pet project). By agreeing to share the tract with the carillon, the Marines seized the disputed territory from its rivals: with the help of savvy friends on the Hill, the authorization sailed through Congress as a rider attached to an appropriations bill. Congress, by special action, also lifted the existing tariff on black Swedish granite so de Weldon could have a pedestal alluding to the black sands of Iwo Jima.[33] The ill-fated Jaquet site plan was abandoned in favor of a simple, natural setting with nothing to distract the eye from the statue, looming above the Potomac. On the ninth anniversary of the now-legendary invasion of Iwo Jima, the directors of the Foundation gathered at the Nevius Tract to break ground for the monument. Lemuel Shepherd, just promoted to Commandant of the Corps, helped to turn the first shovel of earth. It was

Breaking ground for the Marine Corps War Memorial, on February 19, 1954. Left, Major General Merritt A. ("Red Mike") Edson. Right, General Lemuel C. Shepherd, Jr., Commandant of the Marine Corps.

February 19, 1954, and the long, hard task of commemorating the battle was almost done.[34]

De Weldon had almost completed his part of the work, as he stood on the platform behind the generals that day. In 1953, he had finished the enormous plaster and then cut it into 140 manageable pieces, which his crew delivered to a foundry in Brooklyn. At the Bedi-Rassy Foundry, metalworkers made molds of each section, cast them in bronze, and then "chased" or ground down each surface with an electric finishing machine. After the irregularities had been smoothed away and the highlights incised in the metal, the components were welded together into figures and parts of figures, calculated to fit on flatbed trucks. On September 2,

The surface of a cast bronze torso being "chased" at the Bedi-Rassy foundry in Brooklyn.

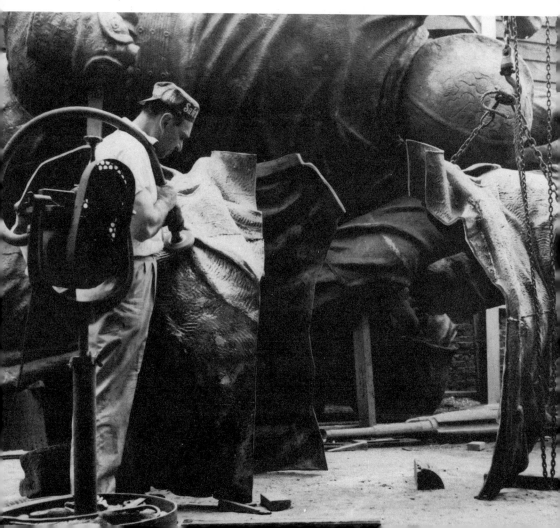

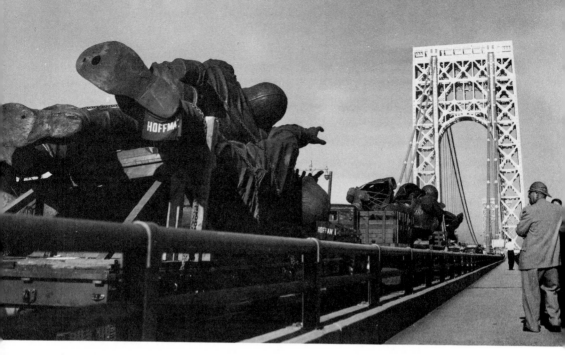

The statue caravan crosses the George Washington Bridge.

1954, at 6:45 A.M., a caravan of three tractor-trailers loaded with a hundred tons of statuary bronze pulled out of Brooklyn and threaded its way through the narrow streets of New York City, bound for the river. The curious lined the sidewalks. A CBS camera crew, another from Fox Movietone News, and still photographers from *Life* and the *Herald-Tribune* dogged the convoy to the George Washington Bridge. Guided by police escorts, the strange caravan headed south through New Jersey. Once, a low overpass mandated a fifty-mile detour: weaving through small towns, cheered by startled locals, the procession finally limped into Baltimore long after dark. The next morning the colossal men of Iwo Jima rolled past the nation's most hallowed monuments, lumbered across Georgetown's Key Bridge, and came to a halt at the Nevius Tract, where the last great Marine flag-raising would soon take place.[35]

For the next two months, workmen labored to finish the base with its elegant golden letters. The immensity of the statuary Marines who lay in segments on the grass captivated everyone. Tourists took snapshots. The papers ran pictorial spreads showing tiny children cradled in huge metal hands and local beauties stroking the manly cheeks of bronze leathernecks the size of Sherman tanks. Cranes hoisted the figures into the air, where

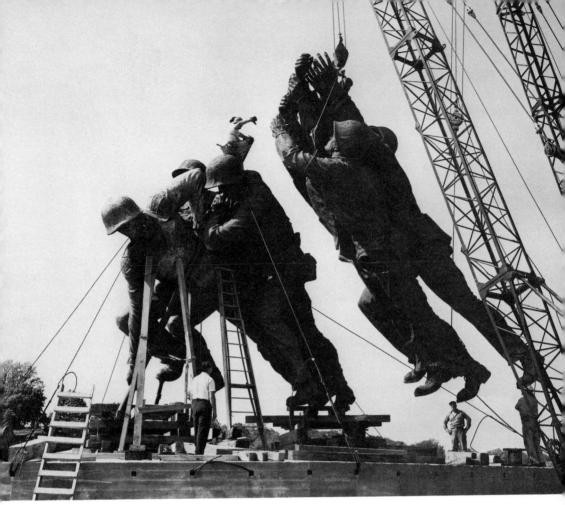

Cranes hoist two colossal flag-raisers into position.

they hung like flying Supermen, silhouetted against the sky. Once atop
the pedestal, the sections were bolted together: workers did it from the
inside, crawling around the hollow innards, popping out comically through
a belt or a sleeve. Rough granite chunks were set beneath the gargantuan
boots, transforming the base into a miniature Suribachi. Finally, the scene
was finished off with a seventy-eight-foot flagpole.[36]

As November 10 grew nearer, gardeners pruned and planted, grounds-
keepers set up rows of folding chairs, planners juggled seating charts, and
dignitaries, or their secretaries, blue-penciled drafts of speeches. The pub-
licity machine moved into high gear. The Foundation's daily press releases
supplied the requisite details about the statue and the heroic deed that
had inspired it. Despite passing references to a first, "small flag" and Lou

Lowery's picture of it, however, the official story aimed for coherence by eschewing all narrative ambiguity. The definitive Memorial Foundation "fact sheet" baldly stated that what had "thrilled" Marines on Iwo Jima at 10:35 A.M. on the fateful morning was what appeared in Rosenthal's photo—and in the statue rising above the Potomac.[37]

In the midst of this last, big publicity push, the Marine Corps released a promotional film—*Uncommon Valor*—about the statue. Packed with romantic images of the sculptor standing dreamy-eyed before his model, the movie also hewed to the line set out in the Foundation's version of the myth of Iwo Jima. Rosenthal's was the only flag-raising and the "most dramatic incident of any war." The raisers about to be fixed in memory forever by the giant bronze effigy became an object lesson in American diversity and democracy. Hayes: a "Pima Indian from the broad plains of Arizona." Bradley: a "student from the dairylands of Wisconsin." Gagnon: a "mill-worker from the hills of New Hampshire." Strank: a "son of Czechoslovakian immigrants . . . from the Allegheny Mountains of Pennsylvania." Sousley: a "war-worker from the fertile tobacco lands of Kentucky." Block: a "truck driver from the rich oil fields of southern Texas." Six Americans, six randomly chosen soldiers, stood for "the indomitable courage of our fighting men."[38] An epic image—a picture, now a monument—became a "great moment" in a new, improved, and rewritten American history.

The Marines raised the flag again on dedication day—November 10, 1954. They did so before a vast, public audience brought together by television and fevered reporting. The sheer pageantry of the day—the uniforms, the bands—led the *New York Times* to dredge up the old plan to unify the armed forces and label it absurd in the face of the pomp and circumstance of the occasion. The "New Breed," the modern Marine Corps, confident and proud, revealed itself in all its splendor as it unveiled the statue. Marine heroes adorned the podium, men like Vandegrift, Rockey, and old General Smith. The presence of national leaders—Ike, Nixon, and their retinues—sealed the triumph. Gagnon, Hayes, and Bradley watched it all from the front row, marveling, perhaps, at the mighty consequences of the least of human actions. As the sculptor droned on about the "accuracy and realism" of the scene before them, far in the back—in the unreserved section—Lindberg and Lowery, Schrier and Michaels sat together, forgotten, and wondering, perhaps, what "realism" really meant. It did not mean truth.[39] For just as the Marines had conquered Iwo Jima in 1945, realism had conquered reality on this autumn morning in 1954.

★★★★★★★★★★★★★**9**★★★★★★★★★★★★★

Everybody on the island knew it was a phoney . . . Guys all over the island were laughing about the phoney flag-raising picture.

Lines spoken by the actor playing Ira Hayes in the 1960 TV drama *The American*

It Didn't Really Happen That Way

Ira Hayes never got over the dedication of the Marine Corps War Memorial—the probing questions, the photos, bad memories of the bond tour, buddies with whom he no longer seemed to have much in common, too many drinks. Steered to the airport by a solicitous Marine escort, he shucked his borrowed topcoat, went back to the reservation, and tried to blot it all out again. One cold January night a few weeks later, Hayes turned up at a penny-ante poker session in an abandoned adobe hut not far from his parents' home. While his brothers played cards, he sat in the corner, cradling a half-gallon of muscatel, and cried. A little after midnight, he went outside to relieve himself. They found Ira Hayes the next morning, frozen on the desert sand, one hand outstretched in a gesture of supplication or despair, not much different from his reaching pose in the big statue in Washington. He was thirty-two years old.[1]

The coroner's verdict: exposure and chronic alcoholism. The truth was that Hayes had fallen on his face, thrown up, and drowned in his own vomit.[2] But the papers didn't print the brutal facts. The laundered version of things was bad enough, where a national hero was concerned. The most that could be salvaged from the story was pathos, the lonely end of a drinker and a bum set off in tacit contrast with the good life Americans had come to expect in 1955—big family cars with tail-fins, ranch houses in pastel colors, color-coordinated appliances, ease and comfort. And in

Ira Hayes's grave, Arlington National Cemetery.

death, Ira Hayes finally attained the trappings of material success denied him in life. He got a fancy casket, honor guards, tributes from governors and generals, banks of flowers, fleets of black Cadillacs in slow procession, no fewer than three splashy funerals, the most lavish military burial since the interment of the Unknown Soldier.[3]

The first of the funerals was held in the little Presbyterian church on the reservation. The second was in the rotunda of the Arizona capitol building. Hayes's body lay in state for a day, attended by young Indian Marines in uniform. The legislature recessed; the governor asked Arizonians to observe a moment of silence in honor of the state's "First Citizen." Afterward, the Marine Corps offered to ship the body to Arlington National Cemetery by train, along with two relatives (four, if the party went by transport plane), but the Hayes family lacked the wherewithal to pay expenses along the way. Friends passed the hat, lest Ira Hayes make his last trip to Washington alone, for the biggest funeral of them all. As congressmen introduced hasty legislation assigning special gravesites and headstones to the Iwo Jima heroes, a canvas marquee was set up over plot 479A in Section 34, close to the spot where "Black Jack" Pershing was buried. Protection from the snow that stopped falling as the burial party finally labored up the knoll, the tent was jammed with mourners and with reporters asking them to comment on the tragic death of a hero who, in the words of a cop on the Phoenix wino detail, "was a hero to everyone but himself."[4]

Felix de Weldon stood in the snow, lost in thought; he had nothing to say. But Rene Gagnon did. Gagnon had wanted to come to the funeral, had worried over whether it might be out west, too far away for him to make the trip. He made a good picture, standing at doleful attention in a dark overcoat, dropping white carnations, one by one, on "the Chief's" casket, standing alone at the Memorial, gazing up at the giant bronze likeness of his friend. "He wanted to live in a white man's world," said Gagnon, "but he ran into difficulties as an Indian": "He saw the world . . . Later he went on war bond drives and stayed at the best hotels. Afterward he just couldn't go home and he wasn't always happy in the other world." "He was great guy—a modest guy who didn't like the spotlight."[5] The other players in the ongoing Iwo Jima drama seemed less interested in the Indian standard of living than in Hayes's innermost feelings about the war, his reaction to being a hero. Reached by phone at his home in Wisconsin, John Bradley called Hayes "truly a war casualty." Contacted

in San Francisco, Joe Rosenthal could only agree: "There was no secret about his drinking, but I think it was a psychological quirk. It had something to do with his position as a hero after the war. He told me he was getting credit for a lot of things that other men deserve[d]."[6]

A full-page ad appeared in the *New York Times* the morning after Ira Hayes was laid to rest on a rise above the Iwo Jima Memorial. "Being Sorry For Ira Hayes Is *Not Enough*," read the headline identifying one of

Monument to Ira Hayes in Bapschule, Arizona; the plaque misdates the battle by a year.

his last photos, taken at Arlington in November. Hayes looked bloated, tired, unfocused. According to the copy, Indians everywhere were "dispossessed, exploited, neglected and forgotten." Funds were needed.[7] The charity that placed the ad failed to receive enough donations to pay for it. The plight of the Indian was not of special interest to those who followed the long and tragic story of Ira Hayes in the nation's press. Yet Ira Hayes and the manner of his dying were. What did his story mean? What had tormented the man? Why did a hero have to die that way?

But life went on. The movie *Battle Cry* opened in Washington the day of the funeral. World War II movies seemed as popular as ever in a perilous and warlike world: in March, Soviet Marshal Zhukov signed the Warsaw Pact, pitting the Eastern Bloc against the United States and her NATO allies. The Marine Corps, still smarting from the adverse publicity surrounding Hayes's death, faced a worse crisis in the spring of 1956. That April, a Parris Island drill instructor took his platoon on an unauthorized night march. Six recruits drowned in Ribbon Creek. Tarawa hero David Shoup was brought in to investigate boot-camp procedures, and the ensuing court-martial put the spotlight on Marine methods and the whole cult of manliness. What about the Pima Marine, Ira Hayes? His name always came up, somehow, when the Marines made the papers. Had Ira Hayes been tough enough? Or had he felt things too deeply? Senator Paul Douglas of Illinois, haunted by the lonely death of the Iwo Jima hero, had written to a friend of his, a published author, suggesting a second look at the Hayes story. It "reveals some of the good things about us as a people —" Douglas thought, "how we usually mean well—but it also shows some of our mistakes."[8]

The senator's correspondent went to Arizona to do first-hand research and negotiated a deal with Nancy and Joe Hayes for the film rights to their son's biography. But others were also working on the Ira Hayes tragedy, with an eye toward a dramatic presentation of the facts. In November 1959, the NBC television network formally announced that production was beginning on a new hour-long segment of the *Sunday Showcase* series: a program on the life and death of Ira Hayes, it was called *The American*.[9]

In many ways, the show was an unusual one. Both the network and the sponsor committed funds far in excess of the normal budget. The producer, Robert Alan Aurthur, an ex-Marine and a veteran of Iwo Jima, took a keen personal interest in exploring the issues raised by the Hayes case in

a "quality" show. He brought in the Hollywood director John Franken-heimer, the West Coast's current "wonder boy." And Frankenheimer, in turn, decided to tape the script entirely on location, the first time a one-hour weekly teledrama had received such treatment. With the TV star Lee Marvin, another former Marine, signed for the lead role, the company moved first to an abandoned gravel pit outside Stony Point, New York, to shoot (on the fifteenth anniversary of Iwo's D-day) a key scene in which Hayes/Marvin recreates the flag-raising in Hollywood, in *Sands of Iwo Jima*. Then the crew went out to Arizona, to film the rest of story on the Pima reservation.[10]

In Arizona, NBC's oral pledge of cooperation from the Pimas fell apart as soon as tribal leaders saw the script. Charging that they had been duped by the network—"Ira Hayes was supposed to be an incidental part of the show, sort of a drawing card," the bill of particulars stated—the Pimas barred the crew from their lands and assembled a delegation to go to Washington and testify before a House committee then investigating irregularities in the broadcast industry. "It doesn't matter if [Hayes is] a lovable drunk or a disgusting drunk," read a petition of protest to the Secretary of the Interior. "He's still just another drunken Indian. The tribe feels this is not a true representation of the man." Although Aurthur defended the script as an accurate picture "of a man who is symbolic of a large segment of the population . . . a victim of society," he prudently moved production to Tucson and the Papago reservation, mollified by the discovery of a jail where Hayes had done a short stretch and a bar he had frequented. Tucson meant no expensive set construction and a pungent, documentary feel—the breath of authenticity the company had come west to find. If a regiment of designers worked for six months, exclaimed the delighted producer, "they couldn't reconstruct the reality that went into that barroom!"[11]

According to NBC, the fuss with the Pimas was all Hollywood's doing. William Bradford Huie, the writer who had tackled the Hayes story at the urging of Senator Douglas, had indeed finished his research and had recently sold the idea to Universal-International. To protect its property against overexposure on television, the studio purportedly hired the chief of the Pimas as a technical advisor for the forthcoming movie, on condition that Frankenheimer and Aurthur be prevented from filming on the res-ervation. Huie, on the other hand, painted NBC as the villain. On March 22, less than a week before *The American* was due to air, he took the

network, the producer, the director, and the scriptwriter Merle Miller to court, charging violation of his copyright on particular facts in the life of Ira Hayes and demanding an injunction preventing the program from being shown.[12]

Judge Edward Dimock studied the script and a side-by-side comparison between certain lines and selected "facts" that Huie claimed to have discovered or subjected to distinctive literary treatment.[13] He read depositions. He went to NBC for a private preview of the finished product. On March 25, a Friday, he ruled that *The American* could go on as scheduled, that Sunday night, in prime time. Huie thought that he had been done in by a squad of high-priced corporate lawyers; the show, he said, was a "cheap 'quickie,' dreary snatches of footage sandwiched between commercials for Sweetheart soap and Beads o' Bleach."[14] Miller was understandably relieved. But the papers filed by both sides with the U.S. District Court in New York show just what was at stake in the judicial action. Fifteen years after the end of the war, people were still curious about the Rosenthal photograph and the men who appeared in it—especially Ira Hayes. Iwo Jima was a hot property.

Miller's affidavit to the court decribed his many inquiries about the flag-raising picture after he first saw it in the Paris edition of *Stars and Stripes;* years of following news stories about Hayes; protracted discussions about potential scripts and articles throughout the 1950s. The plaintiff's submissions detailed a similar record of fascination with the flag-raising and its aftermath. But those whom Huie approached with his story treatment—Paramount, Elia Kazan, Josh Logan, the big magazines—backed off when the time came for signing on the dotted line. The Ira Hayes story was "too depressing," they complained, or "too real" or "too offbeat." Film producers wanted a more "upbeat ending." The studios, in fact, wanted assurance of Pentagon cooperation, without which a war picture—tanks, uniforms, ordnance, locations, and all—could not be filmed at a reasonable profit. And, throughout the 1950s, the Marine Corps remained stoutly opposed to any movie about the errant Ira Hayes.[15]

Marine concerns about dredging up the Hayes story were not ill-founded. Although the TV crew's remarks to the Arizona papers strongly suggested their show would address prejudice against Indians, *The American* was actually an exposé of deliberate fraud on the part of the Corps, a scheme to dupe the American public into believing that a brave and noble deed had transpired atop Mount Suribachi when, according to the

show, just the opposite was true. The Rosenthal picture was a "phoney." There were no Iwo Jima heroes, only fakes and humbugs. The very concept of heroism smacked of a big lie, a yarn spun by the cynical to delude the gullible. Ira Hamilton Hayes, in his reincarnation on NBC, was driven to an early grave by the shame of telling lies at the behest of his military superiors.

The climactic scene came in the second act. Hayes, befuddled with drink, is out in Hollywood, trying to raise the flag on the set of *Sands of Iwo Jima*. Hollywood stands for illusions and deceit, and as the director suspends shooting, to give his star time to remember how to perform the deed that made him famous, Hayes spills his story to an actor playing one of dead flag-raisers. "I didn't carry any flag—Never!" he sobs:

> They'd already took about ten thousand pictures that day . . . and you said —Ira, we might as well get in one of these—So I went with you—Everybody on the island knew it was a phoney—Didn't they, Nick?
>
> When that Colonel flew all the way out from Washington, D.C., and said he was going to take us guys that were in the picture back for some war bond drive . . . I said no, Colonel, I hadn't had anything to do with raising any flag—I was just in the picture that's all. The Colonel—he said— . . . I know it's just a picture, Chief—but to everybody back in the States—you're a hero—and he said it didn't really matter—All that picture is is a symbol of all the guys that were on this island . . . He said—Chief, as far as I'm concerned—every guy on the island was a hero.

Whenever Hayes remembers the lie—"I can't go around for the rest of my life letting people believe I did something I didn't do," he tells the Colonel—he gets drunk, and whenever he gets drunk, he confesses, all over again: "That flag-raising picture was a phoney I am a phoney." Ira Hayes dies alone in the cold, telling an imaginary colonel that he won't raise the flag any more.[16]

The production team must have anticipated adverse reaction to the demolition of a national icon. A postscript, spoken by an anonymous announcer over the credits, piously noted that Hayes's "personal feelings" should not "detract in any way from the famous flag-raising picture in which he figured": "The photograph, which shows the second actual flag-raising on Iwo Jima, was made within hours after the first flag was raised. It will always endure as a symbol of the valor of the United States Marines."[17]

It is also clear, however, that the illegitimacy of the symbol was the

Ira Hayes and the flag-raising were big box-office after the Indian's death. Marine veteran Lee Marvin played Hayes on television in 1960.

point of *The American* as the principals understood it. Interviewed by *TV Guide* during New York rehearsals, for example, ex-Marine Lee Marvin bewailed the fact that Hayes "never could escape being a hero" after he followed orders and shouldered the burden of the Marines' guilty secret. Merle Miller described the Rosenthal photo—"the most familiar symbol of American victory"—as a Marine publicity stunt. *TV Guide* asked Joe Rosenthal to comment on the situation, and for once his chipper honesty played him false. Of course there were two raisings. Yes, they wanted a bigger flag. Sure, they told me when it was going up and I just stepped

back and snapped the picture! But by admitting that his picture did not depict a one-of-a-kind event—by acting on the premise that the existence of two raisings was already widely known—the photographer seemed to support the notion of some dark Marine conspiracy to suppress word of a first flag. Truculent and defensive in denying that *his* picture had been posed, Gagnon, too, acknowledged a second raising. In the retelling, it sounded as though alarming new information had just been dragged out of him.[18] A sensational scandal was in the making.

Sunday Showcase ended at 9 P.M. on the East Coast. Monday morning's papers contained a sharp statement from the Associated Press, deploring the use of the word "phoney": "Rosenthal did not pose the men," a representative insisted, "nor did he suggest that the Marines raise a second Flag." Holland Smith issued a terse statement of his own: "It was no fake!" Joe Rosenthal publicly contemplated a slander suit.[19] But reviewers were quick to seize on the issue regardless. Some simply described the program, treating the dramatic explanation of the photo as fact, revealed for the first time on national television. The documentary format of the show and the "stark vividness" of Marvin's performance invited such conclusions, wrote the TV columnist for the *New York Times.* All the disclaimers in the world would not dispel a "coast-to-coast" impression to the contrary: the picture was a fraud and so was the Marine Corps Memorial in Washington.[20]

Only the *Arizona Daily Star,* indignant over the posthumous exploitation of a native son, denounced *The American* for passing off blatant untruths as documentary facts. The *Star* traced the Rosenthal rumors back to the *Time* broadcast of 1945 and left the last word on the authenticity of the picture to Ira Hayes, recounting his moment in the spotlight to a fellow Marine, on a troopship bound for home: "We then tied it down. Then a Marine hollered over to us and said our picture was taken. About twenty yards away we saw Joe Rosenthal and a couple of photographers. We didn't know they were taking our picture."[21]

The American was a nine days' wonder. But, although the controversy blew over quickly enough, the notion lingered that there was some funny business involved with the picture, something wrong with the whole flag-raising deal. In time, the disclaimer was forgotten. The taint of scandal never was. Why the nation should have been susceptible to a pseudo-exposé in 1960 is not hard to fathom. NBC, which had employed the quiz-show winner Charles Van Doren as the resident intellectual of the *Today*

show, was embroiled in a major scandal of its own during production of *The American.* In October 1959, Van Doren confessed before a House committee looking into quiz shows that he had been given the answers beforehand. NBC fired him—and network commentators and editors preached dire sermons on the state of American morality. With a presidential aide recently forced from the White House for accepting a vicuña coat from a favor-seeker and a New York congressman under indictment for tax evasion, the moralists found ready ammunition for essays on the paralysis of the national conscience. "On all levels American society is rigged," an anguished John Steinbeck wrote to his friend Adlai Stevenson. "I am troubled by the cynical immorality of my country. It cannot survive on this basis." *The American* traced the poison back to World War II, to a war that hadn't brought the peace and justice and universal prosperity the politicians promised. By exposing the lies and the deceptions, *The American* made Ira Hayes a symbol of a new moral fervor, a crusade to right the wrongs of which—on TV anyway—he was a pitiable victim.[22]

He was a victim of prejudice in the movies. *The Outsider* took up the cause of racial injustice in the name of Ira Hayes, although the producer, Sy Bartlett, had probably not anticipated that slant when he bought Huie's version of the story and applied for technical assistance from the Marines in 1959. A former Air Force officer—wartime aide to General Spaatz, intimate of General Le May—Bartlett had made his reputation on war movies, including *12 O'Clock High,* and his hand-picked director, Delbert Mann, had also served on Hollywood's battlefields.[23] Bartlett's credentials, in any case, overcame Marine reluctance to see the story raked up again, and Universal-International was given access to Camp Pendleton for the $2 million production. But the NBC suit and the subsequent showing of *The American* argued against a strong military emphasis in the movie. If the film (then called *The Sixth Man*) was to find an audience, screenwriter Stewart Stern needed to come up with a fresh angle on Hayes, a narrative line distinct from the flag-raising revelations that had recently titillated home viewers.

When filming began in the late summer of 1960, on the fringes of a subdivision in the San Fernando Valley, Bartlett was still deeply enmeshed in the logistics of getting the flag up Mount Suribachi. Two hundred college football players—extras in Marine green—milled around a hill seared into a rough approximation of the original site. Tony Curtis, in dark makeup and a false nose, stretched out in the dirt between takes,

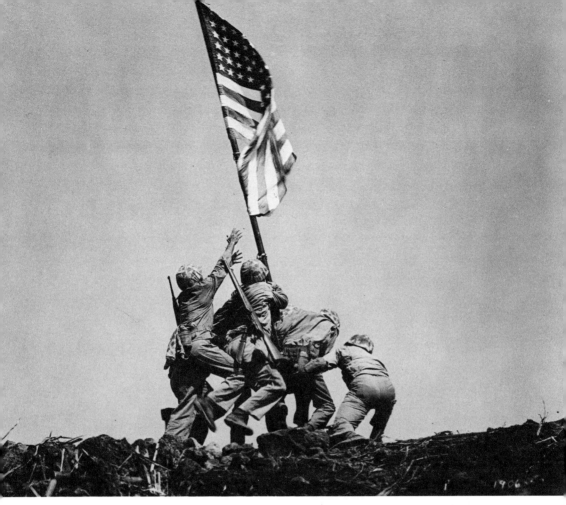

The flag-raising was the centerpiece of *The Outsider* (1961), starring Tony Curtis.

getting "into" his character (like Marlon Brando, who had once considered the role). Mann studied letters from Gagnon and Bradley and rehearsed the scene over and over again, guided by photos by Lowery, Campbell, Rosenthal, and Genaust. "There have been a lot of misconceptions about the flag raising," Bartlett told visitors to the set. "We're going to set the record straight. We'll show it exactly as it happened."[24]

By the middle of October, with Mount Suribachi and the boot-camp scenes filmed at Camp Pendleton behind him, Bartlett disclosed a major shift in focus. "We've de-emphasized the war," he said. "There are only seven pages of war in the script." The revised story instead described the

tragedy "of an Indian boy exposed to the white man."[25] And, in the opinion of the critics who saw the retitled product early in 1962, *The Outsider* had suffered for it. What they liked about the picture was the big Marine scenes, in which the actors seemed to walk in and out of newsreel coverage of the battle, the dedication of the Memorial, or the frenzy of a bond rally. The civilian segments and the attempted linkage between Hayes's problems and white society were thought less successful. One commentator was mystified by the "foggy psychological innuendo" used to explain Hayes's descent into the bottle. Another noted the lack of motivational "clarity" and a disproportionate stress on the friendship between the hero and a pal killed on Iwo Jima, a relationship that was portrayed as the trigger for Hayes's ultimate downfall.[26]

The critics had a point. The plot makes much of Hayes's isolation from the other recruits, he timid, they casually cruel in the use of clichés about

In *The Outsider*, the heroes return to the United States and are swallowed alive by the publicity machine.

In the Hollywood version, the major temptations of the bond tour were women
and booze.

papooses, scalping, and yelling "Geronimo!" When he finds a buddy—
"You're the first white man that was ever my friend," Ira blubbers—he is
a clean-featured, blue-eyed blond named Sorenson (James Franciscus)
whose appearance is as different from that of the hatchet-nosed, coffee-
colored Hayes as the makeup department could contrive. Sorenson's death,
in the foxhole the two men share on Iwo Jima, is evoked constantly
thereafter.[27] Because he dies as the pair make their way back to head-
quarters for the message that summons Hayes to the bond tour, Sorenson
also carries the burden of the hypocrisy theme Merle Miller had attached
to the Marines. Every time Hayes hears the word "hero," he thinks of
Sorenson and sinks deeper into despair. While the friendship is drawn too
sketchily to justify Hayes's excessive and protracted bouts of retrospection,
the visual contrast between the Anglo-Saxon and the man of color creates
an effective introduction to the film's clearest and least ambiguous theme:
the sharp division between white and "colored" in American society.

A profoundly visual film, *The Outsider* works by pictorial means, to
which dialogue and plot are often subordinate. Ira Hayes lives in a black-
and-white world. In the Marine Corps, he stands out in a sea of white
faces. Seated alongside a creamy blonde at a bond luncheon, Hayes recoils
in horror as she flirts with him by pouring dark fudge sauce on a replica
of the flag-raising executed in vanilla ice cream. The white world is lushly
luxurious: Hayes's hotel room in Washington is a riot of satin draperies,
swags, and crystal chandeliers. The reservation is barren and poor, his
mother's house adorned with pictures cut out of the newspaper and a
cheap plaster plaque of the raising, with a miniature flag attached to a
tiny wooden pole.[28] The two parts of America are separate and unequal.
Inasmuch as Sorenson once helped to bridge the gulf between them,
Hayes's immoderate grief may, perhaps, seem more understandable, but
the gulf itself yawns at the heart of the movie, in every room and crowd
the viewer sees.

The obvious correlative for the film's message is the civil rights move-
ment: sit-ins at southern lunch counters, Martin Luther King's march on
Montgomery, and bloody race riots in Biloxi all punctuated the period
when *The Outsider* was under production. But there are also eerie echoes
of Ira Hayes's own abortive career as a spokesman for racial minorities.
In 1947, for example, he spoke at a Hollywood rally condemning housing
discrimination against Indians, recently designated "non-Caucasians" by
a state court.[29] In *The Outsider,* the drunken Hayes finds ready acceptance

The heroic deed, in vanilla ice cream. This is a production still. In the movie, the blonde douses the flag-raising with hot fudge.

only in a black nightclub, among outcasts and "outsiders" like himself. Like the African-American freedom marcher of the 1960s, Ira Hayes has been stereotyped and dismissed because of the color of his skin.

A more gung-ho movie would probably have done better at the box office in 1962, with Kennedy squaring off against Khrushchev, 16,000 American

Hayes/Curtis finally cracks at a big Chicago bond rally.

The mythologizing of Ira Hayes took many forms in the 1960s, when Joe Ruiz Grandee's painting showed the hero as an ancient Pima warrior.

military "advisors" bound for Vietnam, and the Cuban Missile Crisis in the offing. As it was, the picture bombed: in its fifth week in Los Angeles, the gross was $3,100. Universal reneged on a promise to fly the Hayes family to the premiere in Washington, and the model of the Iwo Jima Memorial gathered dust in the lobby of the Metropolitan Theater until late in March, when the film quietly disappeared, leaving another layer of half-remembered folklore on the legend of Ira Hayes, "phoney" hero, Indian, drunk.[30]

In an album of protest songs recorded in March 1964, Johnny Cash added the final touches. "Call him drunken Ira Hayes/ He won't answer any more," Cash growled over a faint wail of taps, sounding in the distance. "Not the whiskey-drinkin' Indian/ Nor the Marine that went to war." And "The Ballad of Ira Hayes" began:

> Ira Hayes returned a hero
> Celebrated through the land
> He was wined, and speeched, and honored,
> Everybody shook his hand.
> But he was just a Pima Indian
> No water, no home, no chance
> At home nobody cared what Ira'd done
> And when did the Indians dance?[31]

Throughout the 1960s, retellings of the Hayes story kept up interest in the other Iwo Jima heroes. The "Mystery Guest" on *To Tell the Truth* in 1960, Joe Rosenthal was identified in the finale of the popular TV game show by a beaming Rene Gagnon. In the absence of Bradley, who removed himself from the public eye after the dedication of the Memorial, Gagnon became the last link with the Suribachi icon. Accordingly, he was much in demand; to Gagnon, a living symbol of World War II, clung the nebulous cluster of memories and feelings Rosenthal's photo and its progeny now summoned up. He rode in parades, dedicated veterans' hospitals, cut ribbons, shook hands with presidents and generals, gave interviews in which the Japanese fire grew heavier and the resistance fiercer as the years rolled on. In 1962, on the seventeenth anniversary of the bond tour, he recreated the flag-raising in Times Square once again, for a Marine recruiting drive. The Marines, he said, had made him aspire to something better than a dead-end factory job in civilian life. After years of moving around the country looking for the right position, Gagnon was now an agent for Northwest Orient Airlines in Manchester, New Hampshire.[32]

In 1965, he won a company contest that gave him a ticket to any place along the route—and went back to Iwo Jima, twenty years after he had helped to raise the flag there. With his wife and son in tow, Gagnon arrived on the island to find anniversary observances in progress. The first man he met was Master Sgt. Andrew Zihor of Brownsville, Pennsylvania, still a Marine, the man who had sent him up Suribachi with a flag and a load of batteries. En route to the island, the Gagnons had stopped in Tokyo and attended a reunion of Japanese widows and survivors of the

battle. They brought with them to Iwo Jima a floral offering in memory of the Japanese dead, sent by Mrs. Kuribayashi. The whole experience left Gagnon shaken. All he could say when pressed by the reporters was "Unbelievable! Unbelievable!"[33]

Things went sour after that. An airline merger meant a transfer to Atlanta or termination: Gagnon lost his job with Nothwest Orient. He worked for his wife's travel agency, managed a motel at night, and drank sometimes, when the mood hit. Reporters still came around for interviews on patriotic holidays, and Gagnon, on a bad day, could be eminently quotable, hinting that the Marines had "hushed up" the first flag-raising, railing against the injustice of hero-dom in America. "You live like a king" on a bond tour, he complained, "and then you're broke when you

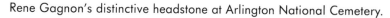

Rene Gagnon's distinctive headstone at Arlington National Cemetery.

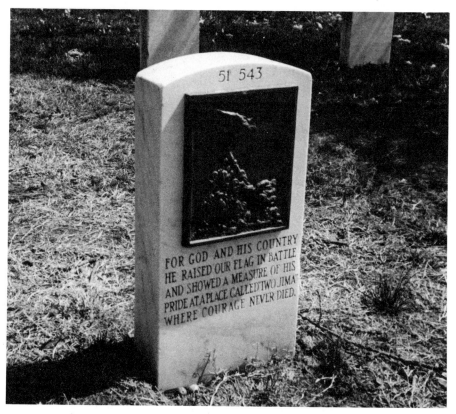

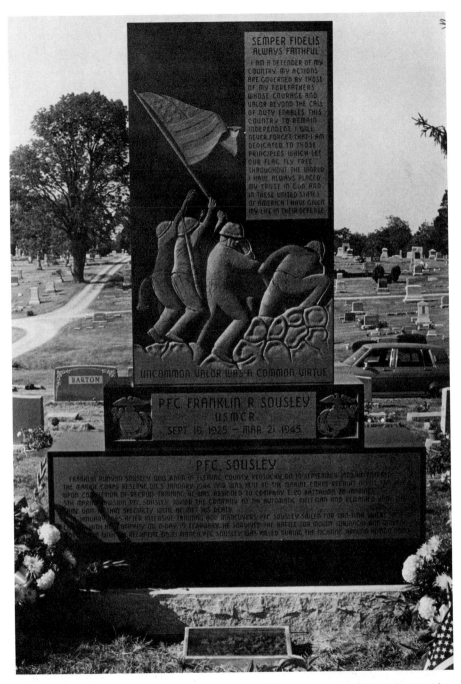

UNCOMMON VALOR WAS A COMMON VIRTUE

PFC. FRANKLIN R. SOUSLEY
USMCR
SEPT. 19, 1925 – MAR. 21, 1945

PFC. SOUSLEY

Other heroes of Iwo Jima were honored, too. This monument to Franklin Sousley was dedicated on February 19, 1984, in Fleming County, Kentucky.

come back." The *Concord Monitor* caught him at a low ebb during Memorial Day weekend in 1978. The family later maintained that his words had been taken out of context, but in the article Gagnon emerged as a problem drinker who couldn't hold a job. Worse yet, the motel sounded like a house of ill-repute and Gagnon confessed to turning off the "vacancy" sign some nights, in sheer disgust. He was fired as soon as the paper hit the streets. It was Memorial Day and nobody, apparently, remembered what Rene Gagnon had done back in '45. "I suppose to them, it's just another day," he said as he crumpled the pink slip from the owners of the Queen City Motel. Coast to coast headlines—"Iwo Jima Hero Fired"— only made things worse. According to the reports, the Gagnon mess was the familiar story of Ira Hayes all over again.[34]

Rene Gagnon died in 1979 in the boiler room of an apartment complex

The Sousley memorial replaced a more modest highway marker erected on Memorial Day, 1965, in the Elizaville Cemetery. Sousley's mother stands at the right.

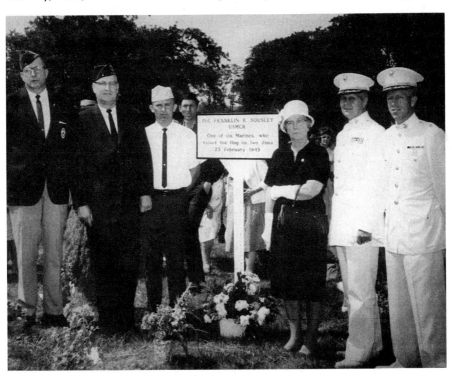

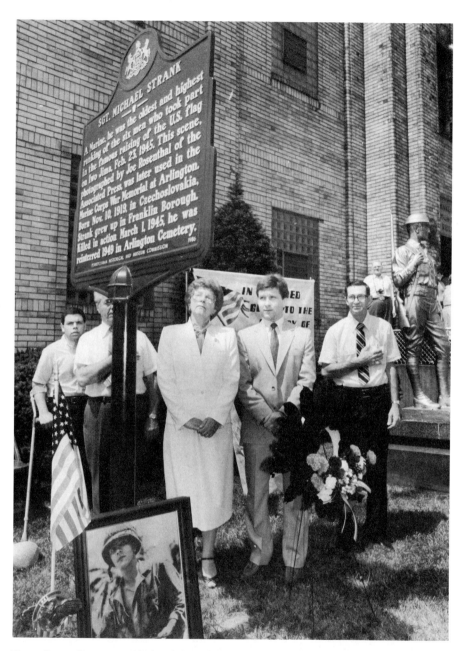

Mary Pero, Sergeant Michael Strank's sister, and his nephew Thomas, at the unveiling of a Strank memorial, Johnstown, Pennsylvania, May 18, 1986.

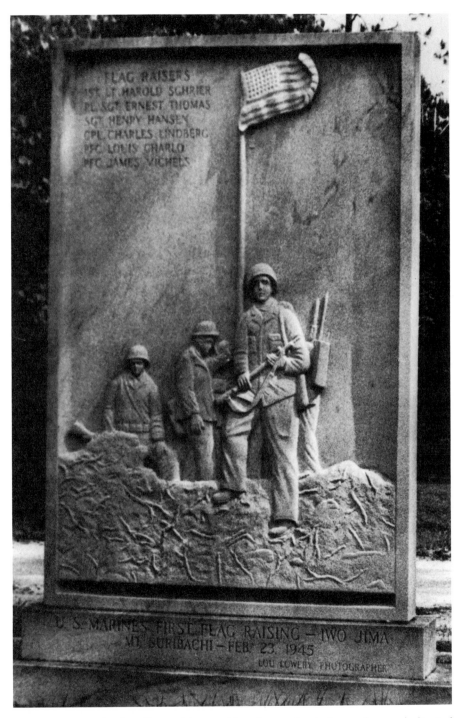

FLAG RAISERS
1ST LT. HAROLD SCHRIER
PL. SGT. ERNEST THOMAS
SGT. HENRY HANSEN
CPL. CHARLES LINDBERG
PFC. LOUIS CHARLO
PFC. JAMES MICHELS

U.S. MARINES FIRST FLAG RAISING — IWO JIMA
MT. SURIBACHI — FEB. 23, 1945
LOU LOWERY PHOTOGRAPHER

A monument to the first flag-raising and Lou Lowery's photograph was dedicated on February 22, 1981, in Monticello, Florida, home of Boots Thomas.

in Manchester, New Hampshire. He was the maintenance man. The tenants said he was reliable, cheerful. Obituaries dredged up the previous year's dismissal and the reasons for it. He was buried in Arlington, but only after a long delay: under new rules in force there, Gagnon hadn't been in the service long enough to qualify. The Marine Corps had to intervene on behalf of another tarnished hero. Gagnon's headstone, set in place in 1981, was different from the others. On the back, in low relief, was the famous picture, with Gagnon, the third man in line, raising the Stars and Stripes over Iwo Jima.[35]

On February 22, 1981, on a plot of land adjacent to a nursery in Monticello, Florida, another relief sculpture was dedicated. A memorial to Boots Thomas and his patrol, this eight-foot slab pictured Lou Lowery's photograph of the first flag going up atop Mount Suribachi.[36] Chuck Lindberg came all the way from Minneapolis for the occasion; he was the last surviving member of that lost detail which, since 1960 and *The American,* had gradually reattached itself to the story of Mount Suribachi. In contrast to the heroic image on Gagnon's tombstone, the Lowery picture was a graphic reproach to phony heroes, cover-ups, military myths, the sort of bogus facts that ultimately blighted American support for the Vietnam War. Now, thirty-six years after the two pictures were snapped, with Hayes and Gagnon dead and Bradley incommunicado, history could be rewritten at last, the record set straight.

Sara Revell, Ernest Thomas's once-upon-a-time sweetheart, came to the ceremony, still bitter over the obscurity to which Thomas had been consigned and scornful of "the men who raised the second flag [and] got all the glory." But others in the crowd of three hundred gathered in the warmth of a Florida afternoon believed the time for rancor was over. An era had passed with the passing of Hayes and Gagnon. Memories—even bitter ones—were fading and with them, a sense of what it had meant, that long-ago war in the Pacific, and what it might mean to those who knew it only from stories and movies and monuments. "If we, the people of his generation, didn't do it," said a boyhood friend of Thomas's, who spearheaded the memorial campaign, "I'm afraid nothing would be erected at all."[37]

Souvenir models of the Marines' monument to their triumph over the Japanese at Iwo Jima are proving to be big sellers . . . Nobody seems to mind that the souvenirs are marked "Made in Japan."

Washington Daily News, July 8, 1959

The Business of Remembering

The new colossus at Arlington was not universally admired. Above a photo of Felix de Weldon's heroic statue, the headline on the front page of the *New York Times* read "Esthetic Numbness." A major art magazine called it "artistically appalling." A writer for the *Washington Post* complained that the flat, unmountainlike base of the statue made Rosenthal's inspiring scene look merely silly: "With all that muscle work all they can accomplish is to push each other over and land on their noses."[1]

Dissatisfaction with the Marine Corps Memorial as a work of art surfaced soon after the dedication, at a time when power in the art world was shifting from academicians and societies to an aggressive new coalition of avant-garde curators, critics, and artists. In 1955 *Art News* spearheaded the generational attack on de Weldon's monument as part of a sweeping indictment of the National Sculpture Society and its virtual monopoly on government commissions. In a landmark article—"Is This Statuary Worth More Than a Million of Your Money?"—Charlotte Devree listed the huge sums recently expended on public sculpture, of which de Weldon's $850,000 fee seemed particularly inflated given his monument's artistic defects. The statue was bad art, Devree charged: worse than that, however, it bore a close "stylistic resemblance to sculptural monuments of the Nazis and Soviets." And so, within months of its completion, the

prime symbol of American heroism had also come to stand for aesthetic complicity with the enemy.

The comparison with totalitarian art was not entirely groundless. In the 1950s oppressive regimes in the Soviet Union, China, and elsewhere —the far left *and* the far right—espoused the kind of "heroic realism" exemplified by the Memorial. As Paul Fussell recently noted, the same connotations were embedded in the Rosenthal photo: "Change the flag to red and you have 'Soviet Art.' Strip the men and you have Italian fascist sculpture."[2] But these and other negative readings of the image constitute only a fragment of the broad spectrum of meanings discovered in the flag-raising over the years. As American attitudes and values changed, so the public estimate of the Iwo Jima motif shifted from near adoration to neglect and back again to a patriotic pride mingled with nostalgia for the lost age of unambiguous heroes. Decade after decade, the men with their flag served as a receptacle for prevailing attitudes about art and appropriate feelings about one's country. Through it all, the symbol survived— a touchstone of American culture, appropriate alike for mourning Marines killed in Beirut and for promoting sales of canned luncheon meat. Most of all, the icon persisted. It lasted, reinvigorated by its own repetition in new monuments, pageantry, cartoons, and clichés.

Although he had created one of best-known monuments of his age, Felix de Weldon never became part of the art world. He remained an outsider, a virtual pariah. Critics ignored him. His work was not collected by important art museums. Textbooks on American art omitted all reference to his name. The right man at the wrong time, he saw his personal fortunes rise just as realism fell from favor among the cognoscenti. Sadder still, the traditionalists who *did* practice his style of art—the conservative membership of the National Sculpture Society, for instance—never accepted him as a serious professional. He was too earthy, too craft- and process-oriented, too closely tied to those whose deeds he commemorated. Thus it was outside the closed circles of high culture that de Weldon finally found his niche. He became the darling of Washington society, sculptor-in-residence for the political and military elite, and one of the most prolific monument-makers of this or any other era.

While glorifying the heroic deeds of the Iwo Jima Marines, de Weldon had begun to construct a kind of heroic legend of himself as sculptor, beginning with stories about the boy prodigy of Old Vienna. "Why did I draw the feet like that?" the schoolmaster asks the six-year-old artistic

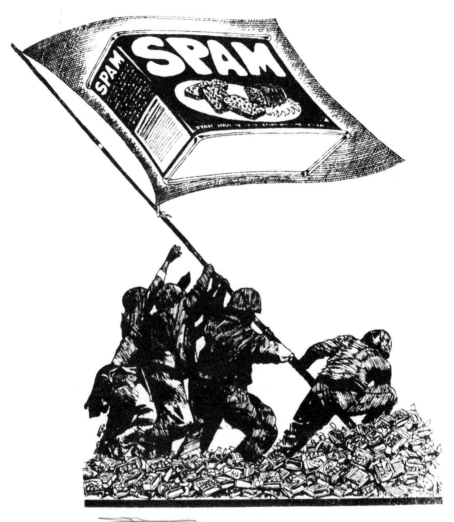

"Now, All Together—Buy Canned Spam!" A fiftieth-anniversary tribute to an American family favorite.

genius. "Because you can't draw!" the boy replies. The press marveled at the intellectual acumen of a scholar who claimed to have earned a B.A., several assorted M.A.'s, and a Ph.D., all within a three-year period. Interviewers came away full of stories of his high standing among the crowned heads of Europe. De Weldon had been—he left his listeners with that distinct impression, at any rate—the official portraitist to the throne of

England. When alluding to the early years of the sculptor's career, star-struck biographers even took to calling it the "Period of Kings."[3]

Official Washington was impressed. In 1947 Harry Truman made de Weldon a member of the Commission of Fine Arts—only months after that body had dared to reject his Iwo Jima statue! A poem was composed in his honor:

> You have crowned the world with statues
> You will never die
> The Iwo Jima proudly stands
> The flag will always fly . . .

And the commissions poured in: three statues for the U.S. Capitol and a full-length "Speaker" Sam Rayburn for a congressional office building; a bust of Admiral Nimitz for the Naval Academy at Annapolis; a portrait bust of Truman for the Democratic National Committee; equestrian statues of García in Havana, Simón Bolívar in downtown Washington, and General Pershing in Paris; monuments to the Red Cross, the polar adventures of Admiral Byrd, the work of the Seabees; a twelve-foot Harry Truman in Athens, Greece; busts of Ike, of Kennedy, of astronaut John Glenn; and a thirty-foot pyramid of freedom fighters in Kuala Lumpur. From minutemen to madonnas, from Sophocles to space trophies, by 1982 de Weldon had produced more than 1,400 sculptures, a substantial number of them paid for by public agencies or bodies closely affiliated with government.[4]

But Iwo Jima always remained the backbone of de Weldon's professional life. Within three years of his Arlington speech, the sculptor was working on yet another version for Parris Island. Like the temporary statue at Quantico, the old painted plaster edition at Parris Island had eroded in the wet heat of Carolina. Cracks webbed the surface. Flaked and pitted, the fake bronze coating was further marred by makeshift patches. Remove it "before it collapses," counseled a report. Some local Marines wanted to replace the monument with a newer model, but money was hard to find. In the absence of funds, one general thought it might be economical to demolish the ruined statue but keep the base (inscribed with the words "Uncommon Valor") to display a Japanese artillery piece or some other "suitable trophy" of World War II. Maybe, thought another officer, it might be best to tear it down, pedestal, inscription, and all, and put up a flagpole instead.[5]

The discussion of the Parris Island statue showed that fiscal pressures and a growing complacency about the war before Korea had eroded the Marines' old Iwo Jima fervor. In fact, the Korean truce had put an end to America's direct military engagement for the first time since 1941. International confrontation now took the form of diplomatic intrigue, "brinksmanship," and speechmaking—not amphibious landings and assaults on volcanic peaks. A Cold War was raging, a war of ideology, not deeds. Without the goad of armed conflict, the active, urgent imagery of the 1940s became a scrap of distant memory. The Marine Corps did eventually pay de Weldon for a new statue for Parris Island, but they bought a cheap, concrete cast. It wasn't written up in the papers. And nobody gave a speech. In the autumn of 1957, the statue simply appeared. Unlike the old Constitution Avenue version, of which it was a copy, the Parris Island flag-raising would not be a model for future monuments. Instead, it was a quaint reminder of the past, of bygone times in another world.

But as enthusiasm for Iwo Jima waned on Parris Island, farther to the south, in a budding municipality along Florida's Gulf Shore, planners were scheming to raise Suribachi's flag one more time—in the name of commerce. In the early 1960s, the Gulf American Land Corporation paid de Weldon almost $80,000 for another concrete cast taken from the mold used in Carolina.[6] It was an easy job for the crew in the Bartlett studio and a lucrative bonus for their boss. The Florida businessmen who footed the bill hoped to cash in handsomely on their investment, however, for this concrete Iwo Jima monument was to provide the centerpiece for their Garden of Patriots, the chief amenity of the new community of Cape Coral Gardens.

Prospective lot buyers drove into town along a tree-lined boulevard that ended at a pavilion in a park. The building housed a 1,500-pound replica of Mount Rushmore. The park contained a variety of marvels, including dancing fountains, trained porpoises, the largest rose garden in the state —and the Garden of Patriots, where the Iwo Jima scene loomed over busts of the American presidents.[7] Any true, red-blooded American—or so the developers earnestly believed—would be helpless to resist the pitch to buy a tract house within sight of the statue. Through such marketing, the principles that had stood behind de Weldon's aesthetic of heroic realism from the very beginning—American prosperity, suburban consumerism, big-car taste, and shopping-mall scale—now became manifest.

Dedication day, June 14, 1965, applied the old ceremonial formula to

new commercial and civilian uses. Generals "Howlin' Mad" Smith and Graves Erskine anchored the platform and warned homeowners about "power-hungry evil forces" still at large in the world beyond the Florida suburbs. Rene Gagnon represented the immortal heroes in the flesh, albeit there was more flesh these days and the hero resembled a suburban homeowner now. A message from Vice President Humphrey was read, noting that the "moment of greatness" depicted in the statue would inspire Floridians for "years ahead." The only real departure from precedent came with the appearance of the president of the Florida Chamber of Commerce, who somehow managed to leap from sober acknowledgment of Cape Coral Gardens' "re-baptism in patriotism" straight into a fervid salute to Gulf American's "tremendous contributions to the rapidly expanding economy of our state."[8]

For a few years, Gulf American kept Cape Coral jumping with celebrity-strewn rites staged in the Garden of Patriots. Bob Hope was once anointed "Patriot of the Year" there. Roy Rogers was similarly honored. But neither Americanism nor trained porpoises could sell enough houses to keep the whole gigantic enterprise afloat. Declining sales forced cutbacks, especially on the patriotic end of things. In 1970 the garden was closed, sliced into plots for a new, 656-unit housing complex. Before construction could begin, weeds reclaimed the site. The corporation tried to fob the statue off on the Marine Corps—but the deal fell through. Vines crept over the noble words. Vandals decapitated Block, Sousley, and Ira Hayes. A national icon was reduced to a heap of twisted rebar decorated with fallen chunks of concrete.[9]

In the mid-1970s, reverence for the Marine Corps Memorial itself reached a new low. The once-hallowed grounds had become Washington's hottest homosexual pickup spot. Men in search of male companionship lurked about by night; strangers met for assignations under one or another of the giant bronze boots. Nearby trees bore crude blazes, pointing the way to hidden trysting points in the shrubbery. Newspapers hinted at the "darker attraction" of the statue and chronicled some 103 arrests for sodomy in 60 days. When such reports were published, roving vigilantes determined to "clean up" the site by luring regulars into cars and speeding off to beat them senseless. One October night in 1976, the police found the body of a naked man lying face down in a creek on the edge of Memorial Woods. A congressional aide and the father of two, he had become the last, belated casualty of the battle of Iwo Jima: within days,

the National Park Service moved in to clear away concealing underbrush and strip the trees of their lower branches. Foot patrols discouraged further nocturnal loitering. As far as Washington was concerned, the siege of the Nevius Tract was over.[10]

Yet, while Iwo Jima monuments suffered in the postwar decades, the symbol itself retained a certain authority. Souvenir vendors, for instance, kept up a brisk trade in flag-raising replicas. But few buyers seem to have grasped the irony of the fact that, these days, such items were made in Japan. Japan, old enemies, and bloodshed, in fact, no longer pertained to the rumpled men with the flagstaff. Nowadays, the Mount Suribachi scene meant something different, something vaguely and positively American.[11]

Cartoonists loved it. In the spring of 1965, when American intervention

The one-time centerpiece of the Garden of Patriots in Cape Coral, this Iwo Jima replica fell into ruin when the Florida real estate market collapsed.

in Vietnam and the Dominican Republic became an issue, Paul Conrad of the *Los Angeles Times* expressed his concern in a drawing of Leathernecks straining to lift a giant globe, as if they were supporting the entire Free World. During the oil crisis of the 1970s, Dick Locher of the *Chicago Tribune* pictured a group of Exxon oilmen raising a derrick, thus casting the American drillers as economic freedom fighters doing battle against the nefarious OPEC cartel. The Cambodian crisis of May 1975 prompted Conrad to return to the image, showing the Marines hoisting Old Glory over the bow of the recaptured container ship *Mayaguez*. In troubled times, the gesture of the raisers (of flags, or oil wells, or globes) validated American grit, American determination to win—the American way of life.[12]

The commodiousness of the Iwo Jima symbol—its ability to represent a variety of different meanings—attracted the attention of the sculptor Edward Kienholz in 1969. Kienholz had earned a reputation in the gallery world for the raw emotional power of his stage-like scenes or tableaux, constructed out of everyday objects. These assemblages often dealt with tough, unpleasant subjects: the death penalty, rape, vile conditions in state mental hospitals. In his *Portable War Memorial* of 1969, Kienholz took on the theme of combat.

On the left side of the scene, Kienholz grouped what he called "propaganda devices"—a poster of the finger-pointing Uncle Sam, Kate Smith singing "God Bless America," and four uniformed soldiers raising a flag. Instead of atop Mount Suribachi, they plant it on a metal table of the sort found on the backyard patio, or at the roadside café. And the raisers are stuffed uniforms, men without faces; they could be anyone, anywhere, at any time. Behind them, a blackboard lists the names of "some independent countries that have existed on earth but are no longer." An inverted cross, dangling over the list of defunct nations, titles the scene: "A Portable War Memorial Commemorating V-_____ Day, 19_____." The viewer is invited to fill in the blanks.[13]

For Kienholz, the right side of the piece stands for "business as usual," suggested by a hotdog stand, tables and chairs, and a working Coke machine. In this setting, the flag-raisers support not some lofty ideal of duty or honor but American consumerism and corporate profit. In the ideological background, beneath the cheery red and white of the Coke machine, lurk corporate self-interest and political manipulation—what Ike once called the "military-industrial complex." Off to the far right, against a blank tablet shaped like a tombstone, a tiny person—

10.3 Edward Kienholz, *The Portable War Memorial* (1968), now in the collection of the Museum Ludwig, Cologne: (above) overview; and (right) detail.

humanity—is crucified and charred by the final, nuclear consequence of business-as-usual greed.

Even among readers of art journals and denizens of art galleries, the piece provoked outrage: "I think Kienholz is insulting our country, and, what is worse, he is insulting those men who died so he today can perform his merry pranks undisturbed." The artist demurred. He would "never insult this country," Kienholz replied. "I love it perhaps even as much as you." But to the sculptor and to many thoughtful Americans in the 1960s, patriotism was no longer a simple matter of following the nation's leaders blindly into war. Real patriotism meant questioning policies, asking if they were right or wrong: "Our moral/ethical posture is not so shining that we should weight other cultures with it. We should, perhaps, as a nation and as individuals, understand ourselves and our influences to a far greater degree." In the end, Kienholz's message was a humane one. "I truly regret those men—all men who have died in the futility of war," he wrote, "because in their deaths I must comprehend our future." *Portable War Memorial* was a gesture from a loyal opposition. It challenged the patriot to measure the nation's actions against the standard of its own self-proclaimed virtues.[14]

With Kienholz's *Memorial,* the Iwo Jima symbol was thrust back into combat, in a divisive internal battle over the morality of waging war. Whatever the flag-raising represented to the generation that had fought World War II, and regardless of what had actually happened on Mount Suribachi in 1945, Kienholz showed that it now stood for a specific political agenda: expanded military power, interventionism on a global scale, and continued prosecution of the Vietnam War. Symbols like Uncle Sam and Iwo Jima no longer united the country. Now they empowered one group at the expense of another. Oppose the war and you dishonored the flag and, by association, America. Hawk or dove: make your choice. You either supported the war or subverted democracy. There was no real room for debate. The symbol that had once stood for upholding American freedom now served to stifle freedom of speech.

But when it finally came time to honor the veterans of Vietnam with their own monument, the symbolism of Iwo Jima cast a long shadow again. For many veterans, everything about Maya Lin's wall of polished black granite inscribed with the names of the dead seemed to contradict what a heroic monument should look like. The Wall was low, horizontal. It didn't aspire, push upward, lift the spirit. It lacked any visible sign of

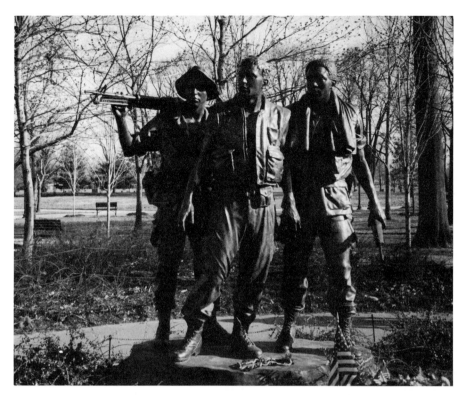

Frederick Hart, *Three Fightingmen* (1984), a politically expedient tribute to the "men and women" who served in Vietnam, added to the Vietnam Memorial in Washington in 1984.

what Americans had fought for in Southeast Asia: there were no patriotic symbols, not even a flag. There were no figures, no soldiers. For all anybody knew, the 58,000 dead might have been killed in traffic accidents or some awful natural cataclysm. Without flags and figures and a proud stance, the list of names seemed merely funereal, defeatist.[15]

The political right wanted "a Vietnam-era update of the Iwo Jima memorial." The angry vet who called the Wall "a black gash of shame" praised the Marine Corps Memorial with equal hyperbole. Acting for the Reagan administration, Secretary of the Interior James Watt attempted to impose an Iwo Jima–like addition on the Vietnam Memorial by withholding the necessary construction permits until a bronze soldier and a flag were added. But even Frederick Hart's *Three Fightingmen*, placed

near the entrance to the complex as a result of a back-room compromise painfully reached in 1984, did not satisfy everyone. For how could any realistic statue unite the nation's sharply divided memories of Vietnam?[16]

In the public consciousness, acts of individual gallantry in Vietnam remained largely anonymous while criminal aberrations made the William Calleys of the war famous: there was no Ira Hayes in Saigon or Hue. During World War II, most information had reached the home front days after the incident, via censored newspaper stories or radio broadcasts; movie footage had taken weeks and sometimes months to reach the theaters. Images had been few—and precious. Two decades later, television brought the war direct to the dinner table, in living color. Americans had seen too much with their own eyes to overlook the heavy toll of casualties, to believe the half-truths spouted by policymakers. They had seen too much blood, perhaps, to believe in unbloodied heroes with flags. Add to all this the reliance on technology—helicopters, napalm, aerial bombing, and computerized weaponry—and the problem of representing modern warfare in conventional sculpture became all the more difficult. Should a Vietnam memorial be a big bronze chopper?

And what about the motives, the spiritual ingredient? What exactly had America been fighting for? How could all Americans rally 'round the flag again when the direct threat of panzers and Pearl Harbor had yielded to fuzzy abstractions, allusions to the "national interest," prestige, the Domino Principle? How did you build a monument to a theory, a global strategy that seemed, in retrospect, absurd? In the Vietnam era, "Now, All Together!"—all the splendid tag lines of World War II, in fact—no longer pertained. National disunity was expressed instead in competing slogans: some shouted "Love It or Leave It!" while others screamed back, "Hell, No! We Won't Go!" For a nation racked by conflict about the war, about civil rights, the counterculture, and Watergate, what single scene, sculpted in bronze, could make it all right again? What scene could possibly seem "real" and "heroic" to everybody? How could the old unities of the Iwo Jima symbol endure?

The sculptor Frederick Hart understood that the subject specified by his arranged commission for a single American soldier—the traditional white GI, presumably—wouldn't do. He tacked on a black, then a Latino. But he forgot the women, nine of whom are named on the Wall, where the inscription specifically honors the "Men and Women" who served in Vietnam. Ever since the dedication of Hart's *Three Fightingmen,* women

veterans have waged a bitter fight to place their own statue—of a combat nurse—on the site to complete the Memorial. During World War II, American pluralism had been sufficiently acknowledged so long as a Louis Charlo or an Ira Hayes was in on the flag-raising. But two generations later, the kind of white-America-plus-one, nation-of-immigrants, "Now, All Together!" rhetoric that had elevated the Iwo scene into national myth had come unraveled. Placing bronze soldiers near the Wall may have mollified conservative factions within various veteran and political communities, but only at the expense of alienating the women who had gone to Vietnam and compromising the monument's claims to inclusivity. For the Vietnam generation, heroic realism could not even pretend to be true.[17]

Monument-builders rightly lamented the lost simplicities symbolized by Iwo Jima, nostalgia for which renewed the bond between the flag-raising symbol and national pride in the 1980s. The country was awakening from the malaise of the Carter presidency, according to the pundits: gas shortages, hostages in Iran, and double-digit interest rates were all behind us. America was urged to fight back—with a popular poster showing the Iwo Jima Marines mounting their flag in the rear end of a prostrate Ayatolla. Such blatant displays of cock-a-doodle-do patriotism made a comeback on the heels of the so-called Reagan Revolution. The Olympic victory of the American ice hockey team over the Soviets at Lake Placid, New York—the "Miracle On Ice"—reminded Paul Conrad of Iwo Jima: this time, his editorial cartoon showed the victorious American team raising the flag on a hockey stick.[18] And suddenly the Marine Memorial itself (or a reasonable facsimile thereof) was back in the news, too.

Down in Cape Coral, Florida, where the real estate brokers had abandoned their Iwo Jima statue to the encroaching flora, a movement was afoot to resuscitate the ruined statue. During a meeting between representatives of Gulf American and the North First Bank, in April 1980, the "current state of conditions" in the world crept into the conversation. Executives deplored the hostage situation playing itself out in Teheran but took cheer from an apparent national tilt toward the right, a revival of "patriotism and honor" that was making military service a respectable profession again. Shortly thereafter, alluding to this "renewal of patriotic fervor," the bank pledged to restore the ravaged monument and move it to "a more prominent position in the city"—right in front of its own branch office. Mike Geml, a North First vice-president and a Vietnam vet, volunteered to manage the restoration.[19]

By 1980, the Iwo Jima image was so closely identified with Americanism, it seemed inconceivable that somebody had actually designed the monument; it took Geml four months to track down the sculptor of the statue. Once run to ground, de Weldon studied photos of the ruin and offered to cast a completely new statue, at a much lower cost than repairing the old one. But Mike Geml would not hear of it. "The heritage and history" behind the original, he insisted, justified any added expense. So, on Flag Day—June 14, 1980—the remains were carted to a spot just behind the drive-in windows at the bank's office on Del Prado Boulevard, where de Weldon and his crew would soon begin the arduous task of remolding missing fragments and grafting them onto what little was left intact.[20]

It was "like finding your child has been mutilated," de Weldon moaned. For most of the autumn, his team worked on restoring the statue. On January 20, 1981—the day fifty-two American hostages came home from Iran, the date of Ronald Reagan's first inaugural—a private flag-raising ceremony marked the rebirth of the Iwo Jima Memorial of Florida. On the following Memorial Day, the official dedication was held, before a crowd of 750, mostly locals. The successful restoration, said Felix de Weldon that day, gave visible proof that "the patriotic flame still burns bright here in Florida."[21]

Meanwhile, back in the artist's Newport studio, the pieces of the colossal plaster from which the Marine Corps Memorial had been cast still stood in the piles to which they had been consigned after the foundry returned them in 1954. For many years, the sculptor had looked for a place to reconstruct the work, and through his service as a trustee of the Naval War College he finally stumbled on a possible venue. The Marine Military Academy in Harlingen, Texas, boasted the kind of warm, dry climate ideal for preserving a plaster statue. And Texas wanted the *original* Iwo Jima monument. Governor Bill Clements spearheaded the drive for contributions and convinced Austin business interests to pony up more than $120,000. The Texas Motor Tranport Association agreed to haul the parts from New England to Harlingen for free. Other donations brought the total to almost $350,000, including a $100,000 endowment set aside for future maintenance. Moved by the enthusiasm for his work, the aging de Weldon donated the statue—an ecstatic Texas secretary of state pegged the value at $4 million—to the Academy.[22]

A remarkable caravan carried the fragments to Texas. One Saturday

In 1980, as America rallied behind the hostages held in Iran, Michael Geml and Felix de Weldon seized the opportunity presented by the new spirit of patriotism to restore the Iwo Jima statue at Cape Coral.

morning in 1981, ten flatbed trucks rumbled to a halt at the gates of de Weldon's Rhode Island estate. The truckers found the old sculptor fully prepared for their arrival, with detailed plans on how to load each piece and a cop on hand to direct traffic. Seventy-eight massive crates, many open to the gaze of passing motorists, were quickly tied down, and the "Freedom Convoy" pulled out.[23]

Advance publicity on the part of Texas boosters meant that every Chamber of Commerce along the 2,100-mile route knew the statue was coming; very early in the trip the truckers realized that this would be no ordinary cross-country haul. On a grassy hillside overlooking the highway in Warwick, Rhode Island, for example, three little boys, one holding an American flag, stood at attention and saluted each truck as it passed. Organizers had routed the convoy through Washington, for a moving ceremony alongside the Marine Corps Memorial: de Weldon wept in the rain between his statues as the Marine Band played. At a truckstop outside Wytheville, Virginia, businessmen, Marine reservists, members of the state legislature, and most of the local VFW turned out to pay their respects.

CB radios spread the word. State troopers did escort duty. Snack vendors set up shop along the highway, and thousands stood in silence on the shoulder, as if a parade were passing by. A delegation welcomed the trucks to Little Rock. In Dallas there were speakers and a band. In Georgetown, Texas, where one of the drivers lived, high school classes were dismissed when the statue rolled through town. Finally, at one-thirty in the morning, a week after leaving Rhode Island, the convoy stopped at the airport in Harlingen. Weary drivers bedded down on the floor of the school gym: all the rooms in Harlingen had been booked for the Confederate Air Force air show. The next day, before an estimated crowd of 35,000 cheering airplane buffs, the Freedom Convoy made its final run—down the runway, out the gates, to the Marine Military Academy.

In the months that followed, construction workers with cranes assembled the statue like a giant puzzle, much as their predecessors had done in Arlington three decades before. Instead of welding the parts together, this time modelers slapped filling compound into the vast crevices inside the sections and connected them with hidden rebar supports. As with the Constitution Avenue model, thick coats of paint provided a bronze-like patina, now treated with an epoxy sealer for greater weather protection. When it was all done, Harlingen geared up for the umpteenth dedication

Plaster scraps become a new memorial: assembling the Iwo Jima monument in Harlingen, Texas, 1982.

of the Iwo Jima Memorial. Governor Clements came, of course. President Reagan sent good wishes. The *Harlingen Morning Star* for April 17, 1982, included a commemorative section, full of ads associating the flag-raising with everything from used cars and home mortgages to good old Miller Beer.[24] As the worthy burghers of Harlingen knew, products sold best when endorsed by the heroes of Iwo Jima, the flag, America herself.

Champions of the American way: Ronald Reagan greets Felix de Weldon at the Army and Navy Club in Washington, January 8, 1988.

The business of commemorating Iwo Jima never ends: Joseph Petrovics, a sculptor at Ettl Farm in Princeton, New Jersey, enlarges a small model of de Weldon's flag-raising, 1989.

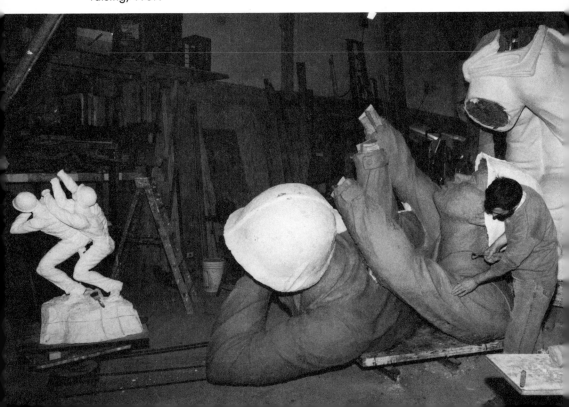

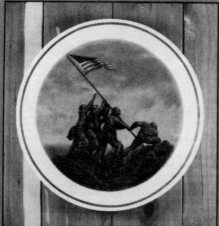

An Iwo Jima plate commemorates the fortieth anniversary of the battle.

As the fortieth anniversary of the battle approached, business boomed for almost any product bearing an Iwo Jima logo. T-shirts, coffee mugs, paperweights, belt buckles, key rings, plaques, charms, watches, rings, and other trinkets graced the pages of periodicals read by veterans and citizen-patriots alike. The Marine Corps Scholarship Fund supported its good works with the sales of collector's items in limited editions: a porcelain Iwo Jima plate rimmed in real gold; a decanter with a picture of the flag-raisers etched into genuine Irish crystal. The same organization raised over $100,000 on the sale of more than a thousand Iwo Jima statuettes, custom-designed by Felix de Weldon himself and accompanied by certificates of authenticity. As a gift for the right-thinking executive, the Danbury Mint offered a "magnificent" desktop miniature of the same subject in pewter.[25]

Iwo Jima became collectible. Hobbyists filled their dens with memorabilia ranging from autographed battle photos and books to caps, ashtrays—even Iwo Jima games for kids. Fran Manucci, a maintenance man from Hockessin, Delaware, built one of the nation's largest collections by scouring gun shows and swap-meets for material. Acquiring the usual official photos from various archives, he tracked down the men in the pictures and sent them prints to autograph. Manucci became such a rabid enthusiast that Marines often mistook him for one of their own (when asked about his service in Carlson's Raiders, he replies that the only thing he ever raided was his own icebox). His interest in Iwo Jima and its veterans has, in effect, made Manucci into a part of the flag-raising phenomenon, after the fact. He attended Easy Company's forty-fifth reunion as the special guest of Chuck Lindberg—and as one of the boys.[26]

The use of the Iwo Jima symbol in recent years has been widespread and persistent. When terrorists bombed the American military installation in Beirut, a cartoonist responded with a proposal for a new Lebanon Marine Memorial, showing the last two raisers slain. The Moscow spy scandal inspired a caricature of six smiling Marines raising panties on their flagpole. The latest Pentagon appropriations scandal elicited a representation of a leering defense contractor picking the back pocket of the last flag raiser in the line. Gun control and the war on drugs were also also given a sardonic twist in pictures that evoked the fading glory of the days of Iwo Jima.[27] Overseas, the image stood for American values in a different way. The government of Kenya modeled the Uhuru National

Fran Manucci and his collection—the World of Iwo Jima.

Monument in Nairobi on the Iwo Jima Memorial, with four Kenyans raising the banner of their own nation.[28]

The flag. Our flag. Wrapping himself in Red, White, and Blue imagery, George Bush took his 1988 presidential campaign to the bunting factories of America and thus set the stage for widespread outrage over the Supreme Court decision that held flag-burning to be another form of free speech, protected by the Constitution. Newpapers from coast to coast carried a syndicated cartoon that showed the black-robed Justices in the posture of the Iwo Jima heroes, hoisting a burning flag over the pediment of their own chambers.[29] It was no accident, therefore, when, on a warm summer morning, President Bush took his place at the base of the Marine Corps Memorial in Arlington and vowed to fight further desecration of the flag through an amendment to the Constitution.

Like so many of his predecessors, like so many other veterans of World

RAISING THE FLAG OVER CALIFORNIA

Raising the flag for new causes: ban assault weapons in California!

Down with the drug lords!

THE WAR ON DRUGS

THE DRUG MERCHANTS

MONUMENT TO THE FIRST AMENDMENT

Iwo Jima imagery applied to the flag-burning controversy of 1988.

"People of Africa, Now All Together": the Uhuru National Monument, Kenya.

War II, Bush had come to stand on sacred ground to reaffirm the values of his own young manhood. Bands played, of course. Dress uniforms looked splendid in the sunshine. Marshaled ranks of senators and congressmen lent gravity to the occasion, as the president read out his amendment on live TV. He could hardly have been expected to remember, in the glory of the morning, the history of the very flag once raised on Mount Suribachi by the six men looming in effigy above him, the flag now on exhibit just across the Potomac. How could he have known that back in 1945, in the days of the Mighty Seventh, the Iwo Jima flag itself had been desecrated by one of the government's own agents—shot through with a bogus bullet hole, to sell more bonds.

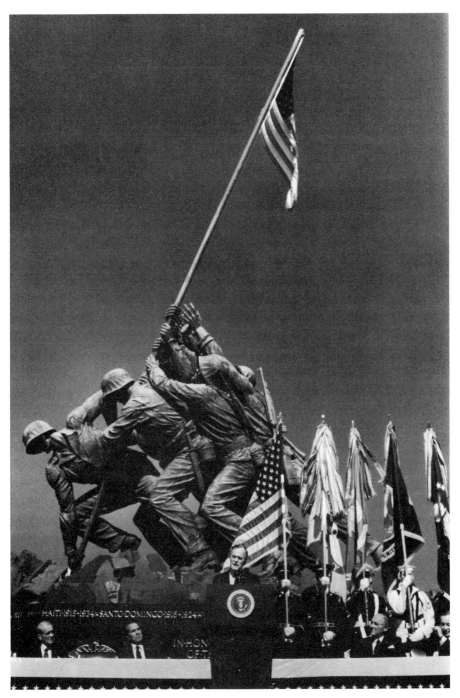

Speaking from the sculpted slopes of Suribachi, President Bush pushes for an amendment to ban desecration of the Stars and Stripes, June 30, 1988.

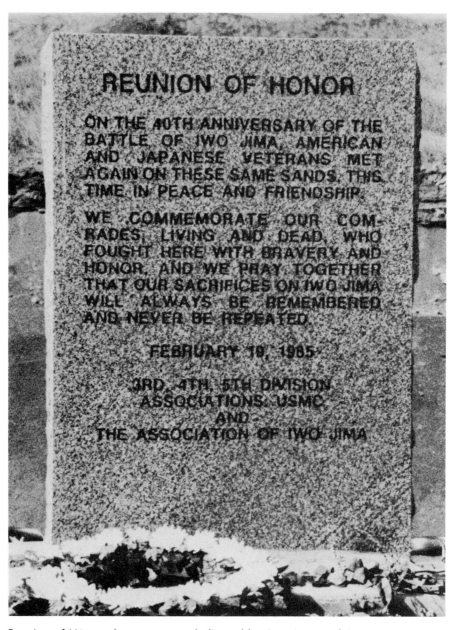

Reunion of Honor: the monument dedicated by American and Japanese veterans of Iwo Jima in 1985. John Wayne's family contributed to the cost.

I had a feeling when I left here . . . that I shouldn't have left. I was leaving people behind. I should have stayed in their place.

Dewey Norman, an American veteran of the battle, back on Iwo Jima,
February 19, 1985

D+Forty Years:
A Gathering of Heroes

The Japanese looked toward the sea, as they had done forty years before. A few war widows, a handful of old men from the garrison, children and grandchildren of those killed on the island, three Buddhist priests bearing trumpet shells, said to be effective in calling forth the souls of fallen warriors: 132 Japanese sat on the black sands, beneath a cloudless sky, facing the Pacific—and the Americans. It was almost noon on February 19, 1985.[1]

The Americans looked inland, toward Mount Suribachi and the steep terraces of sand, smoothed and lowered by the years. Two hundred seventy-seven strong, they shifted their weight on rickety folding chairs under the midday sun: wives and children of veterans, at least one teen-aged grandson, but mainly men who called themselves "survivors," Marines and Navy corpsmen who had lived through a battle that claimed the lives of 6,621 Americans and wounded 19,217 others. There were crutches, braces, limps, and terrible scars among the old men who sat in the sun, between the water and the field of battle. The youngest had just turned fifty-five. The eldest were in their eighties. Most suspected that this would be their last trip to the Pacific, the last time anyone would observe the anniversary of the battle on the island where it had been fought. Today marked the fortieth anniversary of the invasion. Victor and vanquished had come back to Iwo Jima to remember what had happened

A patch commemorates an event conceived during the annual Iwo Jima banquet at Camp Pendleton in 1983.

The reinvasion of Iwo Jima begins: American veterans arrive by military airlift on the morning of February 19, 1985.

there, to honor their dead, to figure out what it all meant, to pray that such a thing would never happen again.[2]

Of the two groups, the Japanese seemed more at ease with the place and the memories it summoned up. Takeo Abe, a former gunnery captain who had lived through twenty-seven wounds and six months in the fetid caves beneath the surface, had spent much of the past seventeen years picking his way through ravines and shellholes in search of the bones of his men. The delegation from the Association of Iwo Jima, to which most of the Japanese pilgrims belonged, was led by Tsunezo Wachi, architect of the island's defenses. After the war, Wachi had turned to religion and devoted his life to performing funerary rites for the estimated 22,000 Japanese dead, many of whom had been buried alive in their underground fortifications. Between 1952, when he first returned to Iwo Jima as a Buddhist priest, and a 1984 expedition on which he found the mummified corpses of fifty-three lost comrades, Wachi had built seventy-two small monuments on the island and recovered countless remains. Embarrassed by a pious zeal that refused to forget World War II, the Japanese government tried to outlaw private bone-hunting in the 1950s, sending out official burial parties instead. Although most of the searchers were militant pacifists, Japanese youth deplored their interest in the war dead. It was a lingering remnant of Shintoism, they said, a deification of those who had given up their lives for the Emperor. Ironically, others shunned the few Japanese to surrender and live: by surviving, they said, the Japanese veterans of Iwo Jima had failed in their duty to the homeland.[3]

But together, the Japanese survivors and the mourners had managed to come back to Iwo Jima, time and time again, looking for whatever message the bones of the missing had to impart. The Marines took the American dead home in 1947. The Army and then the Air Force came and went. The men from the tiny Coast Guard navigation station rotated home after a year. So did the members of the Japanese Self-Defense units stationed at the airfield in the 1960s, and the construction workers building new, top-secret installations throughout the 1970s and 1980s. Only the searchers kept coming back. Only the searchers were there to see a black and blasted place turn green again, little by little. American planes seeded Iwo from the air in the first years of peace. On the defoliated Pacific islands, natives called the plant "tangan-tangan." A mimosa-like shrub, it was hardy and fast-growing, worse than crabgrass. But the emerald leaves crept over the scarred face of Iwo Jima and softened its

cruel angles. The castor bean flourished, and the grasses, a stand of palms waved above Kitano Point, and here and there were scattered the pink and purple flowers, about the size of a dime, that American correspondents had noticed in 1945 as they lay with their faces pressed in the sand and shells whizzing overhead.[4]

Iwo Jima was too green for the Americans who came back in 1985. It was too bucolic, too pastoral, too damned peaceful, with its nine-hole golf course and the manicured lawns of the Japanese base. "It looks very tame now," said seventy-year-old Earl Tharalson, as he edged down the tail ramp of the C-130 transport that morning. Tharalson had come to Iwo Jima "to try to get rid of some of these memories," but with the dense vegetation and the postwar military construction, spots that loomed large in memory would prove hard to locate in reality. Charles Early, fifty-eight, a Florida tax lawyer whose limp testified to his first encounter with Iwo Jima, found himself disoriented by the greenery, too. "I didn't think anything would ever grow again," he told a reporter. In memory, the sun never shone there, no birds ever twittered, no trees ever swayed in a gentle breeze. In memory, it was always 1945, and Iwo Jima remained a place of fear and horror and death. Seeing it forty years later, so still and sweet and green, Claude Duvall, a retired state senator from Louisiana, wondered what 1945 had been all about. "I look around today," he said, "and I wonder what was the point of it. There doesn't seem to be any point."[5]

The ceremony on the landing beach aimed to make some sense of their own history for the Americans and the Japanese who faced each other across a stretch of sand and time and culture. Both sides prayed for guidance, but the American preachers also confessed their puzzlement at the strength of the urge to come back. What was the meaning of this odd homecoming, Chaplain John Pasanen asked the Almighty?

> We have returned to this place, O God, though we vowed never to set foot here again. We have returned to this place . . . to relive a past that has long pervaded our dreams and haunted our sleeplessness . . . We come back, O Lord, of compulsion, drawn by memories and loyalties, deep and firm . . . to make fast the bonds that tie us to our dead . . . for consummation, our one last deed to do.[6]

But what was that final obligation? Was it remembrance—or forgiveness, peace, and a new beginning? Younger men presumed to answer the question for the old veterans. Speaking on behalf of his government, Vice

The first order of business is the dedication of a monument on the invasion beach to mark the coming together of former enemies. The Americans, in the background, face inland. The Japanese face the sea, as they did in 1945.

Admiral Kenichiro Koga pointed to the amity between American and Japanese personnel currently stationed on Iwo Jima, where men from both nations bowed politely after the weekly softball game and socialized at the sandstone cliff that bore the likeness of the flag-raising upon its face. Japan and the United States were now allies in the cause of world peace, the admiral concluded, and "those who are the happiest to know this fact are, I believe, the souls of the dead officers and men of Iwo Jima." Both sides had fought with "uncommon valor," Lt. Gen. Charles Cooper added on behalf of the Marines in the Pacific. Time had all but erased the differences of forty years ago: "Seated here together are men who, on this same soil on an earlier day, were the most mortal of enemies. . . . If peace and friendship is possible between these men, then peace and friendship is possible among all men, everywhere . . ."[7]

The admiral and the general had plausible answers. Arnold Shapiro— he was only four years old when the Marines stormed ashore on Iwo Jima—also thought he knew why the old men had come back. A Hollywood producer with a longtime interest in the battle and in Rosenthal's photo, Shapiro wangled an invitation in 1983 to the annual anniversary banquet held at Camp Pendleton by the Third, Fourth, and Fifth Marine Divisions in commemoration of their landing. The banquet intrigued him almost as much as the battle. While most reunions, he wrote, "are about events best forgotten, this one was about life and death, horror and heroism, duty and bravery." The men who gathered to remember Iwo Jima seemed larger than life, touched with a special greatness.[8]

Shapiro asked if the group had plans to fly to the Pacific for the upcoming milestone year: other units, after all, had made trips to Raban, Tulagi, and Guadalcanal into regular excursions, and small bands of American veterans had, with some difficulty, arranged transportation to Iwo Jima on the tenth, the fifteenth, the twentieth, and the twenty-fifth anniversaries of the battle.[9] Why not on the fortieth? Shapiro volunteered to write the first letter to the prime minister of Japan, proposing a "Reunion of Honor" for February 1985. At the same time, the producer laid plans to film the pilgrimage for television. The drama would come from a real-life situation, the story of "what happens when the former enemies of World War II meet again on the sands of Iwo Jima."[10]

It was clear from the beginning that Japan was reluctant to sanction a reinvasion of Iwo Jima under any circumstances. A reunion there, if

Publicity material for the TV special on the Reunion of Honor featured narrator Ed McMahon.

permission could be obtained, would have to include Japanese veterans. And, as officials warned Shapiro and Bob Hoskins, the Fourth Division veteran who went with him to the Pacific in the autumn of 1984 to strike a deal and scout locations for the filming, there would be "no victor-vanquished attitudes, no American flamboyance," none of the teary-eyed Rosenthal-style flag-raisings that had become a perennial feature of such reunions back home. The keynote of an acceptable ceremony was struck by the old Buddhist, Reverend Wachi, as he sat with Hoskins and Shapiro

atop Mount Suribachi, with his back to the monument on which that familiar symbol of American victory was emblazoned: "So many brave American Marines. So many brave Japanese soldiers. War is such a pity."[11]

The theme of the reunion would be just that—the mutual tragedy of forty years past, a pledge of peace in the years to come; its centerpiece, a marble slab, planted on the invasion beach, on the border between the landing zones where the Fifth and the Fourth Divisions had waded ashore, halfway between the water and the sandy slope rising toward Mount Suribachi. And there, on February 19, 1985, sat the survivors of Iwo Jima, the Americans facing the land, the Japanese facing the sea, the slab of a stone between them. The monument was the gift of the actor John Wayne's family and of Wachi's Association of Iwo Jima. The words—in Japanese on the landward side, in English on the reverse—were Shapiro's answer to the riddle of their coming back, the old Americans turned toward the high ground and the rusting guns, the old Japanese looking out at the water and a fleet that still sailed there in memory:

The first showing of *Return to Iwo Jima:* Joe Rosenthal with producer Arnold Shapiro.

The Americans look wary and tense.

On the 40th anniversary of the Battle of Iwo Jima, American and Japanese veterans met again on these same sands, this time in peace and friendship. We commemorate our comrades living and dead who fought here with bravery and honor, and we pray together that our sacrifices on Iwo Jima will always be remembered and never be repeated.[12]

The slab was uncovered. The Buddhists blew their trumpet shells. A band flown in from Okinawa played "The Marine Hymn," slowly, mournfully, like a dirge. At first, nobody sang. Then a few scattered voices joined in. Finally, all the Americans were singing, and many were in tears. The ceremony was almost over. The only thing left on the morning's agenda was the "Handshake of Peace," led by the organizing committee from California. As the committee members moved across the strip of sand still separating the Americans from the Japanese, as they embraced their former adversaries, the other Americans watched and waited and wondered. Had it really come down to this? To "men in the twilight of their lives" finally "recognizing the futility of war"? To starry-eyed visions of "love and peace for all mankind"? Was war the sport of the young? Of

long ago? And were the old—the survivors—fated to become pacifists in their powerlessness, or in their wisdom?[13]

Those for whom the meaning of Iwo Jima lay back there in 1945, when their friends had died at the hands of the "Japs," stayed away from the Reunion of Honor for the most part. Men who lived in the past could not cross that last yard of beach to clasp the hand of a "Jap." Yet even those who had already decided to forgive but not forget—to forgive one another while refusing to forget the heroism of the honored dead and the tragedy of all war—found it hard to take the first step forward, to grasp the first gnarled and wizened hand. "They were the enemy!" cried Greg Emery, a former Navy corpsman haunted by the memory of the carnage he had

Reverend Wachi, in ceremonial robes at the left, begins the "Handshake of Peace."

seen, the bodies left in pieces, the viscera strewn across the beach. Emery forced himself to shake the hands held out to him and felt better for having done so: the ritual had "expelled some of the demons," he said. Others, who also came to Iwo Jima full of ill will toward the Japanese, felt as if a burden had suddenly been lifted from their hearts. Shuffling forward reluctantly, grudgingly, toward the tearful widows and the clutch of shy old men behind the monument, they realized that these gentle souls were not the foe. Their feelings of enmity belonged in another time, in another place, far away from this green and peaceful island.[14]

And so the ceremony ended in tears and smiles. Speeches, gestures, trumpets, the slow, sad melody of "The Marine Hymn": the lofty rhetoric of reconciliation declared the public significance of the journey back to Iwo Jima. In private, however, confusion and pain still dogged the footsteps of those who walked the shoreline, looking for the stretch of sand where they had been hit, the crater where a friend had died. "I came back to answer a lot of questions," said Tom Abbot of Los Angeles: he had spent two years in a VA hospital reliving the terrible things he had seen on those beaches. Frank Pokrop of Milwaukee had been disturbed in his Tokyo hotel just the night before by his roommate's bad dreams. His buddy awoke in a cold sweat, wishing he hadn't made the trip. As for himself, Pokrop thought he "just might go off and cry." "Jesus, there are a lot of memories," said Joe Buck, of Cherokee, Oklahoma, as he paced the terrace. Scooping wet sand into plastic sandwich bags for a souvenir, Tibor Torok, of Grand Prairie, Texas, remembered coming ashore on the very same spot—"a place of death"—and watching the Marine next to him be cut in half by machine-gun fire, "just like you'd slice a sausage." Why had one man lived and another died? Had the lives of those who went home justified the sacrifices of those who stayed behind, buried in the sands of Iwo Jima?[15]

Trucks made a regular circuit of the battle sites. The time was short and the terrain was treacherous: hours before the unveiling, two live pineapple grenades were found not far from the rows of folding chairs. But the little trips from point to point served a therapeutic function. The reporters and the cameramen, their fellow veterans, and the young Marines and Coast Guardsmen who served as tour guides pulled men out of the world of memory, back to the present, a present in which they were obliged to make sense of the past. On the flight to Japan, one of the time-travelers admitted, "We killed a million Japs." On Iwo Jima, one's per-

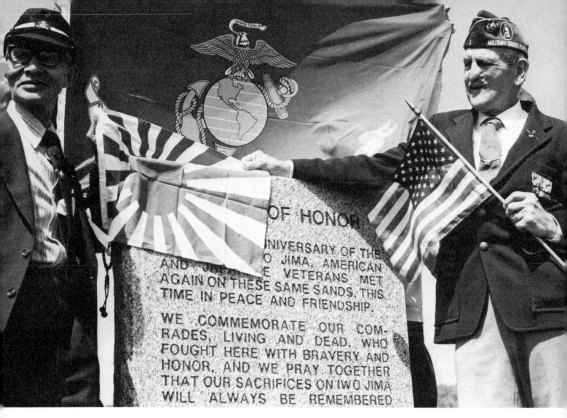

OF HONOR

...NIVERSARY OF THE
...O JIMA, AMERICAN
AND... ...E VETERANS MET
AGAIN ON THESE SAME SANDS. THIS
TIME IN PEACE AND FRIENDSHIP.

WE COMMEMORATE OUR COM-
RADES, LIVING AND DEAD, WHO
FOUGHT HERE WITH BRAVERY AND
HONOR, AND WE PRAY TOGETHER
THAT OUR SACRIFICES ON IWO JIMA
WILL ALWAYS BE REMEMBERED

The beginning of reconciliation: at left, Isao Ohshima, and at right, Edward J. Moraniec.

Footsteps in the sand, photographed by a veteran who came ashore at this very spot.

Trying to find familiar places.

Mount Suribachi looming over a field of flowers.

spective was different, the battle a part of a whole, ongoing lifetime, winding now toward an inevitable end. "I'm 64 years old," said a Fresno banker, "and this [is] my last chance to relive the greatest experience of my life." Wounded on Iwo, a former track star from La Mesa, California, had seen the course of his life altered in a moment. His conclusion: "That living peacefully with our fellow men" is always better than making war. For Connecticut's Ed Moraniec, disfigured by shrapnel, Iwo "was the end of my life." Yet in retrospect the war had taught him a lesson, too. "Back home we thought only of glory. Up here," he mused as the truck labored toward the top of Suribachi, "there's no glory—only death, in its worst form."[16]

The legend of Mount Suribachi was the common thread that knit all the other war stories together. Some men had landed under heavy fire; some had come in standing up, in an eerie silence. Some were maimed and scarred; a lucky few had escaped unharmed. But everybody remembered the flag and the picture. And everybody climbed the mountain that sunny afternoon, swapping recollections of where they'd been and what they'd thought when the Stars and Stripes rippled in the wind. To one, it was "like a touchdown in a football game. It was a small flag, but everybody . . . could see it." "When it went up," said another, "there was a great big cheer, right down on the beach." "It signified victory," added a third

Atop the mountain, where the flag once flew.

vet. "It was a moment of ecstasy." Because the symbol provided a link between the home front and the battlefront, between those who had been there and generations unborn in 1945, the flag-raising was also the focus of questions directed at Marines who had not made the trip back to Iwo Jima. Like their comrades in the Pacific, for instance, Atlanta veterans quoted in special anniversary press coverage remembered "a spindly little thing sticking up [that] showed . . . at least somebody had taken something they were supposed to."[17]

As the delegation on Iwo Jima labored up the mountain where it all began, stateside ceremonies took the cue from the long ago flag-raising. It was recreated by young Marines in a national cemetery outside San Francisco, with Joe Rosenthal, the guest of honor, admonishing a sparse crowd of veterans and their families "to remember the incredible bravery of those men who gave all they had to give to live up to their sense of duty." Whenever he looked at his picture, the seventy-three-year-old photographer said, "I can still see the smoke and smell the blood and guts." The Marine Corps had their monument in Washington scrubbed and polished for the occasion, and observances there opened with a White House reception for 350 survivors. Many had never attended a reunion before. "I've stayed away from this kind of thing for years because you don't want to remember the bad stuff," said Larry Ryan, who came all the way from Greenfield, Wisconsin, to honor the friends he lost on Iwo Jima. When he was younger, Ryan continued, "the flag raising was no big deal" in comparison to all the deaths, but nowadays it had become an obsession. He had nightmares about it, "flashbacks" triggered by the sight of the statue on the nightly TV sign-off, a growing conviction that he had been one of the flag-raisers, misidentified by the Marines for forty years.[18]

Even on Mount Suribachi, in the presence of a monument bearing the Rosenthal picture, skeptics assailed the photo's authenticity. Wallace Morger, of Fort Benton, Montana, remembered Lou Lowery's picture, taken "under fire" and, despite the counterarguments of the Marine officer detailed to handle historical questions, insisted that Rosenthal's was second-best, a staged product. For the Japanese veterans, such quibbles were academic. The flag meant defeat, impending doom. According to Takeo Abe, "The raising of the flag symbolized that the time had come for Japan." There was no joy in recalling it, or in dividing a complex world into winners and losers. "It's not important who won or lost," said Katsuyoshi Morimoto, former army surgeon, "but that both sides remember

the place where our friends . . . died." The deaths were important—and so were other photographs of deep human significance, photographs that Japanese soldiers shared with their American counterparts. Looking back down the corridor of time, an American saw himself as a young Marine, kneeling over the body of "a dead Jap" and finding photos in his wallet— a mother and father, a wife and a baby: "I knew that I was carrying the same pictures in my wallet. It made me very sad and I put everything back. I thought, 'It could have been me,' and 'What for?' I wasn't mad at this soldier. He didn't even know me." A Japanese veteran wiped his glasses, peered mournfully into the camera's lens, and told an identical story.[19]

The stories, many of them, were the same narratives of loss, of fear, of flashes of kinship with men who died on the other side, of guilt at being

After the war, Rosenthal and Lowery always spoke of one another with great affection; Rosenthal said he'd just been luckier on February 23, 1945.

the one who made it through. Like the Americans, the Japanese of the Iwo Jima garrison feared that what they had done there would be forgotten. An airline clerk in Tokyo had had to be told that Iwo Jima was an island in the Pacific; a publisher's assistant on the East Coast had thought that Suribachi was the name of a pizza parlor. An old Marine, down on his luck, had run an ad in a paper out in North Dakota, offering to sell the Purple Heart he got on Iwo Jima: those who inquired about the price had asked only how much gold was in the thing. If the world forgot Iwo Jima, what had the whole, terrible ordeal meant? What difference had it made in the course of history? And the brave young men who fell there—who would remember them after the old veterans answered the final roll call? "For this many people to die, it's supposed to mean something," Bill Steele insisted. "But it don't . . . What did they all die for?"[20]

Whether the answers came or not, the questions asked out loud, the tears, the closeness rehumanized men who had coped with Iwo Jima for these forty years by a studied forgetfulness. At reunions, they mowed down "Nips" by the dozen, like John Wayne in his prime. They talked about good times and old friends. Or they didn't talk at all. They dreamed instead and woke and trembled. Vietnam made it all right for men of valor to look back in sorrow and in anger, and to cry. Vietnam made it all right for patriots to acknowledge an appalling rate of casualties, to question the wisdom of the generals, while keeping faith with the departed. A third of all the Marines who died in World War II died on Iwo Jima. Forty years later, it was finally all right to remember the truth.[21]

Reunions of World War II veterans were curious affairs from the beginning, part clubbish sociability among men who had shared a common set of rules and experiences—like college grads or fraternity brothers—and part self-congratulatory myth. Walt Ridlon went to his first, small Iwo Jima reunion in 1951 in Kansas City. The turnout consisted mainly of guys who had stayed in the Corps. The civilians were still too busy with jobs and new families and buying a house. Ridlon went because he thought of his old outfit as a family: he wondered what had happened to the men he commanded, how the wounded had fared, how life was going for "his boys." But as the years passed, the opportunities for getting together and the attendance both multiplied exponentially. Divisions and even companies held their own annual functions, usually during summer recess in the period when the average member had school-age kids.[22]

The reunion became a vacation, with bands that played Glenn Miller

DAWNS EARLY LIGHT ...

The return to Iwo Jima saluted: California and Hawaii Elks Clubs commissioned this floral tribute to the American veteran for the 1985 Tournament of Roses Parade.

tunes, Iwo Jima ballcaps and coffee mugs, and, almost always, a recreation of the emblematic flag-raising that stood for victory and heroism and thus validated the events that brought the vets together. Nostalgia played a role, too—a longing for the camaraderie and the vigor of youth. In the case of those who had fought on Iwo Jima, nostalgia exalted the glorious epiphany of Joe Rosenthal's picture and suppressed the grisly reality of being there in 1945.[23]

Public remembrances of the battle always centered on the Iwo Jima statue and the men associated with it. Between 1955 and 1975, Joe Rosenthal, General Erskine, Holland Smith, and Rene Gagnon all appeared beneath the giant effigy, affirming by their presence the values it had

Opposite: At reunions of Iwo Jima veterans, a recreated flag-raising is often the centerpiece. This version was mounted by young Marines for the annual Camp Pendleton commemoration.

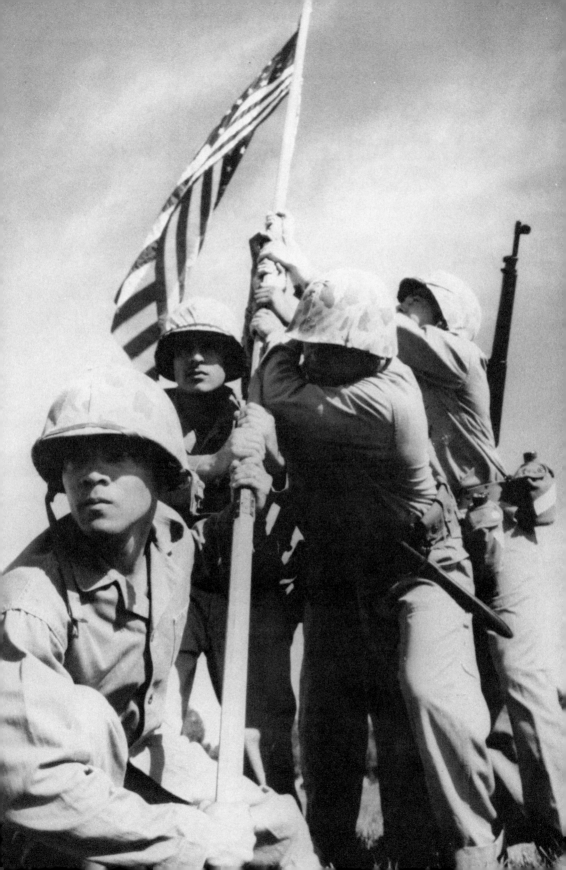

Turning the tables on history: at a reunion in Mobile, Alabama, in 1989, real Iwo vets photograph a recreation of the famous Suribachi scene.

come to represent: the armed will of the nation, the justice of its cause, the inevitability of victory. But during the Vietnam war, when one military historian prescribed books on the Iwo campaign as an antidote to America's failure of resolve, a new breed of old-timer began to turn up at the Marine Corps Memorial, ready to talk about pain. Veterans buttonholed by reporters at the twentieth anniversary rites didn't "feel glorious" about the Iwo Jima they remembered. "I will always have those memories," said an ex- Marine from Alexandria, Virginia. "There is nothing I can do about it because they have left deep scars. The only thing to do is just push them down as far as you can."[24]

By the time the Vietnam vets had built themselves a monument across the Potomac, the men of Iwo Jima were owning up to lonely years of hurt and guilt. "In the past, I had just displaced that part of my life," admitted a man who went to his first reunion in the 1980s, looking for help. "I've

tried *not* to remember it." "I can see it in my mind and I can hear the sounds," wrote another veteran, tormented by ghosts that still prowled the sands of Iwo Jima. "I can walk the island in my mind." It was time to go back and walk the beaches. It was time to climb the mountain—one last time. It was time to forget what should have happened, what other people said, the movies, the pictures, the statues wreathed in glory. It was time to remember what had happened on Iwo Jima in 1945. Forty years later, it was time for the Reunion of Honor.[25]

At three o'clock, the trucks crept back down the mountainside, past the landing beaches, past the site of the old Marine cemetery, toward a rise overlooking the Japanese command post on the island. After twenty-three years in American hands, the Bonins had been given back to Japan in 1968. In 1985, the notion of returning territory purchased with blood still rankled some who had fought there, although the reunion had helped to appease the most intransigent among them. In Tokyo, on the eve of departure, the American contingent had returned swords and flags taken from Japanese corpses by vengeful and thoughtless young men. Although that first meeting between the two camps was stiffly formal, the enemy, it seemed, might have a human face. On Iwo Jima, the handshake of peace and the cathartic excursion into history that followed dissolved the last vestiges of hostility in salty tears. "I didn't really want the United States to give back the island," said Texan Marshall Yates. "But now that they have, well, the Japanese are our best allies and if it helps to have them [here], then fine."[26]

The trucks circled Requiem Hill and stopped at a strange, roofless structure of polished gray granite, a kind of oriental Stonehenge built by the Tokyo police as a memorial to the war dead of both nations. Tables held a buffet—soup, sandwiches, sushi, bottles of Japanese beer. Chairs had been set up in the shade. The weary plopped themselves down gratefully, to inspect postcards and hats purchased at the Coast Guard station, to finish letters that would bear a special Iwo Jima postmark. Filled with the emotion of the day, John Pasanen wrote to his little granddaughter back in California: "I wanted to be sure to let her know when she grows up that I would do anything to prevent her sons from being subjected to what men were subjected to on this island." Lucian Caste, an architect from Pittsburg, added notes to the journal he was keeping for his twelve-year-old grandson, James Lucian McCreight. On his way to Requiem Hill, Caste met a video crew, looking for an interview. What was it *really* like

in 1945? He had always been reluctant to frame an answer, but today, Caste thought he knew. "It was the insanity of war," he wrote in Jimmy's book: "In the beginning it was the glory of going to war—now, it was death, horrible and meaningless death. Men torn apart by hate and false pride, brought here for man to kill his fellow man—it was like standing in the cauldron of hell, performing an act of total self-destruction, killing your brother."[27]

As the plane landed on Iwo that morning, a journalist rushed up to Bill Steele, demanding a statement and a picture. "We're gonna make heroes of you people today!" he quipped. But there were no heroes on Requiem Hill that afternoon. There were only survivors, having a beer, pointing and gesturing when language failed, making friends, swapping stories. Dewey Norman slapped his hip: that was where he had got it. It could have been my bullet, a smiling Japanese veteran indicated, thumping himself on the chest. Taro Kuribayashi, the son of Iwo's wartime commander, moved through the clusters of men, shaking hands, bowing. Laughter could be heard, over the tunes of the Forties, played by the Marine Band: a Japanese party, American songs.[28]

John Bradley, the last of the official Iwo Jima heroes, had been asked to make the trip, but had refused. Arnold Shapiro filmed him in advance for the TV special and asked Bradley the same big questions the men now amiably sharing a beer on a sunny afternoon in the Pacific had just addressed. Who were the heroes? "I just happened to be at a certain place at a certain time," Bradley replied, much as he had for the last forty years: "Anybody on that island could have been in there and we certainly weren't heroes and I can speak for the rest of them as well."[29] Anybody *could* have been there when the shutter clicked. Everybody was a hero. Americans. Japanese. Those who died. Those who lived and suffered for it and came back to find out why. Those who laughed and cried and vowed together that war must never come again. "All go in peace," said Reverend Wachi. The band struck up "Sentimental Journey." The trucks headed down Requiem Hill, to the airstrip. The Reunion of Honor was over.

They flew out of the warm, green softness of Iwo Jima and landed in Tokyo that night in four inches of snow. It was, said some of the weary heroes, their own "white blanket of peace."[30]

The Fifth Marine Division Cemetery on Iwo Jima, after the battle was over. Mount Suribachi looms in the background.

Notes

1 · Uncommon Valor

1. Holland M. Smith and Percy Finch, *Coral and Brass* (New York: Scribner's, 1949), 261.
2. Marine Corps War Memorial Dedication Committee memo, 4 pp., Nov. 8, 1954, USMC Museum, Washington, D.C., Reference Section, Folder: Memorials (Iwo Jima)—"Marine Corps War Memorial Foundation".
3. Newspaper accounts of the ceremony paid special attention to the flag-raisers. These include articles in the *New York Times, New York Herald Tribune, Washington Post,* and *Washington Daily News,* Nov. 11, 1954, and the *Washington Star,* Nov. 10, 1954.
4. The mothers have been the subject of some interest in their own right. See, e.g., Bill Griffin, "Kentuckian Helped Raise Old Glory on Iwo Jima," *Rural Kentuckian* 28 (July 1974), 4–5, and Bob Jordan, "Gold Star Mother," *Leatherneck* 68 (Feb. 1985), 34–35.
5. One transcript of Thomas's broadcast from Admiral Turner's flagship off Iwo Jima, dated Feb. 25, 1945, is in the collection of the Florida State Library, Tallahassee, gift of Jean Thomas Bishop. For brief and somewhat confusing mention of the first raising in relationship to the second, see, e.g., Jack Jonas, "Iwo Jima Marines Honored at Dedication of Memorial," *Washington Star,* Nov. 10, 1954.
6. Quoted in Michele Greenwell, "The Forgotten Man of Mount Suribachi," *Twin Cities Reader* (Minn.), May 22–30, 1989, 13.

7. Charles W. Lindberg, interview with authors, June 15, 1988. A photo caption in the *Chicago Sun-Times,* Nov. 11, 1954, identifies Michaels (as James Michels). Only one Marine Corps War Memorial Foundation press release, dated Nov. 7, 1954, in the private papers of Foundation board member Arthur B. Hanson of Washington, D.C., mentions him. Hanson's surviving papers are now in USMC Museum, Personal Papers Section.

8. Joe Rosenthal, interview with Benis M. Frank, June 25, 1975, pp. 83–85, USMC Museum, Oral History Section.

9. William Bradford Huie, *The Hero of Iwo Jima and other Stories* (New York: Signet, 1962), 42–44

10. Albert Hemingway, *Ira Hayes, Pima Marine* (Lanham, Md.: University Press of America, 1988), 152–155.

11. "Hero's Life Took Tragic Turns," *Daily Breeze* (Torrance, Calif.), Oct. 14, 1979; and Mary Elson, "For Flag Raisers at Iwo Jima, Fame Carried Heavy Price," *Sentinel Star* (Orlando, Fla.), Oct. 29, 1979.

12. "Remarks of Deputy Secretary of Defense Robert B. Anderson," Nov. 10, 1954, USMC Museum, Reference Section, Folder: Memorials—"Marine Corps War (Iwo Jima) Dedication Ceremony." This file contains texts of all the speeches given that day except Nixon's. The program for the ceremony and a sampling of official photos taken that morning appear in Jane Blakeney, *Heroes: U.S. Marine Corps, 1861–1955* (Washington, D.C.: Historical Branch, USMC, 1957), 533, 562–573.

13. Evert Clark, "'Nor Is This a Monument to War'," *Washington Daily News,* Nov. 11, 1954.

14. Lt. Col. William P. McCahill, USMCR, Chairman, Dedication Committee, interview with Benis M. Frank (1989), p. 138, USMC Museum, Oral History Section. Chuck Lawliss, *The Marine Book: A Portrait of America's Military Elite* (New York: Thames and Hudson, 1988), 59–60.

15. Richard Severo and Lewis Milford, *The Wages of War: When America's Soldiers Came Home—From Valley Forge to Vietnam* (New York: Simon and Schuster, 1989), 332. William L. O'Neill, *American High: The Years of Confidence, 1945–1960* (New York: Free Press, 1986), 192.

16. See photos 65-108-1–65-108-7, taken by International News Service, Dwight D. Eisenhower Library, Abilene, Kan. These are mistakenly dated Dec. 6, 1952. The monument Ike examined on Suribachi was dedicated on Oct. 2, 1945, a scant six months after the battle: see "Iwo Lonely U.S. Outpost 9 Years after Suribachi," *New York Times,* Feb. 24, 1954. Don Whitehead, *The "Great Deception"* (New York: Associated Press, [1953]), 6–9.

17. See, e.g., J. W. Moreau to the president, July 2, 1954, and other related correspondence in the Eisenhower Library, Box 106, File OF3-R-4-A (Office Files). This group of documents makes it clear that as late as Nov. 5, Eisenhower's appearance at the dedication was still in question.

18. Earle C. Clements to Eisenhower, Nov. 19, 1954, and related correspondence in Eisenhower Library, Box 106. The crucial letter—Morgan to Clements,

Nov. 29, 1954—contains numerous errors or distortions of fact masquerading as gospel. It asserts, for instance, that "de Weldon himself recognized [the inappropriateness of singling out six men from E Company as heroes] in refraining from reproducing a particular likeness in any of his figures." In fact, although the faces do not seem sharply individualized, de Weldon made portrait busts of the survivors from life before starting his large plaster model and corrected the final version by having them come to Washington to pose a second time. He took similar pains with the likenesses of the deceased Marines, working from a variety of available photos and family snapshots.

19. "Remarks of Felix de Weldon, Sculptor," Nov. 10, 1954, USMC Museum, Reference Section, Folder: Memorials—"Marine Corps War (Iwo Jima) Dedication Ceremony."

20. E.g., "Cartridge Belt Provides 'Door' for Inside Job on Statue," *Washington Sunday Star,* Sept. 12, 1954; Larry James, "To All Marines . . .," *Leatherneck* 57 (Feb. 1974), 38–39.

21. "Vandegrift Unveils Statue to Raising of Flag on Iwo Jima," *Washington Star,* Nov. 11, 1945. "Did You Happen To See?" *Washington Times-Herald,* March 31, 1950.

22. Jack Jonas, "Iwo Jima Marines Honored at Dedication of Memorial," *Washington Star,* Nov. 10, 1954.

23. Brig. Gen. L. B. Cresswell to Lt. Gen. R. Pate, USMC, Nov. 12, 1954, and William McCahill to Colonel Barquín, Nov. 16, 1954, USMC Museum, Reference Section, Folder: Memorials—"Marine Corps War (Iwo Jima) Dedication Ceremony."

24. Jack Charles et al., quoted in Hemingway, *Ira Hayes,* 159. See also "Ira Hayes Buried with U.S. Heroes," *Phoenix Gazette,* Feb. 2, 1955.

2 · Bloody Iwo

1. Robert Heinl, "Dark Horse on Iwo," *Marine Corps Gazette,* Aug. 1945, 3. Horie quoted in Philip N. Pierce, "Blood and Sand," *Leatherneck* 68 (Feb. 1985), 24. Vice-Admiral Richmond Kelly Turner, quoted in remarks of Hon. James W. Wadsworth of New York, Feb. 22, 1945, *Congressional Record* 91, pt. 10 (79th Congress), A780. Robert Trumbull, "The Road to Tokyo: Red Epic of Iwo," *New York Times Magazine,* March 4, 1945, 7. Remarks transcribed in debate, Mr. Grant of Indiana, Feb. 23, 1945, *Congressional Record* 91, pt. 1 (79th Congress), 1391.

2. Gilbert Cant, *The Great Pacific Victory: From the Solomons to Tokyo* (New York: John Day, 1945), 339; Jim Lea, "The Return to Iwo Jima," *Pacific Stars and Stripes,* Feb. 21, 1985. John Toland, *The Rising Sun: The Decline and Fall of the Japanese Empire, 1936–1945* (New York: Random House, 1970), 640. Robert A. Aurthur and Kenneth Cohlmia, *The Third Marine Division* (Washington, D.C.: Infantry Journal Press, [1948]), 222; William Manchester, *Goodbye, Darkness: A Memoir of the Pacific War* (New York: Dell, 1982), 397.

3. Lt. Col. Whitman S. Bartley, USMC, *Iwo Jima: Amphibious Epic* (Washington, D.C.: Historical Branch, USMC, 1954), 2–3.

4. Capt. Raymond Henri et al., *The U.S. Marines on Iwo Jima* (New York: Dial Press, 1945), 7. Howard M. Conner, *The Spearhead: The World War II History of the 5th Marine Division* (Washington, D.C.: Infantry Journal Press, [1950]), 33–35.

5. Tom Ashbrook, "40 years Later, Iwo Jima Remains His Temple," *Sunday Star-Bulletin & Advertiser* (Honolulu), Feb. 17, 1985. Manchester, *Goodbye, Darkness,* 390. "I Am Going to Die Here," *Time* (March 12, 1945), 33.

6. Conner, *Spearhead,* 35. Robert Leckie, *Strong Men Armed: The United States Marines Against Japan* (New York: Random House, 1962), 432.

7. T. Grady Gallant, *The Friendly Dead* (Garden City, N.Y.: Doubleday, 1964), 18. The same rumors were circulated on Guadalcanal before the U.S. landing there; see Lee Kennett, *G.I.: The American Soldier in World War II* (New York: Warner Books, 1989), 132. Toland, *Rising Sun,* 649, 651.

8. Toshihiko Ohno, "A Japanese Remembers Iwo Jima," *New York Times Magazine,* Feb. 14, 1965, 64; "Diary of Lt. Zenrui Sugihara," typescript, July 6, 1945, p. 2, in the papers of Jon D. Allen, Alexandria, Va.

 "On Iwo the Japs dug themselves in so deeply that all the explosives in the world could hardly have reached them," wrote Robert Sherrod, "With Nobility and Courage," *Time* March 12, 1945, 33. Fletcher Pratt, "Long War or Short War? Experts Differ on Pacific," *Minneapolis Tribune,* Feb. 26, 1945.

9. Saburo Hayashi with Alvin D. Coox, *Kogun: The Japanese Army in the Pacific War* (Westport, Conn.: Greewood Press, 1978), 137. Richard F. Newcomb, *Iwo Jima* (South Yarmouth Mass.: John Curly and Associates, 1965), 99. William Craig, *The Fall of Japan* (New York: Dial Press, 1967), 17. E. B. Potter and Chester W. Nimitz, eds., *The Great Sea War: The Story of Naval Action in World War II* (Englewood Cliffs, N.J.: Prentice-Hall, 1960), 441–442. S. E. Smith, ed., *The United States Marine Corps in World War II* (New York: Random House, 1969), 709–711; Robert Sherrod, *On to Westward: War in the Central Pacific* (New York: Duell, Sloan and Pearce, 1945), 151–152.

10. Wesley Frank Craven and James Lea Cate, eds., *The Army Armed Forces in World War II,* vol. 5 (Chicago: University of Chicago Press, 1953), 586–587. Bartley, *Iwo Jima,* 20, summarizes the four-part rationale for the seizure of Iwo prepared by the Joint War Planning Committee in Aug. 1944. John Costello, *The Pacific War* (New York: Rawson, Wade, 1981), 540.

11. Allen R. Millett, *Semper Fidelis: The History of the United States Marine Corps* (New York: Macmillan, 1980), 426–428. Edwin P. Hoyt, *The Marine Raiders* (New York: Pocket Books, 1989), 254; Lt. John C. Chapin, *The Fifth Marine Division in World War II* (Washington, D.C.: Historical Division, USMC, 1945), 3. Holland M. Smith and Percy Finch, *Coral and Brass* (New York: Scribner's, 1949), 243–247; Clive Howard and Joe Whitley, *One Damned Island after Another* (Chapel Hill: University of North Carolina Press, 1946), 300–301; "Iwo: The Red Hot Rock," *Collier's,* April 14, 1945, 16.

12. Fletcher Pratt, *The Marines' War* (New York: William Sloane, 1948), 348–350; "Hell's Acre," *Time,* Feb. 26, 1945, 26; Samuel Eliot Morison, *History of United States Naval Operations in World War II,* vol. 14 (Boston: Little, Brown, 1961), 17, 72–74. Jeter A. Isely and Philip A. Crowl, *The U.S. Marines and Amphibious War* (Princeton: Princeton University Press, 1951), 435–441. Conner, *Spearhead,* 38. On the physical destruction of Suribachi, see Edgar L. Jones, "To the Finish: A Letter from Iwo Jima," *Atlantic* 175 (June 1945), 52.

13. Manchester, *Goodbye, Darkness,* 388–389. Gerald P. Averill, *Mustang: A Combat Marine* (New York: Pocket Books, 1988), 127. Smith and Finch, *Coral and Brass,* 15, 254–255. John P. Marquand, "Iwo Jima before H-Hour," *Harper's* 190 (May 1945), 496. "The Battlefield of Iwo," *Life,* April 9, 1945, 96.

14. David Brinkley, *Washington Goes to War* (New York: Ballantine, 1988), 191. Turner quoted in Newcomb, *Iwo Jima,* 127–129, and in Sherrod, *On to Westward,* 154–156.

15. The volume of reports from Iwo is noted in Heinl, "Dark Horse on Iwo," 3. Quotation from J. Robert Moskin, *The U.S. Marine Corps Story,* 2d ed. (New York: McGraw-Hill, 1987), 361. John Lardner, "D Day, Iwo Jima," *New Yorker* 21 (March 17, 1945), 50. Robert Sherrod, "'It Was Sickening to Watch . . .'," *Time,* March 5, 1945, 27.

16. Newcomb, *Iwo Jima,* 129. Sherrod, *On to Westward,* 160. The new press policy was Forrestal's idea.

17. Isely and Crowl, *The U.S. Marines,* 455. Lardner, "D Day, Iwo Jima," 48.

18. Albert Hemingway, *Ira Hayes, Pima Marine* (Lanham, Md.: University Press of America, 1988), 57.

19. Marquand, "Iwo Jima before H-Hour," 499.

20. James Jones, *WWII* (New York: Grosset and Dunlap, 1975), 233. Lardner, "D Day, Iwo Jima," 49. Bill D. Ross, "Remembering Iwo Jima," *Family Weekly,* Feb. 17, 1985, 13.

21. The southern boy cited in a radio address from Guam by James V. Forrestal, quoted in remarks of Hon. A. Willis Robertson of Virginia, March 7, 1945, *Congressional Record* 91, pt. 10 (79th Congress), A1039; Sherrod and others also quoted this *bon mot.* Conner, *Spearhead,* 57.

22. Paul Hollister and Robert Strunsky, eds., *From Pearl Harbor into Tokyo: The Story as Told by War Correspondents on the Air* (New York: Columbia Broadcasting System, 1945), 196–198; Louis L. Snyder, ed., *Masterpieces of War Reporting: The Great Moments of World War II* (New York: Julian Messner, 1962), 404. The wounded PR officer quoted in Gene Z. Hanrahan, ed., *Assault* (New York: Berkeley Books, 1962), 223. For Basilone, see Rolfe Boswell, *Medals for Marines* (New York: Thomas Y. Crowell, 1945), 126–130.

23. Joe Rosenthal, quoted in W. C. Heinz, "The Unforgettable Image of Iwo Jima," *50 Plus,* Feb. 1985, 60.

24. Joe Rosenthal with W. C. Heinz, "The Picture that Will Live Forever," *Collier's,* Feb. 18, 1955, 64.

25. Newcomb, *Iwo Jima,* 402. The dispatch about Rosenthal's D-day photos came from Turner's flagship on February 21; see Morrie Landsburg, "Photographing Iwo: AP Ace Cameraman Joe Rosenthal Calls It Hottest Pacific Beachhead," *San Francisco Chronicle,* Feb. 23, 1945. E.g., "On the Beachhead," *San Francisco Chronicle,* Feb. 21, 1945; "3,650 Casualties," *New York Post,* Feb. 21, 1945; "3,650 Yanks Fall on Iwo," *Detroit News,* Feb. 21, 1945. The official source was Vice-Admiral Hoover, quoted in a UP dispatch from the fleet, "Volcano on Iwo Captured; Mt. Suribachi Seized; Yank Losses Rise," *Minneapolis Tribune,* Feb. 23, 1945. Radio Tokyo quoted in Isely and Crowl, *The U.S. Marines,* 475. Bill D. Ross, *Iwo Jima: Legacy of Valor* (New York: Vintage, 1986), 81.

26. Conner, *Spearhead,* 57. There are many fine accounts of the battle from D-day thorough D+3. Among the best recent versions are Ross, *Iwo Jima,* 88–95, and Richard Wheeler, *A Special Valor: The U.S. Marines and the Pacific War* (New York: New American Library), 363–380.

27. Herb Richardson, "Iwo Jima," *Leatherneck* 63 (Feb. 1980), 15, discusses "real" (as opposed to "Hollywood") heroes on Iwo Jima.

28. Walker Y. Brooks, "Engineers on Iwo," *Marine Corps Gazette,* Oct. 1945, 48–51. The daily progress of the 28th is plotted in the Unit Journal for Iwo Jima, USMC Museum Archives; see, e.g., entry for Feb. 21, 1945, 1425 hrs.

29. Isely and Crowl, *The U.S. Marines,* 488. Irving Crump, *Our Marines* (New York: Dodd, Mead, 1944), 109, 113–116.

30. Cpt. Patrick O'Sheel and Staff Sgt. Gene Cook, *Semper Fidelis: The U.S. Marines in the Pacific, 1942–1945* (New York: William Sloane, 1947), 215–216. The authors, both Marine combat correspondents, say that the ditty was actually written by a Marine—Capt. Earl J. Wilson. For disparaging reference to the Marine publicity machine on Iwo Jima, see William Bradford Huie, *From Omaha to Okinawa: The Story of the Seabees* (New York: Dutton, 1945), 32.

31. Quoted in Wheeler, *A Special Valor,* 378.

32. Smith and Finch, *Coral and Brass,* 261.

3 · Our Flag Was Still There

1. 28th Marine Regiment, R-2 Journal, Iwo Jima (A 58-1), entries for D-day through D+3, USMC Museum Archives.

2. 28th Marine Regiment, C-2 Periodic Report, Feb. 22, 1945 (signed by T. R. Yancey), USMC Museum Archives.

3. Sherman Watson and Ted White, interviews with Wetenhall, Aug. 16 and 24, 1989. See also "Sergeant Recalls Taking the Mountain," *Pensacola Journal,* Feb. 21, 1985.

4. Watson, interview with Wetenhall, Aug. 16, 1989. Chuck Lindberg, in several long conversations with the authors, could not recall having seen Watson's

patrol. In a letter to Wetenhall, July 24, 1989, Col. David E. Severance, Easy Company's wartime CO, maintains that the patrol from D Company never reached the top. But the papers of Col. Severance, La Jolla, Calif., contain the transcript of an interview with Cpl. John L. Wieland, Nov. 24, 1979 (and published in *Raider Patch,* according to an undated clipping in the same file) giving a different version of things. According to Wieland, when most of his ten-man scouting patrol from D Company could not negotiate the sheer sides of the mountain, he and Pfcs. Fred M. "Fritz" Ferentz and Dale E. Olson pressed on alone. Upon reaching the top, they were challenged by four Japanese defenders and, after a brief fight, killed one and repelled the rest. Wieland says that he returned to base laden with captured maps, documents, a samurai sword, a pistol, and other spoils. Then he went back to the summit, where, he maintains, Joe Rosenthal asked him and Ferentz to help raise the second flag, but they declined out of respect for the men who hoisted the original.

Later, Wieland would receive the Silver Star for climbing Suribachi. Severance, however, argues that the citation "erroneously bears out" a false story. The citation reads, in part: "Leading his men toward the summit . . . in the face of heavy enemy rifle fire, he aided in repulsing several enemy attacks, including one hand-to-hand engagement. Under his skillful leadership, the patrol ascended to the summit of Mount Suribachi, the first American troops to reach this vital position."

5. Severance to Wetenhall, July 24, 1989.

6. Richard F. Newcomb, *Iwo Jima* (New York: Bantam, 1982), 93.

7. The chaplain's movements were recorded by him in a nine-page narrative entitled "Iwo Jima," written in 1945, shortly after the battle, and now in the papers of Father Suver, S.J., Tacoma, Wash. He confirmed many details in an interview with Wetenhall, Aug. 19, 1989. Haynes never had the chance to made good on his boast: he was struck in the back by a sniper's bullet while manning a machine gun at the foot of the mountain. Months later, Father Suver found Haynes recovering in Hawaii and converted him to Catholicism.

8. Lou Lowery, transcript of a videotape interview with Arnold Shapiro, 1985, p. 3, courtesy Arnold Shapiro Productions, Hollywood, Calif. On the Marines of Easy Company, see Bill D. Ross, *Iwo Jima: Legacy of Valor* (New York: Vintage, 1986), 88–92. For discussion of the first flag-raising, see Howard M. Conner, *The Spearhead: The World War II History of the 5th Marine Division* (Washington, D.C.: Infantry Journal Press, [1950]), 65–68; Bill Miller, "First Flag over Iwo," *Leatherneck* 56 (Feb. 1975), 28–37; "The Flag Raisings on Iwo Jima," *Leatherneck* 68 (Feb. 1985), 18–21.

9. Richard Wheeler, "The *First* Flag-Raising on Iwo Jima," *American Heritage* 15 (June 1964), 56. Wheeler himself was a member of Easy Company and was wounded on Iwo on Feb. 21 (D+2), 1945.

10. Lowery, interview with Shapiro, p. 3.

11. Chronicled, in this order, by Wheeler, *"First* Flag-Raising," 104.
12. 28th Marine Regiment, R-2 Journal, entries for the morning of Feb. 23, 1945, USMC Museum Archives.
13. The hole in the flagstaff, by which the flag was fastened to the length of pipe, has become a matter of dispute. Brig. Gen. Edwin H. Simmons, "The Iwo Jima Flag-Raisings," *Fortitudine* (Spring 1979), 4, cites a letter from Gene M. Marshall claiming that Hansen fired Schrier's carbine to pierce the pole. Lindberg, interview with Wetenhall, Aug. 17, 1989, maintains that the hole was already in the pipe. They would not have fired a shot anyway, he continues, for fear of attracting enemy attention. Wheeler, *"First* Flag-Raising," 104–105, says that while searching for a flagpole, Keller met an enemy soldier climbing out of a hole and shot him, starting a brief firefight around the cave openings. But Lindberg, in an interview with Benis M. Frank, Oct. 18, 1985, USMC Museum, Oral History Section, recalls that an eerie quiet settled over the mountaintop as they prepared for the raising: it was the sight of the American colors aloft, he says, that touched finally off the skirmish in his sector.
14. This is Lindberg's position in all the interviews cited above and in other newspaper reports. See, e.g., "He Helped Raise First Flag on Iwo Jima," *Minneapolis Star Tribune,* May 29, 1988.
15. 28th Marine Regiment, R-2 Journal, entries for midmorning, Feb. 23, 1945, USMC Museum Archives. Wheeler, *"First* Flag-Raising," 101. Suver, "Iwo Jima," and Holland M. Smith and Percy Finch, *Coral and Brass* (New York: Scribner's, 1949), 261.
16. Paul Hollister and Robert Strunsky, eds., *From Pearl Harbor into Tokyo: The Story as Told by War Correspondents on the Air* (New York: Columbia Broadcasting System, 1945), 199. 28th Marine Regiment, Unit Journal, Iwo Jima (A58-3), Feb. 23, 1945, USMC Museum Archives.
17. Ted White, interview with Wetenhall, Aug. 24, 1989, recalled that Fox Company followed closely behind Schrier's patrol, veering off toward the southern end of the crater. Lowery, interview with Shapiro, pp. 5–6.
18. Suver, "Iwo Jima."
19. A letter from Joe Rosenthal to Suver, March 18, 1955, in the Suver papers, verifies the time of the Mass in relation to the more famous second flag-raising. Rosenthal had previously thought that he took his picture around noon. But given Suver's account, he changed his mind: if the Mass took twenty-five minutes, he probably arrived at the summit just after it ended (since he saw nothing of the kind up there), or around 12:30. He then took pictures for another twenty-five minutes and "bummed a ration package for lunch" at 1:05, when he did check his watch. The end of his letter: "Sorry I missed Mass, Father!"
20. Ross, *Iwo Jima,* 98.
21. Lindberg, interview with Frank, Oct. 18, 1985.
22. 28th Marine Regiment, Unit Journal, Iwo Jima (A58-3), entry for Feb. 24,

1945, USMC Museum Archives. As ranking officer on top of Suribachi, Schrier also directed the flag substitution.

A transcript of Pryor's interview with Thomas for CBS is dated Monday, Feb. 26: D 4–6, 5th Marine Division, D–2 Mess, Feb. 23–26, 1945, Iwo Jima, USMC Museum Archives. But dating is further complicated by an entry in 28th Marine Regiment, R-2 Journal, for 10:00, Feb. 25, 1945: "Lt. Schrier, E. Co., requests copy speech broadcast from ship re capture Suribachi."

Another entry in the 28th Marine Regiment, Unit Journal, Iwo Jima (A58-3), for Feb. 27 (Tuesday) points to a second interview: "Request Platoon Sergeant Ernest I. Thomas report aboard Eldorado (AGC 11) today for repeat news broadcast with CT-28." See also Chapter 1, note 5, above.

23. Tech. Sgt. Keyes Beech, "Florida Hero of Suribachi Disclaims Chief's Plaudits," *Florida Times Union* (Jacksonville), March 16, 1945.

24. Transcript of Pryor's radio interview with Thomas, unpaginated, Feb. 26, 1945, USMC Museum Archives.

25. Lee Kennett, *G.I.: The American Soldier in World War II* (New York: Warner Books, 1989), 89–90.

26. Tom Bartlett, "Marines Don't Forget," *Leatherneck* 68 (Feb. 1985), 37. Beech, "Florida Hero."

27. Tech. Sgt. Keyes Beech, "Sgt. Ernest I. Thomas, Jr., Was Up Front Leading His Men When He Died," *Florida Times-Union* (Jacksonville), undated clipping in personnel file for Ernest Thomas, USMC Museum, Reference Section. This story erroneously stated that Thomas died on his twenty-first birthday, which would have been March 10. See also "Flag-Raising Hero Is Killed on His Birthday," *Daily Democrat* (Tallahassee), undated clipping in the same file.

28. Ross, *Iwo Jima*, 248–251. Ross, p. 257, suggests that Johnson may have been hit by friendly (U.S.) fire.

29. Lt. Col. Whitman S. Bartley, USMC, *Iwo Jima: Amphibious Epic* (Washington, D.C.: Historical Branch, USMC, 1954), 218–219, gives the casualty figures: 4,924 killed in action; 1,402 later died of wounds received; 449 missing and presumed dead; and 19,217 wounded in action—or total casualties of 25,992 with 6,775 dead. Miller, "First Flag over Iwo," 33, gives Keller and Michaels as uninjured. Wheeler, "*First* Flag-Raising," 104, adds Pfc. Graydon W. Dyce and Pvt. Philip L. Ward to the list.

30. See personnel files for Schrier, Lindberg, and Thomas, USMC Museum, Reference Section. Schrier's citation for the Navy Cross suggests that the ascent was undertaken "in spite of enemy small arms and artillery fire." A related press release claims that the platoon climbed "under heavy enemy artillery and sniper fire."

31. Other photos taken by Lowery reveal the face of the radio operator more clearly. These shots make it clear that the radioman was not an Indian and that he was more slender than Charlo. For the identification of Charlo, see Chapter 5. For Marshall, see Simmons, "Iwo Jima Flag Raisings," 4. Sever-

ance, however, says that he kept Marshall—his radioman for Easy Company—at the foot of the mountain. A letter from Nancy Jacobs of Walnut Creek, Calif, in the Severance papers (also published in *Us,* April 22, 1985) claims that her father, Raymond Jacobs, is the radioman in the picture. Jacobs was Fox Company's operator, but his daughter's claim has not been substantiated.

32. Lowery, interview with Shapiro, pp. 13, 12.

4 · Eyewitnesss to History

1. Harold Evans, *Pictures on a Page: Photojournalism and Picture Editing* (Belmont, Calif.: Wadsworth, 1978), 146; J. Campbell Bruce, "The War's Greatest Picture," *True,* Feb. 1955, 58.

2. Joe Rosenthal, interview with Benis M. Frank, June 25, 1975, p. 38, USMC Museum, Oral History Section.

3. Rosenthal used a 4×5 Speed Graphic for his AP pictures and took "personal" pictures with the Rolleiflex; see Susan D. Moeller, *Shooting War: Photography and the American Experience of Combat* (New York: Basic Books, 1989), 246. Joe Rosenthal with W. C. Heinz, "The Picture That Will Live Forever," *Collier's,* Feb. 18, 1955, 64. "Rosenthal Calls Iwo Jima Photo a Combination of Luck, Foresight," *Washington Star,* Nov. 9, 1954. The picture of Smith and Forrestal appeared in, e.g., *San Francisco Chronicle,* Feb. 27, 1945.

4. Bruce, "The War's Greatest Picture," 58. Holland M. Smith and Percy Finch, *Coral and Brass* (New York: Scribner's, 1949), 261, maintain that the climbers seen from the *Eldorado* (the same climbers Rosenthal's coxswain saw) were actually wearing fluorescent white panels on their backs to distinguish them from Japanese. These are certainly not visible in Lowery's photos.

5. Sheryle and John Leeckley, *Moments: The Pulitzer Prize Photographs* (New York: Crown, 1978), entry for 1945.

6. Rosenthal and Heinz, "The Picture That Will Live Forever," 64. See also "Joe Tells How He Got His Picture," *Detroit News Pictorial,* April 8, 1945. Whatever Rosenthal heard at the command post, it was not word that the flag was up. When he left that point, headed up Mount Suribachi, he still thought there was a chance at a picture. This fact makes the timing of the second photo especially difficult to establish. Official logs list the first flag-raising at 10:35 A.M., and in the earliest published reports Rosenthal says he was forty-five minutes late in getting to the top. But clearly neither Rosenthal nor his companions heard the tremendous outpouring of happy noise—whistles, horns, guns—that Lindberg and others recall greeting the sight of the first flag. Forrestal, who arrived on the beach shortly after Rosenthal did, saw the flag and heard the noise. Yet Rosenthal took Forrestal's picture, went ashore, and went straight to the command post without hearing either the noise or the news.

7. Walter Millis, ed., *The Forrestal Diaries* (New York: Viking, 1951), 30.

8. Richard Wheeler, *Iwo* (New York: Lippincott and Crowell, 1980), 161. A stern message on souvenir hunting went out to the troops several weeks later. See, e.g., 28th Marines, Message and Incident Log, March 15, 1945, USMC Museum Archives.

9. Col. Dave E. Severance to Henry I. Shaw, Jr., March 25, 1986, USMC Museum Reference Section, and ibid., undated USMC release ("Iwo Jima: Flags"), listing the second flag as "Ensign No. 7, Oct. 1943."

10. Danny J. Crawford, "The Flag Raisers of Mount Suribachi," *Marines* 17 (Feb. 1988), 28. Over the years, many pretenders have come forward, claiming to have played roles in the flag-raising. See, e.g., the case of Carl Jackel, a Californian who says he carried the second flag to the summit and handed it to a group of six waiting Marines (who appear in the Rosenthal photo, of course): David Ferrell, "Part of History," *Valley Morning Star* (Harlingen, Tex.), April 17, 1982. Another pretender claims to have toted Rosenthal's camera up Mount Suribachi for him: see Jack McKinney, "'Hell's Half-Acre,' Nightmares of Iwo Jima," *Philadelphia Daily News,* Feb. 20, 1981.

11. The conversation between Lowery and Rosenthal is quoted in "Iwo Jima Vet Recalls Real Flag Raising," *Blade-Tribune* (Oceanside, Calif.), May 29, 1988. It is also discussed in Arnold Shapiro's interviews with Rosenthal, p. 2, and with Lowery, pp. 6–7, courtesy Arnold Shapiro Productions, Hollywood, Calif. The meeting is also described in Boris Yaro, "No Glory for Iwo Jima '1st Cameraman'," *Los Angeles Times,* March 3, 1983.

12. For a spirited debate on whether or not the Rosenthal flagpole was the first flagstaff, reused (it wasn't!), see E. H. Simmons, "The Iwo Jima Flag-Raisings," *Fortitudine* (Spring 1979), 3–8.

13. Rosenthal, interview with Frank, p. 39.

14. "Masterpiece," *New Yorker,* April 7, 1945, 18. The wording and the substance of all the first-hand accounts are virtually identical. See, e.g., Rosenthal and Heinz, "The Picture That Will Live Forever," 65, and Rosenthal, interview with Shapiro, pp. 3–5.

15. Bruce, "The War's Greatest Picture," 59. Moeller, *Shooting War,* 246.

16. See photo in, e.g., *San Francisco Chronicle,* Feb. 28, 1945.

17. See Shirley Povich, "How Photographer Made Flag Picture," *Washington Post,* March 13, 1945. On press boats, see Lance Bertelsen, "Icons on Iwo," *Journal of Popular Culture* 22 (Spring 1989), 92–93.

18. Rosenthal, interview with Shapiro, pp. 7–9.

19. "Forrestal Tells of Iwo Battle," *Minneapolis Tribune,* Feb. 26, 1945, quotes the secretary watching the "tiny figures, scrambling skyward against a background of blue." The Rosenthal picture appeared on the same page. See Bertelsen, "Icons on Iwo," 88, for discussion of efforts to localize the men shown indistinctly in the wirephoto picture.

20. E.g., [Bill Hipple], "This Is Iwo: Hell's Own Island of Blood, Agony and Terror . . .," *Newsweek,* Feb. 26, 1945, 27. Paul Fussell, *The Boy Scout Handbook and Other Observations* (New York: Oxford University Press, 1982), 231–233.

21. The Iwo color detail was headed by Sgt. Anthony C. Yusy; see Emmett Crozier, "Bloody, Bitter Iwo—Ours," *American Legion Magazine* 38 (June 1945), 11. On the March raising, see also Michael Russell, *Iwo Jima* (New York: Ballantine, 1974), 138–140.

22. "The Famous Iwo Flag-Raising," *Life,* March 26, 1945, 17. Remarks of Rep. Joe Hendricks of Florida, March 1, 1945, *Congressional Record* 91, pt. 10 (79th Congress), A929. Newcomb, *Iwo Jima,* 405. "Iwo Jima" by Louanne Wilder, quoted in remarks of Rep. Gordon L. McDonough of California, *Congressional Record* 91, pt. 11 (79th Congress), A2627.

23. E.g., offer in the *Washington Post,* March 31, 1945, for a special Easter edition of its pictorial magazine, and "Iwo Photos Ready in Few Days," *San Francisco Chronicle,* May 3, 1945. I. Cohen, "'A Picture of My Son'," *New York Times Magazine,* April 1, 1945, 41.

24. Condensed version of Bruce, "The War's Greatest Picture": "The Picture That Thrilled the Nation," *Reader's Digest* 66 (Feb. 1955), 87. "Story of a Picture," *Time,* March 26, 1945, 60. General A. A. Vandegrift, as told to Robert B. Aspery, *Once a Marine* (New York: Norton, 1964), 283. Blanche McKnight, "Versatile Sculptor," *Sunday Star Pictorial Magazine* (Washington, D.C.), Feb. 13, 1949, 3. ". . . Sincerest Flattery," *Newsweek,* April 16, 1945, 82. Telephone transcript #838, Treasury Secretary Henry Morgenthau and Mr. Connolly, April 17, 1945, 9:04 A.M., pp. 1–2, Morgenthau Papers, Franklin D. Roosevelt Library, Hyde Park, N.Y.

25. UP report, "Marines Will Take Iwo, Commander Pledges," *Times-Union* (Rochester, N.Y.), Feb. 22, 1945. UP report, "Marines Win Iwo Peak Fort," ibid., Feb. 23, 1945.

26. E.g., "Marines Gain 2nd Airfield," *Times-Union,* Feb. 24, 1945. "Marines Seize Tip to Iwo Airfield," *San Francisco Chronicle,* Feb. 24, 1945.

27. "Navy Answers a Woman's Cry at Iwo Losses," *New York Post,* March 16, 1945. Forrestal replied: "There is no short cut or easy way." The military had considered the use of poison gas against Iwo Jima; the White House forbade it. John Toland, *The Rising Sun: The Decline and Fall of the Japanese Empire, 1936–1945* (New York: Random House, 1970), 659.

28. See AP story, "Marines Irked By Editorial," *Times-Union,* Feb. 28, 1945, and "Marines Resent 'Slur': Riot Call in San Francisco," *New York Post,* Feb. 28, 1945. "The Marines and MacArthur," *San Francisco Chronicle,* Feb. 28, 1945.

29. Frankfurter quoted in Moeller, *Shooting War,* 20. David Brinkley, *Washington Goes to War* (New York: Ballantine, 1988), 105; Ross Gregory, *America 1941: A Nation at the Crossroads* (New York: The Free Press, 1989), 31. Wilbur Zelinsky, *Nation into State: The Shifting Symbolic Foundations of American Nationalism* (Chapel Hill: University of North Carolina Press, 1988), 203. Rosenthal, interview with Frank, p. 39., and interview quoted in Moeller, *Shooting War,* 224.

30. Remarks of Rep. Homer D. Angell of Oregon, March 9, 1945, *Congressional Record* 91, pt. 10 (79th Congress), A1106-07. "Photographer Wins Praise for

War Job," *New York Times,* Feb. 25, 1945. See Ellen Austin, "Iwo Jima Remembered," *VFW,* Sept. 1984, 36, and Tom Bartlett, "Gallagher Rule," *Leatherneck* 68 (March 1985), 50–51.

31. "Art from Life in Defiance of Death," *Times-Union,* Feb. 27, 1945.

32. Rosenthal and Heinz, "The Picture That Will Live Forever," 66. The confusion is still being discussed: see AP report, Sandy Colton, "Despite Rumors, Iwo Jima Flag-Raising Wasn't Posed," *Antigo Daily Journal* (Wis.), Feb. 1, 1989. Alvin M. Josephy, Jr., "Iwo Jima," *American Heritage* 32 (June/July 1981), 100.

33. "Story of a Picture," *Time,* March 26, 1945, 60. By way of retraction for its doubts, *Time* printed the picture but was careful to quote its own prior suspicions. W. C. Heinz, "The Unforgettable Image of Iwo Jima," *50 Plus,* Feb. 1985, 61, accuses Sherrod of casting doubt on the picture. The radio show is quoted in Rosenthal to E. H. Simmons, Dec. 6, 1984, USMC Museum Archives. Robert L. Sherrod, "Another View of the Iwo Flag Raisings," *Fortitudine,* Winter, 1980–81, 7–10, actually raises more questions about that reporter's persistent role in the affair than it answers.

34. "Masterpiece," *New Yorker,* 18.

35. Bartlett, "The Flag Raisings on Iwo Jima," 20–21. The Genaust footage was used in 1945 in the Marines' highly acclaimed publicity film *To the Shores of Iwo Jima.* It is readily available in home video versions today. See *Heritage of Glory: The United States Marine Corps Story,* produced by Turner Broadcasting System in cooperation with the Department of Defense, ISBN #1-55607-143-4 (1985).

36. For Thomas, e.g., AP report, Morrie Landsberg, "Hero of Suribachi Flag Climb Still Bewildered," *Times-Union,* Feb. 26, 1945. It was obviously in the best interests of the Marines not to have the public thinking that fakery was involved. But Sherrod, "Another View," 9–10, would have it that Capt. Edward Steichen, then on naval duty, asked him to suppress word that Rosenthal's picture was not of the first raising—for the good of the Marines. Rosenthal, according to all contemporary sources, was perfectly candid from the outset about "getting there late."

Even among those who accept the Lowery and Rosenthal photos for what they are, there is a tendency to think the first raising was superior. See, e.g., Richard Wheeler, "The *First* Flag-Raising on Iwo Jima," *American Heritage* 15 (June 1964), 105, stating, correctly, that the second was less "impromptu and dangerous." And many authors—including those claiming some expertise about Iwo Jima photos—persist in the belief that Joe Rosenthal faked his picture. For the most glaring recent example, see Marianne Fulton, *Eyes of Time: Photojournalism in America* (Boston: Little, Brown, 1988), 160–161.

37. ". . . Sincerest Flattery," *Newsweek,* 82. "Rosenthal Gets Award," *New York Times,* June 6, 1945. "The Pulitzer Awards for 1944 Announced," ibid., May 8, 1945. Mary Braggiotti, "He Captured a Highlight," *New York Post,* March 29, 1945. Rosenthal and Heinz, "The Picture That Will Live Forever," 61. The

photo was also reproduced in hamburger! Records of the Pasadena Tournament of Roses for 1946, reproduced in a letter to Marling, Jan. 11, 1989.

38. Charles R. Townsend, *San Antonio Rose: The Life and Music of Bob Wills* (Urbana: University of Illinois Press, 1976), 240, 347, and "Strictly by Ear," *Time,* Feb. 11, 1946, 50–51. The lyrics cited here were transcribed from a rare tape provided by Bob Pinson of the Country Music Foundation, Nashville. The band had success with several other war songs, including one based on the Okinawa campaign. A song by James McHugh titled "There's a New Flag on Iwo Jima" was also registered for copyright in July 1945; see Richard R. Lingeman, *Don't You Know There's a War On? The American Home Front, 1941–1945* (New York: G. P. Putnam's, 1976), 223.

39. "Iwo Flag Picture Ousts News," *New York Times,* Feb. 28, 1945. On Marine reaction to news from home, see Jeter A. Isely and Philip A. Crowl, *The U.S. Marines and Amphibious War* (Princeton: Princeton University Press, 1951), 488.

40. "Persistence Gains Recognition for World War II Sculptor on Iwo Jima," *The Link,* July 1985, 3. (A newsletter published by Litton Systems, Inc., of California, *The Link* is in the papers of Jon D. Allen, Alexandria, Va.) See "Iwo Jima Still Bears Scars of U.S. Victory," *Los Angeles Times,* Feb. 24, 1954. Illustrated many times since the war, the relief has previously been credited to a Coast Guardsman stationed on the island in the 1960s or an "unknown Marine." See, e.g., Henry L. Charlesworth, "Iwo Today," *Leatherneck* 38 (Feb. 1955), 18. It remains an attraction for the island's few tourists and has been repainted frequently over the years, most recently by Robert Hoskins and Jon Allen in advance of the "return" of American veterans in 1985.

5 · The Shifting Sands of Heroism

1. "Error Disguises Famous Name's Part in Exploit," *Daily Missoulian,* March 2, 1945.

2. Remarks of Rep. Mike Mansfield of Montana, March 7, 1945, *Congressional Record* 91, pt. 10 (79th Congress), A1061-62.

3. *Yank* (Pacific edition), March 16, 1945.

4. Remarks of Rep. Joe Hendricks, March 1, 1945, *Congressional Record* 91, pt. 10 (79th Congress), A929. Remarks of Senator Joseph C. O'Mahoney, March 12, 1945, A1133-34.

5. There is some disagreement about the timing of the inquiry. A letter from Oscar Peatross, Chief Operations Officer of the 28th Marines, quoted in Albert Hemingway, *Ira Hayes: Pima Marine* (Lanham, Md.: University Press of America, 1988), 119, testifies that Schrier got a copy of the Rosenthal photo while he was "still on top of the mountain." According to Peatross, the identification of the fifth man occurred "shortly afterwards." But in a letter to

Wetenhall, July 24, 1989, Col. Dave Severance thought that the inquiry might have taken place two to three weeks after the flag-raising.

6. John Bradley, transcript of videotape interview with Arnold Shapiro, 1985, p. 7, courtesy Arnold Shapiro Productions, Hollywood, Calif.

7. Severance to Wetenhall, July 24, 1989.

8. Bill D. Ross, *Iwo Jima: Legacy of Valor* (New York: Vintage, 1986), 250–251; Richard F. Newcomb, *Iwo Jima* (New York: Bantam, 1982), 182, 235. Severance to Wetenhall, July 24, 1989. Bill Griffin, "Kentuckian Helped Raise Old Glory on Iwo Jima," *Rural Kentuckian* 26 (July 1974), 4.

 The congressional investigation was begun at the request of Congressman Milton H. West, responding to the pleas of a constituent, Mrs. Ada Block of Weslaco, a town in his south Texas district. After a six-month inquiry (Sept. 1946 to Feb. 1947), the Marine Corps officially changed the identification of the flag-raiser at the base of the pole in the Rosenthal picture from Henry Hansen to Harlon Block. The records of the inquiry were deaccessioned by the USMC Museum Archives in 1972 and transferred to the custody of General Arthur B. Hanson of the Marine Corps War Memorial Foundation; our search for them in the Hanson papers proved unsuccessful, however. See "Marines Rechecking Flag Raisers at Iwo," *New York Times,* Dec. 15, 1946, and Hemingway, *Ira Hayes,* 149.

9. Bradley won the Navy Cross for his valor in aiding wounded Marines: see personnel file for John Bradley, USMC Museum, Reference Section. His citation was for action during the charge to the base of Suribachi on Feb. 21, the same day Thomas took charge of the Second Platoon, Easy Company. For reasons that remain clouded, the decoration was delayed and was only awarded in September 1947, after the personal intervention of Colonel Severance.

10. Beech's priority orders of transfer, March 23, 1945, are recorded in D4–14, 5th Marine Division, D-2 Mess, March 18–27, 1945, Iwo Jima, USMC Museum Archives. 28th Marine Regiment, Unit Journal, Iwo Jima (A58-1), entry for March 23, USMC Museum Archives.

11. The proposed coin is mentioned in "The Famous Iwo Flag-Raising," *Life,* March 26, 1945, 17. Shirley Povich, "How Photographer Made Flag Picture," *Washington Post,* March 13, 1945, observed that the photo had "all the beauty of a sculptural piece." See also letter to the editor from Mrs. J. F. Provoo, "Old Glory on Suribachi," *San Francisco Chronicle,* Feb. 28, 1945.

12. Remarks of Sen. Raymond Willis, March 13, 1945, *Congressional Record* 91, pt. 10 (79th Congress), 2079. Remarks of Rep. Brooks Hays, March 15, 1945, ibid., 2273. Remarks of Rep. Joe Hendricks, March 1, 1945, ibid., A929. According to "House Bill Seeks Iwo Flag-Raising Monument Here," *Washington Star,* March 2, 1945, legislation authorized the Secretary of the Navy to select an artist, who would be flown to Iwo Jima to study details of the site.

13. "The Flag above Iwo Jima," *The Oregonian,* March 3, 1945, introduced into *Congressional Record* 91, pt. 10 (79th Congress), A1106–07, by Rep. Homer D. Angell, March 9, 1945. Remarks of Sen. Willis, March 13, 1945, ibid., 2079–80.

14. The story of de Weldon's first statue is included in the remarks of Rep. Brooks Hays, March 1, 1946, *Congressional Record* 92, pt. 9 (79th Congress), A1083. It is also discussed in "Dedication of Iwo Statue Also a Tribute to Sculptor," *Quantico Sentry,* Nov. 8, 1951. Details confirmed by de Weldon in interviews with Wetenhall conducted at the sculptor's home and studio in Newport, R.I., July 18, 1988, and June 20, 1989.

15. See office diary, "The President's Engagements," entry for June 4, 1945, in Harry S. Truman Library, Independence, Mo. At least two versions of this early Iwo Jima statue still exist, one in the Truman Library and another in the Museum of the United States Naval Academy, Annapolis. The version at Annapolis now carries a flag of perforated bronze, but publicity photos show that when General Vandegrift presented it on June 28, 1946, the flag was of solid, incised metal.

16. Remarks of Sen. Joseph C. O'Mahoney, March 12, 1945, *Congressional Record* 91, pt. 10 (79th Congress), A1133-34. "Flag-Raising Stamp," *Washington Star,* March 12, 1945. California State Legislature, March 30, 1945, Senate Joint Resolution no. 17, "relative to the issuance of a United States postage stamp reproducing Joe Rosenthal's photograph." Letters from private citizens supporting the stamp idea have been preserved in the Iwo Jima file, the National Philatelic Collection, National Museum Of American History, Smithsonian Institution, Washington, D.C.

17. Letters detailing postal department objections are also included in the Iwo Jima file, National Philatelic Collection, NMAH; these expressions of doubt came after the department had already announced initial enthusiasm. See "Flag Picture May Go on Stamp," *New York Times,* March 23, 1945.

18. Gridley Adams to the President, June 7, 1945, in Iwo Jima file, National Philatelic Collection, NMAH. This is one of many letters of protest from Adams's committee in this file.

19. Post Office memorandum, July 16, 1945, in Iwo Jima file, National Philatelic Collection, NMAH. Letter from Philip G. Nordell, "Pictures on Stamps," *Evening Bulletin,* (Philadelphia), June 14, 1945.

20. For the chronology of the approval process, see "Reproduction of Picture Doubted for Iwo Stamp," *New York Times,* May 27, 1945; "Iwo Raising of the Flag to Go on 3-Cent Stamp," ibid., June 7, 1945; "Iwo Jima Design," ibid., June 10, 1945; and "News of Stamp World," ibid., June 17, 1945.

21. Postmaster General Robert E. Hannegan, remarks during first-day ceremonies for Iwo stamp, quoted in Sol Glass, *United States Postage Stamps: 1945–1952* (West Somerville, Mass.: Bureau Issues Association, n.d.), 18. According to Glass, p. 20, first-day sales were impressive: 400,279 first-day covers were cancelled and 2,731,487 stamps sold.

22. J. de M. Cirne Crane, *The United States Marines: A Pictorial History of the Marines* (Baton Rouge, La.: Army and Navy Publishing Co., 1952). Folder "Flag, Iwo," USMC Museum, files of the curator for special projects, contains memoranda showing that three Iwo Jima flags—those in the Lowery and Rosenthal pictures and the one officially raised three weeks later at the Corps command post on Iwo Jima—were donated to the museum on July 18, 1945.

23. Lt. Col. John G. Johnson presided. Gen. Lemuel C. Shepherd, future commandant of the Marines, selected G Company, 22nd Marines, for the honor. The men who participated were Sgt. Samuel S. Semetsis, Sgt. Narolian H. West, Pfc. Daniel Dereschuk, and Hospital Apprentice 2d Class Joseph Bangert: see Bevan G. Cass, ed., *History of the Sixth Marine Division* (Nashville: Battery Press, 1987), 175–177. (The spelling of some names has been corrected by Edward L. Fox, former member of G Company and founding sponsor of the joint American-Japanese memorial on Okinawa, dedicated in 1987: Fox to Wetenhall, undated letter, summer 1989.)

24. The layers of imagery and intention are tricky. The Marines on Okinawa emulated a picture they thought showed the actual capture of Suribachi (whereas it really showed a flag-substitution rite performed well after the seizure of the peak). In other words, the Okinawa ceremony was meant to look like an impromptu gesture—just like the Rosenthal photo, which the participants believed to be a real battle scene. The Okinawa flag-raising was a media icon by intent, therefore, while the Iwo Jima raising became one by accident. Both images artificially evoked the improvisations of combat. But the Okinawa raising was a ceremony based on a ceremony (mistaken for a battle), twice removed from the act of conquest.

25. Remarks of Rep. Joe Hendricks, March 1, 1945. Remarks of Sen. Joseph C. O'Mahoney, March 12, 1945.

26. "Joe Rosenthal Flies In," *San Francisco Chronicle,* March 18, 1945. Remarks of Sen. Raymond Willis, March 13, 1945. Vandegrift, address to the Textile Square Club, Hotel Astor, New York, March 20, 1945, USMC Museum, Personal Papers Section, Vandegrift Papers, Box 7 (Speeches). Edmund C. Mayo, President, Gorham Mfg. Co., to Vandegrift, May 10, 1945, USMC Museum, Personal Papers Section, Vandegrift Papers, Box 5 (Correspondence).

27. "The Famous Iwo Flag-Raising," *Life,* March 26, 1945, 17. "Story of a Picture," *Newsweek,* March 26, 1945, 60.

28. Morgenthau Diaries, vol. 832, p. 66 (transcript of phone conversation between Morgenthau and Admiral Brown, March 24, 1945), in Franklin D. Roosevelt Library, Hyde Park, N.Y.

29. Ibid. Louis Rupple, executive editor of the Chicago *Herald American,* had suggested to FDR that the flag-raisers be brought home.

30. "A Marine Returns to Identify His Buddies on Iwo," *New York Times,* April 10, 1945. See also "Three of Six Who Raised Flag on Mt. Suribachi Are Dead," *New York Herald Tribune,* April 10, 1945. Sgt. Michael Strank, whom Gagnon

identified as one of the flag-raisers, thought Gagnon looked like a movie star; see "The Youngest Flag Raiser," *Leatherneck* 68 (Feb. 1985), 29.

31. Hemingway, *Ira Hayes,* 129, 130.
32. Morgenthau Diaries, vol. 839, p. 18, in FDR Library.

6 · The Mighty Seventh

1. Louis Effrat, "3 Surviving Service Men Who Raised Flag on Iwo Steal Show before Contest," *New York Times,* April 21, 1945. Al Castello, "Iwo Jima Heroes Cheered; Opening Day Throng Pays Tribute to Late President," *Washington Post,* April 21, 1945.
2. "President Receives War Loan Painting," *Washington Post,* April 21, 1945.
3. John Morton Blum, *Roosevelt and Morgenthau* (Boston: Houghton Mifflin, 1970), 426.
4. Richard Polenberg, *War and Society: The United States, 1941–1945* (New York: Lippincott, 1972), 29.
5. Jarvis M. Morse, "Paying for a World War: The United States Financing of World War II" (ca. 1971), 275, and Laurence M. Olney, "The War Bond Story" (1971), 93, typescripts in the library of the U.S. Treasury Department, Washington, D.C.
6. Joe Rosenthal, interview with Benis M. Frank, June 25, 1975, pp. 62, 72, USMC Museum, Oral History Section. "Rosenthal Gets Photographic Welcome Here," *Washington Post,* March 31, 1945.
7. C. C. Beall illustrated a number of war stories for *Collier's;* see "Official Poster for Seventh War Loan, Marines Raising Flag on Iwo Jima," *Collier's,* May 12, 1945, 74. "Story of the Iwo Jima Flag Photo," *San Francisco Chronicle,* Feb. 3, 1955. "Famous War Picture Inspires War Bond Insignia," *New York Times,* March 25, 1945. Several painted versions of the Rosenthal picture date from 1945, including those by Howard Chandler Christy (who had done Marine recruiting posters during World War I), Major John Capolino (his was presented to the Senate Naval Committee by General Vandegrift in Sept. 1945), and Tom Lovell.
8. Minutes of poster committee meeting, March 26, 1945, National Archives, Treasury Department correspondence regarding graphic material for campaigns, Folder: "War Bonds," Record Group 208, E237, Box 1126C. "Famous War Picture Inspires War Bond Insignia," *New York Times,* March 25, 1945. The clamor for nongovernmental, commercial use of the Rosenthal picture had begun before the photographer came home. A promoter offered him $200,000 in cash for exclusive use of the image. Congressman W. Sterling Cole of New York, sensing its value, introduced a bill authorizing the Navy to acquire the rights. "This photograph," said Cole, "has been accepted by the public as representative of all the forces at work in this war." Instead, the Associated Press agreed to allow free federal use for the war effort and to

turn the proceeds for commercial use over to Navy relief projects (a practice no longer in effect). See "Cole Offers Bill to Buy Rights to Suribachi Flag Picture," *New York Times,* April 24, 1945; "Lauds AP on Flag Photo Sale," ibid., April 28, 1945; Kent Cooper, *Kent Cooper and the Associated Press: An Autobiography* (New York: Random House, 1959), 240.

9. E.g.,"14 Billion Again," *Business Week,* April 7, 1945, 73; "Iwo Jima Flag Raising Picture To Spark Appeals," *New York Times,* April 10, 1945.

10. E.g., Mary Braggiotti, "He Captured a Highlight in History," *New York Post,* March 29, 1945; "Joe Tells How He Got Historic Picture," *Detroit News,* April 8, 1945. "Official War Loan Poster," *Christian Science Monitor,* May 7, 1945.

11. Marc Parrott, *Hazard: Marines on Mission* (Garden City, N.Y.: Doubleday, 1962), 217. Albert Hemingway, *Ira Hayes: Pima Marine* (Lanham, Md.: University Press of America, 1988), 131.

12. "Iwo Flag Raised at Capitol," *Washington Post,* May 10, 1945.

13. Cosmetic improvements to the flag are discussed in William Bradford Huie, *The Hero of Iwo Jima and Other Stories* (New York: Signet, 1962), 37. "Two Heroes Raise Famed Flag from Suribachi over Capitol," *Washington Evening Star,* May 9, 1945.

14. Undated sample ad (ca. Feb. 1945), National Archives, Treasury Department records relating to war bond drives, Folder: Seventh War Loan, RG 208, E54, Box 177. A. A. Hoehling, *Home Front, U.S.A.* (New York: Thomas Y. Crowell, 1966), 136. "Iwo Jima Statue to Be Unveiled in Bond Drive," *Washington Times-Herald,* Nov. 7, 1945.

15. "For a United People," *Time,* May 28, 1945, 14. Betty Grable's hosiery was worth $40,000. "Exhibitors Move into Front Line for 7th Bond Drive," *Motion Picture Herald* 159 (May 5, 1945), 35. Untitled program listing, *Washington Post,* May 14, 1945. Henry Morgenthau, Jr., to Bing Crosby, March 22, 1945, Morgenthau Diaries, vol. 831, p. 80, Franklin D. Roosevelt Library, Hyde Park, N.Y. Jimmy McHugh wrote "Buy, Buy Bonds" and a number of other popular bond songs of 1945.

16. Rolfe Boswell, *Medals for Marines* (New York: Thomas Y. Crowell, 1945), 126. "Jersey Marine Died 1st Day on Iwo," *New York Post,* March 8, 1945.

17. Parrott, *Hazard,* 216. Resentment in the 28th about the extraction of the survivors of the second raising was strong, according to Charles Lindberg; see Michele Greenwell, "The Forgotten Man of Mount Suribachi," *Twin Cities Reader* (Minn.), May 22–30, 1989, 12. Front-line reaction is discussed in Walter Davenport, "Poisonous Little Iwo," *Collier's,* March 31, 1945, 17. For Gagnon, "Lone Marine Survivor of Iwo Photo Due Home," *New York Times,* April 7, 1945. For Bradley, "Bond Rally Cheers Iwo Flag Heroes," *Chicago Sun,* May 20, 1945. In his introduction to George P. Hunt, *Coral Comes High* (New York: Harper, 1946), x, Vandegrift discusses the Marine's need for the respect of his comrades.

18. "Greeting to Men who Participated in Flag Raising on Iwo Jima," April 20,

1945, *Congressional Record* 91, pt. 3 (79th Congress), 3611. "State E-Bond Goal Set at $460,000,000," *New York Times,* May 11, 1945. "Statue to Stand in Times Square for War Loan Drive," ibid., April 27, 1945.

19. "St. Albans to Get Iwo Statue," *New York Times,* Oct. 5, 1945. The statue in Times Square went to the hospital in Queens at the conclusion of the drive. "Statues Unveiled for 7th War Loan," ibid., May 12, 1945.

20. Huie, *Hero of Iwo Jima,* 41. Hemingway, *Ira Hayes,* 131.

21. A 1957 memo from Beech, quoted in Huie, *Hero of Iwo Jima,* 38.

22. Hayes, letter of May 10, 1945 (on Waldorf stationery), quoted in Huie, *Hero of Iwo Jima,* 38. "Iwo Jima Heroes and Flag They Flew to Feature Seventh War Loan Parade," *Christian Science Monitor,* May 9, 1945; "Wounded Vets to Open Drive for War Loan," ibid., May 4, 1945. "Purple Heart Parade Tomorrow," ibid., May 13, 1945; "Big War Loan Drive Off to Lively Start," ibid., May 14, 1945. Rain forced cancellation of a demonstration of field maneuvers on the Common. Joe Rosenthal had been expected to visit Boston during the event—for an emotion-filled "meeting" with the three raisers?—but did not do so.

23. Bernard C. Nalty, *The United States Marines on Iwo Jima: The Battle and the Flag Raising* (Washington, D.C.: Historical Division, USMC, 1970), 7. "Iwo Heroes—And Mothers of Three Left There—Open Bond Drive," *Democrat and Chronicle* (Rochester, N.Y.), May 16, 1945.

24. Hayes, letter written from the Statler Hotel in Boston, May 14, 1945, quoted in Huie, *Hero of Iwo Jima,* 39.

25. "Main Street Stage Set Up in Bond Drive," *Times-Union* (Rochester, N.Y.), May 10, 1945. Ad, "Three Heroes of Iwo Jima Will Be Here *In Person!*" *Democrat and Chronicle,* May 16, 1945. "10-Million Bond Goal Set for 55 Industries," *Times-Union,* May 15, 1945.

26. "City Opens Bond Drive, Chilly But Enthusiastic," *Democrat and Chronicle,* May 17, 1945. "Fete Tonight to Open City Bond Drive, Iwo Jima Heroes Highlight Parade," ibid., May 16, 1945. "There I Am!" ibid., May 17, 1945. "Iwo Jima Flag Heroes Push City Bond Drive, But They'd Rather Be Sticking to Fighting Job," *Times-Union,* May 16, 1945.

27. "Iwo Hero Prefers Action to Steak Feasts," *Democrat and Chronicle,* May 17, 1945.

28. "100,000 Crowd Loop Center in 7th Bond Rally," *Chicago Daily Tribune,* May 20, 1945. Rene Gagnon, Jr., remembered hearing from his father that "there was a lot of heavy drinking on that tour": see Mary Elson, "For Flag Raisers at Iwo Jima, Fame Carried Heavy Price," *Sentinel-Star* (Orlando, Fla.), Oct. 29, 1979.

29. Jim Leusner, "Corps Hushed First Flag-Raising Says Flagman in 2nd Photo," *Times-Union* (Jacksonville, Fla.), March 18, 1978. "Bond Rally Cheers Iwo Flag Heroes," *Chicago Sun,* May 20, 1945. "Hero Tells Story of Flag Raising," ibid., May 19, 1945.

30. "Lives and Loan Contrasted," *Chicago Sun,* May 20, 1945. Huie, *Hero of Iwo Jima,* 41.

31. "Iwo Flag Raisers Visit Chicago," *Chicago Daily Tribune,* May 19, 1945. Keyes Beech, quoted in Huie, *Hero of Iwo Jima,* 42. For Vandegrift's discovery of Hayes's condition, see also William Bradford Huie, "Our Torture Execution of Marine Hero Ira Hayes," *Cavalier,* Dec. 1958, 55.

 The text of Vandegrift's speech at Soldier Field (dated May 20, 1945) suggests his disgust with Hayes may have been heightened by personal circumstances. His son had been wounded on Iwo Jima and the general had just returned from a pilgrimage to see "the spot where these men had so gallantly raised their flag." USMC Museum, Personal Papers Section, Vandegrift Papers, Box 8 (Speeches).

32. "'American Day' Welcomes New Citizens Today," *Chicago Daily Tribune,* May 20, 1945. "Rally Warned of Sacrifices Still to Come," *Chicago Sun,* May 21, 1945. "Keep Isle Bases, 3 Heroes Plead, Unfair to Dead Marines to Give Them Away," *Chicago Daily Tribune,* May 21, 1945. In 1945, "I Am an American" rallies were held nationwide. At the Rochester, New York, edition, for instance, high school students in costume reenacted the Iwo Jima flag-raising; see "Iwo Tableau Highlights Citizenship Glory," *Democrat and Chronicle,* May 21, 1945.

33. Beech, quoted in Huie, *Hero of Iwo Jima,* 44. Unidentified clipping, "Ira Hayes Abandons Bond Sales Tour to Fight War," May 25, 1945, Arizona State Library and Archives, Phoenix. Unidentified clipping, "Iwo Heroes Due at Rally Here," [*Tucson Citizen?*], June 5, 1945, Arizona Historical Society, Tucson.

34. Quoted in Joe Rosenthal with W. C. Heinz, "The Picture That Will Live Forever," *Collier's,* Feb. 18, 1955, 67.

35. From a letter from Hayes to his mother, July 16, 1945, quoted in Huie, *Hero of Iwo Jima,* 45. For the reaction to Hayes in his old outfit, see Hemingway, *Ira Hayes,* 133–135.

7 · Guts and Glory: *Sands of Iwo Jima*

1. *The Iwo Jima Flag Raising: The Event and the People* (Washington, D.C.: Historical Division, USMC, 1962), 8, 11–12.

2. Strank was reburied at Arlington in January 1949; see James Edward Peters, *Arlington National Cemetery: Shrine to America's Heroes* (McLean, Va.: Woodbine, 1986), 168. H. H. Arnold, *Global Mission* (New York: Harper, 1949), 567, tells of encountering Japanese belligerents on Iwo Jima several months after the island was declared secure. The Army estimated that 200 more enemy troops were hiding underground. Capt. Raymond Henri et al., *The U.S. Marines on Iwo Jima* (New York: Dial Press, 1945), 232. Edwin P. Hoyt,

Closing the Circle: War in the Pacific, 1945 (New York: Van Nostrand Reinhold, 1982), 107, 129. Gordon Thomas and Max Morgan Witts, *Enola Gay* (New York: Pocket Books, 1977), 257.

3. *The Iwo Jima Flag Raising,* 11–12. Postwar expectations among vets are discussed in William L. O'Neill, *American High: The Years of Confidence, 1945–1960* (New York: Free Press, 1986), 6.

4. "Marines Rechecking Flag Raisers at Iwo," *New York Times,* Dec. 15, 1946. See also "Ira Hayes—Our Accuser," *Christian Century,* Feb. 9, 1955, 167. For the investigation see, e.g., personnel file for Lt. Col. Harold G. Schrier, USMC Museum, Reference Section, and Commandant of Marine Corps to Capt. Dave E. Severance, Dec. 16, 1946, in Severance papers, La Jolla, Calif. During the same period, there was a move in Congress to award the Medal of Honor to the flag-raisers, and the Marines conducted an inquiry among Iwo officers on that issue as well. The inquiry resulted in the determination that "the act itself" was not a sufficient demonstration of heroism to merit any citation.

5. "Iwo Jima Heroes in V-J Day Ceremony," *New York Times,* Aug. 16, 1946. Taped interview with Chuck Lindberg, Oct. 18, 1985, USMC Museum, Oral History Section. Lindberg met Gagnon and the others at the Soldier Field rally in 1945. "Gagnon kind of made one mad with some of his stories," he said. "I was ready to clobber him."

6. Gagnon and Hayes quoted in "Found Iwo Raisers Disillusioned by Vets' Treatment after a Year of Peace," Aug. 14, 1946, unidentified clipping, personnel file for Rene Gagnon, USMC Museum, Reference Section.

7. Adaptations of all sorts are mentioned in J. Campbell Bruce, "The War's Greatest Picture," *True,* Feb. 1955, 58; W. C. Heinz, "The Unforgettable Image of Iwo Jima," *50 Plus,* Feb. 1985, 59; and Joe Rosenthal with W. C. Heinz, "The Picture That Will Live Forever," *Collier's,* Feb. 18, 1955, 62. Vandegrift to Edmund C. Mayo, May 5, 1945, USMC Museum, Personal Papers Section, Vandegrift Papers, Box 5 (Correspondence). "Minutes of First Annual Meeting of Board of Directors of Marine Corps War Memorial Foundation, Inc.," June 16, 1949, in papers of Arthur B. Hanson, USMC Museum, Personal Papers Section.

8. Russell Earl Shain, *An Analysis of Motion Pictures about War Released by the American Film Industry, 1930–1970* (New York: Arno, 1976), 31. Ivan Butler, *The War Film* (South Brunswick, N.J.: A. S. Barnes, 1974), 82.

9. Lawrence H. Suid, *Guts and Glory: Great American War Movies* (Reading, Mass.: Addison-Wesley, 1978), 94–95.

10. James Edward Grant, who shared the writing credit with Brown, was brought in by Wayne to rewrite his dialogue. Jack McKinney, "'Hell's Half Acre': Nightmares of Iwo Jima," *Philadelphia Daily News,* Feb. 20, 1981, outlines the claims of a man who insisted that he had written a screenplay on Iwo Jima for the Marine Corps which the Corps subsequently sold to Republic for a John Wayne movie. Rumor also has it that a *real* Sergeant Stryker, USMC,

successfully sued Republic for invasion of privacy when the movie came out, but lost on appeal.

11. Wayne quoted in Suid, *Guts and Glory,* 96. Sgt. William Milhon, "'Sands of Iwo Jima'," *Leatherneck* 32 (Nov. 1949), 9. *Motion Picture Herald* 176 (July 23, 1949), 33. Filming ended on Sept. 17.

12. Grainger quoted in Ezra Goodman, "From the Halls of Montezuma to Hollywood, General Smith Leads Marines Again in Movie Reenactment of Tarawa and Iwo Jima," *New York Times,* Aug. 7, 1949. L. E. Fribourg to Marling, April 3, 1989. Occasionally, Fribourg was overruled by Marine headquarters, as when he objected to the famous scene in which Wayne hits a recruit in the jaw with a rifle butt (to teach him a valuable lesson). With Wayne's connivance, the incident stayed in the picture.

13. Goodman, "From the Halls of Montezuma." The film's art director, James Sullivan, made the ersatz Suribachi approximate people's idea of what Iwo Jima looked like by a liberal dose of oil and lampblack, applied after the area had been blackened with a flamethrower. The flag's trip from Quantico is detailed in "Survivors of Historic Iwo Jima Flag Raising Reunited in California," unidentified clipping, July 25, 1949, Arizona Historical Society, Tucson.

14. See, e.g., "Survivor and Star," *Washington Post,* Jan. 25, 1950, and illustrations in "Movies Try to Capture Marine Spirit," *Marines* 15 (Dec. 1986), 25. Presumably de Weldon's appearance was facilitated by the Marines, but it is curious that Rosenthal was never involved in the project. Perhaps the AP copyright was the stumbling block; having de Weldon pose the raisers would make it clear that this was *not* the Rosenthal version. Gagnon quoted in Wes Barthelmes, "Ira Hayes Is Buried, Lies Near Generals," *Washington Post and Times Herald,* Feb. 3, 1955.

15. Shoup quoted in Suid, *Guts and Glory,* 95, 98. Goodman, "From the Halls of Montezuma." Tom Bartlett, "John Wayne and 'The Sands of Iwo Jima'," *Leatherneck* 68 (Feb. 1985), 38, credits Shoup with the realism of this whole section of the movie.

16. H.H.T., "'Sands of Iwo Jima,' Starring John Wayne, at the Mayfair," *New York Times,* Dec. 31, 1949. Review, *Variety,* Dec. 14, 1949. John McCarten, review, *New Yorker,* Jan. 14, 1950, 76. See also Richard L. Coe, "'Iwo' Magnificent in Fighting Shots," *Washington Post,* Jan. 25, 1950.

17. Agee quoted in Raymond Fielding, *The American Newsreel, 1911–1967* (Norman: University of Oklahoma Press, 1972), 293. *Gung Ho!* (1943), the story of Carlson's Raiders and the Makin Island raid, stars Randolph Scott as a tough Marine training raw troops. It therefore anticipates *Sands of Iwo Jima,* but, unlike the 1949 film, it tolerates no shades of meaning.

The first flag-raising on Iwo Jima (and Ernest Thomas's role in it) is mentioned in a "historical note" in the opening credits of *Sands of Iwo Jima.* A further proof of the quest for fearless realism that inspired the filmmakers,

the reference is also an obvious afterthought. Thomas and the dual raisings play no part in the script, and one of Wayne's men is named "Thomas," suggesting that characters were named and filming completed before Ernest Thomas came to Grainger's attention.

18. Review, *Variety,* Dec. 14, 1949.
19. Shain, *Motion Pictures About War,* 317–320.
20. See trade ads, *Variety,* Aug. 3, 1949.
21. Roger Manvell, *Films and the Second World War* (New York: Delta, 1974), 241. Jeanine Basinger, *The World War II Combat Film: Anatomy of a Genre* (New York: Columbia University Press, 1986), 169–170. Suid, *Guts and Glory,* 9.
22. Bartlett, "John Wayne and 'The Sands of Iwo Jima'," 38. According to Bartlett, Wayne got 10 percent of the gross, or $380,000—a small fortune in 1949–50. Allen Eyles, *John Wayne and the Movies* (New York: Grosset and Dunlap, 1976), 17, 119. George Carpozi, Jr., *The John Wayne Story* (New Rochelle, N.Y.: Arlington House, 1972), 105. Broderick Crawford took the Oscar for his portrayal of the venal Southern governor in *All the King's Men,* a film Wayne loathed. Maurice Zoloton, *Shooting Star: A Biography of John Wayne* (New York: Pocket Books, 1979), photo.
23. Eyles, *John Wayne,* 17. Zoloton, *Shooting Star,* 256.
24. "Iwo Marine Officers Here for Premier," *San Francisco Chronicle,* Dec. 13, 1949. Ad and "Premier of 'Iwo Jima' on TV Tonight," ibid., Dec. 14, 1949.
25. See captioned stills from *Sands of Iwo Jima, San Francisco Chronicle,* Dec. 12, 1949. Stories on the Agar-Temple divorce appeared in the *Chronicle* regularly, beginning on Dec. 6, 1949. The Tucker case, too, proved to be long-running serial. E.g., "Forrest Tucker Sued," ibid., Dec. 14, 1949.
26. "Film Premiere Honors Iwo Jima," *San Francisco Chronicle,* Dec. 15, 1949.
27. "'Iwo Jima' Coast Preem," *Variety,* Dec. 7, 1949. Goodman, "From the Halls of Montezuma." Publicity pictures for the San Diego premiere show Marine brass in conference with Herbert J. Yates, the president of Republic; see *Motion Picture Herald* 177 (Dec. 10, 1949), 10. H.H.T., "'Sands of Iwo Jima,' Starring John Wayne." Coe, "'Iwo' Magnificent in Fighting Shots." Ad, Jan. 23, 1950, and Richard L. Coe, "'Iwo Jima' Making 3-Theater Splash," *Washington Post,* Jan. 24, 1950. "Marine Gets Key Staff Job," ibid., Jan. 25, 1950.
28. "Three Survivors of Flag-Raising on Iwo Jima Have Reunion Here," *Washington Star,* Jan. 24, 1950.
29. "Suribachi to Skid Row," *Newsweek,* Oct. 26, 1953, 44. "Ira Hayes—Our Accuser," *Christian Century,* 166. William Bradford Huie, *The Hero of Iwo Jima and Other Stories* (New York: Signet, 1962), 44.
30. "Welcome Iwo Jima Flag Raiser," *Chicago Tribune,* May 19, 1953; "Chicago Greets Indian Hero," *Chicago Sun-Times,* May 19, 1953.
31. Quoted in Marc Parrott, *Hazard: Marines on Mission* (Garden City, N.Y.: Doubleday, 1962), 219.
32. Jack McPhail, "Hero of Iwo Jima Starts His Comeback," *Chicago Sun-Times,*

Oct. 17, 1953; "Hero of Iwo Jima Jailed, Freed When Friends Pay Fine," *Chicago Tribune,* Oct. 16, 1953. Jack McPhail, "Iwo Jima Hero in New Battle For Comeback as Fund Grows," *Chicago Sun Times* Oct. 20, 1953. "Nation's Letters Bolster Iwo Jima Hero," ibid., Oct. 21, 1953; "Iwo Jima Hero Ready to Unfurl New Banner," ibid., Oct. 22, 1953. "Iwo Jima Hero Heads For New Job," ibid., Oct. 23, 1953.

33. "Dean Martin's Ex-Wife Gives Ira Hayes a Job," *Chicago Sun-Times,* Oct. 25, 1953; "War Hero Takes Job Here for Fresh Start," *Los Angeles Times,* Oct. 23, 1953. The recent Greenlease kidnapping in Kansas City had prompted many celebrities to take measures to protect their children. Letter from Hayes quoted in Huie, *Hero of Iwo Jima,* 58, 59. Rosenthal quoted in Gene McLain, "Ira Hayes Dies—Hero of Iwo Jima Flag Raising Bows to Old Foe," *Arizona Republic,* Jan. 25, 1955. The television show is also discussed in Rosenthal and Heinz, "The Picture That Will Live Forever," 67.

34. "Iwo Jima Hero Discovered in Stupor Here," *Los Angeles Times,* Nov. 3, 1953; "Hero of Iwo Jima Seized on Coast for Drunkenness," *Chicago Sun-Times,* Nov. 3, 1953. During Hayes's stay in L.A., the *Times* was covering John Wayne's divorce trial, in which excessive drinking on both sides played a major role; see, e.g., "Almost Shot Wayne after Night Out, Wife Testifies," Oct. 21, 1953.

35. Leon Uris, *Battle Cry* (New York: Bantam, 1954), 475.

8 · A Marine Corps for the Next Five Hundred Years

1. "Vandegrift Unveils Statue to Raising of Flag on Iwo Jima," *Washington Star,* Nov. 11, 1945.

2. "Sculptor Finances Iwo Statue, But GIs Donate Labor," *Washington Daily News,* Nov. 10, 1945. On March 1, 1946, Rep. Brooks Hays read the dedication speeches by Vandegrift and de Weldon into the *Congressional Record* 92, pt. 9 (79th Congress), A1083-84.

3. Laurence M. Olney, "The War Bond Story" (1971), 96–99, and Jarvis M. Morse, "Paying for a World War: The United States Financing of World War II" (ca. 1971), 281–284, typescripts in the library of the U.S. Treasury Department, Washington, D.C. Although organizers feared that postwar apathy might make it impossible to reach the $11 billion goal, the Victory Loan eventually took in more than $21 billion—the highest percentage of oversubscription of the entire war bond program.

4. "Vandegrift Unveils Statue," *Washington Star,* Nov. 11, 1945.

5. Undated document, "Previous Attempts to Abolish or Radically Modify the Marine Corps," USMC Museum, Personal Papers Section, Vandegrift Papers, Box 10 (these papers hereafter cited as VP, Box 10).

6. House Report no. 1645 (78th Congress), June 15, 1944, and Ferdinand Eberstadt to James Forrestal, Sept. 25, 1945, VP, Box 10. For other bills, see

Vandegrift's testimony before the Senate Military Affairs Committee, Oct. 30, 1945, VP, Box 10.

7. "Brief of Oral Presentation to President Truman," Dec. 9, 1946, VP, Box 10.

8. See memo, Commandant to All Officers, Aug. 6, 1947, VP, Box 10. The relationship between maintaining Marine autonomy and building the Marine Memorial did not cease with passage of the 1947 bill. Speaking before the board of the Marine Corps War Memorial Foundation only two years later, Col. J. W. Moreau stressed the "national security implications" of the project; see minutes for Nov. 21, 1949, USMC Museum, Personal Papers Section, Arthur B. Hanson Papers.

9. "Sculptor Finances Iwo Statue," *Washington Daily News,* Nov. 10, 1945; "Dedication of Iwo Statue Also a Tribute to Sculptor," *Quantico Sentry,* Nov. 8, 1951.

10. "Iwo Jima Statue Is Being Moved For Building," *Washington Star,* Nov. 14, 1947; "Iwo Jima Photo Contest Extended," *Washington Times-Herald,* Jan. 13, 1946. "Remember Iwo Jima" (caption under photo of General Cates placing a wreath at the statue), *Washington Post,* May 31, 1946; "Two Young Veterans Accused of Iwo Jima Statue Vandalism," *Washington Star,* Feb. 9, 1946.

11. De Weldon, interviews with Wetenhall, July 18, 1988, and June 20, 1989.

12. "The United States Marine Corps Memorial," brochure, USMC Museum, Reference Section, Folder: Memorials—Marine Corps War (Iwo Jima), "Fact Sheets/Brief Histories." The plan also included a reflecting pool and a huge amphitheater.

13. Thomas Hine, *Populuxe* (New York: Knopf, 1986), 10–14.

14. Maj. Gen. U. S. Grant III to Gilmore D. Clarke, Chairman, Commission of Fine Arts, Oct. 9, 1947, in National Archives, Record Group 66, Papers of the Commission of Fine Arts (hereafter cited as RG 66). Jackson E. Price, National Park Service, to Clarke, Sept. 23, 1947, and B. H. Griffin, Washington National Airport, to Commission of Fine Arts, Sept. 9, 1947, RG 66.

15. George Gurney, *Sculpture and the Federal Triangle* (Washington, D.C.: Smithsonian Institution Press, 1985). Sue A. Kohler, *The Commission of Fine Arts: A Brief History, 1910–1976* (Washington, D.C.: U.S. Government Printing Office, 1977). For correspondence advocating a limited competition, see RG 66.

16. Donald De Lue to Gilmore D. Clarke, Aug. 15, 1947, RG 66. Maurice Sterne to H. P. Caemmerer, Aug. 15, 1947, RG 66. Undated letter (ca. Aug. 1947) signed by William H. Coffee and nine other members of the American University faculty, RG 66.

17. Confidential memo, Wheeler Williams to James V. Forrestal, Feb. 28, 1946, RG 66. In a letter to Wetenhall, Sept. 19, 1989, the registrar of the National Portrait Gallery, London, Kai Kin Yung, states that the museum owns a bust of George V by Felix Weiss (see note 18). Yung also supplied a copy of Privy Purse Office, Buckingham Palace, to H. M. Hake, director of the National Portrait Gallery, May 10, 1935, asking Hake to accept the bust as a gift from

the artist: "An Austrian sculptor has executed a bust of the King, having been down at Eastbourne and sketched His Majesty whenever he went for a walk. As the King did not actually give a sitting, the Academy have refused to accept this bust."

18. In a letter to Wetenhall, May 12, 1989, Mag. Porges, the vice-director of the Akamedie der Bildenden Kunste, Vienna, states that although the name of Felix de Weldon does not appear in the school's records, a Felix Weiss was enrolled there between 1925 and 1930. The official transcript lists Weiss's date of birth as April 12, 1907—de Weldon's birthday, too.

19. Testimony of Col. J. R. Halford, Proceedings of the Commission of Fine Arts, Aug. 28, 1947, RG 66. Gilmore D. Clarke to Col. Halford, Oct. 30, 1947; Clarke to Adm. C. W. Nimitz, Dec. 1, 1947, RG 66.

20. De Weldon, interviews with Wetenhall, July 18, 1988, and June 20, 1989. "Huge Iwo Jima Statue Planned for D.C. Area as Marine Memorial," *Washington Evening Star,* Dec. 12, 1949.

21. The voluminous records of the Marine Corps War Memorial Foundation, including minutes of board meetings, are in the papers of the late Arthur B. Hanson, USMC Museum, Personal Papers Section. "Officer Is Seized in Marine Larceny," *New York Times,* June 1, 1951; "Ex-Marine Major Held in Iwo Jima Fund Theft," *New York World Telegram,* June 1, 1951.

22. Details are contained in the Hanson Papers, File: "Harry Dash."

23. According to a letter from Hanson to representatives of the Fireman's Fund Indemnity Co. and the American Security and Trust Co., Dec. 19, 1951, Dash had made off with $64,413.29. The bank was liable for over $40,000., leaving the bonding company responsible for the rest (paid in full). Threatening to involve the Foundation in prolonged litigation, the bank haggled its share down to an even $30,000, leaving a balance of $10,719.70. That is the amount Colonel Streeter covered (noting that the bank had behaved "very badly"). See Streeter to Hanson, Dec. 15, 1951, and Streeter to Hanson, Feb. 8, 1952, in Hanson papers. On her resignation, see board minutes for Feb. 26, 1952.

24. "Honorary Fireman Held in Theft," *New York Post Home News,* June 1, 1951. "Heard Around City Hall: Indictment of Dashing Marine Reservist Shows Up Phony Deputy Commissionership," *New York World Telegram,* June 8, 1951. "Admits Taking $41,000 from Marine Fund" and "Admits Theft of Funds for Marine Shaft," undated clippings from New York City newspapers (Nov., 1951) in Hanson Papers. Dash pleaded guilty to only one of nineteen felony counts.

25. Arthur B. Hanson to Irving W. Halpern, Chief Probation Officer, Jan. 12, 1952. Stanley D. Brown to Hanson, Feb. 5, 1952. The Foundation board minutes for June 21, 1951, quote Dash's lame explanation: "Not stolen, let's say I owe it. I considered it a loan. If the Washington bank had not cashed the checks, I would not be in this trouble. The bank is to blame." Decision by Hon. Saul S. Streit, Jr., in *New York vs. Harry R. Dash* (Case #1494/1951), Feb. 5, 1952. All in Hanson Papers.

26. See Shari Lawrence, "Iwo Jima: Looking Back on a Monument in the Making," *Pentagram* (Washington, D.C.), Nov. 8, 1984. Late in life, Santini claimed that he was responsible for 90 percent of the work on the monument—and for many other statues for which de Weldon took full credit. "Famed Sculptor's Aide Claims He's the Real Master," *Washington Star-News,* Nov. 12, 1974.

27. The vertical file for de Weldon in the National Museum of American Art Library, Smithsonian Institution, Washington, D.C., contains clippings with pictures of the sculptor "at work."

28. Blanche McKnight, "Versatile Sculptor," *Washington Sunday Star Magazine,* Feb. 13, 1949, 2–3; "Creator of Iwo Jima Statue," *Washington Star Pictorial Magazine,* Nov. 7, 1954; and biographical materials in the papers of Felix de Weldon, Newport, R.I. "Uncommon Valor Was a Common Virtue," *Washington Star Pictorial Magazine,* Feb. 21. 1954, 8.

29. "In Memory of Iwo Jima . . . The Marines' Own Statue," *Washington Star Pictorial Magazine,* Nov. 11, 1951, 2. Memo, Director of Personnel to the Commandant, Jan. 10, 1950; Memo, Lemuel C. Shepherd, Jr., to Commandant, Dec. 20, 1949; Memo, C. W. Harrison to Assistant Chief of Staff, Feb. 18, 1957. All in USMC Museum, Reference Section, Folder: Iwo Jima Memorial —Quantico.

30. "Unveiling of Iwo Statue Climaxes 176th Birthday," *Quantico Sentry,* Nov. 14, 1951. "Iwo Jima Flag Group Dedicated by Marines at Quantico Ceremony," *Washington Star,* Nov. 11, 1951.

31. De Weldon, interviews with Wetenhall, July 18, 1988, and June 20, 1989. "CG Praises Spirit of Iwo Flag Raisers," *Parris Island Boot,* Sept. 12, 1952. According to Jack Wetenhall, USMC Ret, the base cinema showed *Sands of Iwo Jima* often during this period, to cheering audiences. Other boot-camp favorites were *Back to Bataan* (1945) and *Guadalcanal Diary* (1943).

32. Letter from Don Maclean, "Ex-Marine Blushes for the Marines," *Washington Daily News,* Feb. 18, 1954. Documents outlining the various fund-raising plans and periodic audits of the Foundation's books are in the Hanson Papers.

33. "Nevius Tract Is Eyed for Parking," *Washington Post,* Jan. 25, 1954. "Nevius Tract Now Claimed by Marines," ibid., Jan. 26, 1954. Gen. James D. Hittle, interview with Wetenhall, Aug. 24, 1989. Concessions for the stone were buried in unrelated legislation. See "Tariff Reclassification of Dictaphones," Senate Report #1984, July 26, 1954, and "An Act to Declassify Dictaphones in the Tariff Act of 1930," House Resolution #8932, in USMC Museum, Reference Section, Folder: Memorials—Marine Corps War (Iwo Jima), "Marine Corps Memorial Foundation."

34. The new plan by the landscape architect Horace Peaslee also included a parade ground, a modest ceremonial entrance from the parking lot, and a ring road.

35. "Iwo Jima Statue Nearly Ready, Sculptor Says," *Washington Times-Herald,* Sept. 15, 1953. On the sculpting process, see C. Earl Hindsman, *The Iwo Jima*

Story (Washington, D.C.: privately published, 1953), 26–41. For a description of the trip, see Loy Baxter to Wallace E. Clayton, Sept. 8, 1954, in Hanson Papers. See also "Trailers with Iwo Jima Statue Inching Their Way to Capital," *Washington Evening Star,* Sept. 2, 1954.

36. "Historic Iwo Jima Flag-Raising Scene Arrives . . . in 100 Tons of Bronze," *Washington Post and Times-Herald,* Sept. 4, 1954; "Iwo Jima Statue Is Ready to Take Its Place among Washington's Famous Memorials," ibid., Sept. 6, 1954; "Cartridge Belt Provides 'Door' for Inside Job on Statue," *Washington Star,* Sept. 12, 1954.

37. Press release, Marine Corps War Memorial Foundation, Oct. 27, 1954, in Hanson Papers. Undated fact sheet attached to other dedication plans and announcements dated Nov. 8, 1954, USMC Museum, Reference Section, Folder: Memorials (Iwo Jima)—"Marine Corps Memorial Foundation."

38. Transcribed by Wetenhall from the print of *Uncommon Valor* in the collection of Felix de Weldon.

39. "Homage to the Marines," *New York Times,* Nov. 11, 1954. "Remarks of Felix De Weldon, Sculptor," Nov. 10, 1954, USMC Museum, Reference Section, Folder: Memorials—"Marine Corps War (Iwo Jima) Dedication Ceremony."

9 · It Didn't Really Happen That Way

1. William Bradford Huie, *The Hero of Iwo Jima and Other Stories* (New York: Signet, 1962), 63. "Then There Were Two," *Time,* Feb. 7, 1955, 16. Marc Parrott, *Hazard: Marines on Mission* (Garden City, N.Y.: Doubleday, 1962), 224.

2. "Flag Hero Found Dead: Cold and Excess Alcohol Killed Indian of Iwo Fame," *New York Times,* Jan. 25, 1955. Huie, *Hero of Iwo Jima,* 63. In a 1960 suit for infringement of his rights to the life of Ira Hayes, Huie claims to have been the only one to have uncovered the whole story of the manner of death; see Huie's affidavit, March 25, 1960, p. 4, in case 60 civ 1183, U.S. District Court, Southern District of New York, hereafter cited as *Huie v. NBC.* Despite that claim, others who did research in Arizona in the 1950s came to the same conclusion. John Bradley, too, clearly knew the truth; see transcript of videotape interview with Arnold Shapiro, 1985, p. 12, courtesy Arnold Shapiro Productions, Hollywood, Calif.

3. Jack Jonas, "Bugles Sound No More for Ira Hayes—Hero Finds Peace and Rest in Arlington," *Washington Star,* Feb. 2, 1955.

4. "Ira Hayes to Lie in State Here," *Arizona Republic,* Jan. 26, 1955. Don Dedera, "Pima Tribesmen Weep for War Hero Brother," ibid., Jan. 28, 1955. "In Memoriam," Feb. 2, 1955, *Congressional Record* 101, pt. 1 (84th Congress), 1073. "Bill Introduced Providing for Burial of the Six Participants in the Famous Iwo Jima Flag Raising Near Its Memorial," March 22, 1955, ibid., pt. 3, 3469. Unidentified clipping, "Ira Hayes Buried at Arlington Near Statue of Flag-Raising," Feb. 2, 1955, Arizona Historical Society, Tucson.

5. See photos of Gagnon, *Washington Star,* Feb. 2, 1955, and "Last Salute," *Arizona Republic,* Feb. 3, 1955. Gagnon quoted in Wes Barthelmes, "Ira Hayes Is Buried, Lies Near Generals," *Washington Post,* Feb. 3, 1955, and in Lawrence Malkin, "He Was a Hero to Everyone but Himself," *Washington Star,* Jan. 25, 1955.

6. Quoted in Gene McLain, "Ira Hayes Dies—Hero of Iwo Jima Flag Raising Bows to Old Foe," *Arizona Republic,* Jan. 25, 1955.

7. *New York Times,* Feb. 4 and 5, 1955.

8. Edwin H. Simmons, *The United States Marines, 1775–1975* (New York: Viking, 1976), 254. Douglas quoted in Huie, *Hero of Iwo Jima,* vii.

9. The *New York Times* announcement of Nov. 11, 1959, is among the exhibits submitted in *Huie v. NBC,* along with drafts of the TV script, the book of Huie's stories in which his Ira Hayes story first appeared, etc.

10. Merle Miller affidavit, p. 6, in *Huie v. NBC.* Unidentified clipping, "Ira Hayes Film Shooting Ends," ca. March 1, 1960, Arizona Historical Society, Tucson. "Recreating a Footnote to History: Lee Marvin Acts Out the Tragic Life of an Iwo Jima Hero," *TV Guide,* March 26, 1960, 12.

11. Unidentified clipping, "Pima Indians Protest NBC Television Show," Feb. 28, 1960, Arizona Historical Society, Tucson. "Aurthur's 'American' (Ira Hayes) an All-Location Refresher on Tape," *Variety,* March 16, 1960.

12. "Recreating a Footnote to History," *TV Guide,* 12, describes the Pima dispute solely from the NBC side of things. "Author Sues Network," *New York Times,* March 22, 1960; "NBC Court Rap on Ira Hayes Story," *Variety,* March 23, 1960.

13. By his own testimony, Huie's case hinged on his right to "facts" that he had actually invented or embellished: the number of watches Hayes accumulated on tour, the colloquial name of the Phoenix drunk tank, details of a scheme to recreate the flag-raising for tourists on the reservation. Because of the detail with which it isolates legitimate data from such dubious "facts," his affidavit is a valuable document for researchers trying to find the real Ira Hayes in Huie's pioneering studies. Miller admitted to reading Huie's work and to taking facts from it—as he had taken other information from a variety of other sources, published and unpublished. The judge did not believe, in the end, that Miller had copied material of such startling originality that the injunction should be issued.

14. Ad, *TV Guide,* March 26, 1960, A-21. "Judge Rules On Play," *New York Times,* March 26, 1960. Huie, *Hero of Iwo Jima,* viii.

15. Miller pitched the Hayes idea to *Argosy* in 1950; in 1958 he proposed it as a subject for TV's prestigious *Playhouse 90.* His first script outline was completed on Sept. 28, 1959. Huie's affidavit, p. 3, discusses Marine opposition to his project bitterly. In *Hero of Jima,* viii, however, he praises the Marine Corps for cooperating in the production of *The Outsider,* the film eventually made from his script.

16. The script calls Hayes's dead buddy "Nicholson" or "Nick." Another Sousley-

like figure, named "Sorenson," is a key figure in *The Outsider.* Quotations from *The American* script, pp. II-9–II-12, in *Huie v. NBC.*

17. Script, monologue to be spoken over rolling credits.
18. "Recreating a Footnote to History," *TV Guide,* 12.
19. "TV's Label of 'Phony' Brings Quick Defense of Iwo Jima Photo," *Washington Post,* March 28, 1960. Smith quoted in "Ira Hayes Story . . .," *Arizona Daily Star,* April 10, 1960. "Photographer Sues Network," *Denver Post,* Nov. 25, 1960. Joe Rosenthal, in an interview with Benis M. Frank, June 25, 1975, USMC Museum, Oral History Section, pp. 76–78, says that he dropped the suit after eighteen months when NBC offered a settlement, including an apology. To win the case would have taken years of expensive litigation, Rosenthal said, and in any event his suit "sort of killed the thing."
20. See review, *Variety,* March 30, 1960. Jack Gould, "Television: 2 Flags on Iwo, Marine's Story Centers on Historic A.P. Photo," *New York Times,* March 28, 1960.
21. "Ira Hayes Story . . .," *Arizona Daily Star,* quoting a story in the *Knoxville News Sentinel,* Feb. 28, 1955. An unidentified clipping, Cpl. Ira H. Hayes, "Story of Mt. Suribachi Told by Marine Hero" [1955], is in the Ira Hayes memorabilia collection of Phil Pusateri, El Toro, Calif.
22. Eric F. Goldman, *The Crucial Decade—And After: America, 1945–1960,* rev. ed. (New York: Viking, 1960), 316–323. Paul A. Carter, *Another Part of the Fifties* (New York: Columbia University Press, 1983), 110–111.
23. Paid $5,000 against $35,000 forthcoming only if Bartlett exercised his option to film the story, Huie had every reason to try to prevent NBC from stealing his market; see Huie affidavit, p. 5, in *Huie v. NBC.* Lawrence H. Suid, *Guts and Glory: Great American War Movies* (Reading, Mass.: Addison-Wesley, 1978), 166–168.
24. "Hollywood Raises Iwo Flag Again," *Denver Post,* Sept. 8, 1960. "Movie Will Portray Indian Hero's Life," *Phoenix Gazette,* Nov. 10, 1959. According to the title credits, Col. Clement Stadler was the Marine technical advisor assigned to the film.
25. Joe Finnigan, "Tony Curtis to Play U.S. Indian War Hero," *Denver Post,* Oct. 22, 1960. Ironically, the studio job Hayes got as a result of making *Sands of Iwo Jima* was with Columbia Pictures' Indian Education Department, a project aimed at depicting Indians as real people rather than as savages scalping settlers. But he swiftly drank himself out of the position; see Edward Linn, "Marine Ira Hayes: War Made Him—Peace Destroyed Him," *War Stories,* Spring 1965, 48–49, rpt. from *Saga,* June 1955.
26. "The Night They Lit Up the Marine Memorial," *Washington Post,* Feb. 25, 1962. The photo shows Tony Curtis, Curtis Le May, and Felix de Weldon at the base of the Memorial during the final phases of the filming. A. H. Weiler, "'The Outsider' Opens with Tony Curtis in the Starring Role," *New York Times,* Feb. 8, 1962. "'The Outsider'," *Variety,* Dec. 12, 1961. Rosenthal, interview with Frank, pp. 78–79, thought the film "took it all out of context." He

was especially distressed with the way in which both the TV show and the movie linked the death of Hayes to the flag-raising by the hero's dying gesture. Clyde Jeavons, with Mary Unwin, *A Pictorial History of War Films* (Secaucus, N.J.: Citadel, 1974), 239, also finds the script "muddy," with too many big issues—prejudice, alcoholism, patriotism, guilt—intermingled promiscuously.

27. Persistent and unfounded Iwo Jima folklore still puts one of the three dead flag-raisers in Ira Hayes's foxhole.

28. The plaque really hung in the Hayes home; see Paul Dean, "Pima Parents Still Mourn for Marine of Iwo Fame," *Arizona Republic,* May 25, 1969.

29. "Indian Heroes Visit City Hall," *Los Angeles Times* [1947], in the collection of Phil Pusateri.

30. Financial report, *Variety,* Feb. 14, 1962. "She's 'Outsider' Inside," *Washington Post,* March 1, 1962.

31. Lyrics by Peter LaFarge, © 1962, 1964, used by permission of Edward B. Marks Music Company (all rights reserved). The album, *Bitter Tears,* consisted of songs written by Cash and LaFarge. "The Ballad of Ira Hayes" was not well received by the Indian community in Arizona; see editorial and letter to the editor by Frank Tyndall, *Mesa Tribune,* Jan. 9, 1975. Joe Grandee's 1965 painting *Ira Hayes: The Dream and the Reality* (see illustration, p. 187) gives final form to the mythic Hayes, an Indian warrior astride a painted pony with the Rosenthal scene faintly visible in the sky above. It is the visual equivalent to Cash's ballad; see "Ira H. Hayes Canvas Has Pima Setting," *Marine Recruiting Notes,* Feb. 1965, and *True West,* Jan.-Feb. 1971, 5.

32. Rosenthal, interview with Frank, p. 80, and USMC Museum Reference Section, personnel file for Rene Gagnon. See, e.g., Gagnon's remarks at the dedication of a VA hospital in Elizabethtown, Tenn., in Rene Gagnon, "I'll Always Remember . . .: Two Men on Iwo," *Washington Post-Times Herald,* Feb. 23, 1959. "Iwo Jima Flag-Raising Re-enacted in Times Square," *New York Times,* Feb. 24, 1962.

33. "Back to Suribachi for Ex-Marine," *Christian Science Monitor,* Feb. 13, 1965; "Iwo Jima Flag Raiser Selects Trip to Pacific as Contest Prize," *Navy Times,* Dec. 28, 1964. Robert Trumbull, "20th Anniversary of Iwo Jima Battle is Marked," *New York Times,* Feb. 20, 1965. A photo, ibid., Feb. 26, 1965, shows Gagnon visiting Mrs. Kuribayashi again on the way home and presenting her with a rock from Mount Suribachi. Gagnon's last major public appearance came in Washington in 1975; see "Ford Salutes Marine Corps on Its 200th Birthday," ibid., Nov. 11, 1975.

34. Jim Leusner, "Corps Hushed First Raising, Says Flagman in 2nd Photo," *Jacksonville* (Fla.) *Times Union,* March 10, 1978. David Seifman, "Iwo Hero Is Fired on Memorial Day," *New York Post,* May 31, 1978. "Ex-Iwo Jima Marine Dismissed From Job," *New York Times,* May 31, 1978. Bradley, interview with Shapiro, p. 12, says of Gagnon and Hayes: "They were both sad situations, you know . . . Gagnon had a few problems—I'd rather not comment."

35. Mary Elson, "For Flag Raisers at Iwo Jima, Fame Carried Heavy Price," *Sentinel Star* (Orlando, Fla), Oct. 29, 1979. "Rene Gagnon, of Iwo Fame, Dies," *Manchester Union-Leader,* Oct. 13, 1979; "The Last Marine at Iwo Has Fallen," *New York Post,* Oct. 13, 1979; and "Rene Gagnon Dead; Flew Iwo Jima Flag," *New York Times,* Oct. 13, 1979. Mrs. Rene Gagnon to Commandant, USMC, Jan. 22, 1981, USMC Museum Reference Section, personnel file for Rene Gagnon. "Tribute to Rene Gagnon," Dec. 20, 1979, *Congressional Record* 125, pt. 28 (96th Congress), 37564.
36. Cpl. Liz Kelley, "A Proper Tribute," *Dixie Digest,* April 1981, 2.
37. Sara Revell quoted in Tom Bartlett, "Marines Don't Forget," *Leatherneck* 68 (Feb. 1985), 37. See also "Iwo Jima Hero Is Forgotten," *St. Petersburg Times,* March 7, 1978, for the origins of the project. The boyhood friend was James S. Sledge, a Monticello dentist, who was the prime mover behind the creation of the monument. Sledge, quoted in Kelley, "A Proper Tribute," 2.

 Monuments to other raisers were also erected in the 1980s, Strank's in Franklin, Pa. (1986), and Sousley's near his home in Kentucky (1984); see "Marker Dedicated to Iwo Flag Raiser," *Leatherneck* 69 (Oct. 1986), 61–62, and "Kentucky's Iwo Jima Memorial," ibid. 68 (Feb. 1985), 30–31. After a long period of misidentification, the reburial of Block in Texas was also a major a event; see "Thousands View Hero's Reburial," *San Antonio Evening News,* Jan. 24, 1949. In recent years, there has been talk of moving Block's grave to Harlingen, Tex., to the site where the plaster model from which the Memorial was cast has been reinstalled.

10 · The Business of Remembering

1. "Public Sculpture in U.S.A. Deplored," *New York Times,* March 31, 1955. The full headline above the photo read: "'Esthetic Numbness' in Official War Monuments Is Criticized." Charlotte Devree, "Is This Statuary Worth More Than a Million of Your Money?" *Art News* 54 (April 1955), 34. Letter to the editor from Ingrid Paddock, *Washington Post,* April 21, 1955.
2. Paul Fussell, *The Boy Scout Handbook and Other Observations* (New York: Oxford University Press, 1982), 232.
3. "Did You Happen to See: Felix de Weldon," *Washington Times-Herald,* March 31, 1950. The artist's degrees are so listed in *Who's Who in America,* for instance, and in an undated biography compiled by curator Lisa Oshins for an unspecified exhibition, in the papers of Felix de Weldon, Newport, R.I. For his educational background and his portrait of the king, see Chapter 8, notes 17, 18. C. Earl Hindsman, *The Iwo Jima Story* (Washington, D.C.: privately published, 1955), 45.
4. Undated poem by Ann Love, in papers of Felix de Weldon. Clippings and other documentation on de Weldon's career may be found in the Office of the Curator, United States Capitol; USMC Museum, Reference Section; and the vertical files of the National Museum of American Art Library. "Felix de

Weldon, 1907–," *Washington Post Magazine,* Oct. 16, 1982, cites 33 bronze monuments in Washington, D.C., and 1,200 other works.

5. C. W. Harrison to Assistant Chief of Staff, G-3, Dec. 14, 1956. De Weldon wanted $48,000 for a bronze or stone piece; cast cement would cost less; see de Weldon to Lt. Col. John H. Magruder, Jan. 15, 1957. Maj. Gen. H. L. Litzenberg to Commandant of the Marine Corps, Nov. 19, 1956. Gen. Wallace M. Greene, Jr. to Commanding General, Marine Corps Recruit Depot, Nov. 5, 1956. All these documents in USMC Museum, Reference Section, Folder: "Parris Island—Iwo Jima Memorial."

6. C. E. Mundy, Jr., to Assistant Commandant, Sept. 18, 1970, USMC Museum, Reference Section, Folder: "Iwo Jima Monument, Cape Coral, Florida."

7. "Iwo Jima May Move to Cape Bank," *Fort Myers News Press,* April 31, 1980.

8. "Host of Dignitaries Attend Dedication at Rose Gardens of Iwo Flag-Raising Statue," *Cape Coral Breeze,* June 17, 1965. "Dedication of Sculpture 'The Flag Raising at Iwo Jima'," *Congressional Record* 111, pt. 12 (89th Congress), 15946.

9. "Iwo Jima May Move," *Fort Myers News Press,* April 30, 1980, and Michael Geml, interview with Wetenhall, Sept. 13, 1989. "Iwo Jima Memorial Dedication Postponed," *Fort Myers News Press,* undated clipping in papers of Michael P. Geml, Cape Coral. Many memos discussing possible Marine acquisition of the statue in 1970 are in USMC Museum, Reference Section, Folder: "Iwo Jima Monument, Cape Coral, Florida."

10. "Iwo Jima Monument Grounds Have a Darker Attraction," *Washington Post,* Oct. 7, 1976. "Gone Are Brambles and Bushes at Iwo Jima Gay 'Battlefield'," *Washington Star,* Oct. 23, 1976.

11. "Japs Are Profiting from a Loss," *Washington Daily News,* July 8, 1959.

12. The cartoons by Conrad and Locher, dated only as to year of publication, are in USMC Museum, Curatorial Section, Works on Paper Collection.

13. Kienholz described his intentions for the *Portable War Memorial* at length in a letter to *Artforum* 7 (Summer 1969), 4–5. See also James M. Mayo, *War Memorials as Political Landscape: The American Experience and Beyond* (New York: Praeger, 1988), 264–265.

14. Letter to the editor from Robert Witz, *Artforum* 7 (March 1969), 4. Kienholz letter, *Artforum* 7 (Summer 1969), 5.

15. Karal Ann Marling and Rob Silberman, "The Statue Near the Wall: The Vietnam Veterans Memorial and the Art of Remembering," *Smithsonian Studies in American Art* 1 (Spring 1987), 4–29, analyzes the controversy.

16. James H. Webb, Jr., "Reassessing the Vietnam Veterans Memorial," *Wall Street Journal,* Dec. 18, 1981. Testimony of Tom Carhart before the Commission of Fine Arts, Washington, D.C., Oct. 13, 1981, in the files of the Commission. For discussion of the political action leading to the addition of a statue, see Jan C. Scruggs and Joel L. Swerdlow, *To Heal a Nation* (New York: Harper and Row, 1985), 76–111. James Watt to J. Carter Brown, Chairman of the Commission of Fine Arts, Feb. 25, 1982, in the files of the

Commission, indicates that proponents of the statue anticipated a single figure—"a statue of an American soldier."

17. Karal Ann Marling and John Wetenhall, "The Sexual Politics of Memory: The Vietnam Women's Memorial Project and 'The Wall'," *Prospects: An Annual of American Cultural Studies* 14 (1989), 341–372.

18. Cartoons: Iwo Jima cartoon file, USMC Museum, Curatorial Section, Works on Paper Collection, and collection of Paul Conrad, Los Angeles.

19. North First Bank press release, April 29, 1980, USMC Museum, Reference Section, Folder: "Iwo Jima Memorial Statue, Florida, 1980." "Proud Soldiers to Get Facelift and a New Place of Honor," *Cape Coral Breeze,* April 29, 1980.

20. First estimates put repair costs at $15,000, but de Weldon's revised estimate quickly ballooned to $58,000 (of which $48,000 was earmarked for repairs). His bill for a brand-new statue on the existing base would have been $36,000. See Michael P. Geml to Alfred M. Johns, July 7, 1980, and Cape Coral North First Bank press release, Aug. 4, 1980, in papers of Michael Geml.

21. Marine Corps press release, Jan. 28, 1981, and Geml to Farrell R. Broyles, "Progress Report—Iwo Jima Monument," in papers of Michael Geml. Marine Corps press release, June 9, 1981, USMC Museum, Reference Section, Folder: "Iwo Jima Memorial Statue, Florida, 1980."

22. "Iwo Jima and a Rain of Memory," *Washington Post,* Oct. 7, 1981. "Marines and the Miracle of a Monument," *Retired Officer* 10 (Feb. 1984), 30–31. An unidentified brochure, "The Texas Iwo Jima Memorial," contains an itemized list of expenses totaling $338,160: USMC Museum, Reference Section, personnel file for Felix de Weldon. George W. Strake, Jr., to Brig. Gen. E. H. Simmons, undated letter, also in personnel file for de Weldon.

23. See Jim Shillinburg, "Convoy Diary: Moving a Monument across the U.S.," *Harlingen Valley Morning Star,* April 17, 1982.

24. "Texas Iwo Jima Memorial Edition," *Harlingen Valley Morning Star,* April 17, 1982.

25. The records of the Marine Corps Scholarship Fund are in the USMC Association Papers, Quantico, Va. Brig. Gen. Edwin H. Simmons, "Dr. De Weldon's Iwo Jima Statues," *Fortitudine,* Fall 1981–Winter 1982, 5. "Victory at Iwo Jima," *Leatherneck* 68 (Feb. 1985), 1.

26. Fran Manucci, interview with Wetenhall, June 16, 1988.

27. Steve Benson, "Lebanon," *Arizona Republic,* Aug. 30, 1983; Steve Kelly, "U.S. Marine Corps Monuments . . . ," *San Diego Union,* 1983; Wright, untitled cartoon, *Miami News,* 1987; Scott Willis, "Raising the Flag over California," *San Jose Mercury News,* 1989; and Clyde Wells, "The War on Drugs," *Augusta Chronicle,* 1988. All these in Iwo Jima cartoon file, USMC Museum, Curatorial Section, Works on Paper Collection. Bill Schoor, "Defense Contractor Overcharges," for *Kansas City Star,* rpt. *Washington Post,* Aug. 20, 1988.

28. The international popularity of de Weldon's statue in the 1970s and 1980s led to a flurry of new commissions for overseas monuments and huge projects in the United States. The latter included another Iwo Jima memorial for a

military school in New Mexico and a still unbuilt Korean War Memorial for the West Coast, projected to be as large as the Arlington statue.

29. The case in question was *Texas v. Johnson* of 1989. Paul Conrad, "Monument to the First Amendment," *Los Angeles Times,* June 23, 1989.

11 · D+Forty Years: A Gathering of Heroes

1. "Back to the Sands of Iwo Jima," *Newsweek,* March 4, 1985, 38.

2. Walter J. Ridlon, Jr., Robert E. Hoskins, and Ed Harloff, "A History of the 1985 Return to Iwo Jima" (San Diego: 4th Marine Division Association, 1985), typescript. See also "Iwo Jima—No Price Was Too High," *San Francisco Chronicle,* Feb. 19, 1985. Joseph A. Reaves, "Back to the Sands of Iwo Jima," *Chicago Tribune,* Feb. 24, 1985. American government and military officials expected the 1985 trip to be the last such observance. The island had been returned to Japan in 1968, and there was considerable Japanese resistance to the "return"; see e.g., Coast Guard memo, Lt. Jon Allen to "All Hands," Feb. 13, 1985, in the papers of Jon Allen, Alexandria, Va., discussing the historic nature of the upcoming ceremony.

 Many Marines who fought on Iwo Jima had joined the Corps in their early teens, with or without parental permission; see Anthony Muscarella, *Iwo Jima: The Young Heroes* (Memphis, Tenn.: Castle Books, 1989). This accounts for the relative youth of many of the returnees.

3. E. S. Browning, "Forty Years after the Bloody Battle, Iwo Jima Still Moves Returning Marines," *Wall Street Journal,* Feb. 20, 1985. [Lt. Jon Allen], "Iwo Jima Guidebook," typescript, in papers of Jon Allen. Robert E. Hoskins, "Iwo Jima—D-Day Forty Years Plus," typescript (ca. Feb. 1986), pp. 4–5, in papers of Robert E. Hoskins, Carlsbad, Calif., contains a detailed biography of Wachi. John M. Lee, "Japanese Search Pacific Isles for Bones of War Dead," *New York Times,* March 15, 1972.

4. Hal Drake, "Iwo and the War That Passed This Way," *VFW,* Sept. 1984, 38, estimates that 7,000 Japanese who fought on Iwo are still unaccounted for. Jim Lea, "Successful Iwo Return Owes to Hard Work," *Pacific Stars and Stripes,* Feb. 25, 1985. Jim Lea, "Iwo Jima Duty: Life on a 'Slice of Pie'," ibid., March 2, 1985.

5. Lucian Caste, *The Return to Iwo Jima: 1945 to 1985* (Pittsburgh: privately published, 1985), 14. Sam Jameson, "Old Foes Mark Bloody Battle for Iwo Jima," *Los Angeles Times,* Feb. 20, 1985. Browning, "Forty Years after Bloody Battle." "Forty Years after the Battle, 200 Marines Make a Return Trip to the Sands of Iwo Jima," *People Weekly,* March 11, 1985, 101. Reaves, "Back to the Sands of Iwo Jima."

6. Jim Lea, "The Return to Iwo Jima: 'You Can Almost Feel the Ghosts'," *Pacific Stars and Stripes,* Feb. 21, 1985. Text of Pasanen's prayer in the papers of Lucian Caste, Pittsburgh, Pa.

7. Jon D. Allen, interview with Marling, Jan. 12, 1989. Text of commemorative

message by Vice Admiral Koga in papers of Lucian Caste. Text of remarks by Lt. Gen. Charles G. Cooper in papers of Ed Harloff, Encinitas, Calif.

8. Robert E. Hoskins, interview with Marling, Feb. 17, 1989. Arnold Shapiro, "The 38th Anniversary of Iwo Jima," *Los Angeles Times,* March 5, 1983.

9. See, e.g., "Rust in Peace," *New York Times,* Dec. 10, 1978; Robert Trumbull, "20th Anniversary of Iwo Jima Battle Is Marked, Services on the Island Honor U.S. Dead—Japanese Also Remembered," ibid., Feb. 20, 1965; Joe Rosenthal, "Iwo Jima Marines' '45 Triumph; Forces on Pacific Isle Join in Tribute," ibid., Feb. 20, 1955. Such ceremonies were minimized after control of the island was turned back to Japan in 1968; the American flag came down on Mount Suribachi and was replaced by a copper replica added to the existing monument.

10. Ed Harloff to Prime Minister Nakasone, April 20, 1983, in papers of Ed Harloff. This letter was drafted by Shapiro. "Foes in War, Friends in Peace, 'Return to Iwo Jima' by Arnold Shapiro," press release [1984], Arnold Shapiro Productions, Hollywood, Calif. "Arnold Shapiro Productions Presents 'Return to Iwo Jima' with Host Mr. Lee Marvin," press release [1983–84], in papers of Jon D. Allen. Ed McMahon hosted the program in the end.

11. Hoskins interview, Feb. 17, 1989.

12. Rubbing, in the papers of Ed Harloff. Arnold Shapiro, interview with Marling, Dec. 28, 1988, discussed his pride in the authorship of the inscription.

13. Quotations from the speech delivered at the Reunion of Honor by Walt Ridlon, Jr., a member of the three-man California organizing committee, tape in the collection of Walter Ridlon, Jr., Vista, Calif.; and from a poem written by Eleanor Tharalson on the reunion trip, in the papers of Ed Harloff.

14. Richard Matthews, "Nobility of Iwo Jima Vets an Example for Leaders," *Atlanta Journal,* Feb. 22, 1985. Arnold Shapiro Productions, *Return to Iwo Jima,* broadcast nationally on PBS, Memorial Day, 1985. We are grateful to Mr. Shapiro for making a videotape of this program available to us. "'Handshake of Peace' on Iwo Jima," *San Francisco Chronicle,* Feb. 20, 1985. Browning, "Forty Years after Bloody Battle."

15. E.g., Caste, *The Return to Iwo Jima,* 18, on the death of a friend. Reaves, "Back to the Sands of Iwo Jima," *Chicago Tribune,* Feb. 24, 1985. Jameson, "Old Foes Mark Bloody Battle for Iwo Jima," *Los Angeles Times,* Feb. 20, 1985.

16. "Forty Years after the Battle," *People Weekly,* 99. Grover Groves and Lyle Harris, quoted in Jim Lea, "Steps up Suribachi: Reliving Iwo Jima," *Pacific Stars and Stripes,* Feb. 19, 1985. Shapiro, *Return to Iwo Jima.*

17. Unidentified clipping, "U.S., Japanese Veterans Revisit Iwo Jima," *The Post,* Feb. 20, 1985, in papers of Jon D. Allen. Reverend Pasanen in Shapiro, *Return to Iwo Jima.* Scott Thurston, "'So Many Crosses': 40 Years Ago the Marines Fought a Savage Battle for a Speck in the Pacific Called Iwo Jima," *Atlanta Journal,* Feb. 17, 1985.

18. Kevin Leary, "Heroes of Iwo Jima Honored in Bay Area," *San Francisco*

Chronicle, Feb. 20, 1985. "Remembering the Terrible Toll of Iwo Jima," *Stars and Stripes,* Feb. 21, 1985. Liz McLean, "Tears for Iwo Jima's Fallen," *USA Today,* Feb. 20, 1985. Larry Ryan, letters to Wetenhall, Sping, 1989.

19. Lea, "Steps up Suribachi." "The Veterans Speak," press release [1985], Arnold Shapiro Productions. "Back to the Sands of Iwo Jima," *Newsweek,* 38. Shapiro, *Return to Iwo Jima.*

20. Henry Berry, *Semper Fi, Mac: Living Memories of the U.S. Marines in World War II* (New York: Arbor House, 1982), 301–302. "Medal Goes Begging," *New York Times,* Dec. 29, 1979. Reaves, "Back to the Sands of Iwo Jima."

21. See Studs Terkel, *"The Good War": An Oral History of World War II* (New York: Ballantine, 1984), 179. Walter Friedenberg, "Vietnam Report Says Casualties, Not Press, Lost the War at Home," *Minneapolis Star Tribune,* Sept. 8, 1989.

22. Walter Ridlon, Jr., interview with Marling, July 26, 1989. *Leatherneck* runs special reunion pages; see, e.g., *Leatherneck* 68 (Jan. 1985), 5, or 67 (Feb. 1984), 26.

23. Lee Kennett, *G.I.: The American Soldier in World War II* (New York: Warner Books, 1987), 229–239, provides a searching analysis of the 40th reunion of the 84th Infantry Division of the U.S. Army. The important distance between the remembered mythology of war and its reality is a theme of Paul Fussell, *Wartime: Understanding and Behavior in the Second World War* (New York: Oxford, 1989).

24. See, e.g., "Joe Rosenthal Honored," *New York Times,* March 26, 1957, and "Iwo Jima Memorial Service," ibid., July 20, 1959. Robert Leckie, review of Richard Newcomb's *Iwo Jima, New York Times Book Review,* Feb. 21, 1965, 7. Ernest A. Lotito, "Those Who Were There Recall Iwo Jima, Where 6821 Americans Died in 1945," *Washington Post,* Feb. 19, 1965.

25. Sgt. Raymond Braud, "Iwo Jima Veterans Reunite," *Dixie Digest* 26 (March 1988), 3. Herb Richardson, "Iwo Jima," *Leatherneck* 63 (Feb. 1980), 12.

26. Robert Trumbull, "Iwo Jima: Isolated Outpost for Americans and Japanese," *New York Times,* Dec. 16, 1979. Hoskins interview, Feb. 17, 1989. Japanese skulls taken by American troops also continue to cause friction between the two governments. After the Reunion of Honor and some public discussion of the distress felt by relatives of the deceased, a number of skulls and other spoils of war turned up anonymously at the California office of the reunion organizers. Browning, "Forty Years after Bloody Battle."

27. Jameson, "Old Foes Mark Bloody Battle." Caste, *The Return to Iwo Jima,* 19.

28. Bill Steele to Dave Severance, Feb. 24, 1988, in papers of Dave E. Severance, La Jolla, Calif. Shapiro, *Return to Iwo Jima.*

29. Shapiro, *Return to Iwo Jima.*

30. Ridlon, Hoskins, and Harloff, "A History of the 1985 Return to Iwo Jima," final page.

Illustration Credits

page 186 Bill Bridges photo, Tony Curtis Collection, Department of Special Collections, University Research Library, UCLA; © Universal Pictures, used by permission

187 National Archives

189 Karal Ann Marling photo

190 *Leatherneck*

191 Kentucky Historical Society

192 Roger Kerekes photo; Johnstown *Tribune-Democrat*

193 James S. Sledge

197 *Baltimore News American*

201 Michael P. Geml collection

203 Museum Ludwig; Rheinisches Bildarchiv photo

205 Karal Ann Marling photo

209 Michael P. Geml collection

211 *Leatherneck*

212, top Brig. Gen. James D. Hittle, Army and Navy Club

212, bottom John Wetenhall photo

213 Marine Corps Scholarship Fund; *Leatherneck*

215 John Wetenhall photo

216, top © Scott Willis; *San Jose Mercury News,* used by permission

216, bottom © Clyde Wells; *Augusta Chronicle,* used by permission

217 Joe Bensen photo

218 © Paul Conrad; *Los Angeles Times,* used by permission

219 David Valdez photo; the White House

220 Arnold Shapiro Productions, Inc.

222, top Ashley Wilkes photo; collection of Karal Ann Marling

222, bottom United States Marine Corps photo; Ed Harloff

225 United States Marine Corps photo; Ed Harloff

227 Arnold Shapiro Productions, Inc.

228 Arnold Shapiro Productions, Inc.

Acknowledgments

We never planned to write a book about Iwo Jima. The subject kind of ambushed two virtual strangers late one Friday afternoon in 1987. We were sitting at opposite ends of the office we temporarily shared, trying to make polite conversation. Did we have anything in common, anything to talk about? Much to our delight, we did. Both of us had written about American public sculpture. Both of us had recently taken an interest in the Vietnam Veterans Memorial in Washington, D.C., and in fresh efforts to add a statue of a combat nurse to the grouping. According to the papers, the Women's Memorial Project was based in the neighborhood. We decided to take a look. Maybe we could work on the nurse together. And so we began.

Now whenever historians really get into it, precedents are bound to creep into the conversation. In the case of the proposed realistic supplements to the abstract Vietnam monument, we kept coming back to the Marine Corps Memorial at Arlington Cemetery. But, amazingly enough, there seemed to be almost nothing in print on the statue. That fact in itself intrigued us, given the massive presence of the piece and its derivation from what was, perhaps, the most famous combat photograph of World War II. Here was a matter worth looking into. We spent an afternoon talking Iwo Jima with Chuck Lindberg, a Minneapolis retiree who had raised the first American flag over Mount Suribachi, a couple of hours before the famous photo was snapped. Just as there were other raisings, other photographs, so there were other Iwo Jima memorials, he told us, rummaging through his snapshots: somebody ought to set the record straight.

A friend mentioned that he had seen a television special about Iwo Jima. We were sort of working on Iwo Jima, weren't we? He didn't remember when he had

seen the show, but Ed McMahon was in it. That much was certain. Yes, Mr. McMahon had appeared in such a program, and he provided an introduction to the producer, Arnold Shapiro. Yes, Mr. Shapiro had done a documentary following a group of American and Japanese veterans who went back to Iwo Jima in 1985, on the fortieth anniversary of the battle. And he graciously supplied videotape, transcripts, photographs. He consented to a long interview. From Hollywood, he sent formidable lists of names and addresses: the three vets from San Diego who had organized the "Return to Iwo Jima," the Coast Guard officer in command of the American base there, a man in Minneapolis who had been in on the original and all-but-forgotten flag-raising. Our old friend, Chuck Lindberg!

New friends soon emerged from Shapiro's directory of names. Lt. Jon Allen of the Coast Guard, now based in Washington, led the list. He talked to us by the hour, lent his pictures and his own poetry, boxes of clippings, postcards, maps of the island, and taught us to share his reverence for the monuments to the Japanese war dead that now dot Iwo Jima's inhospitable terrain. Bob Hoskins, Ed Harloff, and Walt Ridlon wrote and called from California, offering to share their reminiscences of the big trip back to the Pacific. And did we know about Marine Corps reunions? they asked. Would we like to come and meet the guys and ask questions in person? In February of 1989, on the forty-fourth anniversary of the battle, we found our own forces split between Mobile, Alabama, where an All-Iwo reunion was in progress, and the NCO Club at Camp Pendleton, where the annual Iwo Jima Commemorative Banquet opened with a moving sunset salute to those who had fought there.

Both trips were memorable. At the airport in San Diego, the recognition signal was a copy of Bill Ross's *Iwo Jima*—the one with the bright red cover. The color matched the intensity of the days ahead. A search for the place where John Wayne's crew had built a make-believe Mount Suribachi for a movie. A look at Ed Harloff's collection of memorabilia and war souvenirs. Major Hoskins playing innkeeper and chauffeur. Endless talk about 1945 and 1985: whose idea *was* the "Return to Iwo Jima"? Who went? Why? Copying documents. Meeting Marine brass. An appointment for a chat with Lucian Caste of Pittsburgh, who kept a marvelous journal during the 1985 Return and brought his album of pictures to share. A chance meeting with Phil Pusateri, a high school teacher from El Toro, California, who became the resident expert on the biography of the flag-raiser Ira Hayes while researching American lives his class might find absorbing.

In Mobile, it was much the same. Dave Carey, Tom Cottick, Jim Westbrook, Bill Bouthiette, Colonel Ridlon: men talked about what had happened to them on Iwo Jima and how they felt about it now. They talked about war memorials and war movies and the meaning of heroism, as they saw it. They talked about Vietnam, about how war and people's attitudes toward armed conflict had changed. About the Japanese—the old enemy. About their hopes for peace. It was hard and it was often painful. The veterans who opened their memories to us did so, at great personal cost, because they thought their stories were worth remembering.

Iwo Jima counted. There were lessons to be learned from what they had done in the days of their youth.

It was the veterans of Iwo Jima—many of them unnamed here—who defined the issues we have tried to explore. In the attempt, we enlisted the help of other vets, their widows, and their children; of geographers, musicologists, movie buffs, historians, archivists, and librarians; cartoonists and news photographers; a builder of parade floats; a banker; several retired Marine generals; our colleagues and students; even our fathers. The inventory of those who put themselves to considerable trouble on our behalf runs to five densely spaced pages. Their names all appear in the notes and credits, but the wholehearted cooperation of several individuals and institutions proved vital to our research. We are, therefore, especially grateful to Felix de Weldon and to Doris Lowery, the widow of Marine combat photographer Lou Lowery; to *Leatherneck,* the Marine Corps magazine, and its helpful editors; to the United States Marine Corps Historical Center at the Washington Navy Yard; to Al Hemingway; to Harrold Weinberger, Bud Lesser, and James D. Hittle; to Bill Steele, Dave Severance, Father Chuck Suver, Ed Fox, and Larry Ryan; to Fran Manucci; to Wendy Owens, Cori Ander, Steve Benson, and Tom Trow; to the late Arthur B. Hanson; and to Sherman B. Watson.

Our feelings about this book are, in large part, indistinguishable from our feelings about those who helped us see through the smoke of battle that once obscured the beachhead, through the mists of time that have colored and reshaped the living memory of Iwo Jima. Nobody said no. Nobody so much as hesitated. People laid out the most intimate details of their lives for our inspection. People cried—and we cried with them, more often than not. We hope this book does justice to the depth and the urgency of their emotions.

Lindsay Waters, our editor and erstwhile commanding officer at Harvard University Press, was unruffled when a study of a war memorial turned into something else. We are also indebted to the Graduate School of the University of Minnesota and to the National Museum of American Art, the Smithsonian Institution, for materiel and logistical support.

Finally, we need to say a word about the pleasures of collaboration, about writing separate chapter outlines for the book and then discovering, in the D.C. watering hole that served as our field headquarters, that we had come up with the same topics, arranged in precisely the same order. Each of us could have written a book about Iwo Jima—but not *this* one. Because we could debate every point, because we saw every fact twice, but most of all, because we could trust in an emotion when two of us felt it with equal intensity, this is a book that could not have been finished alone. It belongs to both of us and to the men and women who lived the stories we have to tell.

Index